DEFINITIVE STATEMENTS

DEFINITIVE STATEMENTS

AMERICAN ART: 1964-66

An Exhibition by the
Department of Art, Brown University

David Winton Bell Gallery
List Art Center
Brown University
Providence, Rhode Island
March 1-30, 1986

The Parrish Art Museum
Southampton,
Long Island, New York
May 3-June 21, 1986

Previous exhibitions of the Department of Art, Brown University, and the Museum of Art, Rhode Island School of Design.

Early Lithography, 1800—1840
 26 March—19 April 1968

The Portrait Bust: Renaissance to Enlightenment
 5—30 March 1969

Jaques Callot, 1592—1635
 5 March—11 April 1970

Caricature and Its Role in Graphic Satire
 7 April—9 May 1971

To Look on Nature: European and American Landscape, 1800—1974
 3 February—5 March 1972

Drawings and Prints of the First Maniera, 1515—1535
 23 February—25 March 1973

Europe in Torment: 1450—1550
 6 March—7 April 1974

Rubenism
 30 January—23 February 1975

The Classical Spirit in American Portraiture
 6—29 February 1976

Transformations of the Court Style: Gothic Art in Europe, 1270—1330
 2—27 February 1977

The Origins of the Italian Veduta
 3—26 March 1978

Festivities: Ceremonies and Celebrations in Western Europe, 1500—1790
 2—25 March 1979

Ornament and Architecture: Renaissance Drawings, Prints and Books
 8 March—6 April 1980

Edouard Manet and "The Execution of Maximilian"
 21 February—22 March 1981

All the Banners Wave: Art and War in the Romantic Era, 1792—1851
 26 February—28 March 1982

Gold Jewelry: Craft, Style and Meaning from Mycenae to Constantinopolis
 25 February—3 April 1983

Children of Mercury: Education of Artists in the Sixteenth and Seventeenth Centuries
 2—30 March 1984

Ladies of Shallot: A Victorian Masterpiece and Its Contexts
 23 February—23 March 1985

Partial financial support for this catalogue has been provided by the Endowment Gift of Mr. and Mrs. Edward Goldberger and by the Albert and Vera List Endowment Fund.

© Department of Art, Brown University, 1986
Library of Congress Catalogue Card No.: 86-70127

ISBN 0-9-33519-01-X

Design: Christopher Campbell, Michael Plante
Typesetting: Don DeMaio, Allen H. Renear
Printing: E.A. Johnson Co., Inc.

Contents

Lenders to the Exhibition

Friedel Dzubas

Helen Frankenthaler

Mr. and Mrs. Graham Gund

Betsy B. Jones

Albert A. List Family

Viki List

Mr. and Mrs. Boyd Mefferd

James Rosenquist

Ruth and Jerome Siegel

Department of Art, Brown University

Leo Castelli Gallery

André Emmerich Gallery

Gund Art Foundation

Sol LeWitt Collection

Museum of Fine Arts, Boston

Museum of Art, Rhode Island School of Design

Rose Art Museum, Brandeis University

University Gallery, University of Massachusetts, Amherst

Vassar College Art Gallery

Wadsworth Atheneum

Wellesley College Museum

Whitney Museum of American Art

Yale University Art Gallery

Preface

Definitive Statements is the nineteenth project in the Brown University Graduate Art History Exhibition series. It represents something over one year's work by a group of second-year students — work increasingly complicated in recent times by collapses in Federal funding, escalating costs for printing, shipping, insurance, etc. What began nearly two decades ago as a generously serviced and more or less straightforward curatorial training exercise has by now become a comprehensive team effort in electronic publishing, graphic design *and* exhibition scholarship. After the "baptism under fire" character of the Brown graduate exhibitions in their current form it seems highly unlikely that any student participating in them has anything practical to fear in the "real" museum world of their subsequent careers. This year's exhibition is unlike any previously undertaken in the Brown graduate series. From its beginning this series has featured established art historical material — the emphasis being on "historical." The challenge in *Definitive Statements* was to attempt an essay — both in the exhibition itself and in the accompanying catalogue — in art history of the most recent sort. The history is in fact only twenty years old! Yet, in my judgment as exhibition supervisor, American art of the 1964-66 period has become, in spite of its recentness, historical rather than any longer contemporary. Standing as a kind of sealed aesthetic unit containing both major work and major criticism, this period appeared positively ripe for scholarly review. In order that the review be in so far as possible scholarly rather than residually ideological, the students producing the exhibition were made to saturate themselves in the considerable written record of the period and to avoid increasingly unreliable verbal history.

The temptation of consulting the artistic and critical "characters" of the period has been averted by an act of enforced discipline mandated by me and respected (at least for the most part) by my students. Having realized early on in this exhibition project that my own memories of a period in which I played a "bit" part (if that) were highly selective and often downright inaccurate, I assumed the condition to be a general one for my colleagues of the time. While I cannot claim to have insulated my students totally from the defects of *my* historical memory, I hope at the very least to have minimized my intrusions. Judging from the contents of the catalogue which follows, it does appear that something like

"real" history has been served - an accomplishment due perhaps more to the enormous talent, industry and integrity of the students involved than to any methodological prescription.

The period surveyed by *Definitive Statements* has something of the character of a golden age when seen from the vantage point of twenty years. The exhibition title is intended to re-evoke the feeling of conclusive aesthetic accomplishment that marked the mid-sixties. Distinctive, yet at base complementary, artistic positions had emerged at full force. Nothing was seen as immanent; everything was demonstrably certain. Several major period exhibitions celebrated that certainty with confidence unseen before or since in the history of American art, *and* as has seemed necessarily the case in all "great" moments of American aesthetic achievement, the moment was one of war, or quasi-war (or whatever Vietnam was)!

There have been difficulties with this exhibition as there are with any ambitious museum undertaking. Some were routine and predictable; others were uniquely surprising. The latter deserves some comment, since they will be endemic to all future exhibitions of sixties American material. Pre-eminent among the "unique" difficulties is the fact that so much of the major work is no longer in America. Only slightly less distressing are the conservation problems emerging, particularly in Color-Field paintings - problems so severe as to make one as hesitant to request loans as to grant them. A high priority for National Endowment of the Arts funding should be support for any serious project conceived to develop reliable ways of repairing and preserving early sixties "stained" painting; otherwise a recognized national treasure will very soon vanish from proper sight.

On a more positive note, I would like to thank once again my students for their nearly obsessive efforts with *Definitive Statements*. Where the exhibition succeeds the credit is fully theirs. The staff of the Bell Gallery, Nancy Versaci, Director and Judith Tolnick, Associate Curator, have been, as always, sympathetic, tireless and relentlessly professional in their supervision of the mechanics of the exhibition. Kathryn Brush, a veteran of previous graduate exhibitions, served this present one as general form and proof editor, with skill (as well as tolerance) born of hard experience.

Finally, let me say that while many northeastern museums

and galleries have been extremely generous with their granting of loans, *Definitive Statements* quite simply could not have happened without the support of several major private collectors. In particular, Vera List, the "great lady" of sixties collectors, has been patient and generous to the tune of lending eight objects, several on last-minute notice! For this and her many other acts of support to the programs of the List Art Center, I herewith dedicate *Definitive Statements* to Vera List.

Kermit S. Champa

Acknowledgements

The following groups and individuals generously lent encouragement and support to the present undertaking: Jan E. Adlmann and staff, Vassar College Art Gallery; Laurie Averill, Library, Rhode Island School of Design; Martha Baer and Julie North, Christie's; Vivian Barnett, Lisa Dennison and Diane Waldman, The Solomon R. Guggenheim Museum; James Barron, Jan Kreugier Fine Art; Richard Bellamy, Oil and Steel; Carl Belz, and Suzanne Koppelman, Rose Art Museum, Brandeis University; Leo Castelli and staff, Leo Castelli Gallery; Charles Chetham, Michael Goodison, Betsy B. Jones and Louise A. LaPlante, Smith College Museum of Art; Helen Cooper and Rosalie Reed, Yale University Art Gallery; Paula Cooper, Paula Cooper Gallery; Regina Coppola and Betsy Siersma, The Art Gallery of the University of Massachusetts at Amherst; Robert Croker and Donna M. de Salvo, DIA Art Foundation; Friedel Dzubas; André Emmerich, Sandra Kunhart and staff, André Emmerich Gallery; Helen Frankenthaler and Maureen St. Onge, assistant to Miss Frankenthaler; Phyllis A. Goldman, Phyllis A. Goldman Fine Arts; Gregory Hedberg, Andrea Miller-Keller, and Muriel A. Thompson, Wadsworth Atheneum; Nancy Heiner, The Whitney Museum of American Art; Deborah Johnson, Franklin W. Robinson, Daniel Rosenfeld and Robert Workman, Museum of Art, Rhode Island School of Design; Amy Lighthill, Cathy Modica and Theodore Stebbins, Jr., Museum of Fine Arts, Boston; Viki List; Mr. and Mrs. Boyd Mefferd; Kenneth Noland and staff; S.I. Newhouse; Christina F. Petra, Graham Gund Collection; Ruth Siegel; James Rosenquist; Susan M. Taylor, Wellesley College Museum.

We gratefully acknowledge the cooperation and assistance, above the call of duty, of the following individuals: Barbara Haskell, Whitney Museum of American Art; Michael Komanecky, Yale University Art Gallery; Mr. and Mrs. Albert A. List; Morgan Spangle, Leo Castelli Gallery; Susan L. Stoops, Rose Art Museum, Brandeis University; Liane M. Thatcher, Graham Gund Collection; it is no exaggeration to say that without the contribution of their time and enthusiasm, this project would never have taken its present form.

We are especially appreciative of the support of Trudy C. Kramer, Director, Alicia Longwell, Registrar, and Maureen C. O'Brien, Associate Director for Curatorial Affairs, The Parrish Art Museum, Southampton, Long Island, who have assisted us in numerous and significant ways.

We are most indebted to those at Brown University who made it their business to facilitate this undertaking: Nancy Versaci, Director, and Judith Tolnick, Associate Curator, The David Winton Bell Gallery, Brown University, provided models of curatorial excellence and expertise; the staff of the John D. Rockefeller, Jr., Library, including Duane Davies, reference librarian for fine arts, and Janet Draper, Shared Resources Coordinator, were especially helpful in locating often elusive source material; Norine Cashman and the staff of the Slide Library, Department of Art, ensured that visual material was always available to us; Brooke Hammerle was kind enough to take on a last minute photo assignment; Trish Blake, Jane McIllmail, Betty Massie, Patricia Morrisey, Janice Prifty and Anne Richards, Department of Art, provided unstinting support and encouragement. We most gratefully acknowledge the tireless efforts of our copyeditor, Kathryn Brush, who performed that unrewarding task with steadfast good cheer. Allen H. Renear and Don DeMaio saw the computer typesetting of the catalogue through to its present form.

Finally, all of us must declare a debt to Professor Kermit S. Champa. This exhibition was originally his inspiration, and it is a measure of his generosity that he turned such an extremely fertile field of study over to us. Without his full intellectual and moral support this exhibition could never have achieved what we feel is its present coherence and integrity. Therefore, we return and dedicate our labors to him — an unoriginal gesture for one of his exhibition groups, but a heartfelt one.

Christopher Campbell
Ima Ebong
Megan Fox
Mitchell F. Merling
Michael Plante
Jennifer Wells

Essays

The Fifties Legacy: Toward a New Aesthetic

Michael Plante

The period from 1964 to 1966 represented the culmination of a twenty-five year development in which American art — particularly that produced in New York City — reached the zenith of avant-garde production in terms of both originality and quality. What emerged from this period was regarded as a distinctly American aesthetic armed with a mature self-critical sensibility and bent on extending the modernist tradition beyond its European origins.

It was the supreme accomplishment of the Abstract Expressionists that they succeeded in replacing the School of Paris at the forefront of avant-garde activity. By the time the artists in the present exhibition came to maturity — during that 1964-66 period — New York artists in general possessed a painting culture more informed and more sophisticated than that of any other working artistic group. The consistent quality of artistic production and critical response, coupled with a heightened awareness of the historical context of modernist art, enabled these younger artists to produce a body of work which was formally dissonant, yet creatively and intellectually communicative. Thus, three apparently unrelated aesthetic directions — Color-Field, Minimalism, and Pop — not only developed and matured side by side, but maintained mutually informative connections.

The first artistic group of international stature to emerge in New York, the Abstract Expressionists (or the New York School as Robert Motherwell later dubbed them), came to maturity in the years immediately following World War II. Composed of artists as varied as Pollock and Kline, de Kooning and Newman, the artists were unified in their unwillingness simply to continue European-derived directions. These painters (and associated sculptors) reacted to their own private visions and insights in the search for a new subject matter, thus establishing an aesthetic of individuality which refused to limit emotional content.

In the postwar period, each succeeding generation of painters and sculptors was able to establish itself within the artistic community more quickly than the preceding generation. Consequently, while members of the later generation were forging a reputation for themselves, certain of the Abstract Expressionists were just hitting stride within a mature phase. This curious progression was such that while members of the Color-Field, Minimalism, and Pop groups were rejecting many of the postures and processes of the older generation, the Abstract Expressionists were themselves able to react to the challenge of the younger generation. In a sense, each generation was given the luxury of an intense form of give-and-take with its immediate past.

In the middle of the 1950's, when Abstract Expressionism represented the dominant force in American avant-garde art, the hegemony of de Kooning over picture-making in New York was virtually uncontested. A large group of younger artists clustered around de Kooning's example, a second generation of gesture painters whose emulation of the master remained unembarrassed. Reflecting back on that period, Robert Rosenblum describes his impression of the gesture painters as "living under the oppressive yoke of the coarse and sweaty rhetoric of Action Painting, whose supreme deity, de Kooning, suddenly loomed large for many younger spectators and artists as a conservative force, a tyrant of past authority who demanded the instant embalming of any youthful, liberated spirit."[1] Though gesture painting represented only one of many directions being pursued in New York during the fifties, as an example it lent substance to the notion that most of the painting produced during the mid- and late fifties was either emulative or critical of the work produced by the Abstract Expressionists. American art was threatening to become academic. The younger gesture painters were strangely enough the least concerned with strictly American accomplishment. Various members of this group (i.e., Al Held, Joan Mitchell, Norman Bluhm) assumed residence in Paris, assimilating the French tradition as deliberately as the preceding generation had discarded it. It was the formation of this "de Kooning academy" that signaled to many younger artists the need to find a way around de Kooning. Rosenblum writes, "If, at the time de Kooning's art looked like the most huge and insurmountable roadblock on the path to younger-generation freedom, the work of what was then quickly defined as a group of de Kooning disciples rather than enemies appeared even more of a congestion in the traffic of art history."[2]

Throughout the fifties, Pollock's genius was acknowledged, but as a source for younger artists he was commonly considered too radical to emulate. De Kooning, along with Hofmann who was still teaching actively, represented "conservative forces." De Kooning and Hofmann offered more than their pictures to the Tenth Street artists. Hofmann

was a vintage modernist with a carefully structured theoretical framework; de Kooning's style seemed a natural progression from European modernism, and his attachment to the figure proved more accessible (and perhaps more valid) to contemporary tastes. However, to a growing number of critics and younger artists, the younger gesture painters had become "loyal, but growingly irrelevant satellites."[3] For the next group of artists, the "way out" would lie with Pollock, and certain others of the least gestural Abstract Expressionists.

In the postwar years of Abstract Expressionism, there were two currents operating within the movement. The more recognized current was that of the gesture painters: de Kooning, Hofmann, and Kline. The more recessed current — recessed in the sense that it developed slightly later, and was significant only toward the end of the fifties — comprised the Color-Field painters: Mark Rothko, Clyfford Still, and Barnett Newman. By comparison with their contemporaries, these artists were radically reductive in sensibility producing pictures in which brushwork was minimal, color was primary, and the overall design structure was highly simplified and repetitive.

Rothko's and Newman's work provided an early demonstration of the non-relational image, based in an anti-compositional (no dominant or subordinate elements) mode of image making. This mode was to become characteristic of much of the painting and sculpture of the Color-Field, Minimalism, and Pop groups. The non-relational image is an alternative to traditional, European-derived design principles which rely heavily upon compositional balancing, or what Mondrian termed, "dynamic equilibrium." The idea of dynamic equilibrium continues in the work of the gesture painters, particularly Hofmann, where the balancing of shape, texture, color, and movement reaches an apex of self-consciousness and intricacy. In Rothko's pictures of 1956 and 1957, the design is standardized with two or three rectangles poised on the canvas, one hovering above the other. The rectangles occupy most of the picture plane and engage in ambiguous relationships of overlapping and recession with each other. Thus, it becomes difficult to interpret the ground in relation to the rectangles, and the picture becomes resolutely flat and field-like. The totemic placement of the slabs within the structure — one atop the other — discourages a narrative reading of the picture, and forces the image to be read as a whole with little or no relational dynamic appearing to operate between the elements. As Rothko becomes more attentive to his color and more confident with equivocal spatial and anti-spatial manipulations, succeeding pictures become increasingly less incidental and more whole (or absolute) in their character.

Field painting, as promoted by Rothko, Newman and Still produced powerful responses in the succeeding generation, most obviously in the work of Louis, Olitski and Poons. Newman and Still — and to some extent Rothko — painted large pictures which were indivisible into passages and demanded interpretation as a single unit. Barnett Newman's canvases of evenly-regulated fields proved a provocative and instructive source for younger painters as well. Each of his paintings constitutes a continuous field, with one or more vertical zips running through it (Plate 1). The zips, though they may suggest the figure, are not perceived as separable from the ground, as advancing or receding from the picture plane. They are consciously flat. The zips function, however, to energize the field, preventing it from becoming too vast, inert, or characterless.

This second current in Abstract Expressionism, which provided not only a source for the Color-Field canvas, but for so-called one-image art, also provided the prototype for the series, or run in American abstract painting. The production of a run involves the re-use of a formal structure, adapted from one art work and continued in another. The perceived procedural advantage was seen to lie in the assumption that the artist begins each painting further along in content and formal sophistication, deeper into the process, thereby able to concentrate on the subtler aspects of expression. The prime historical example of this structurally constant approach to picture-making for Newman and Rothko was Mondrian, whose pictures after 1917 were masterful examples of the aesthetically fecund re-usage of formal elements. Explaining Mondrian's move to limit experimental additions to his pictures, Kermit Champa writes, "His painting will continue — in fact it will never cease — to 'represent' relationships of a plastic sort, but the origin of those relationships selected for representation will remain resolutely internal to his work of the moment. What is represented in successive paintings becomes, as a result, a demonstration of structurally perfected meaning addressed from the inside of the painting to the outside world of random, subjective vision."[4] This tendency toward the series runs counter to the Tenth Street (gestural abstract expressionist) idea of confrontation, in which the bare canvas is approached with no preconceived format. Ultimately, the production of extensive runs and series by Rothko, Newman and Still contradicted the supposition made by gesture painters — particularly Hofmann — that invention was the true test of the artist.

Yet, as we have already suggested, the most fertile route

around de Kooning was through Pollock, and it happened not in New York, but in Washington, D.C. Working away from New York seems to have given Morris Louis and Kenneth Noland a broader perspective, and enabled them to accomplish one of the most productive *and* earliest breaks with Abstract Expressionist facture. Noland wrote, "It gave us some distance to reflect upon things that we could see happening in New York which was the center. It gave us a little objective distance."[5] As well, their friendship with critic Clement Greenberg ensured for them an insider's guide to work being produced in New York, as well as the benefit of a uniquely fine, critical eye. Greenberg wrote, "From Washington you can keep contact with the New York art scene without being subjected as constantly to its pressures to conform as you would be if you lived and worked in New York."[6] Greenberg warned them early of the dangers of the "Tenth Street Touch."[7]

The first time Greenberg hosted Louis and Noland in New York he brought them to Helen Frankenthaler's studio to see a painting from 1952 called *Mountains and Sea* (Plate 2). Frankenthaler's picture is a large landscape-oriented abstraction in which stained paint is gradually layered into what is still a residually Cubist structure. The color is weak, but the picture harbors a peculiar luminosity brought about by the staining technique. As in watercolor painting, the ground becomes the light source and the sustaining force for determining the tonal character as certain sections of the picture are left untouched, and others are built up — the tone deepened — with each additional layer of color. Frankenthaler's picture provided Louis and Noland with a foothold into the work of Jackson Pollock, whose paintings they strongly admired, but felt were inaccessible. Frankenthaler's technical and intellectual achievement with *Mountains and Sea* was to exploit Pollock (particularly his large black and white stained works) as a source, without resorting to direct imitation.

Jackson Pollock — generally accepted by the younger generation as "far out" — had explored the most complex and intricate formal possibilities of field painting in his all-over canvases (Plate 3). And Pollock was the first artist to find his way out of gestural painting by using a stain technique. Pouring very thin black Duco paint onto raw canvas, and manipulating the puddles and pools, Pollock eliminated the dense, gesture-laden surface of Abstract Expressionism in favor of a more reductive one. His pictures achieved a pure, optical quality (a quality predicted in his earlier drip paintings) which was supported by the lack of tactile distinction between the painted and unpainted portion of the canvas (a

quality Louis would later explore). The single black used in these paintings re-asserts the flatness of the canvas and negates the Cubist influence (figure-ground fluctuation) which persisted throughout much gestural painting.

Upon returning home to Washington from that first visit with Greenberg, Louis and Noland began using the same staining techniques which Frankenthaler had appropriated from Pollock. Louis, twelve years Noland's senior, was the first to reach an individual working style using the stains. Between 1957 and 1962 Louis completed 600 pictures which encompassed several runs including the Veils and the Unfurleds (Plate 4). The originality of his pictures is partly the effect of a new material, acrylic paint, which set a different texture and tone from the canvases of the previous generation. Louis was able to make more of a connection to the richness of Pollock's 1948-51 drip masterpieces using the stains than either Frankenthaler, or even Pollock himself had managed. As opposed to Frankenthaler and Pollock who were essentially drawing with the diluted paint, Louis poured and flooded his canvas, negating drawing, working against shape, and avoiding light and dark contrasts. Ultimately, this pouring technique served Louis in much the same way that the "drip" had served Pollock during the previous decade, allowing him to bypass the limitations both of conventional drawing and conventional (Cubist) compositional methods.

Although Louis made use of the non-relational image, and explored the device of the run, the character of the flatness and all-over evenness of his pictures is unlike that of the Abstract Expressionist field painters. As with Pollock, Louis eventually felt the need to gain some form of his original control over graphic qualities and to balance them with coloristic ones. In his Unfurleds from 1961, Louis placed parallel bands of color in wing-like diagonals at the edge of large areas of canvas which are left unpainted. The bare canvas of the center functions as a conceptual analogue to Newman's zips. Michael Fried wrote of them, "The banked rivulets . . . open up the picture plane more radically than ever, as though seeing the first marking we are for the first time shown the void. The dazzling blankness of the untouched canvas at once repulses and engulfs the eye, like an infinite abyss, the abyss that opens up behind the least mark that we make on flat surface, or would open up if innumerable conventions both of art and of practical life did not restrict the consequences of our act within narrow bounds."[8] Two points can be made about the Unfurleds. First, they are clearly an attempt on the part of Louis to return to drawing. Second, the Unfurleds represent a conceptual — even intellectual — breakthrough for Louis. Up to this point, his pictures had

demonstrated a highly complex optical prowess in using color and light. His retention of runs consisting of a one-image composition ensured that he would make the most of incident, color and texture. This ceases with the Unfurleds. Fried's response makes this clear: "abyss," "least mark," and "restrict" are all signals of Louis changing directions, moving toward a more precise, and ultimately more conceptual mode of aesthetic discourse.

Kenneth Noland's work differs most markedly from Louis' in his preference for formal, geometrical layout softened by staining. Noland worked in serial form, developing more extensively the idea of non-relational image than Louis did. The first important motif in Noland's work is the target shape of concentric rings, which he arrived at in 1957, three years after Louis' first Veil cycle (Plate 5). Although Jasper Johns had earlier made use of the target format with the intention of referring to its banality, for Noland it is strictly a formal device, a method of concentrating on color relationships and texture. In the earliest of the Target pictures, the band which is furthest from the center has a ragged edge which implies a quick gesture, a spinning motion, an expressionist touch. As the Targets progressed into the early sixties, Noland dropped this band in favor of a cleaner, more continuous image.

The radical difference between the mature work of Louis and Noland, two painters who felt connected enough to have "jam" painted together, might be explained by the influence of Josef Albers, the German-born painter (and ex-Bauhaus professor) Noland studied under at Black Mountain College. Albers had been an instructor at the Bauhaus during the 1920's, and had taken part in the annual Abstraction-creation group exhibitions in Paris during the 1930's. Albers was systematic and orderly, with some capacity for controlled experiment with new materials. His own painting culminated in a series entitled *Homage to the Square* (Plate 6) which he worked on throughout the 1950's and 1960's.

In *Homage to the Square* factors revealing Albers' aesthetic bases emerge. There is about the series an evident "anti-French" process operative, not only in color tone and touch, but also in the deliberate (and brilliant) method he adopts for destroying the relational intricacy of the Cubist grid. In *Homage to the Square* Albers endlessly explores the visual conversations between color-saturated squares which lie within larger squares, the largest of which encompasses the picture plane. These are in runs of three squares or four squares. The organizing visual principle employed in these works is classic linear perspective, which when unsupported by representational subfeatures achieves flatness and avoids

Cubist and Constructivist overtones. However, the use of the square in perspectival alignment results in the lingering (if minimal) illusion of recession, somewhat offset by the featureless flatness of squares. This type of straightforward quasi-spatial illusion would have been unthinkable to the Abstract Expressionists, who insisted on a more overt assertion of the integrity of the picture plane, of flatness. Their idea of planar integrity was disseminated throughout the New York artistic community first through the work of Piet Mondrian (and indirectly, through Hofmann whose analysis of Mondrian was very careful). Kermit Champa writes:

> A desire to determine all relationships definitely lies at the root of Mondrian's art whether representational or abstract in its point of origin. Only by gaining control over illusion could he learn to make relationships speak the clear language of his own elevated feeling instead of the unclear and 'tragic' language of illusionistic relativity. Thus, 'expression' and control of the picture object stand as one and the same thing in Mondrian's painting. Control of feeling in the flat of the picture does not remove feeling as the subject. On the contrary, it makes 'feeling' a free subject, responsive to pure artistic intuition and pure artistic intuition alone.[9]

A radical impasse developed between the Abstract Expressionists, who adopted Mondrian's demonstration of emphatic flatness and concern for responsive picture-making in which lateral pictorial elements are tested and modified, and Albers' compositions using recessional perspective which are totally preconceived. At Black Mountain College Albers ruled the art program completely, and his influence over Noland was almost inevitable.[10] Noland and Albers had a strained relationship — apparently they took an immediate dislike to each other — but Noland at least familiarized himself with Albers' color theories. Albers' classes at Black Mountain stressed the need for setting theory and procedures for a wide variety of artistic activities. He stressed the need to be aware of everyday objects and their individual properties, as well as the importance of primary experience and the ability to see and feel directly.[11] These ideas were ultimately influential in the development of Robert Rauschenberg, another student of Albers. Evidently, what Albers tolerated least was the spontaneous approach which characterized most Abstract Expressionist painting, in particular the gesture painters. He was equally opposed to Hofmann's "push and pull" *and* Mondrian's "plus and minus." Albers stressed the need for economy, structure, and the creation of order. Scholars have long debated the actual influence which Albers may ultimately have had on Noland, considering that Noland disliked him. Yet, by the end of the 1950's, Albers

and Noland seemed to be pursuing some noticeably similar aims in their pictures: juxtaposition of distinct, separate colors, symmetrical and concentric designs held constant, and color appropriated in terms of intuitive relationships.[12]

Albers' influence on Rauschenberg was profound, though once again, the two men did not get along amicably. Rauschenberg's own art departed radically from the Bauhaus-mode which Albers pursued. Despite this, Albers' stress on the need to confront the everyday object, the importance of direct handling of material, and the optimal abandonment of art history inspired Rauschenberg. In one sense, Albers' Bauhaus-derived emphasis on "vocation" and "craft" served to free Rauschenberg from an overly intellectual and elite handling of materials — a move away from Mondrian's purity. As if Albers had been able to predict it, Rauschenberg emerged as an effective critic of Abstract Expressionism "from the inside." His art reveals both respect and ambivalence for that generation of painters. Though he remains an Abstract Expressionist in sensibility, he also retains a self-conscious critical suspicion regarding certain of the movement's notions and practices.

In 1953 Rauschenberg exhibited canvases painted flat white, organized into rectangular panels. In a letter to Betty Parsons, Rauschenberg described the appeal of nothingness, silence, of absence.[13] These pictures are understood to have been inspired by John Cage's insistence that there could in fact be no void either in hearing or in vision. Of these paintings, Cage wrote in 1961, "The white paintings were airports for the lights, shadows, and particles."[14] In a similar vein, Rauschenberg inscribed the following on Autobiography, a lithograph from 1968, "The white paintings were open composition by responding to the activity within their reach."[15] From these two statements, we can infer that the White paintings are conceptually one level removed from gesture paintings. In gesture, or "action" painting, the canvas becomes a repository for the movement, the presence, and the being of the artist, so the rhetoric goes. In the White paintings it is the viewer whose movement, whose emotion is echoed by the canvas, through shadow, echo and presence. In one sense, these pictures are the ghosts of Abstract Expressionism, in the same way that Rauschenberg's *Erased De Kooning Drawing* is. The *Erased De Kooning Drawing* is precisely that — an oedipal gesture of denial in which Rauschenberg erased all but the outlines of a de Kooning drawing. In *Erased De Kooning Drawing*, and in the White paintings, Rauschenberg retained the concept of Abstract Expressionism — the content — but has removed that which had become cliched, the actual physical deposit of that content.

Rauschenberg's impact on American art was through the development of the combine painting, a medium in which a painted surface is combined with various objects affixed to that surface (Plate 11). With the combine painting, Rauschenberg carried the art object still further into the realm of the viewer than he did in the White paintings. By bringing both banal and curious objects from the world of "everyday" life onto the plane of high art, Rauschenberg engaged the full participation of the viewer, making the picture there to be entered on several loosely programmed levels. His pictures realize a new "aesthetic of heterogeneity," often retaining heavy, gestural brushwork to unite the various images and objects across the picture plane. For all their complex composition and multiple parts, Rauschenberg's pictures remain non-relational mostly because the parts of the picture retain such clear evidence of their originality — their "real" identity in the non-art world — that they cannot ever be totally reconnected visually with each other.

The extent of Rauschenberg's participation in the myth of Abstract Expressionism can be measured in his statement, "I'd really like to think that the artist could be just another kind of material in the picture, working in collaboration with all the other materials . . . but of course I know this isn't possible really."[16] The pictorial vocabulary which Rauschenberg employs consists of objects which are highly personal in nature, as subjective as de Kooning's brushstrokes, and oftentimes more sentimental. His later influence on Jim Dine and other Pop artists is great. However, when Warhol or Lichtenstein appropriate everyday imagery, they make use of objects which are emotionally charged, intellectually loaded, and direct in address. The combine paintings carry many loosely related visual incidents, inviting careful attention to detail and incident, but necessitating a backing away in order to comprehend the whole. In this sense, the pictures are analogous to those of Hofmann or de Kooning which also support extensive looking, and require some distance and concentration to perceive everything at once.

Rauschenberg's ambivalence toward gesture painting is particularly clear in his two pictures, *Factum I* and *Factum II* of 1957. *Factum I* contains images of President Eisenhower, a calendar, two trees, a bold letter "T" and other collage elements which are united visually on the picture plane by five or six broad, gesticular brushstrokes. *Factum II* uses the same collage elements — images which are easily reproduced — united with the same brushwork, complete with the same drips and scrapes. Any harsh critique of Abstract Expressionist technique which Rauschenberg might have wished to deliver with these pictures is of necessity tempered by his own

obvious dependence on this same brushwork to finish his paintings. These two pictures on one level attempt to reveal the nature of production in Abstract Expressionist painting, and on another level, confront, and perhaps dissipate, the romance of the spontaneous "struggle" associated with Abstract Expressionism.

Even more than Rauschenberg's, Jasper Johns' art is about objects and images of banal, regularly-encountered objects: targets, lower case letters, American flags and numbers. The early Flags and Targets from 1955 were executed in encaustic with the paint built up almost in relief. Each image occupies the whole of the picture plane. This along with the busy neutrality and repetition of touch with which the pictures are executed serves to encourage the illusion that the paintings are more like what they represent, rather than a representation in fact. The "presentation" versus "representation" issue is heightened in *Target with Four Faces* of 1955. where four plaster casts of the lower portion of the human face are set above one of Johns' encaustic targets. The usual objectivity found in Johns' pictures takes on a more romantic (mysterious) pose with the juxtaposition of target and heads. The two components of the picture do not inform each other, and there is no apparent relational dynamic operative. Instead, the unmediated juxtaposition of two seemingly legible images rejects the possibility that the art object might be a representation of a "non-art" subject, thus specifying its identity as a thing in itself with considerable force.

Johns' pictures find their ultimate source in Duchamp's ready-mades, particularly in the games both men indulge themselves in concerning art and non-art, real objects and art. But Johns develops the idea further by extending it into the formal aspects of his pieces. Johns produces pictures which are literal objects, but he develops a facture and flatness normally associated with non-literal abstract art. He chooses his subjects carefully, tending toward those which can be depicted flatly (without having their recognizability compromised), and which will respond (in a strange self-negating way) to a dense, consistent surface. Johns is particularly careful to select objects which correspond naturally to the shape of a canvas, so that any figure-ground dynamic is eliminated in advance.

The ambiguous relationship which exists in Johns' work between two- and three-dimensional objects, as well as the conversation between art and "object" proved an enormous influence on the younger artists just emerging in New York at the end of the 1950's. The three distinct trends which will emerge in the art of the early sixties — second generation Color-Field, Minimalism, and Pop — are all anticipated in Johns' work. Johns' pictures ultimately establish the conditions for painting and sculpture to move more closely together, to operate, as it were, tangentially. His pieces (along with those of Rauschenberg) encouraged the type of quasi-sculptural painting that is later produced by Stella and Kelly, as well as the painterly sculpture produced by Anthony Caro. Johns' art is as strong formally as it is intellectually. Stella spoke of the reputation Johns had developed in 1956 when the former was the frequent subject for discussion in the art department at Princeton. At the time, Stella had never seen any of Johns' pictures (or reproductions), "I had never seen it, but yet it was a kind of palpable reality of some sort that was in the air ... It was interesting to hear about something strongly reputed to be good, and then actually see it be good."[17] The repetition of stripes parallel to the framing edge was the feature of Johns' art that most impressed Stella at the time, as well as the general repetition of motif. The flatness of Johns' formats, contrasted with the depth-implying painterliness of the encaustic, influenced Stella's Black paintings. Yet, Johns' most valuable lesson for Stella was probably in finding a definitive and totally self-contained way out of Abstract Expressionism. Stella recalls, "I think I had been badly affected by what would be called the romance of Abstract Expressionism, particularly as it filtered out to places like Princeton I began to feel strongly about finding a way that wasn't so wrapped up in the hullabaloo, or a way of working that you couldn't write about ... something that was stable in a sense, something that wasn't constantly a record of your sensitivity, a record of flux."[18] Particularly troublesome to Stella was the Abstract Expressionist conception of the open-ended picture. Johns' simple format pictures, with series and repetitions, were easily conceived and examined, providing a model for Stella's later box and stripe pictures.

The idea of a sculptural piece, particularly free-standing, exploiting a structure which defies analytical (part-to-part) comprehension drives the early work of John Chamberlain, who also studied at Black Mountain College. Composed of junked automobile metals, Chamberlain's pieces balloon as a single pronouncement, and seemingly float with no explanation as to how the singularity is achieved (Cat. 7). This quality is what Rosalind Krauss has termed "irrational volume."[19] There is no apparent constructive rationale, and the volume seems strangely to defy any notion of structure at all. Krauss writes, "The obvious hollowness of the sculpture insures that one will not see its material surface as the outward manifestation of an internal armature or core.... They are

not provided with the aesthetic justification of an object made lucid through the visual procedures of analysis."[20]

In this dialectic of implosive structure versus a seemingly explosive manifestation, we are reminded of Brancusi's concept of "absolute balance" in the quest for the "absolute value" of a form. But where Brancusi carves and simplifies to reach the absolute balance, Chamberlain seeks tension and expansion in crushed metal which ultimately creates beautifully organic, at times biomorphic, forms. For him, it is "the idea of the squeeze and the compression and the fit."[21] Chamberlain's compression is the factor which makes his "irrational volumes" possible, and the fact that his sculptures are composed of junked automobile parts serves to deflect attention away from the potentially classical forms Chamberlain unearths. The commonness of the automobile metal — the "recycled" quality of the medium — serves to firmly attach Chamberlain's aesthetics to the less classically minded Johns and Rauschenberg. But it is his work's avoidance of a logical poise which connects him to his sculptural generation in general, and more particularly, to the work of Anthony Caro and David Smith.

Anthony Caro exploited from an early point in his "American" work the painterly (or pictorial) potential of non-figurative sculpture (Cat. 6). His exploitation does not rest merely on the optical complexity which his pieces generate given their painted surfaces, but is buttressed by an enterprising ambition to resist "solidity." Caro made use of ready-made steel parts, I-beams, sheet steel and pieces of coarse metal mesh which are assembled into sprawling picture-like combinations that at the same time seem to grow (or metamorphose) along a path. Paradoxically, the pieces are ground-devouring but not space-devouring. Caro is able to construct complex relationships through careful spatial articulation, never relying upon massive visual displacement. This articulation is achieved using what is in essence a "drawing in space" linear style recalling David Smith's constructions of the fifties, which in turn had developed from the Cubist and Constructivist tradition in sculpture.

Caro conceives of sculpture, it appears, from a primary sense of landscape. The frontal view of much of his sculpture from the period is static, and eloquently constructed with solid horizontals which echo the curvature of natural surfaces. However, the literalness of his pieces is contradicted by a side view, which contracts into nearly two-dimensions. The fact that Caro painted his pieces uniformly — thereby emphasizing a consistent visual surface — encourages the flat, planar sensations of the whole. While the front view is highly constructivist and relational, the side view functions less logically. In this sense, Caro's constructions find their direct source in the Cubis, David Smith's last sculptural series (Plate 8).

In the Cubi series, Smith employs the cube and the cylinder, constructed out of polished and abraded stainless steel. Paradoxically, by devising large architectonic monuments of reflective steel, he creates strangely weightless structures. The carefully articulated surfaces and shapes which discretely comprise the Cubis are a major departure in sensibility from the found objects (machine parts etc.) which were used in the construction of the Sentinel series and the Tank Totems during the 1950's. The Cubis — though still based on the human figure — are less relational and organically generated than his work from the previous decade. Smith avoided in the Cubis any predictable relationships between the front and profile view of the sort found in his pieces of the 1950's. Not only does he negate most of the clear, Cubist-derived relationships which he had explored during the forties and fifties, but he developed as well an analytically unpredictable method of combining parts that cause certain of the Cubis virtually to defy sequential or relational descriptions of arrangement. The topmost cube of XVII seems poised to topple off the monument. Usually Smith's work when seen from the front assumes some unifying poise. Only from the side does the structure become overtly destabilized, with a precarious balance, and with parts which refuse to cohere into a logical sequence.

The Cubis also represent Smith's most subtle — and yet dramatic — integration of color into his sculptural conception. The textured and reflective surfaces of the monuments respond to their immediate environment to present varied and ever-changing ranges of color and tone. Significantly, Smith's formal training was as a painter, and throughout his career he remains conscious of the impact color can have on sculptural meaning. The Zig series of 1963 consists of discrete geometric shapes which are combined and uniformly painted, thus adding another level of visual coherence. Formally, this series relates to contemporary painting, in particular to the chevrons and disks of Kenneth Noland.[22]

The Cubi series provides an obvious formal link between David Smith and the development of primary sculptures, which overlapped somewhat with the production of the Cubis. Smith was influenced by the younger generation of American artists who were just emerging. However, his interest in this group was confined to the arena of painting, rather than sculpture. It was not uncommon for critics (as cited above) to perceive influential relationships between Smith's sculpture and the work of painters such as Kenneth Noland.

Certainly Smith's work was headed in the direction of the one-image, non-relational composition practiced by Color-Field painters. In the Cubis, the assimilation of the vertical base support into the whole of the piece (as opposed to remaining separate, a "base") thwarts a traditional top-and-bottom reading of the piece, thereby reducing its potential as a relational composition.[23]

The production of the Cubi series raises many issues surrounding the role of (sometimes older) more established artists during the 1964-66 period. David Smith was routinely grouped with the Abstract Expressionists, and his reputation had been firmly established for two decades by 1964. Yet entering the 1964-66 period, the character of Smith's sculpture shifts, somewhat in accordance with the developing aesthetic evolution of the younger generation. This problem necessitates more attention than merely unscrambling the question of stylistic influence. There are members of the first generation of New York School painters who are able to meet the challenge of the younger generation, to respond to the younger generation's repudiation. As an example, Barnett Newman's production over the ten years preceding this period predicts, in a very general way, the direction the younger artists' growth will take. Although he is thrust into the mode of a role-model of sorts, he labors to re-assert his own individuality and skirt inclusion into their movement. As well, there are artists who in a sense straddle the two generations. These artists (Held, Kelly, Frankenthaler) formed a valid working style in the shadow of the first generation, and laid down some of the formal and technical innovations which are exploited by the second generation. Yet, they form more than a bridge, for during the 1964-66 period, each one forges a major stylistic breakthrough driven by an awareness of the new art being produced. Other artists who undergo re-evaluation during the period remain essentially faithful to their signature processes (Hofmann, Motherwell), but internalize a sense of the new visual tastes and formats.

There are many reasons which might compel more established artists to re-examine their output during the period, not the least of which is market consideration. The art market experienced a surge of growth during the 1964-66 period fueled by the art produced by the younger generation. As well, it would be naive to assume that those artists within the ranks of the older generation did not recognize that Abstract Expressionism had lost much of its wind by 1963. Donald Judd writes in 1964, "Right now, things are fairly closed for Abstract Expressionism . . . There is a vague, pervasive assumption that Abstract Expressionism is dead, that nothing new is to be expected from its original practitioners, and that

nothing will be developed from it . . . It is obvious, though, that Abstract Expressionism . . . just collapsed."[24]

Upon his return to New York in 1953, after three years spent in Paris, Al Held quickly immersed himself in the art world of Tenth Street. Shortly before embarking for Paris in 1949, Held had seen a show of Jackson Pollock's work, and then spent much of his time in Paris attempting to synthesize the subjective power of Pollock's pictures with what he perceived as the European-based objectivity operative in the work of Mondrian and the School of Paris. Back in New York during the mid-1950's, Held's pictures are composed of thickly brushed, highly colored patches of paint distributed in an all-over format across the canvas. This heavily impastoed, divisionist format recalls — on a much grander scale — Lee Krasner's Little Image paintings of 1946-48. This manner of working owes an obvious debt to de Kooning, but Held was not part of that coterie of de Kooning disciples, preferring to remain in the Pollock camp.

Held was attracted to the rhetoric of Action Painting as formulated by Harold Rosenberg, but was apathetic toward Action Painting's alleged "expressionist" content.[25] His interest in Action Painting was process-oriented rather than philosophical, ultimately concerned with muscular brush work and heavy surface build-up. Held's paintings from the mid-fifties quickly distinguished themselves from the bulk of Tenth Street production not only by virtue of their high-keyed color, but more exceptionally their tendency toward pronounced geometrical organization. Remarkably, for all the directness and spontaneity which Held espoused during this period under the guise of Action Painting, he maintained a prodigious control over the elements of each painting which guaranteed a consistent clarity of color and form even though he was working with wet paint into wet paint.[26]

By the end of the 1950's, the shapes and blocks of color in his paintings become predominant, and the expressionist brushwork functions only as a veil, as a plane dropped behind the geometrical structure. The later transition into reductive, geometrical abstraction which Held pushes to maturity by 1964 is consistent with, and perhaps even predicted by, his pictures from the end of the 1950's (Cat. 13). During this transition into an imagery comprised of geometrical abstraction, Held was encouraged by his friendships with Kenneth Noland and Frank Stella, but he does not seem to be influenced in any direct fashion by the painting of either artist. Instead, as the sharpened edges and hermetic color attest, Held is finding a source in Henri Matisse, whose cutout collages (in particular Jazz) Held saw while he was in Paris.

Al Held's position within the ranks of the emerging van-

guard is ambiguous. The development of imagery consisting of hard-edged geometrical shapes, the placement of which along the edge of the picture plane abnegates traditional figure-ground relationships, certainly converses with the paintings of Stella and Noland. But Held was never a purist. His pictures resist the flat opticality associated with post-painterly abstraction. The weighty surface of his abstractions from 1964-66 are clearly the result of numerous revisions and overpainting. Each painting begins with biomorphic forms which are gradually metamorphosed into pure, curvilinear geometry; each painting "contains a hundred submerged works beneath its surface."[27] This approach to picture-making where each canvas is a problem needing resolution and where form is revealed gradually smacks of Abstract Expressionist rhetoric, and is clearly antithetical to the type of programmatic painting produced by Stella and Noland.

Ellsworth Kelly, like Held, spent his formative artistic years (from 1948-54) in Paris. Unlike Held, Kelly did not travel to Europe under the influence of American postwar painting, and therefore felt no need to reconcile Abstract Expressionism with the European tradition. From the mid-fifties on, Kelly's concerns were with achieving a high level of formal sophistication while using reductively simple shapes and colors.

Kelly studied the Surrealists — Joan Miro, Jean Arp, and Sophie Taeuber-Arp — but was probably more influenced by the level of "finish" — the closed, hard surface — he found in Jean Arp's wood constructions than with Arp's use of biomorphic and automatic shapes. As with Held (although unrealized for years), Kelly's most important lesson was found in Matisse. The ideas which Kelly formulated while looking at the French master's work would guide his production through the next decade. The fundamental concept which is operative in Kelly's paintings and sculpture was probably derived from Matisse: the reduction of drawing drives a heightened awareness of color relationships; and conversely, the juxtaposition of flat areas of strong color serves to create an edge, a tight line which has the capacity to structure a composition.

If in 1955 Kelly's output seemed strangely unrelated to the art being produced by his American contemporaries, by 1965 Kelly was a participant in a Minimalist-directed avant-garde which he had informed a decade earlier. As one critic noted, "Ellsworth Kelly's work is the standard for the 'hard-edged' label. He was working in this way when abstract expressionism was dominant and when it appeared that his kind of art was a sidetrack."[28] What ensures the dy-

namism and interest in Kelly's post-Matisse abstractions is the visual tension which he is able to maintain consistently.

Pictorial tension in Ellsworth Kelly's compositions is brought about in one of two ways. In the pictures from the 1950's, the composition is bilaterally symmetrical — divided down the mid-point — and the identical, though reversed, shapes exert pressure against each other, producing a dynamic which resounds across the composition. The force-counter-force tension in these pictures is often directed toward the center of the plane. In later paintings from the mid-sixties, the shapes exert pressure against the edge of the canvas, usually in the form of a curvilinear shape pushing against a straight edge. This placement of a shape tangentially to a support is subversive to the creation of pictorial depth. The ambiguous figure-ground relationship which ensues from this peculiar design creates a lateral tension which visually highlights the taut surface of the painting.[29] The lateral pressure produced by these pictures further extends Kelly's challenge to traditional notions of line, edge, and plane.

In the mid-sixties, Kelly moved from these aggressive, flat images to a structure in which the dominant shape is literally lifted up out of the field and localized a few inches in front of the backdrop, or what was formerly the picture plane (Cat. 17). E.C. Goossen argues that this development is entirely consistent with Kelly's "historical determinism" as an artist, and that the consideration of influences from other artists is not necessarily productive.[30] In all probability, the development of this relief structure is not wholly derivative, and there is evidence in his work of an attention to contour and edge from which this could logically emerge. Yet, the development does parallel the increasing concern with "deductive structures," and the shaped canvas has entered into the art-world vernacular.

Helen Frankenthaler remained a pivotal figure throughout the 1950's, unique as one of the few "action" painters to remain uninterested in de Kooning's work (Al Held was another). Her central role in the development of the soak-stain technique and the importance it held for Color-Field painting has been discussed above. Interestingly, it is a direction she chose not to take during the fifties, when she continued to explore the spontaneous image, painting Abstract Expressionist pictures with the reduced facture produced by her soaked colors. By the middle of the decade she is aggressively layering her colors one atop the other, negating the fields which naturally form from the staining process with layers of thick drawing and splattered paint.

It is only in the pictures from 1957 that Frankenthaler be-

gins to retrieve the airy, open quality which she achieved with *Mountains and Sea* of 1952. In these pictures Frankenthaler's imagery becomes spare, reduced from the pictures of only two years earlier, and she is more courageous in her manipulation of raw canvas. The organizational structure of the pictures becomes increasingly geometrical, with a self-assertive flatness made more dramatic by the large areas of exposed canvas. In a sense, Frankenthaler begins to trust her own visual intelligence, gaining the confidence to allow shapes to emerge and interact. Evidently she found the process of soaking paint into raw canvas too predictable, and in 1960 she began priming her canvases in an effort to create harder edges and more brilliant areas of color.[31] This technical innovation was quickly followed by a deliberate centering of her images, surrounding them with bare canvas on all sides. Directing her pictorial structure toward the center resulted in what is essentially a "safe" design, allowing her to concentrate on the potential of color and edge. The pictures from 1961-62 are landscape-oriented, but also more abstract than the work from the fifties. She has eliminated spills and splatters, and other vestiges of expressionism, allowing her stains to spread, to become planar.

Frankenthaler's stylistic development is fairly slow-moving throughout the 1950's, focusing on one pictorial problem at a given moment, and working it through. The most dramatic shift in her production since *Mountains and Sea* (Plate 2) is contained in the group of pictures she produces in 1964. In the "interior landscapes" Frankenthaler relies on a symmetrical image which she encloses within a series of rectangles which echo the framing edge. The familiar airiness of her pictures is completely gone, and though the central regions are composed of soft, billowing color, there is an explosive quality to these pictures. A tension is created between the self-expanding central core, and the implosive, restrictive colored frames around the image. Goossen writes, "The 1964 pictures, however, seem to have been deliberately undertaken to confront the validity of her own approach with that of the newly developing, minimalist style."[32]

Clearly, by 1964 Helen Frankenthaler's entire approach to picture-making has altered. One gets the sense that her pictures are created from the center — from within — and worked outwards. She said in 1965, "I used to try to work from a given, made shape. But I'm less involved now with shape as such. I'm much more apt to be surprised that pink and green within these shapes are doing something."[33] In a series of paintings which begin in 1966, the edges of the picture take precedence over the area bounded by them. Frankenthaler pushes the planes of color, at first only four and then

more, almost completely off the canvas opening up a neutral central area. The inner space becomes ambiguous: it can be read as void, or as active space pushing the shaped elements off the picture plane. The dialogue which this type of image shares with the slab-stain pictures produced by Jules Olitski in 1965-66 is unmistakable. Where Olitski employs the slab, Frankenthaler uses a flat, stained area. And where Frankenthaler allows raw canvas, a void, Olitski employs a continuous rush of color.

Hans Hofmann was discussed above, along with de Kooning, as a major proponent of gesticular Action Painting in New York. Throughout the 1950's Hofmann's pictures become less gesticular and organize themselves around grounded rectangles, or slabs. As Hofmann brings his pictorial structure under greater control, he, like Frankenthaler in 1961-62, becomes more sensitive to issues of color and shape. By the early sixties, Hofmann is working in a more reductive mode — fewer shapes, fewer colors — and frequently using the staining technique which recalls Frankenthaler's work from the later fifties. Hofmann's approach to picture-making never really changes during the last two decades of his life, but he adopts a new visual taste rooted in a careful attention to Color-Field painting.

In pictures from 1961-62, Hofmann reduces his palette, using at times only two colors, to compose the image. In *Agrigento* of 1961 in the collection of the University of California at Berkeley, the picture is composed of only one color, a luminous raw umber, which is stained very thinly into the canvas. The composition is centered, with planar elements emerging from the central axis to group along the edges of the support structure. Because the blocks of color are all overlapping, the relational quality of the image is reduced.

In addition to exploring the technical innovations of the younger generation, there is another way in which Hofmann's career is bound to the emergent vanguard. The strong coloristic direction which he pursued in the 1950's was re-evaluated by an art audience newly sensitive to color, and cultivated by Color-Field painting. Sam Hunter writes, "It took Color-Field painting to revive Hofmann's reputation. Hofmann's flat colors were principles of that style, and when Hofmann began to be conceived of as a colorist, his reputation rose."[34] Hofmann's retreat from expressionism during the fifties in favor of a more controlled, color-oriented direction provided a transition between the Abstract Expressionists and the Color-Field painters.[35] Hofmann's later painting *Memoria in Aeterne* from 1962 in the collection of the Museum of Modern Art, New York, is dedicated to the memory of Carles, Gorky, Pollock, Tomlin and Kline (Plate 10).

The picture consists of two slabs, one red and the other yellow, hovering above a stained ground which stops just short of the top edge, exposing raw canvas. Curiously, Hofmann is memorializing his fellow Abstract Expressionists with a painting in which he self-consciously excludes himself from their aesthetic concerns and more openly allies his own work with more avant-garde painting sensibilities. In a sense, Hofmann utilizes an Abstract Expressionist context to evidence the influence which the emerging sixties generation has had over his own painting.

It is difficult to determine the route which Robert Motherwell pursues in his painting during the years 1964-66. It is not a period of great production for Motherwell, and what did emerge from this period is difficult to locate. Motherwell was clearly aware of the work being produced by the younger generation, and his reaction took two directions. In his pictures of the late fifties and early sixties, Motherwell's design is simplified and his facture is drastically reduced (Plate 9). Staining techniques provide him with a challenging automatic technique to explore. The second response to the younger group of artists makes itself visible in 1967 with the beginning of his series of paintings entitled the Opens.

The Elegy series had assumed enormous proportions by 1961, the date of *Elegy to the Spanish Republic No. 70* in the collection of the Metropolitan Museum of Art, New York. Throughout the 1950's, the Elegy remained Motherwell's strongest, most loaded image. The series maintains the same basic shapes and sequences in each picture, varying aspects of color, tone, and texture. The ambiguous relationship between the aggressive, frontal quality of the picture and its large scale presents an image which is both monumental and intimate. *Elegy No. 70* has lost much of the epic quality of the earlier Elegies due to its flattened surface. The sleek black shapes are hung against an almost completely white background, emphasizing the thin, flat quality of the paint. The shapes look like jagged cutouts. The tensions created in the earlier Elegies—the difficulty of reading the figure-ground relationship—are absent here.

Other images from the early sixties, such as the *Summertime in Italy* series begun in 1960 and continued through 1963, show the influence of Frankenthaler, with sections of billowing colors forming rather simple designs. Even in such reductive images as those from *Summertime in Italy*, Motherwell is unable to abandon expressionism altogether, as he allows edges of the stained passages to splatter and drip.

Motherwell began work on the Opens series in 1967, a group of paintings in which pictorial incidence is reduced to a standard geometrical structure set against a field. Each picture in the series consists of a basic color field, of various degrees of painterliness, set behind a drawn rectangle which is hinged, usually off-center, to the top edge of the canvas. Motherwell completely abandoned the painterly directions he had pursued throughout the previous decade to work exclusively on this series. H.H. Arnason argues that Motherwell's development out of the Spanish Window pictures from the early forties predicts this move into strict format control.[36] Yet the Opens with their strong color tendencies are highly responsive to the work of the Color-Field painters, particularly Jules Olitski.[37] Olitski's pictures allow color to predominate without sacrificing structure or form, and provide a strong example for Motherwell, who is always consciously holding back his color in paintings executed before 1967. Although based on a regularized geometrical format, the Opens retain Motherwell's expressionist heritage. With the pictorial structure reduced to only a few elements, subtle variations of painterly touch or quickness of drawing are sufficient to project emotion. The minimal sensibility which emerges from the 1964-66 period functions here only to lower the pitch of expressionist painting.

Barnett Newman, a member of the second, somewhat later, current in Abstract Expressionism, provided an enormous source for painters and sculptors of the younger generation. His relatively early move to reduce the formal complexity of the elements of painting to large areas of single color predicted a shift in sensibility that would take a decade to gain a foothold. During the late years of the fifties and into the sixties, Newman's painting becomes a transitional point between an art predicated on expression, and one which operates from its self-consciousness as an object. Essentially, there were two camps of Newman admirers: the first group he gathered from his New York exhibitions of 1950-51, and the second composed of the large audience from the late 1950's which welcomed the general shift away from gestural art.[38] Newman's 1958 exhibition at Bennington College was timely in terms of its influence: within two years Kenneth Noland's Target pictures became less gestural and more uniformly tight, Frank Stella's paintings became elaborately shaped, and in 1962 Larry Poons painted his first pieces in which fields of color were inflected with disks.

Barnett Newman's most ambitious project from this period is the fourteen-piece *Stations of the Cross* (Plate 12). Newman produced the first two canvases in 1958, two more in 1960, two in 1962, three in 1964, three in 1965, and two in 1966. This group of fourteen pictures was not initially intended to function as a series, but after the completion of the fourth painting, Newman realized the subject and number

the project would ultimately assume. On its own, each painting functions as an object, but together, the pictures reach a level of expression which no single canvas could convey. The *Stations* are a departure for Newman, whose paintings have been composed of strong color fields divided by sharp zips fragmenting the field. In the *Stations*, the color is absent, and the zips which divide the field of raw canvas are much more tenuous, and at times painterly. The sculptural zips serve to inform the more regularized ones, as well as to construct a dialogue between the panels of the series. Precisely at the time when the flat, reductive sensibility which Newman pioneered throughout the fifties took hold and informed a new generation, Newman retreated from that interpretation, producing a body of work — the *Stations of the Cross* — which is expressionist and emotional. In much the same manner that Hofmann uses the Abstract Expressionist context created by *Memoria in Aeterne* paradoxically to provide support for the younger generation, Newman uses a minimalist format — or at least a format which his audience is conditioned to regard as minimalist — to re-assert the power of expressionism. Newman asserts this expressionist identity in much the same way that Motherwell will right after him, by imposing only slight variations of brushwork and texture onto the taut, clean surface. Pressing the sensibility for reduced pictorial complexity to his advantage, Newman exerts the variation in surface which then propels his canvases away from the new generation, back to his own, in a plea for the restoration of emotional content.

1. Robert Rosenblum, "Excavating the 1950s," *Action Precision: The New Direction in New York 1955-1960* (San Francisco: Newport Art Museum, 1984), 13.

2. Rosenblum, 13.

3. Rosenblum, 14.

4. Kermit Swiler Champa, *Mondrian Studies* (Chicago: The University of Chicago Press, 1985), 54.

5. Kenworth Moffett, *Kenneth Noland* (New York: Harry N. Abrams, 1977), 95, note 45.

6. Clement Greenberg, "Louis and Noland," *Art International,* 4, no. 5 (May 1960): 27.

7. Moffett, 27.

8. Michael Fried, *Morris Louis,* (New York: Harry N. Abrams, 1970), 33.

9. Champa, Introduction, xvii.

10. Diane Waldman, *Kenneth Noland: A Retrospective* (New York: The Solomon R. Guggenheim Museum, 1977), 10.

11. Martin Duberman, *Black Mountain: An Exploration in Community* (New York: E. P. Dutton, 1972), 73.

12. Moffett, 38.

13. Lawrence Alloway, "Rauschenberg's Development," *Robert Rauschenberg* (Washington, D.C.: National Collection of Fine Arts, Smithsonian Institution, 1976), 3.

14. John Cage, *Silence: Lectures and Writings* (Middletown: Wesleyan University Press, 1961), 102.

15. Alloway, cat. no. 180.

16. Calvin Tomkins, *The Bride and the Bachelors* (New York: The Viking Press, 1968), 204.

17. William Rubin, *Frank Stella* (New York: The Museum of Modern Art, 1970), 12.

18. Rubin, 13.

19. Rosalind Krauss, *Passages in Modern Sculpture* (Cambridge: MIT Press, 1977), 181.

20. Krauss, 181.

21. Phyllis Tuchman, "Interview with John Chamberlain," *Artforum* 10 (February 1972): 39.

22. Barbara Rose, *American Art Since 1900* (New York: Holt, Rinehart and Winston, 1967), 253.

23. Donald Judd, "In the Galleries," *Arts Magazine* (December 1964), reprinted in *Complete Writings 1959-1975* (Halifax, Nova Scotia: The Press of the Nova Scotia College of Art and Design, 1975), 144-45.

24. Donald Judd, "Local History," *Arts Yearbook 7* (1964), reprinted in *Complete Writings,* 148.

25. Irving Sandler, *Al Held* (New York: Hudson Hills Press, 1984), 24.

26. Sandler, 27.

27. Eleanor Green, *Al Held* (San Francisco: San Francisco Museum of Art, 1968), 4.

28. Donald Judd, "Young Artists at the Fair and at Lincoln Center," *Art in America* (1964), reprinted in *Complete Writings,* 130.

29. E. C. Goossen, *Ellsworth Kelly* (New York: The Museum of Modern Art, 1973), 73-74.

30. Goossen, 79.

31. Barbara Rose, *Frankenthaler* (New York: Harry N. Abrams, 1971), 90.

32. E.C. Goossen, *Helen Frankenthaler* (New York: Whitney Museum of American Art, 1969), 13.

33. Rose, *Frankenthaler*, 98.

34. Sam Hunter, *Hans Hofmann* (New York: Harry N. Abrams, 1963), 24.

35. Clement Greenberg, *Hans Hofmann* (Paris: Edition Georges Fall, 1961), 40.

36. H.H. Arnason, *Robert Motherwell* (Harry N. Abrams, 1982), 71.

37. Laurie Rubin, *Robert Motherwell: The Open Series*, Unpublished thesis, Brown University, 1984, 14.

38. Lawrence Alloway, *Topics in American Art* (New York: W.W. Norton, 1975), 78.

Art of the Sixties: Soliloquies and Conversations

Christopher Campbell

To view the achievement of American artists in the years 1964-66 with the perspective implicit in the passage of two decades is one of the primary goals of this exhibition. It is hoped that within the group of work exhibited it will be possible to see clearly some of the most important conceptual, formal and historical connections that constitute the aegis under which Color-Field, Pop and Minimal art found their maturity and made their first "definitive statements."

The central problem of the sixties was one of discovering how to take into account the achievement of the first generation of postwar American painters and sculptors, loosely referred to as the Abstract Expressionists, while discovering how to do something fresh and thereby avoiding mannerist variants on their styles. The artists of the sixties wished to create work as direct, powerful and advanced as their predecessors, but they wished to do so without the overt appearance of existentialist searching, the rhetorical self-consciousness of posture and paint that had marked the previous decade.

Instead of seeking to advertise art's capacity for communicating profoundly *personal* feeling in a physically heated way, this new generation turned to new materials and new formal structures to make a set of discoveries offering profoundly new experiences. The uniqueness of individual sensibility would continue to be visible, but it would be communicated through comparatively depersonalized means. Geared to the exploration and development of carefully focused issues derived from various points in the traditions of modernist art in such a manner that these issues (and these points) were continuously re-examined and ultimately rediscovered, several new pictorial and sculptural strategies emerged, providing a set of flexible conditions from which radical conclusions could be drawn. As Clement Greenberg has written, "The essence of Modernism lies, as I see it, in the use of the characteristic methods of a discipline to criticize the discipline itself — not in order to subvert it, but to entrench it more firmly in its area of competence."[1] Thus modernist art can be interpreted as a series of putative aesthetic advances predicated on the ever more historiated and self-critical manipulations of a particular medium's formal elements. This essay will attempt to identify some of the specific evolutionary developments and transformations which constitute modernist American art's historical patrimony, defining the nature of several of the sixties most remarkable

achievements and the formal connections binding these together as a unique product of their time.

Between 1964-66, the dominant trend was to reduce the number of formal variables in art in such a manner as to comprise a focused and deliberate critique of prior work, especially that of the Abstract Expressionists. In general, the subjective was made more objective and literal, the personalism of kinesthetic gesture was replaced by the purity of geometry, and aggressive emotiveness was displaced by a kind of analytic passivity. Instead of internally balancing elements into classical compositions dependent upon an elaborated pictorial relationality (spatial and volumetric), the art of the sixties is frequently dependent upon symmetrical or repetitive structures that require less *ordering* even though they may superficially appear to be *more ordered*. The gestural drawing, frequently using high-value contrasts, that had served to create a linearly differentiated space in Abstract Expressionist work was dramatically renounced in the sixties, in favor of a new space created by unitary color fields or the juxtaposition of comparatively uninteresting shapes. Color was given an accentuated optical potency not only by the development of *intensely* saturated acrylic paints, but by a period desire to minimize variations of texture and maximize the unity of surfaces by creating a hard even paint surface, staining paint into canvas, or using intrinsically colored materials such as plexiglass. This simultaneous stress on color and non-autographic surfaces is visible in the work of virtually all the Color-Field and Pop painters (Stella, Noland, Poons, Kelly, Lichtenstein for example), and found in new extremes of both anonymity and intensity among the Minimalist's fabrications (Andre, Judd, McCracken, Flavin). The concern in this period for making art objects that clearly stand apart from their makers as separate *things* fundamentally connects such apparently disparate forms as Stella's, Kelly's or Wesselmann's shaped canvases, Oldenburg's vinyl and canvas Pop constructions, or Judd and Andre's Minimal forms.[2] Color-Field and Minimal artists found their formal independence in continuing the pattern of modernism's formalist reductionism while Pop found its alternatives in reincorporating the given forms of commercial art and popular imagery. With most of the artists in this exhibition working in a relatively limited geographic area and in routine personal contact with each other (and aided by a consistent and con-

tinuous series of exhibitions showing the most recent work, examined by a number of very capable critics from the viewpoint of formalist, or alternative modernist propositions) the mid-sixties saw one of the richest and most complexly interdependent bodies of work ever managed at a single historical moment.

Frank Stella is a typical, if in many ways very special, "new" artist of this period. He is at once one of the most important links with the Abstract Expressionists and one of its most discontinuous successors. Trained entirely in the making of abstract art during the fifties, he liked the openness and directness of the Abstract Expressionist address but wanted to make his painting ". . . something that was stable in a sense, something that wasn't constantly a record of your sensitivity, a record of flux."[3] Thus if the kinesthetic mark could be read as a trace of the particular state of muscular tension and emotional feeling of its maker at the moment of its creation, it was natural that Stella and the artists of his generation would turn towards the impersonality of geometry.

Using 3" deep stretchers that accentuated the separation of the painting's surface from the wall and stressed it as surface, Stella made several series of monochromatic canvases in the late fifties and early sixties. The Black series of 1958 (Plate 13) eschewed most of the characteristics usually thought essential to painting — drawing, color, modeling, space and relationality. However, what appeared to be a sealing off of painting's internal development became part of its invigoration, permitting an investigation of the pure structure immanent in the rectangular support of the easel painting tradition. The desire to investigate and to integrate the holistic "single-image" field structure of painters like Newman and Rothko and the movemented "all-overness" of Pollock, in which no area of canvas is subordinated to any other, led Stella to seek a means of organizing his painting so that one area would not constantly be balanced with another, but would be inexorably connected in a repeated cadence.

Painting free-hand black bands that constantly acknowledged the axes and edges of the canvas, Stella discovered that "The obvious answer was symmetry — make it the same all over."[4] Extraordinarily hermetic at first glance, Stella's Black paintings are in fact densely historiated, incorporating the lack of illusionistic depth that is progressively notable in painting after Manet, the expansive breadth of Barnett Newman and the disciplined neutrality of Jasper Johns' uninformative and repetitious stripes. Although none of Stella's early symmetrical, monochrome paintings are in fact the same all over physically, they are absolutely non-relational. Instead of calling for the viewer to organize the parts into a comprehen-

sible pattern, the order is plainly given through geometric, symmetrical relations expunging traditional illusionistic space and creating a new evenness of space uniquely available to abstract painting.

Having found in the Black paintings a means of completely identifying figure with ground, painting with drawing and structure with content, new sources of pictorial richness and interest emerged seemingly without Stella's overtly manipulative intervention. For example, the optical complication generated by the paint application turning a corner was developed in the next two series of pictures, the Aluminum and Copper series. Focusing on the localizations of intensity along the diagonals where the paint changes reflectivity, Stella capitalized on the spectator's reading of these optical knots by using dense metallic paints. Given the post-Renaissance tradition of investing paintings with illusionistic space and the extraordinary capacity of our perceptual system to extract depth from virtually any visual stimulus, Stella's early series should be considered in light of the difficulty of making a painting with no "space" in it, even as they demonstrate how subtle a change is required to recreate it.

Incorporating right-angle bends in the parallel bands of the Aluminum series induced sets of "traveling movements" rippling through each painting. Carried completely across the surface, these patterns necessarily created structurally superfluous areas. Walter Darby Bannard, a painting classmate from Princeton, provided a solution as rigorous as the problem's derivation — physically cut the offending areas away![5] This incorporation of the painting's internal structure into its external profile, a process of pictorial "deduction," continued to develop the object quality of the painting, stressing its nature as physically taut and cut "into," making it feel denser than a purely two-dimensional surface.[6] The slab-like, object-like, non-illusionistic quality of the painting that resulted would become extremely important to the Minimal sculptors almost immediately. Both Carl Andre and Donald Judd were friends of Stella and were later to develop many of the metallic surfaces, syntactical relationships and simplified gestalts of Stella's shaped monochrome paintings in their subsequent three-dimensional work.

By 1963, Stella felt sufficiently in control of his pictorial structures to be able to re-introduce multiple colors into his paintings. In the Valparaiso and Notched "V" series, the monochrome, unitary field structures of earlier works were combined into opposing triangular fields of growing complexity. The tension of interlocking flats of close value, but distinct hue, and the opposition of the "vectored" bands in works like *Valparaiso Flesh and Green* of 1963 (collection the artist),

served as an intermediary step towards full-scale polychromy. In the Moroccan series of 1964-65, opposing vectors no longer threaten to buckle the painting illusionistically, but the value range of Day-Glo color does, only to be held in check by the rigor of Stella's pattern.

In *Empress of India* of 1965 (collection Irving Blum Gallery, Los Angeles), the sequential addition of the "Notched V"s maintains the discipline of his previous work at the local level but develops a halting, irregular flow over the whole because of the complexity of its composition and its sheer scale (6' 5" x 18' 8"). By 1966, Stella was ready to relinquish symmetrical patterning altogether and permit a smoother, more intuitive flow of structure and color in the irregular polygons. Thus *Sunapee IV* of 1966 (Cat. 36) takes the kinds of risks that the earlier paintings had so carefully excluded. In the taut interrelations between the various geometric figures, there is simultaneously a feeling of continuity and an equivalent sensation of continuous deformation as if the shapes were interpenetrating like tectonic plates, changing color in response to the forces exerted upon them, and constantly threatening to snap into three-dimensional space. Stella has said, "My painting is based on the fact that only what can be seen there is there.... If the painting were lean enough, accurate enough or right enough you would just be able to look at it. All I want anyone to get out of my paintings, and all I ever get out of them, is the fact that you can see the whole idea without any confusion.... What you see is what you see."[7] The fact that Stella's forms ask to be read in this manner clarifies the further transition in the sixties of the modernist trend from art as the illusionistic window of narrative, autographic meaning to the construction of images in which meaning is conveyed directly by the organization and nature of its phenomenological character.[8]

The increased formal role played by color in Stella's, and indeed in most painting of the sixties, can be attributed in part to the work of two Color-Field painters, Jules Olitski and Kenneth Noland. Like Stella, Noland had been completely trained as an abstract painter and had been encouraged by David Smith to work in series.[9] But whereas for Stella the structure was primary, with color being developed later, for Noland color was the beginning and the pictorial problem one of finding the appropriate structure that permitted it maximum freedom and expressiveness. Noland said that "the thing is color ... to find a way to get color down, to float it without bogging the painting down in Surrealism, Cubism or systems of structure."[10]

In 1959, Noland saw Stella's paintings and these seem to have provided part of the structural plausibility he needed,

the regularity of the support creating a stable environment for his complicated color development. Seeking to integrate figure and field, Noland's stained, brushy periphery in the early Targets (Plate 5) had belied the lingering presence of an uneasy connection to Abstract Expressionism. By 1961, however, the paint application had been made as rigorous as the structure, and Noland was painting a nested series of centered concentric circles where the nature of the chosen hue determined its optical projection, some colors pushing aggressively forward while others slipped back. So, too, the regularity of the structure organizing and aiming the color clarified the relative differences in paint application, thickness and absorption, with the quality of the color appearing by turns to sit on top of the surface or to soak deeply into the canvas weave. These two factors in combination, hue and optical density, in turn control the degree to which the color is read as being optically connected to the neutral ground.

Gradually increasing the width and internal connections between his rings of color, by 1962 Noland felt the need to activate more of the canvas surface, and began painting the entire field of the canvas as well as the rings. This, while providing more color, provided less structure, and therefore a less secure scaffold for his color development. In 1963 Noland began the Chevrons, a series of sharply bent, parallel bands that incorporated the slowly turning, parallel bands of the Targets but simultaneously opened a new series of relationships with the edges of the support as a whole, eliminating the relatively neutral areas leftover in the corners. This important decision can be understood as integrating the rigorous deductive logic of Stella's symmetrical structures with the intuitive grace and grandeur of Morris Louis' color sequences, producing a dialectical synthesis of structure and color driven by Noland's sensitivity to the impossibility of proceeding in his chosen direction without the support of both.

Ironically, Noland's new use of regularized stripes to provide a controlled ambience in which to explore color relationships, and his serial approach to painting as the solving of plastic problems, reclarified his connections back to Josef Albers and Ilya Bolotowsky at Black Mountain College which began in 1946 (Plate 6).[11] It is a connection, however, in which Albers' small-scale, delicate color sequences have been invigorated by an Abstract Expressionist conception of scale and grandeur and a distinctly post-Pollock organizational sense, thence evolving into Noland's great breathing channels of pure color.

Noland's development in the mid-sixties exemplifies the general tendency of modern abstraction to evolve from some

combination of structural regularity to a more "intuitive" use of structure and color. Pushed to its limit, it finds the means to reclarify itself and release the inert and superfluous before precariously advancing again. As such, the Chevrons were first used to link the opposite sides of a square together. They then released the bottom edge, tensing the lower half of the canvas, but leaving it symmetrical to the left and right. In 1964, Noland pulled the Chevrons to one side, activating the ground anew as the asymmetric colored vectors stretched and compressed the whiteness of the painting.

This manipulation of the colored shapes in relation to the framing edges of the canvas began to suggest to Noland, however, that the two were somehow independent of each other, and beginning in 1963 Noland rotated his squares on the wall to make diamonds, reformulating the interdependence of the energetic chevrons with the shape of the canvas, and restraining the subtle tendency towards figurative freedom that had been exhibited by the previous asymmetric bands (Cat. 26). In some of the best diamonds, there is a fascinating relationship between bands of identical width that change their character from a square plane to a restraining edge as they march across the canvas and are sequentially elongated. In others, the orthogonal bending of the chevrons along a horizontal axis generates a powerful expectation of a value change at the mid-point. Never seeing under ordinary circumstances two orthogonal surfaces so evenly illuminated that their intersections display identical brightness values, we experience a powerful urge to read an illusionistic deformation into these "corners," only to be frustrated by the perfection of a surface that refuses to display the slightest modulation. The result is that the painting becomes a "plastic" bear-trap, armed with a hair-trigger.

Another possibility for the Diamonds was to use the old chevron pattern, anchored at the top, so that the bands coincided precisely with the shape of the canvas. This decision to deform the diamond format by elongating it on one axis, begun as early as 1964, had the effect of appearing to remove an a priori constraint upon the color, giving it more room to grow and conferring upon it the power to expand its own perimeters as if it were broadcasting waves of energy. In a number of elongated chevrons such as *Grave Light* of 1965 (collection Graham Gund, Boston), Noland also sustained an indefinite illusionistic effect of square planes of diminishing size and varying color hovering over each other, separated by a uniform distance and maintaining a perfect alignment in three-dimensional space, as if to form a pyramid seen obliquely.

By 1966, Noland relinquished the systemic use of the chevrons in favor of parallel bands aligned with two opposite edges of the elongated diamonds. This apparent reduction in pictorial, illusionistic incident, was more than compensated for by the increased power conferred upon the colored bands. For now the clear "object quality" of the diamond no longer seemed to be intrinsic unto itself, an object manipulatively shaped for aesthetic pressure, but appeared to be something "stamped" out of a larger, open color field, as if we were privy to a glimpse of an enormous heaving piece of opening color, the nature and pattern of which determined the shape of our vision. A few years before, Louis' color structures had demonstrated a means of gathering the white ground into the painted structure, and now Noland's color managed to conjure up the presence of an almost inconceivably large-scaled, colored life.

In addition, the diagonal bands of the "needle diamond" format subvert the firm, axial geometry of the earlier diamonds and chevrons. And while occasionally threatening to be read as the perspectival projection of a square, they remain held firmly against the flat of the wall by their surface, and not least, by their sheer dimensional breadth. Noland's tendency, in and after about 1966, to keep the center open and free of specific incident makes possible the apprehension of the whole "field" as the dominant sensation without resorting to obsessively linear configurations, a characteristic also of Jules Olitski's painting of the same period. This nonsequential, undirected use of color in which we are permitted to play freely among taut constructions also shares important characteristics with the sculpture of Anthony Caro, with whom Noland had been close friends since 1959.[12] As Noland's bands relate primarily to each other, not clearly either generating or being generated by the physical limits of their support, but are closely related to it, so Caro's component parts retain a sense of individuality and character parallel to the character of a given color band; the parts relate primarily to each other and only secondarily create the total configuration. This absence of Cubist dimensionality and Abstract Expressionist compulsion gave to the pure materials of artistic sensibility — paint, canvas and metal — a freedom never before possible. For Noland, the clarity and vigor of the horizontal stripe pictures was "the payoff . . . no graphics, no system, no modules, no shaped canvases. Above all, no thingness, no objectness. The thing is to get that color down to the thinnest conceivable surface, a surface sliced into the air as if by a razor. It's all color and surface, that's all."[13]

Superficially similar in a visual sense in his use of hard-edged juxtapositions of geometric color, Ellsworth Kelly (Cat.

17) represents the re-introduction into American painting of the training and traditions of sensuous French color at mural scale, combined with a proto-Minimalist sensitivity to surface and detail. Kelly's negation of classical compositional modes was not conceptually derived from an intellectually critical stance, as was later the case with the Minimalists, but grew from abstracted observation. Often working from drawings or photographs of natural or architectural motifs, Kelly discovered that the subtlest inflections present in visual configurations provided sufficiently rich beginnings for painting and sculpture (he had long been an able practitioner in both media). For Kelly, "From then on, painting as I had known it was finished for me. The new works were to be painting/objects, unsigned, anonymous. Everywhere I looked, everything I saw became something to be made, and it had to be made exactly as it was, with nothing added. It was a new freedom — there was no longer the need to compose."[14]

Thus Kelly, paradoxically, derived his vision from a perceptual sensitivity rather than a conceptual stance, but sought an autonomous color structure similar to, and chronologically preceding, that of Noland and Stella. Many of Kelly's paintings of 1963 involve two or three large, simple shapes brilliantly colored in straightforward hues. They are thickly painted to achieve a smooth, anonymous finish that does not detract from the clarity of the color and form, but their intensity of hue contrast, particularly along the "hard-edge" junctions of shapes, generates an optical buzz and blur that negates any attempt to read a given shape as either figure or ground, creating instead a plastic heave that would have been lost with a soft, stained boundary. Frequently playing one purely orthogonal colored shape against a curved shape reminiscent of his earlier naturalistically derived compositions, Kelly taunts us to anthropomorphize the organically curved form into figure, and then confounds the reading by making the adjacent color more optically aggressive in projection. The scale and intensity of his color precludes the possibility of a stable reading of *any* hue and stresses instead the oppressive forces generated by one color upon another, reminiscent of some of Olitski's Falling Curtain pictures of 1964. Becoming increasingly symmetrical, Kelly's paintings of the mid-sixties depended not only on the nature of his clean colored edges, but on getting the forms as "quiet" as possible, getting the "masses to perform."[15] This tendency towards an optical projection based on color became physical relief in the painted aluminum sculptures of 1965-66, done simultaneously with paintings in this period, in which a color shape literally asserts its independence by breaking free from the ground and moving into three dimensions.

In his shaped canvases such as *Yellow Piece* of 1966 (collection the artist), a square, unitary field of yellow with two opposite rounded corners develops an axial stress that begins to bend the color. At the same time, the brilliant yellow seen against a white wall conjures up a complementary blue haze around its perimeter, floating it away from the larger plane. In others, formed of two rectangular panels joined at right angles so that one lies on the floor and the other rises conventionally up the wall, one is less impressed by the painting's literal possession of a space mapped by X-Y-Z coordinates than by its insistence upon the planar, slab-like quality of the "painting." Thrust under our noses and bumping our feet, the flatness of Kelly's surfaces and colors are never so clear as when they spread across the floor. This capacity to envelop with definitive color is perhaps clearest in the works consisting of large, unitary panels of a single color deployed in sequence on a wall with slight separations. Using values of color that keep the colors at nearly an equivalent optical location, the separations of the panels keep the boundaries of the colored field ambiguous, creating an *environment* of color, and reiterating Kelly's connections back to Matisse's late cutouts and Monet at Giverny, but using an austere structure for a sensuous, plastic color development.

Walter Darby Bannard (Cat. 3) shared some of Kelly's interest in developing a tensed coloristic space through the interaction of hard-edged forms, but significantly without using value shading that could potentially be read as light falling upon the edge of a shape in any "real" space. Deploying increasingly complicated geometric forms in the center of inert, pastel fields of color, Bannard generated powerful illusionistic bucklings of his painting's surface as shapes seem to break free in one area, almost comprehensible as perspectival readings of unknown geometric solids. The curving profiles of many of his shapes carry a sweeping inevitability for the eye, almost promising the completion of independent form but ultimately grounding themselves into the field color, there to be pinioned by a flatness and lateral spread that re-affirm their original cohesion. The complex and elegant spatial irrationality of the whole is contradicted by the shiny density of the field color, which seems to declare the impossibility of any form ever penetrating its surface. Bannard's unique achievement in this period derived largely from his sensitivity to the potential degree of relative advance and recession derived from color interactions, a set of relations controlled with excruciating care in the choice of color, value change, and pigment gloss from area to area. Support-

ing an illusion of space that is purely optical in its derivation from the literal juxtapositions of edges, Bannard's paint cannot be read as forming three-dimensional boundaries. In this sense, the subtlety of his formal discriminations was an important precedent for much future Minimalist work, demonstrating as it did the capacity for relatively small-scale shapes and slight changes in surface and color to generate an equivocation that questions its own nature as form or aperture. Solid, planar or buckled, Bannard's forms have a plasticity commensurate with that of very large works by Stella or Kelly.

Less obviously structural than Bannard, but equally concerned with the creation of an uninhibited arena for the free optical interaction of large colored shapes, Friedel Dzubas (Cat. 10) brought to the sixties some of that lyrical freedom characteristic of Jackson Pollock and Helen Frankenthaler. Banishing the drawn expressionist line in 1961-62, Dzubas began making large colored biomorphs with ragged, expressionist edges. By 1964, he was smoothing their boundaries and simplifying his pattern and number of colors, while enlarging the scale of individual forms within the confines of the canvas so as to possess the entirety of its surface. In 1965, the last vestiges of protozoaic engulfment disappeared and Dzubas switched from oil to turpentine and Magna. His paintings became more obviously concerned with purely optical relationships, aided by the switch to a more resistant medium that restricted the potential for calligraphic facility.

At that time, the pictorial stress also shifted from lateral connections of object and surround to forward/backward alternations. Deliberately overlapping some of his shapes, and working color and value to establish progressions in depth, Dzubas' forms loosened their figure/ground interchanges and began to slip fluidly in relation to each other, pressing out from the picture's surface to establish the necessary space for their movement, using areas of white canvas as a neutral ground in front of and in back of which forms could be established. The change in 1966 to a more clearly "shaped" canvas with long, slender proportions, marked an increased awareness not only of the importance of the support's proportions but the role of internal shape to edge. The concomitant flatness of facture and color tightened the space within which his shapes communicated, thus intensifying their formal interactions.

The intensified differentiation of center/edge, figure/field areas in a canvas is perhaps best polarized in the work of Frank Stella and Jules Olitski. Whereas Stella had clarified the possibility of identifying the two with each other through systems of regularized geometric structure in which neither could be seen as generative, Olitski separated and cultivated their unique capacities for pictorial organization by exploring maxima of chromatic and structural freedom. Olitski's injection of a loose, open color deployed in a kinesthetic, intuitive manner was an essential alternative to Stella's deductive compositions. Instead of determining structure first, and then attempting to find the color "called for" by the structure, Olitski *begins* with color and thinks of "painting as possessed by a structure — i.e., shape and size, support and edge — but a structure born of the flow of color feeling."[16]

The gradual expansion of the dense Cubist-derived core of the Abstract Expressionists into the openness seen in both the painting and sculpture of the sixties is an essential characteristic of the period. In Cézanne's late watercolors as well as those of John Marin's, natural landscape motifs seem to have provided an important incentive for the softened edges and massed expanses of diffuse color that have no apparent textural modulation but which generate virtually infinite depth. The renewed formal importance in sixties painting of pure color opened out, cut free and discovered anew may be traced in part back to Helen Frankenthaler's cardinal work, *Mountains and Sea* of 1952 (Plate 2), in which thinly stained paint, derived from Pollock, was used to make very large spreading shapes of liquid color. Made upon returning from a painting trip to Nova Scotia, Frankenthaler has remarked that ". . . I know the landscapes were in my arms as I did it."[17]

Olitski's importance in the loosening of sixties color abstraction was largely predicated upon his integration of multiple strains of modernist painting. Trained in Europe, Olitski's work of the forties and fifties had brought together the luxurious color sensibility of Matisse and Bonnard with an element of Surrealist automatism deriving from artists such as Masson and Miro.[18] In the later fifties, Olitski's admiration for the richness of the material paint surface in artists as historically disparate as Rembrandt and Dubuffet found expression in heavily impastoed canvases of very limited chromatic range. Abruptly exchanging heavy surface and light color in 1959 for stained surface and pure color, Olitski joined the Color-Field mainstream of American painting.

Often overtly biomorphic, many of Olitski's paintings of 1960-63 (Cat. 29) were based on photographed configurations of the nude female body, a point of origin from which Olitski developed his stained shapes into rounded, concentric compositions. By 1963, color was no longer secondary to shape but seemed to be its creator, suggesting in the Falling Curtain pictures a sheet of color sliding inexorably down the surface of the painting, maintaining the tension of continued motion and promising to engulf any sol-

itary forms still at liberty in the lower corners.

In 1964, the echoes of figurative details and gravitational impulsion both disappeared, leaving Olitski's painting a purely pictorial arena in which a single color tenuously possessed the center of the canvas, challenged at its borders by other (frequently complementary) colors. In these field paintings such as *Tin Lizzy Green* of 1964 (Boston Museum of Fine Arts), Olitski developed his understanding of hue change and interaction as saturated acrylic color met color across a charged neutral space, just touched, or overlapped and blurred. Continuing to find essential new options within the processes of technical discovery and exploration, Olitski applied paint with sponges and rollers in 1964 and finally with spray guns in 1965 (Cat. 30).

As early as 1959, Olitski had seen paintings by David Smith made with a spray gun but had not liked them.[19] Now the spray's pulverization of color permitted him to maximize chromatic interaction, but without the slippage into depth implied by overlying planes. Sprayed pigment also permitted an all-over flow of color capable of possessing the entire canvas surface without drawing, a chromatic analogue for Pollock's calligraphically derived spatial web and a non-geometric parallel to Noland. Olitski has expressed his interest in unifying color and ground, saying, "Edge is drawing and drawing is always on the surface. The color areas take on the appearance of overlay, and if the conception of form is governed by edge — no matter how successfully it possesses the surface — paint, even when stained into raw canvas, remains on or above the surface. I think, on the contrary, of color being in, not on, the surface."[20]

Olitski's formal, constructive acts of spraying and soaking the raw canvas in a trough of acrylic paint both assured that the paint was truly *in* the surface and that the paintings from 1965 forward created by combinations of these methods would make clear not only the conceptual stance that gave them birth, but the technical means by which they had been created. In this sense, they continue the historical precedent of Pollock's gravitationally driven line, Louis' sluice of liquid paint, Stella's hand-painted imprecision and Noland's spreading color stains. However, Olitski's spray achieved an additional dynamism in that his rolling clouds of color, suspended in air at their creation over a liquid soak, never seem to completely alight, remaining indeterminate and full of possibility. Using multiple spray guns, Olitski was able to produce extremely complex changes in color and surface by momentarily holding or moving the gun, and by optically mixing the pigment spray on the surface without a loss of saturation. The paradoxical result is to stress both the physicality of the color deposit and its optical capacity to dematerialize.

In 1965-66 (Cat. 31), Olitski began to mask areas at the borders of his canvas between color applications and to mark the approach to the edge of the support with final applications of chalk, pastels or heavier oil paint, tickling the color field at its limits. These gestures served not only to indicate an increasing consciousness of the relationship between the framing edge and the interior of the painting, but to suggest painting's traditional coalescence of paint itself into discrete shapes of a single, distinct hue that required definitive consideration in terms of placement. Olitski's oppositions thus make not only structure, but color, literal; suggesting that the volatility of the color necessitates firm restraining marks at the edge, and thereby emphasizing the looseness and richness of the internal color development. This might be understood as an act of *inductive* structure, the dialectical inverse of paintings in which the particulars proceeded from a knowledge of the whole system. For Olitski, the ultimate containing shape and frame was suggested by the particular complexes of color structure that had been freely made, the exterior shape and edge markings becoming the final decisions rather than the preconditions of the painting's birth.

The last of the Color-Field painters to be considered in this essay, Larry Poons (Cat. 32) achieved an extraordinary synthesis of Stella's deductive Minimalism and Olitski's sensuous color. Inspired by Mondrian and Van Doesburg as a student of music at the Boston Conservatory, Poons had first sought to find the musical equivalents of visual structures.[21] However, in 1959 he was powerfully affected by the experience of seeing Barnett Newman's *Vir Heroicus Sublimus* of 1951, with the result that by the early sixties Poons exchanged musical composition for painting. Like Stella, Poons often worked first with graph paper, developing a field structure of such complexity that its pattern was not immediately accessible to ordinary perception, while the whole was felt intuitively to be organized.

Working from a penciled grid on the canvas but refusing to adhere to an absolute regularity of placement, Poons capitalized on the simultaneous architectonic stability of Mondrian's grid and the antithetical freedom of his intersections to generate an optical "bounce." Poons' paintings can often be simply described as a large field of a single, deeply-stained color which has been inflected with small circles or ovals of color the position of which relates them systematically to the grid. However, this by no means prepares a viewer for the interactions that result. At first nearly overwhelmed by the sea of deep color, the eye quickly begins to

form associative groupings between ovals of similar color, creating interlocking planes of space. The axial orientation of the ovals is then taken into account, establishing subsets of positional variations within any single set of colored dots. Sets of dots are seen projectively or recessively according to their hue, and finally the sheer intensity of the color interactions sets up a rapid-fire barrage of optically complementary after-images that shift, burst and swim with every eye movement. The net effect is to transform a rigidly conceived geometric pattern into a completely optical, fluid sea of rich sensation, making Poons another significant inheritor of Pollock's formal legacy.[22]

The development of Poons' paintings in the mid-sixties shows a distinct progression away from geometric rigidity and limited color combinations towards a freedom of unit placement and a multiplicity of colors in a given painting, as well as an increased subtlety in these colors' relative values (their light/dark quality). Thus the paintings become distinctly looser, richer and less manipulatively predetermined, permitting and requiring an ever greater participation from the viewer to organize the visual sensations. The sheer density of visual experience in many of Poons' paintings is such that it can be very difficult to sweep one's eyes smoothly across the canvas, for the color fields are so heavily modulated by so few stimuli that they create the impression of encountering *physically* resistant fields of force. Poons' decision to continue the interior pattern of the painting without diminution into the edges and corners, and in fact to frame the canvas so that some ovals are randomly cut by the frame, seems to imply that infinite continuity of color already suggested by the sheer size of the painting. Poons himself has said that, "The edges define but don't confine the painting. I'm trying to open up the space of the canvas and make a painting with a space that explodes instead of going into the painting."[23]

Larry Poons' work is a prime example of the evolutionary interchange that characterized Color-Field painting in the period examined by *Definitive Statements*, for it is inconceivable without, among other things, a self-critical understanding of Pollock's optical density, Louis' saturated stain, Newman's physical scale, Stella's structural geometry, Noland's active color and Olitski's controlled freedom — a complicated paternity for an apparent formal conceit of "dots on a plane."

This pattern of re-incorporating prior historical achievement as the basis for new aesthetic advances was also at the heart of Pop art, which at first sight seemed to many to be an offensively deliberate repudiation of the modernist tradition through its presentation of banal things readily seen in real life but apparently unmodified (or only slightly modified) by aesthetic reformulation. Perhaps it was the astonishment at seeing Pop art's blatant incorporation of the ubiquitous objects of material existence, usually commercial and inartistic, that directed its early critics to focus on questions of whether Pop artists such as Oldenburg, Lichtenstein, Rosenquist and Warhol were embracing or excoriating their "subjects." From a more distant perspective, it seems clear that the Pop artists were utilizing a realist substructure primarily as the support from which they could most effectively critique late Abstract Expressionism's hermetic mysticism and mannered painterliness, even as they did find new forms, new means of visual address and new issues about the nature of contemporary American society that could be addressed through their sculpture and painting.

It is, therefore, not surprising that the practitioners of Pop necessarily appropriated what they critiqued, reinterpreting in the classic modernist tradition many of the preceding generation's most salient forms and characteristics: expansive scale, all-over composition, a stress on surface, self-evident flatness and optical dazzle. What was new was seeing all this enacted upon the familiar images and objects of everyday life, using these forms as a means of abrogating excessive personalism. Thus while the visual contrast between a de Kooning and a Warhol might seem to be unbridgeable, there is also an important continuity, not least in the replacement of the Surrealist/figural armature lurking in much Abstract Expressionist work (Newman's zips, de Kooning's women and David Smith's totems, for example), with their explicitly realist equivalents.

Andy Warhol's training and early work as a commercial artist particularly suited him to address simultaneously two distinct audiences — the small and hermetic circle of artists, buyers and critics of abstract painting, and the exploding popular audience titillated by the presence of clearly recognizable imagery and re-assured by an art whose comprehensibility did not seem to depend upon an understanding of its modernist historiography (Cat. 38-41).

An extremely capable commercial draftsman who decided to be a "serious" artist at the beginning of the decade, Warhol's images equivocate between their accomplished form and technique and their apparently obvious content in such a way that a painting of Campbell's soup cans undeniably recreates a familiar image, but at the same time resonates with the optical complexity of previous hard-edged abstraction, glows with the crude phosphors of early color television and vibrates in its serial mis-registration like an image from mass-produced printing. But even in 1962, Donald Judd had

pointed out that the critical attention paid to the subject matter in Warhol's work was a less interesting issue than his translation of commercial images and materials into "'overall' paintings of repeated elements."[24]

Because Warhol's formal manipulation was primarily limited to his choosing pre-known images and then subjecting them to enlargement, multiplication and color change, his painting was seen as an outrageous attack upon the non-representational form-building sensitivity associated with "real" artistic activity. However, it is clear that the formal challenges and opportunities provided by translations of scale and media interested Warhol as much if not more than calling into question the nature and role of the reproduced image. As such, the Brillo boxes (Cat. 38) parallel Warhol's paintings in three dimensions, reading as familiar forms displaced and made strange not by the grain of half-tone screens but by the wooden surface of their plywood box supports, as inelegant and impersonal as a Morris or a Judd, equivocating as "literal or depicted shape."

Viewed abstractly, Warhol's paintings based on commercial art and popular culture allowed him to establish both their independence and their points of contact with long-standing visual traditions. Thus the iconic presence of a brutalized and lurid Marilyn Monroe, smudged and damaged, but pristinely placed in the midst of a vast gold field of gothic opacity reconnects the most typical products of contemporary mass media with their most venerable precedents. Eventually silk screened instead of hand painted, and printed in burgeoning multiples, Warhol's images deliberately inverted the inflated, personal rhetoric of Abstract Expressionism by looking more machine-made than hand-made.

In the *Disaster* series (Cat. 40, 41) of the early sixties, Warhol reproduces the psychological innoculation performed by the soulless imagery of the television and newspapers, even as he builds upon their distinctive visual signatures. Individual paintings of car crashes and death chambers typically repeat a single image, but their juxtaposition encourages comparison and examination, a process that highlights the ephemeral abstractness of any single unit of form. At the same time, the bleeding/fading quality of the silk screen relates the transformed photograph (both partially anonymous, mechanical reproduction techniques) to the brushy surfaces of fifties painting, a relationship further clarified by its juxtaposition with the hollow passion of large areas of blank, scumbled paint. Warhol's deadpan conclusion seems to be that meaning can no more be associated with fields of abstract paint than with the mangled realism of the machine age.

Like Frank Stella, Claes Oldenburg (Cat. 27, 28) wished to enlarge the "plastic" boundaries of art by displacing attention from an obviously personal sensibility, to a created object apparently devoid of traditional aesthetic concerns. However, his interest in "an art that takes its forms from the lines of life"[25] required that this be accomplished not by banishing every trace of traditional illusionism, but by creating objects so overwhelming in their "thingness" that they become very difficult to analyze purely as "works of art." Oldenburg discovered that at wildly intensified levels of scale, color and texture, the formal qualities of an object reassert themselves with extraordinary vigor, disarming the question of its creator's expressive intentions just as one of Stella's metallic paintings calls attention to itself primarily as an uncomposed object and only secondarily as the product of a specific "creating" individual. Simultaneously demoting the art object and promoting life, and just as surely creating a greater equivalence between the two, Oldenburg himself said, "So if I see an Arp and I put that Arp into the form of some ketchup, does that reduce the Arp or does it enlarge the ketchup, or does it make everything equal? You do not have to reach any conclusions about which is better. It is just a matter of form and material."[26]

It was primarily the desire to manipulate materials in a new formal manner, implying an artistic rather than a social critique, that dictated the incorporation of a new, and only apparently literal, subject matter into Pop art. And yet there is an inescapable sense in which by translating abstract relations into tangible form, the concrete nature of the object's physicality cannot help but focus attention on the objects and environments that populate the artist's, and our own, material and mental lives. Thus while the impetus behind "a soft object is to introduce a new way of pushing space around in a sculpture or painting,"[27] Oldenburg's creations often evoke a distinctly figurative quality. Even more immediately, their simultaneously intriguing and repellent squishiness provides a richly erotic sensation that partially fulfills Oldenburg's dream of giving concrete form to ephemeral fantasy.

Recalling the "combines" of Robert Rauschenberg, the "presence" of actual objects is also central to the Pop paintings of Jim Dine (Cat. 9). Drawing upon childhood experiences in his grandfather's and father's hardware stores in Cincinnati, Dine had always been interested in "the juxtaposition of tools to ground or air or the way a piece of galvanized pipe rolls down a flight of gray enamel steps."[28] It was a similar sense of the fecundity of physical specificity that would later be isolated and highly developed by the Minimalist's "Specific Objects." After moving to New York in

1959 and coming into contact with Johns, Rauschenberg and Oldenburg, Dine combined an Abstract Expressionist facture with recognizable objects, usually common tools, that made the most subjective qualities of a modernist painting's aesthetic maneuverings explicitly literal.

Dine's often brutal juxtapositions of painted surface and literal object destroy the unitary mode of the easel painting tradition and make it impossible to take his canvases at face value. Instead, Dine forces a mutual reconsideration of the expressive qualities of each component, both alone and in combination with others. Thus the presence, in the midst of an obviously aesthetic environment, of axes, saws, hammers, clamps and oil cans requires first an analysis of their specific capacities *as* objects in the normative world, and second, their relation to the nature of the painting. This interaction ultimately elevates Dine's superficially "Pop" works to the level of explicit critical commentaries on loose painterly surfaces in need of tightening (with a crescent wrench?), of compulsively tight surfaces in need of loosening (oiled and lubricated?), being opened up (hacked or sawed apart?) or forcibly unified (with pipe clamps?).

In *Double Isometric Self Portrait (Serape)* of 1964 (Whitney Museum of American Art), we are initially encouraged in the painting of the tautly rendered robe to consider figure/ground interchanges made literal by the presence of the figural robe. Using clear, hard edges and flat, carefully controlled color, one is made to think of formal precedents such as exist in the works of Ellsworth Kelly and Walter Darby Bannard. However, the additional presence of hardware bolted to the ground to which has been attached a chain ending in a handle just made for pulling (with both hands!), destroys any purely aesthetic reading and virtually demands that the viewer grab hold and rip the perfect "modernist" flatness of the paint layer away from the canvas. Significantly, the nature of Dine's painterly critiques during the sixties parallels the movement among the Color-Field painters from heavily brushed and dripped Abstract Expressionist surfaces to flattened, geometric color planes and even in 1966 parodies Olitski's definitive marks applied over a loose spray of paint. That Dine's witty addition of a few pieces of ordinary hardware or Stella's surgical notching of corners could so transform "paintings" into "objects," capable of powerfully stimulating our awareness of their changed nature, indicates both our usual insensitivity to the forms which surround us, and the virtually infinite potential for variations on a standardized theme provided by the easel painting tradition.

Like Jim Dine, Robert Indiana (Cat. 14, 15) introduced explicitly recognizable images into his painting in the early six-ties as the basis for re-examining the possibilities inherent in the traditions of abstract painting as practiced by artists such as Kelly, Noland and Stella. Using complex, hard-edged patterns, Indiana's paintings generate enormous optical vitality through their juxtaposition of sharp boundaries, brilliant colors and flat surfaces. The neutrality of his brushwork is maintained by the exclusive use of stenciled letters, literally preventing the intrusion of any personal "handwriting." This leaves the painting surface free to react internally as a geometric construct, pulsing with violent value contrasts and popping with the after-images of saturated colors forcefully jammed or superimposed against each other.

Unlike his purely geometric predecessors, however, Indiana frequently refused to leave his compositions at the level of a purely visual complexity by incorporating verbal messages that are sometimes socially and emotionally charged, sometimes aggressively confrontational. Assuming our familiarity with the tricks of high visibility signage, Indiana confounds our expectations for the sign's informative blandness by replacing their messages with pointed commentaries on Southern racism or exhortations to "EAT," "YIELD" or "DIE." A reversal of the neutrality of Jasper Johns' uninformative supports such as targets and flags, Indiana's appropriation of popular culture integrates intricate and exciting formal experiences with provocative literal *and* metaphoric content.

Independently, Roy Lichtenstein (Cat. 19, 20) also began using reproductions as the source of his originals when he blew up the image on a gum wrapper to the scale of a painting.[29] This choice created a form that occupied a previously unconsidered position between painting as the illusionistic recreation of visual experience, and abstract painting as form expressing interior feeling. For Lichtenstein, as for most of the other Pop artists, the use of comic book sources was an attempt to make new kinds of paintings that did not build their meaning on kinesthetic gesture and personal symbolism, but incorporated literary and recognizable subject matter so brazenly that formal intentions were masked with "humor."[30] That the pleasant banality of Lichtenstein's subjects was only a disguise for an aggressive formal intelligence was made clear in an interview with Bruce Glaser in 1963 in which Lichtenstein said, "I want my images to be as critical, as threatening and as insistent as possible. Q: What about? As visual objects, as paintings — not as critical commentaries about the world."[31]

Whereas Abstract Expressionist form had symbolized its content, Lichtenstein's popular subjects were primarily an armature upon which advanced painting could be built. To optimize their dramatic and theatrical impact, and thus the

narrative appeal of his images, Lichtenstein used the intensity provided by the cinematographer's close-up. Considering comic strips as a series of selected frames from a continuous imaginary drama, Lichtenstein chose yet again the single frame epitomizing the entire narrative and containing a maximum of compositional possibility. Tuning up and refining the small-scale clarity of the comic book image, Lichtenstein's tremendous magnification of the frame made it possible to achieve an instantaneous comprehensibility of pattern that derived not only from his familiarity with classic relational composition, but from his awareness of the major abstract painters such as Stella, Kelly and Noland who were his contemporaries. The pictorial organization of Lichtenstein's painting is, in fact, the one obviously "artistic" component of the whole, contesting the non-art anonymity of the stenciled Ben Day dots and flats and the vernacular subject matter.

Lichtenstein's manner of neutralizing the prior content of his "subject matter" is particularly clear in the brushstroke paintings of the mid-sixties that spotlight the archetypal gesture of Abstract Expressionism. As paintings made from a previous painting of his own made from a comic book image made from real paintings made from real life, the brushstroke works achieve a comprehensive summary of preceding modernist painting in their monumental forms; Neo-impressionism in their dots, biomorphic Surrealism in their organic undulations, Abstract Expressionism in their angst-laden track (complete with deteriorating "Tenth Street" silhouette) and Op art in the all-over optical vibration of the whole.

The tenuous conversation between pre-existent images and abstraction, between "popular" and "high" culture, that characterizes the Pop artists is even more obviously the source of James Rosenquist's painting (Cat. 33). Having worked as a billboard painter and window display designer at the same time that he was painting for himself, it was probably inevitable that Rosenquist should attempt to incorporate the excitement he felt for advertising's visual inflation into his own statements. Paradoxically, to be a billboard painter means to paint in such a manner that at the normal working distance of an artist to his canvas, images designed for long distance legibility deteriorate into patterns of color and shape that assert an abstract life of their own. Thus even though Rosenquist prefers to paint "objects well enough to sell them," he does so to give things an "unexpected immediacy — as if someone thrust something right next to your face — a beer bottle or his shirt cuff — and said, 'how do you like it?'"[32]

Unpretentious in intent, Rosenquist's vividly representa-tional paintings force a confrontation with fragmented pieces of the things we produce and consume, from canned spaghetti to mushroom clouds, a lurid and frightening vision of the world we have made for ourselves and sold to each other. Rosenquist shares with Lichtenstein a delight in the standardized tricks of visual simplification as well as a penchant for packing his surfaces with images that fairly cry out for narrative and metaphoric connections. However, the Cubist relationships binding the parts remain primarily visual ones, and Rosenquist modestly claims for his paintings only the benefits of a casual orgasm when he says, "I only hope for a colorful shoe-horn to get the person off, to turn him on to his own feelings."[33]

If Pop art can be said to have staged simultaneously a self-conscious critique of modernist tradition and of the preoccupations of America in the sixties by creating an illusionist effulgence, then Minimalism shared its goals but inverted its means by creating what initially appeared to be an abstract *reductio ad absurdam*. The purification of means and reliance on the minimal inflection that characterizes the most important sculpture of 1964-66 has an important precedent in the work of the English sculptor Anthony Caro (Cat. 6) whose spare, quiet pieces accomplished a major redirection of sculptural energies in line with Clement Greenberg's tenet that the "modernist work of art must try, in principle, to avoid dependence upon any order of experience not given in the most essentially construed nature of its medium."[34] At the beginning of the sixties, Caro relinquished the overt psychological content and expressionist surfaces of his modeled figures and replaced the vertical, figurative axis of the standing person with the gravitationally induced axes of the ground, saying "I want to make sculpture which is very corporeal, but denies its corporeality."[35]

Just as modernist painting found new expressive power in its renunciation of painting's traditional illusion of depth, using non-illusionistic devices on a two-dimensional support to create an optical space unique to painting, modernist sculpture's command of three dimensions found its greatest challenge in the use of elements subject to gravity in order to suggest their opposite, an "achieved weightlessness."[36] In 1963, Caro began to work at Bennington College, near both Jules Olitski and Kenneth Noland, with whom he began an important exchange of ideas and working techniques.[37] Caro preferred the evident anonymity of industrial materials, not for any allusion to "industrial use," but for reasons diametrically opposed to the Pop artists. Whereas Pop uses pre-existent objects that set up a barrage of narrative and metaphorical complications, industrial materials such as bolts,

girders and pieces of sheet steel act as purely neutral signifiers, showing no evidence of their maker's hand and conveying no sense of a previous life. In this sense, they are free to become points of articulation in purely non-representational configurations, a piece of joist functioning like "a blob of color in a Monet painting."[38] Caro explains, "I have been trying to eliminate references and make truly abstract sculpture, composing the parts of the pieces like notes in music. Just as a succession of these make up a melody or sonata, so I take anonymous units and try to make them cohere in an open way into a sculptural whole. Like music, I would like my sculpture to be the expression of feeling in terms of the material, and like music, I don't want the entirety of the experience to be given all at once."[39]

Building through improvisation, Caro formed expansive, welded assemblies of metal whose open forms extend themselves to the onlooker and whose parts only find their meaning in conversation with each other and with the piece as a whole — in their "syntax" to use Michael Fried's term.[40] The apparent simplicity and clarity of Caro's individual elements in no way prepares one for the synergistic meaningfulness of the whole system, an emotive power entirely unpredicted by the behavior of the parts considered separately. This power derives primarily from Caro's ability to create phenomenological complexes which the viewer can intuitively understand as analogues to physical relationships — relationships between his or her own body and forms in and of the environment of which one is hardly conscious. A beam, succumbing to gravity, lies dormant on the ground. A small angle rises up and takes a tentative step. A long strip of metal sallies forth but is caught by the assertive magnetism of a large, columnar pipe and drawn into a narrowing spiral. A band of thin, defiant pipes, attempting to rise and stand free, wavers and sways uncertainly.

Caro positions his elements in such fertile arrangements that new pictorial configurations are recreated from each available viewpoint, the relative groupings of parts changing and recoalescing to form a continuous drama of living abstract relations. This drama becomes an equivalent to the human figural drama that had been exorcised by non-representational modernism, and whose presence seems to be essential to prevent a language of purely formal relations from dissolving into monotony.[41] In this sense, Caro's sculpture has much in common with Stella's irregular polygons of 1965-66 and their continuous sense of interpenetration, deformation and connection. At the same time, it can be understood as very different from the work of his important predecessor David Smith, whose Cubi series (Plate 8) persis-

tently retains the totemic presence of the gesturing human body.

Like many of the Color-Field painters in the early sixties, Caro began using a variety of shapes and colors in a single piece. But by 1964-65, just as Stella and Noland had previously simplified their shapes and the alignment of those shapes to their defining surface (the canvas support), Caro stripped down the number and complexity of his parts in works such as Kasser of 1965 (Boston Museum of Fine Arts), while their more obviously horizontal configurations responded more explicitly to the ground plane on which they stood.[42] By 1966, having subjected himself to this discipline, Caro sought to achieve a greater intuitive freedom and openness by incorporating "expanded metal" mesh that has very different formal properties from his linear and planar solids. Frequently, these relationships between painted mesh and solid elements of the same color seem to be parallel to those of Olitski's clouds of color in the central areas of his paintings and the defining slabs bounding and demarcating them. In a work such as Carriage of 1966 (collection Andre Emmerich Gallery), the tendency for the mesh to want to float free is dramatized by a mesh panel placed at a sharp angle to the hard, definite, orthogonal elements, its dissolution of the solid into space (again paralleling the distinct material grit of Olitski's spray at close range) testing the capacity of the linear structure to hold and define its openness, and suggesting the potential expansion of color fields. Caro originally painted his pieces simply to keep them from rusting. However, material necessity rapidly became aesthetic. Occasionally using polychrome in his early work, Caro early began painting all the parts of each piece a single, uniform color, encouraging its recognition as a cohesive optical whole, masking the particular nature of his various materials and fulfilling the sculpture's "call" for a certain color to further its expressive capacity in what might be called an act of "deductive" coloration.[43]

The sculpture of Tony Smith can be seen as an intermediary presence between the work of David Smith and Anthony Caro on the one hand, and the fully Minimalist sculpture of artists such as Robert Morris, Donald Judd and Carl Andre on the other. The constructed assemblies of David Smith and Caro usually communicate, albeit at a highly abstracted remove, relations between forms that have the character of the relationship of the human body or other "known" forms to the physical presence of other bodies and presences, a character that the developing body of work termed "Minimalist" would seek to banish completely.

Tony Smith provided an important visual precedent in the

extraordinary severity of his pieces (one of which consists entirely of a forbiddingly black steel cube measuring 6' on an edge). Paradoxically, the conceptual basis from which Smith derived this work was entirely at odds with the philosophical tenets of the later Minimalists. Smith's association with the New York School, both in terms of his prior painting and his personal friendships, had long confirmed his sense of abstract form's emotive capacity.[44]

Working first with cardboard models, Smith proceeded to full-scale plywood mock-ups that were given permanent form in steel. His monumental sculptures such as *Amaryllis* of 1965 (Wadsworth Atheneum), are topological structures based on the complex addition of regular polyhedra such as the tetrahedron and octahedron, forms the individual presence of which can still be felt in the smooth-sided steel of the final sculpture. These belie Smith's interest in organic systems of order (such as crystallography), and his conception of his sculpture as participating in a continuous spatial grid in which the pieces can be conceived "as seeds or germs that could spread growth or disease."[45] Their "reductive," "minimal" appearance notwithstanding, and despite their completely geometric, non-pictorial structure, Smith understands his work to participate in larger constructs, both physical and philosophical, that exist prior to their creation. It was to be the complete rejection of any such preexistent systems that characterized the conceptual basis of mature Minimalist production.

For an artist such as Robert Morris (Cat. 24, 25) the work of art functions as the instigator of an aggressive dialectic between the perceptual experience of the viewer and his or her aesthetic preconceptions about what constitutes a "work of art." Thus works that are uniquely direct in their physical address to the viewer reveal themselves to be uniquely intellectual in intent, not in traditional terms of program or iconography, but as sources of historiated provocation. Instead of being presented with the material evidence, the kinesthetic translation of an individual's feelings, we are presented directly with a *specific material* phenomenon or proposition devoid of recognizable content, but still plainly aesthetic in intention. This strategy of deploying "specific objects" was part of what appears to have been a collective sixties endeavor to open up the making of art as much as possible, discarding presumptions that had not even been consciously made by previous artists about scale, aesthetic materials, historical evolutionism, invasive composition, theatricality, and the role of boundaries between two- and three-dimensional media.

Morris typically used materials without an aesthetic or fine arts history such as hemp rope, cast lead, gray painted plywood or fiberglass, or limp felt to construct his objects. He has written that "Objects were an obvious first step away from illusionism, allusion and metaphor . . ."[46] For Morris, the creation of these objects was a means of reversing the precedence of form before substance, thereby permitting substance to occupy the position previously held by formal preconception. By establishing infinitely changeable material as the basis for art, and not a pre-existent (and presumably finalized) conception of order, the path was opened for art to function as "irreversible process" in which finality and relative judgments of "quality" had to be suspended indefinitely.

In 1964-65, Morris had two exhibitions at Robert Bellamy's Green Gallery, the first in lead and metal that incorporated a measure of Dadaist, Duchampian wit, the second in painted plywood forms of a unitary, geometric nature precluding sensate division into component qualities of hue, shape, value, texture, etc., and deployed so as to orchestrate and involve the entire space of the gallery (Plate 14). Whereas Frank Stella had sought to remove visual climax and unify his painted slabs from edge to edge, Morris sought not only a visual but a *conceptual* unity in which the form of the literal mass was so immediately comprehensible that its perceptual and conceptual gestalt were identical. In 1966, Morris wrote in his seminal "Notes on Sculpture" that "Simplicity of shape does not necessarily equate with simplicity of experience. Unitary forms do not reduce relationships. They order them."[47] In this sense his *Cloud* in the Green Gallery show, a 10" thick suspended slab 6' square, is not an artifact of order itself but creates by its simple presence a phenomenologically understood column of space above and below it, a literal as opposed to an illusionistic or pictorial space.[48] Morris understood by fabricating sculpture neutral in color, unfussy in surface and large enough to force a consideration of its surrounding space, that sculpture's unique capacity to employ, and therefore confront, mass and gravity could be most powerfully addressed.

Like the forms of Robert Morris, those of Donald Judd (Cat. 16) so completely reject any paternity in the traditions of constructivist sculpture, any reference to the observed forms of nature or individual psychology, that they constantly call the lack of these to mind by their definitive absence, highlighting their conceptual origin as an act of radical criticism of prior sculpture and painting. This self-critical attitude reinforces the Minimalist's profound connection with the most advanced non-representational painting, presented by Greenberg as the quest for those expressive capacities and experi-

ences uniquely available to a medium and discovered only through a reductionist clarification and evolution.

Judd's statement entitled "Specific Objects" of 1965 noted the increasing use among both "painters" and "sculptors" of three dimensions as part of the attempt to make something "specific," since it was found that virtually any deposit on the surface of a painting exchanged its specificity for an illusionistic representationalism, suggesting something more (or less) that what it actually *was*.[49] Judd's pieces of this period are strong without being gestural (are not invested with an expressive force deriving from something outside themselves), are non-additive in construction, non-hierarchical in their parts and therefore as clearly *one* powerful thing as possible. They are also fabricated from industrial materials by industrial concerns from the artist's plans, and therefore have few of the traditional, autographic craft associations of earlier art. Of his perception of the disparity between conceptual and literal structure in prior work Judd has said that:

> The separation of means and structure — the world and order — is one of the main aspects of European or Western art and also of most older, reputedly civilized, art. It's the sense of order of Thomist Christianity and of the rationalistic philosophy which developed from it. Order underlies, overlies, is within, above, below or beyond everything.
>
> I wanted work that didn't involve incredible assumptions about everything, I couldn't begin to think about the order of the universe or, the nature of American society. I didn't want work that was general or universal in the usual sense. I didn't want it to claim too much.[50]

By rejecting art based on a priori cosmological systems that purported to understand the nature of the world and made portentous artifacts to prove it, Judd and the other Minimalists sought to make art from which large claims were excluded at the outset, finding meaningful expression in specific objects whose symmetrical form, as with Noland and Stella, was given by geometry and did not require relational "composition" to invest them with structure. Judd's reduction of the number of parts reduced the amount of order needed to deploy them, thereby reducing the relative *importance* of order, and increasing the importance of the whole. But while critics were quick to term this process "nihilistic" and "reductionist," both Stella and Judd pointed out in their joint interview with Bruce Glaser that their work was only reductionist, "because it doesn't have the elements that people thought should be there," like imagery and composition![51] By discarding traditional components of art, the Minimalists attempted to work through a process of consideration and rejection of those elements understood not only as unessential but irrelevant for artistic expression — unexamined preconceptions that exemplified the dangerously retardataire patterns of repressive thinking they recognized as burdening American society at large.[52]

Another of the artists first recognized as Minimalist was Dan Flavin (Cat. 11), who had first exhibited with Morris and Judd at the Green Gallery in 1963. Rejecting the oppression of his childhood's ascetic Catholicism, Flavin constructed a series of electric light "icons" in the early sixties. Later, while working as a security guard in the American Museum of Natural History, he began to cram his pockets "with notes for an electric light art."[53] Deploying standard commercial fluorescent strip lights on the floors and walls, Flavin exhibited (or remade) spaces in the Kaymar and Green Galleries in 1964 in such a manner that unspecified physical areas took on the character of specific, aesthetic events. Flavin's "image-object" strip lights remain unremittingly impersonal objects, even more so than Judd's pieces, because they are mass-produced. Even when colored, they retain their specificity as objects and reject the illusionism of painted color by filtering an actual *source* of light, not just coloring a canvas or metal surface. Instead of intending them to stand as symbolic configurations, Flavin desires his light pieces to function as "psychologically indifferent decoration — a neutral pleasure of seeing known to everyone."[54]

In the sixties it was perhaps Carl Andre (Cat. 1) who was the most brilliantly and brutally minimal of the Minimalists. Using raw wooden timbers, firebricks, cement blocks and metal slabs in groupings of stunning clarity and simplicity, he demonstrated unimagined levels of specificity and actuality that still conveyed significant sensation. Andre worked in "sculpture" because he did not want to make something out of something else, but wanted to present matter undisguised, as itself, inverting what he felt to be the hubris of artistic imposition by submitting to his materials and the conditions they imposed.

In a one-man show at the Tibor de Nagy Gallery in March 1965, Andre showed how 120 bricks could assume eight different rectilinear configurations, each necessarily occupying an identical physical volume but demonstrating with concrete clarity the psychological complexity and variation possible by simply varying proportions. Making his arrangements as "primary" and as inconspicuous as possible, Andre used what he called "anaxial symmetry," in which any part could replace any other. In this way he established a form of non-compositional order derived from his understanding of Stella, with whom Andre had attended Phillips Academy in Andover, Massachusetts and later shared studio space.[55]

Extraordinarily responsive to his environment, Andre's experience of canoeing on a quiet New Hampshire lake suggested that he make a new and more explicit use of an absolutely flat ground plane, thus upsetting the implied hierarchy of prehistory in which the tallest rules with priapic force.[56] One of the most remarkable manifestations of a Minimal artist expressing his desire to expand a viewer's sensitivities (clearly relevant and referent to issues beyond the range of aesthetics), is Andre's suggestion that we have basic capacities for perception that go virtually unnoticed and unused. One example would be the ability to detect differences in mass between materials of similar appearance simply by walking on them. This suggestion is one of the sources for his patterns of flat metal plates composed of aluminum and lead. Utterly without recognizable subject matter or historiated iconography to distract us, Andre's non-structural creations have the ability to awaken us to the larger interactions of things in the world. How else could one express the force and counter-force upon the earth of a "column of air that extends to the top of the atmosphere" than by laying out thin, resilient plates of metal upon the ground?[57]

For Andre and the Minimalists as a whole, art's most expressive potential lies in expressing that which can be expressed in no other way: "The sense of one's own being in the world confirmed by the existence of things and others in the world."[58] In this sense, Minimalism can be seen as the archetypal expression of American art in the sixties — art as the instigator of an aggressive dialectic between perceptual experience, historical knowledge and philosophical preconceptions. Visible in the new Color-Field painting, in Pop art and the first mature Minimal sculpture, there was among American artists of the period an openness that reflected a changed consciousness of what it meant to occupy a vanguard position and an unwillingness to play the role of ultimate arbiter that precluded the presentation of overwhelmingly personal viewpoints. In astonishingly fresh and direct work of new scale, color, wholeness and specificity, characterized not by an order imposed from without but discovered from within, these artists made a point of presenting visual forms that are arguably as complex, moving and beautiful as any art before them. As creative solutions which have the capacity to generate sensation and, ultimately, emotion, their work establishes meaningful connections with uniquely human concerns. Definitively resolved internally, the explicit clarity of their statements makes an ongoing demand for integration into the larger aesthetic and philosophical wholes of our lives. After twenty years the demand still sounds.

1. Clement Greenberg, "Modernist Painting," *The New Art*, ed. Gregory Battcock (New York: E. P. Dutton, 1973), 67.

2. For a provocative essay on the philosophical implications of this formal stance see Sheldon Nodleman, "Sixties Art: Some Philosophical Perspectives," *Perspecta* 11 (1967): 74-89.

3. William S. Rubin, *Frank Stella* (New York: Museum of Modern Art, 1970), 13.

4. Rubin, 22.

5. Rubin, 48.

6. Michael Fried, *Three American Painters* (Cambridge, Mass.: Fogg Art Museum, 1965), 23.

7. Rubin, 41.

8. For a concise explanation of the Modernist development from the representational to the abstract, see Clement Greenberg, "Abstract, Representational, and so forth," *Art and Culture* (Boston: Beacon Press, 1961), 133-38.

9. Kenworth Moffett, *Kenneth Noland* (New York: Harry N. Abrams, 1977), 27.

10. Moffett, *Noland*, 51.

11. Moffett, *Noland*, 16.

12. Moffett, *Noland*, 89.

13. Moffett, *Noland*, 65.

14. John Coplans, *Ellsworth Kelly* (New York: Harry N. Abrams, 1972), 28.

15. Henry Geldzahler, "An Interview with Ellsworth Kelly," *Art International* 8, no. 1 (15 February 1964): 47.

16. Kenworth Moffett, *Jules Olitski* (New York: Harry N. Abrams, 1981), 214.

17. Henry Geldzahler, "An Interview with Helen Frankenthaler," *Artforum* 4, no. 2 (October 1965): 36.

18. Moffett, *Olitski*, 8-9.

19. Moffett, *Olitski*, 76, note 19.

20. Moffett, *Olitski*, 54.

21. Lucy R. Lippard, "Larry Poons: the Illusion of Disorder," *Art International* 11, no. 4 (20 April 1967): 22.

22. For a seminal discussion of "opticality" in American abstract painting, see Michael Fried, *Three American Painters*, 19-23.

23. Lippard, 23.

24. Donald Judd, "Andy Warhol," *Complete Writings 1959-1975*

(Halifax: Press of the Nova Scotia College of Art and Design, 1975), 70.

25. Barbara Rose, "Claes Oldenburg," *Readings in American Art* (New York: Praeger, 1975), 151.

26. Bruce Glaser, "Lichtenstein, Oldenburg, Warhol: A Discussion," *Artforum* 4, no. 6 (February 1966): 23.

27. Glaser, 22.

28. John Gordon, *Jim Dine* (New York: Whitney Museum of American Art, 1970), n. p.

29. Glaser, 21.

30. Glaser, 22.

31. John Coplans, "An Interview with Roy Lichtenstein," *Artforum* 2, no. 4 (October 1963): 31.

32. Lucy R. Lippard, "James Rosenquist: Aspects of a Multiple Art," *Artforum* 4, no. 4 (December 1965): 41.

33. G. Swenson, "What is Pop Art?," *Art News* 62, no. 10 (February 1964): 63.

34. Clement Greenberg, "The New Sculpture," *Art and Culture*, 139.

35. Andrew Forge, "Anthony Caro interviewed by Andrew Forge," *Art International* 171, no. 873 (January 1966): 7.

36. Michael Fried, "Anthony Caro," *Art International* 7, no. 7 (25 September 1963): 71.

37. William S. Rubin, *Anthony Caro* (New York: Museum of Modern Art, 1975), 131.

38. Forge, 7.

39. Rubin, *Caro*, 99.

40. Rubin, *Caro*, 43.

41. For a recent discussion of the continued vitality of the *idea* of abstract painting see Calvin Tomkins, "Knowing in Action," *The New Yorker* (11 November 1985): 144-49.

42. Rubin, *Caro*, 183. These pieces were produced at Bennington after a conversation with Olitski about making sculpture as "naked" as possible.

43. Forge, 8.

44. Sam Hunter, "The Sculpture of Tony Smith," *Tony Smith* (New York: Pace Gallery, 1979), 3.

45. Wadsworth Atheneum, *Tony Smith* (Hartford: Wadsworth Atheneum, 1966), n. p.

46. Robert Morris, "Notes on Sculpture," Part IV, *Artforum* 7, no. 9 (April 1969): 54.

47. Robert Morris, "Notes on Sculpture," *Artforum* 4, no. 6 (February 1966): 44.

48. Judd, "Robert Morris," in *Writings*, 165.

49. Judd, "Specific Objects," in *Writings*, 181.

50. Donald Judd, "Portfolio: 4 Sculptors," *Perspecta* 11 (1967): 44.

51. Lucy R. Lippard, "Questions to Stella and Judd," (Interview by Bruce Glaser), *Minimal Art*, ed. Gregory Battcock (New York: E. P. Dutton, 1968), 159.

52. For a very interesting statement about connections between art and social and political attitudes, see Donald Judd, "Statement," in *Writings*, 196.

53. Dan Flavin, "Dan Flavin: An Autobiographical Sketch," *Artforum* 4, no. 4 (December 1965): 22.

54. Dan Flavin, "some remarks . . . excerpts from a spleenish journal.," *Artforum* 5, no. 4 (December 1966): 27.

55. Phyllis Tuchman, "An Interview with Carl Andre," *Artforum* 8, no. 10 (June 1970): 57.

56. David Bourdon, "The Razed Sites of Carl Andre," *Artforum* 5, no. 2 (October 1966): 15.

57. Tuchman, 61.

58. Tuchman, 60.

The New Criticism: Prescriptive or Responsive?

Megan Fox

In 1961, the publication of two volumes of art criticism set out for art critics, historians and aestheticians what had become since the forties the two most significant critical positions on contemporary art. Clement Greenberg's *Art and Culture*, and Harold Rosenberg's *Tradition of the New* were strategically edited collections of each author's writings from the preceding two decades. More than mere summaries of the art scene of the mid-forties to the mid-fifties, the collections represented the aesthetic programs which had fueled a critical polemic from the moment of the rise of the New York School and its "style," Abstract Expressionism. The writings selected were strongly rooted in the writer's particular philosophies of art criticism and aesthetics generally, and this aspect of the books had a greater impact on the new generation of critics than their actual evaluations of the traditions of modern art. The publication of these two volumes exerted major formative influences on the new generation of art critics and art writers of the sixties. Historically, their publication occurred at a pivotal moment in both the art scene and the situation of art criticism. A new American aesthetic was immanent, and simultaneously there arose the demand for a fresh response to a thoroughly new generation of art.

The "new" criticism, was characterized by an accelerated variety of aesthetic positions taken up by the critics of the sixties. These critics were well-versed in and reactive to the tradition of modern art criticism generally, but were substantially influenced as well by the new art which was the subject of their discussions. Often highly conceptual, the new art seemed to demand clarifying responses from various perspectives. With the increased conceptualization of art up to the mid-sixties, what was said about a piece or artist was more crucial than ever in gaining an understanding of new art. The new criticism of the sixties is therefore composed of a complex combination of past influences and responsive as well to the advances of the moment. By tracing the roots of this criticism, much can be gleaned about the views of the period, the critic's influence on the production of art, and finally, the ways in which the criticism subsequently formed still current conceptions of the period.

The dialectic operative between Greenberg's and Rosenberg's positions in the late fifties was not new, only intensified and expanded by their political and philosophical backgrounds and by the intensity of their involvement with the matured Abstract Expressionist movement. Their positions follow a tradition of discussion among modern critics which took shape in two distinct ways. First, the theory of art for art's sake, which denies any representational or ethical function for art, was one doctrine invoked to explain and claim value for the purely visual address of art after Manet. The opposing theory ascribed a definite ethical function to art, one which postulated and demanded that the artist undertake to represent the experiential structure or situations within which the work of art was made.

These divergent views were the groundwork of Abstract Expressionism's critical history when, in roughly 1945, there existed a climate of ideas, a philosophical and stylistic mesh which led quite logically to two mutually antagonistic conclusions. The polemics of the period had to do with labeling the work of art as self-expression, and/or the vehicle of historical consciousness. Aesthetic crisis and moral content in art emerged as major issues in criticism, finally producing major disagreements regarding the function and identity of criticism itself. The two schools of contemporary critical thought separated over these issues into the aesthetic programs of Greenberg and Rosenberg. Greenberg stood essentially alone as the proponent of a radically updated formalist point of view, and Rosenberg supported ideologically by Thomas Hess, editor of *Art News*, assumed a more philosophical, political, often deemed "existential" stance. The oppositions between these two notions of criticism and the aesthetic values that lay under them became pronounced during the rise in prominence of Abstract Expressionism in both the United States and abroad, when there was increasingly a pronounced need for an adequate mode of critical accounting.

In spite of the fundamental differences between the Greenberg and Rosenberg positions, they began with an agreement that genuine art must be a form of self-discovery and self-revelation. This was a critical staple of the modern tradition after Manet, but at no point more exhaustively articulated than in New York criticism in the late forties. The necessity of elaborating variously upon this concept derived from the fact that within the milieu of the Abstract Expressionists, there was an overriding prominence of inherited modern European tradition and a somewhat unfocused emergence of post-European style from among a small group of relatively un-

known American artists. Rosenberg and Greenberg as spokesmen for these artists undertook the responsibility of addressing the new American art as an expression of the artist's unique historical situation in order to divorce it responsibly from its European sources and defend it from its least sympathetic critics.

On the whole, the attitude of the leading art magazines to postwar American abstract art was negative. Most either ignored the new painting entirely or evaded it with faint praise. *Life* did publish a two-page spread on Pollock in 1949 with the text, "Jackson Pollock: Is he the greatest living painter in the U.S.?" But they left the question dangling. This led then to *Time* magazine's sneers at "Jack the Dripper." *Art News* was consistently hostile to the Abstract Expressionists until Thomas Hess became its managing editor in 1948. The partisan critics Greenberg and Rosenberg, along with Meyer Schapiro, writing in small circulation magazines such as *The Nation* and *Partisan Review* seemed to belong to the enclosed world of the artists themselves, fortified in the Cedar Tavern and Tenth Street studios and standing against hostile or indifferent factions without.[1] The milieu of the New York School was one of shared political/philosophical/ social outlooks expressed in art, and verbalized by Rosenberg and Greenberg. The critical dogma supporting ultimate emergence and maturity took on much from left-wing political dialectics. In 1947, Rosenberg said of a show which included Gottlieb and Motherwell:

> Their nostalgia is for a means, a language that will formulate exactly as possible what is emotionally real to them as separate persons Art is the country of these painters . . . the standpoint for a private revolt against the materialist tradition that does surround them.[2]

For his part, Greenberg believed too that art was the embodiment of the painter's self-identity as artist. But, in his early reviews in *The Nation*, he focused less on art's embodiment of the emotion and personal self-awareness of the artist and more on overseeing and illuminating the aesthetic progression of given artists in successive shows, hoping to arrive at some ultimate distillation of potentials, aesthetic frailties and accomplishments. For example, he observed of Gorky in 1946 that "On occasion, he still relapses into dependence on Miro Yet the chances are now that he has discovered what he is, and is willing to admit it, that Gorky will soon acquire the integral arrogance which his talent entitles him to."[3] Gorky became a point of common interest for both writers, Greenberg's formalism seeing an eclectic but potentially explosive expression of great French precursors, and Rosenberg's seeing a sequence of self-expressions of artistic personality through Surrealist forms.[4]

Extending the issue of the expressive role of art, Rosenberg wrote later in the catalogue of the exhibition *Action Painting* (March 5 — April 13, 1958 at the Dallas Museum for Contemporary Arts):

> Action Painting has to do with self-creation of self-definition of self-transcendence but this dissociates it from self-expression which assumes the acceptance of the ego as it is.[5]

In other words, the artist must, to a certain extent, nullify his consciousness in order for his capacity for self-fulfillment to be achieved. Greenberg would have agreed that the artist must extend beyond himself in the process of artistic realization, but he would (and did) focus on the critical faculty of the artist — his decision-making as the pivot of activity. At each new moment, the artist is confronted with a problem in his work which must be answered before he is to progress to the realization of his fullest artistic capacity.

Self-transcendence as individual or as artist is the focus of the discussion of the "crisis" of Abstract Expressionism. "Crisis" was the catchword crucial to the understanding of the criticism of Abstract Expressionism and indicated a sense of constantly heightening conflict or change. This conflict in the development of modern art was not new to Abstract Expressionism, but in past movements, it had been associated with the decline of a style, whereas now "crisis" was seen by both Greenberg and Rosenberg as the genesis of the productive aesthetic movement. For Greenberg, "crisis" was the evolving concept of the contemporary painters' problematical relation to the tradition of modern art. For him, the decisive critical task was to sense the original within the continuous. And whereas past achievements must be acknowledged, the present situation is the focus in a traumatic process of birth. Visually, this genesis of style is seen by him in the optical awkwardness of works — the struggle manifested formally.[6]

Where optical awkwardness fulfills Greenberg's program for the artist's extension of his critical faculty Rosenberg's parallel term is "risk," a notion which he develops in his 1957 article, "The American Action Painters." Rosenberg says that "there is nothing to an act when you already know what it contains" referring here to the creative act of the artist. For him, the whole course of art-making is an openminded one, the very freedom of which imposes an impressive burden of decisions. He writes:

> The new painters stand . . . between a discipline of vagueness by which one protects oneself from disturbance while

keeping one's eyes open for benefits; and the discipline of the Open Road of risk that leads to the farther side of the object and the outer spaces of the consciousness The test of any of the new paintings is its seriousness — and the test of its seriousness is the degree to which the act on the canvas is an extension of the artist's total effort to make over his experience.[7]

And further:

Action painting is the abstraction of the moral element in art; its mark is moral tension in detachment from moral or aesthetic certainties and it judges itself morally in declaring that picture to be worthless which is not the incorporation of a genuine struggle, one which could at any point have been lost.[8]

In the same tone, Thomas Hess remarked upon Pollock's art as "the turbulent process of the artist identifying his painting with himself and then fighting to bring it out."[9]

The pronouncements of Rosenberg and Hess were meant to elevate the excited insecurity which the writers saw in the works of the New York School and which they deduced from the words of the artists themselves. They were not writing from armchair positions, but were in active working association with the Tenth Street group. The positive interpretation of the artist's ego animatedly generating value within a work was a conscious attempt to overthrow emotionally detached aesthetic judgments of works of art. Here, in direct opposition to Greenberg, Rosenberg asserts, "The apples weren't brushed off the table in order to make room for perfect relations of space and color. They had to go so that nothing would get in the way of the act of painting The new painting has broken down every distinction between art and life."[10] His aim was to formulate a theory which was most in keeping with the Abstract Expressionists' own creative ideologies and the milieu within which they developed them. His theory fit with the fact that the art of Abstract Expressionism was made from a relatively continuous process. The "act" of the painter on the canvas was not pre-conceived, and seemingly therefore not a conceptually guided process.

Rosenberg seems to have arrived at the details of his theory of Action Painting through a combination of Sartre and Dada. An existentialist stance not entirely divorced from his earlier political notions, Rosenberg's historical perspective when applied to Abstract Expressionism serves to cut off the artists and style from the rest of history, as a collective strike into the "unknown."[11] This negative historicism is characterized by his terms Redcoatism or academism, and Coonskinism. Redcoatism is the term used to describe a style of art which had fully matured but became obsolete when continued into a new political and social moment. In order to get beyond the established style, the artist had two choices, either exaggeratedly to perfect it (mannerism) or to resort to Coonskinism — radically altering the style or rejecting it entirely in a singular revolutionary strike into the "unknown." The latter choice is Rosenberg's "risk." Not to make something of something, but simply, "to make." This is his concept of the "tradition of the new" — that the revolution of a new style over another is an ongoing and self-perpetuating process.

Greenberg, on the other hand, seems to owe more to French and English formalist critics, and especially, to the formal lessons gleaned from the Cubists and Matisse. To this he adds sense-data analysis which for him solidifies his own theory of empiricism.[12] For Greenberg, the great moment in twentieth-century Western art was 1907-10 when the space in Cubist painting oscillated between depicted flatness of the facet planes and an affirmation of the literal surface. Successive developments, including "Synthetic Cubism" opted for a flat, constructional and in his opinion, decorative solution. The "Cubist trauma" is really Greenberg's own concept, and this coupled with his new empirical theory seeking renunciation of illusionistic depth in favor of ever more flatness in the picture plane began to mesh his program into a prescriptive one, which sought to change or move the art in question into what he saw as the answers to currently pressing problems. He anticipated the critical problems facing artists and to a certain degree, prescribed their eventual solutions. That Greenberg had an influence on the painters about whom he wrote has been stated often in the past. His close association with the artists in their studios reiterates the role which his criticism played in the actual art-making among artists he advised. His criticism was then, practically influential in a way that Rosenberg's was not.

Greenberg's view of the role of criticism required that it proceed from qualitative judgments. A recurring phrase in Greenberg's writing is that any art is successful "if it works." Yet, there was something inevitable as well about the course painting was supposed to be taking though its projected outcome was not always explicitly stated. Eventually, this began to be formulated in broad terms as a systematic renunciation — first of extra-pictorial concepts, but more importantly, of the formal devices such as modeling which inhibited a post-Cubist style. It was therefore necessary for Greenberg to condemn certain figurative and painterly works as impeding the modernist process.

In the mid- to late fifties, Greenberg's criticism took some major detours, but at no time was his method of radical empiricism more solidly adhered to. Greenberg had turned

against the "gestural wing" of Abstract Expressionism represented by the recent works of de Kooning. In his 1959 essay, "American Type Painting" reprinted in *Art and Culture*, Greenberg argued that "painterly painting" in the de Kooning manner was not truly modern after all, because its turbulent contrasts of light and dark tonal values set up an illusion of space and thereby denied the essential flatness of the painted surface. Greenberg stated at this time more explicitly than ever before that the basic modernist tendency of an art was to purify itself of everything except what was unique to the medium of that art. What was unique to painting was the flat plane, and for this reason, the non-gestural, non-painterly work of Barnett Newman, Mark Rothko and Clyfford Still was now deemed by Greenberg as the true pursuit.[13] His ultimate designation of these painters as the newest wave carrying the tradition of modern painting is logical in terms of his own established formal dialectic, and ultimately correct in historical prognosis. These painters were not the only progenitors of post-Cubist style, but they were given a primary importance which future developments bore out.[14] Greenberg subsequently came to the conclusion that painterly painting was degenerating into a set of mannerisms, a formula that proved too easy to imitate, and thus, died the sort of death which Rosenberg might have labeled Redcoatism.

Extending the role of the critic, as a consultant to the contemporary section of the French and Company Gallery on Madison Avenue, Greenberg organized several exhibits of the sort of work he now favored. The first, in 1959, was a show of Newman's Stripe paintings which re-established him as a major figure. This was followed by shows of Noland and Louis, who borrowed the staining technique of Frankenthaler in line with Greenberg's insistence on ever more flatness. Greenberg became very much involved with the work of both Noland and Louis, and brought them to Frankenthaler's studio to introduce them to her methods. Both were greatly influenced by her work as well as by the advice of Greenberg. Their undeniably flat and "cool" abstraction ushered in the Color-Field mode of painting which Greenberg now strongly supported, as he saw in it extensions of the theoretical empiricism he had already established.[15]

Greenberg saw alternative but not contradictory extensions of his "modern tradition" in the work of Jasper Johns in 1958 and 1959. Greenberg continued to deal with Johns' work in terms of his previous discussions of Cubist and Abstract Expressionist painting in his 1961 article, "After Abstract Expressionism." He says of Johns:

The motifs of Johns' paintings ... are always

two-dimensional to start with, being taken from a repertory of man-made signs and images not too different from the one on which Picasso and Braque drew for the stenciled and affixed elements of their 1911-1913 Cubism. Unlike the two Cubist masters, Johns is interested in the literary irony that results from *representing* flat and artificial configurations which in actuality can only be *reproduced*; nonetheless, the abiding interest of his art, as distinguished from its journalistic one, lies largely in the area of the formal or plastic By means of this "dialectic" the arrival of Abstract Expressionism as homeless representation is declared and spelled out. The original flatness of the canvas, with a few outlines stenciled on it, is shown as sufficing to represent adequately all that a picture by Johns really does represent.[16]

Though Johns' Flags and Targets of 1958 and 1959 fit quite definitively into Greenberg's established cosmology of modern painting his incorporation of "found objects" into the picture plane, (such as *Target with Faces*) was not addressed. There were collage effects in these paintings, similar to the equally influential works of his contemporary Rauschenberg, which for Greenberg violated the surface, the essential pictorial essence of the work as a painting. The incorporation of extra-pictorial, sculptural elements placed these works in an ambiguous category between sculpture and painting — a category which did not fit into Greenberg's notion of modern painting continually purifying itself in terms of its medium.

Leo Steinberg was among the first of the critics to accept this aspect of Johns' and Rauschenberg's work, to explain it on its own terms and to place it within a history of similar avant-gardes. A professor at Hunter College at this time, Steinberg had earned his Ph.D. at New York University and had been a columnist for *Arts Magazine*. In an article of 1962 in *Harper's Magazine*, "Contemporary Art and the Plight of its Public," Steinberg points out that not only the ignorant or "Philistine" as he calls them, experience the discomfort of the new work, but that even the critics are confused.[17] But confusion with the avant-garde is not new, and he traces a tradition of this adverse reaction back to Baudelaire. In this he echoes Rosenberg's theory that art moves in a series of consecutive revolutions which do not emerge without struggle, making it necessary for the critic to go beyond this confusion to discover the new aesthetic.

The subject matter shown in the work of Johns at his first one-man show in 1958 was in itself enough of a revolution to develop a crisis in criticism. After nearly fifty years of formalist discussion, many critics were at an impasse in considering anything other than "quality," and thus ignored subject matter as irrelevant. But now it seemed that critical responses

continually returned to the subject matter presented by Johns, and discussions and explanations built upon one another. As Steinberg noted in his 1962 discussion of Johns, the first critical reflex at the appearance of something new is an attempt to assert that nothing is really new at all. Hence the occurrence on the cover of *Art News*, in January 1956 of Johns' *Target with Four Faces* labeled "Neo-Dada." The notion stuck, and critics launched into perpetual clarifications of this assertion.[18]

Steinberg observed that there was an even more fundamental disagreement regarding the role of the subject matter or especially "sign systems" in Johns' work. Fairfield Porter described them as a way of "seeing" as when a child sees something which has no meaning to him. John B. Meyers asserted instead that the signs are a way of naming, while Robert Rosenblum wrote that the subject matter was posed in a demonstrative way forcing the viewer to look at qualities never seen before in the object. Others found exactly the opposite — that Johns chose his subjects and incorporated them into pictures in a way that made them virtually disappear.[19]

It was this sort of critical discrepancy which Steinberg characterized a "heuristic event," which led him to the question: what in the work, invites such contrariness? The perpetual oscillation wherein subjects are found and lost, submerged and recovered was seen by Steinberg as a personal idiom of Johns' in which object and emblem, picture and subject, converge indivisibly. Subject matter was explained as the very condition of Johns' painting so that the distinction between content and form was no longer intelligible. With Johns, Steinberg saw an "end of illusion" saying:

> The pictures of de Kooning and Kline it seemed to me were suddenly tossed into one pot with Rembrandt and Giotto. All alike suddenly became painters of illusion.[20]

What he meant by this was that the signs and symbols filled the entire picture space, leaving no distinction between figure and ground. The result was that there was no sense of an object being depicted in the picture, rather, the picture was the object.

Steinberg then developed an elaborate and systematic analysis of the shared characteristics of Johns' subjects up to 1958 in an effort to determine how the method of their depiction invites such contrariness between reality and illusion — the literal and the depicted. His discoveries or common factors in Johns' subjects form an extensive system of signs and their presentations which attempts to answer how and why Johns' paintings are read in the way they are, how forms serve to convey symbols.

Steinberg's method of interpreting the meaning and perception of meaning in Johns' sign systems is closely linked to the methodology developed by Erwin Panofsky in his *Studies in Iconology* (1939) in which he writes:

> Let us, then, try to define the distinction between subject matter or meaning on the one hand and form on the other. When an acquaintance greets me on the street by removing his hat, what I see from a formal point of view is nothing but the change of certain details within a configuration that forms part of the general pattern of color, lines and volumes which constitutes my world of vision. When I identify, as I automatically do, this as an event (hat-removing), I have already overstepped the limits of purely formal perception and entered a first sphere of subject matter or meaning . . . we shall call . . . the factual meaning.[21]

Steinberg alludes to the recognizable aspects of Johns' subjects and to the viewer's reactions to and recognition of them in a way similar to the method of interpretation set up by Panofsky. That Steinberg would be influenced by the iconographic fascinations of Panofsky is not surprising. Having studied at New York University with Meyer Schapiro, whose own writings of the forties belie an emphasis on the contextual and interpretive aspects of art and art writing, Steinberg's foundations seem to be largely tied to the character of the New York area graduate schools of art history and their prevailing emphasis on iconography. Johns' deployment of something like subject matter and the ambiguous relationship which he set up between reality and illusion would influence, in various ways, later Pop artists. Moreover, Steinberg's theoretical discussion of the work gave these artists a powerful conceptual arsenal to work from. But Johns' work was not the exclusive realm of discussion and contention among critics and artists in the late fifties.

An even more drastic reduction of painting to its essential elements appeared in the stark, geometrical Black paintings of Frank Stella. An outgrowth of Greenberg's modernist prescriptions, Stella's painting was based on an exclusive foundation in abstract painting. Stella saw his reductive painting as the answer to the formal problems of his historical moment, as this was defined by Greenberg and the artists whose work he praised. Reacting strongly against the romance of Abstract Expressionism, Stella sought in painting "something that was stable in a sense, something which was not constantly a record of your own sensitivity." The critics and even many older Abstract Expressionists, such as Newman, Rothko and Still reacted negatively to the works but more so, to the attitude behind them. Stella rejected any retention of humanistic values in painting, saying that the older painters

always found something else on the canvas. But his painting was based on the idea of "what you see is what you see."

This nihilism was ultimately too "cool" even for Greenberg, but the birth of the idea coupled with the outrage of the older generation signified that old attitudes were no longer incontestably in force. The spirit of high seriousness and moral urgency of Abstract Expressionism was out of place in the sixties. The coolness of execution and diverse theoretical concepts underlying the art meant that Stella's reductive approach could influence and co-exist with the proliferation of new directions: Pop, Minimalism and Color-Field. Though Greenberg did not immediately deal comprehensively with the new generation of Color-Field and reductive/minimal painters, their work constituted a new formal strategy which was no longer exclusively reactive to forties romanticism and which was ready instead to carry the modernist tradition. But Greenberg's writings of the past forty years had already exerted a strong influence on a new generation of critics who accepted his modernist definitions and their basis in a continuous tradition of critical testing from Manet to Pollock.

A group of relatively young critics, centered around the Fine Arts graduate school at Harvard had absorbed the modernist (Greenbergian) tradition of criticism with its emphasis on post-Cubist, post-Matissian empiricism. Kenworth Moffett, Kermit Champa, Michael Fried, Rosalind Krauss, and Jane Harrison-Cone produced some of the most significant criticism of the period on those artists whom they jointly held in esteem: Stella, Noland, Olitski, Poons, and Bannard. That the phenomenon of such a strong shared aesthetic stance developed among these individuals seems to have resulted from a complex series of factors.

The dominant stress of Harvard's graduate program was on connoisseurship, as opposed to the emphasis on iconography prevalent in the New York program. Though removed from the center of the art production in New York, the students and faculty at the Fogg maintained via continuous travel, a first-hand awareness of contemporary New York developments. Kenworth Moffett and Kermit Champa had already begun to share an interest in historically based criticism when Michael Fried, the most radical and critically seasoned of the group, entered Harvard in 1962. Sidney Friedberg, professor of Renaissance painting at the Fogg had just published his *High Renaissance in Rome and Florence*, the post-Wölfflinian character of which further strengthened the convictions of the Harvard students, while alienating many of the New York area scholars for what was deemed outdated methodology. Friedberg's method was in fact not so much outdated, as just directly opposed to the predominating iconographical methods preferred by New York scholars. It was essentially a formalist approach applied in an unprecedentedly rigorous way to historical art styles. The great Rembrandt scholar, Jakob Rosenberg also had a strong influence in confirming the stance of the Harvard critics. His "methods" course, reflected later in his writings in *On Quality in Art*, was founded in a methodology of evaluative connoisseurship. But the writings of Greenberg, and particularly his volume *Art and Culture* exercised probably the highest impact on the group. He was invited to the Fogg to speak in 1961. His influence was not confined to the Harvard graduate students, but extended as well to the Boston collections of Lewis Cabot, and later Graham Gund as well as the Museum of Fine Arts, Boston under the contemporary curatorship of Kenworth Moffett.

Michael Fried was unquestionably the most rigorous and critically consistent figure among the Harvard group of modernists. He had studied first at Princeton earning a B.A. in English, then studied philosophy at Oxford and later at the University of London on a Rhodes Scholarship. It was there that he began to publish poetry and write art criticism for *Art International* in the form of periodic "London Letters." He entered the Fogg in 1962. His strong background in both literary criticism and philosophy greatly strengthened the force of his criticism. His writings reveal a supremely self-confident tone, acutely conscious of and attentive to the way in which personal positions are defined within traditions of art criticism. Indeed many of Fried's writings include discussions of the role of master critic, in particular, of his necessarily prescriptive and evaluative role. Fried's writing is grounded in Greenberg's modernism but with a strong influence as well from the writings of and conversations with the philosopher, Stanley Cavell and from the aesthetics of Ludwig Wittgenstein.

In his 1965 article in *American Scholar*, "Modernist Painting and Formal Criticism," Fried calls for the necessity of art writers to move art writing to the level of literary criticism and proposes to show how formal criticism, namely that of Fry and Greenberg, has been better able to throw light on the new art than any other approach. Three points are essential to the understanding of Fried's methodology. First is his notion of empiricism, shared by Greenberg, which establishes and traces a direct formal progression through the advances of modern painting. He says:

> There is in a sense, an inner artistic logic in Mr. Greenberg's view of the history of modernist painting in France and America, but it is a logic that has come about as the result of decisions made by individual artists to engage with formal

problems thrown up by the art of the recent past — decisions and formal problems that Mr. Greenberg has done more than any other critic to elucidate. Moreover, the element of internal logic in the development of modernist painting can be perceived only in retrospect, and I can think of no passage in *Art and Culture* that so much as hints at the existence of immutable laws.[22]

This was said largely as a defense against those critics who accused Greenberg and Fried of trying to impose a legislated inevitability on future art. It is also the point where Fried's empiricism begins to diverge from that of Greenberg. Fried's own methodological emphasis is essentially phenomenological in matters of development in art, and he owes much of his emphasis to the writings of Wittgenstein as well as to Maurice Merleau-Ponty. He names his phenomenological component the "dialectic of Modernism" and says that it:

> . . . has in fact been at work in the visual arts, painting more than sculpture for roughly a century now; and by dialectic I mean what is essential in Hegel's conception of historical progression, as expounded in this century by the Marxist philosopher George Lukacs in his great work, *History and Class Consciousness* and by the late Maurice Merleau-Ponty in numerous books and essays. More than anything else, the dialectic in the hands of these men is an ideal of action as radical criticism founded upon as objective an understanding of one's present situation as one is able to achieve. There is nothing in the least teleological about such an ideal: it does not aim toward a predetermined end.[23]

In this sense then, Fried is not proposing a horizontal, teleological historicism, but rather a vertical one, in which each moment is engaged in perpetual radical criticism of the existing state of affairs in order to achieve in the next level the answers to the present.

The third point of Fried's methodology which he continually espouses in his criticism is that of the moral imperatives facing the artist and consequently the critic. In *Three American Painters*, Fried first developed this idea when he asserted that in the process of art-making the artist is continually confronted with formal problems which he is morally obliged to address before he is able to proceed with his creative process. To deny any advances of the past or to circumvent the problems at hand is to fail to achieve historically mandated potentialities. Further, he asserts in his article, "Modern Painting and Formalist Criticism" that the formal critic must not only expound the significance of new painting that seems to him to be exploratory and to distinguish between such painting and work that seems merely to exploit the formal innovations of prior modernists, but in discussing the work of

painters he admires, he must point out flaws in putative solutions to particular formal problems; he is even justified in calling the attention of modernist painters to formal issues that in his opinion demand to be grappled with but which are not. In this sense, like Greenberg, Fried sees his role as critic as not only including qualitative judgments, but as projecting the next steps, the issues, in other words, which must be addressed by the modern painters.

Philosophically, Greenberg and Fried share a common grounding in Kantian aesthetics — both frequently mention them in their writings. Greenberg states, "I conceive of Kant as the first real modernist." The following Kantian points can be considered the elements which Fried and Greenberg borrowed: 1) the aesthetic is a distinct sort of experience based upon feeling, not taste as intellectual comprehension; 2) the aesthetic is an experience of formal values of the art work; 3) these formal values themselves suggest aesthetic ideas. It is clear that Greenberg and Fried both saw the potentially guiding role of Kant's philosophy for art criticism. They fused this philosophical base onto the practical formalist tradition developed by Roger Fry and others. They saw it as the most reliably objective, responsibly analytical approach to art, because it based aesthetic discussion on the formal qualities of the work in question, not on implicit or projected humanistic notions.[24]

Fried's great achievement was not merely in the method of criticism he formulated, but in the role his writing played in the early and mid-sixties as an extension of Greenberg's empiricism, at a time when Greenberg seemingly could go no further. Greenberg's pronouncements of Newman, Rothko and Still as the culmination of modern painting traditions and his subsequent focus on the ever-flatter stained paintings of the Washington painters, Noland and Louis, did not give him much critical leeway to deal effectively with any other types of painting. He was not necessarily averse to the new art being created, but it did not blend easily into what had nearly become a closed empirical plan. He was, as has already been stated, averse to the severity of Stella's painting, and at this point, Fried was able to pick up and extend Greenberg's original conceptions so as to include Stella.[25] Fried ultimately brought Greenberg further than Greenberg himself seemed capable, because he managed to argue for other governing possibilities for painting besides a continual linear self-criticism and self-definition of the medium.

In addition, Fried had established his practical role as contemporary "studio" critic, a role which Greenberg gradually abandoned. He was directly involved with the work of Frank Stella, his undergraduate friend at Princeton, and with Olitski

and Noland as well. Fried and Stella, and to a lesser degree Bannard, were engaged throughout the early sixties in a continual process of mutual aesthetic and critical interchange. This culminated in Fried's exhibition and catalogue, *Three American Painters* in 1965. Fried's articulate formalist stance was very important to Stella's developments in this period, as the two seem to have shared many close if not identical notions with respect to the nature and possibilities of painting.

But Fried and the others of the Harvard group were not the only writers operating from a modernist and essentially Greenbergian approach. Barbara Rose, at the time married to Frank Stella, wrote also from an essentially formalist standpoint at this time. Yet compared to the Harvard group, she was methodologically more flexible, often adapting her argument to her subject. In her 1965 discussion of Kenneth Noland, Rose applied the empirical and formal concepts common to the modernist/formalist approach:

> Coming after the series of tipped and spilled "pinwheel" and "star" paintings that preceded them, the "bull's eye" paintings represent a major step forward for Noland, whose decision to reject an ambiguous image in favor of a definitely geometric one not open to interpretation, gave his statement new authority. After this Noland's paintings . . . are more strictly "abstract" than either Frankenthaler's . . . or Louis's Noland's paintings after 1961 are not necessarily either better or less good than Frankenthaler's or Louis's but they are more abstract, because more resistant to interpretation. I regard this higher degree of abstraction, however, present from this point on in Noland's work, as one of his particular strengths. For, in light of the growing inability of representational painting to carry the burden of expressive content, even poetic allusiveness may be suspect of affording a weaker, less direct or profound visual experience than that of an abstraction which suggests or calls to mind nothing other than itself. Noland's great contribution . . . is his use of familiar geometric shapes as the arbitrary boundaries for areas of color which are consequently not open to a reading as either denotative symbols or connotative images; but become, instead, the means for the direct sensuous perception of color aesthetically ordered.[26]

Her praise of Noland's abstract format and his suppression of emotional or symbolic content is in keeping with the Greenberg/Fried prescriptions for modern painting, and her empirical approach to the development of Noland's painting shares much of their methodology.[27] But Rose was never a staunch formalist, and much of her other writing could be characterized as strongly contextual. After her study at Smith and Barnard, Rose did graduate work at Columbia, and there presumably came under the influence of the critical tenden-

cies operative in New York critics. Her interest in "iconography" and her praise of Steinberg's criticism combine to demonstrate the hybrid nature of her writing.

Her article "ABC Art," was one of the first major essays devoted to Minimal art and its stylistic and theoretical characteristics. She developed her discussion under subcategories headed with quotes from Malevich, Stein and Panofsky, posing and developing various theoretical explanations of Minimal art forms. She saw Minimalism as developing from Abstract Expressionism, but rejecting many of its salient contextual features. At one point, she explores Panofsky's "levels of meaning" notions. Her contextual criticism seems most obvious as a type of discussion when she treats an art which is so formally reductive with such an enormous proliferation of interpretive conjectures, all theoretical in character. In her conclusion, she states that Minimal art is obviously a negative art of denial and renunciation, normally the type of activity associated with contemplatives or mystics. Her view of the art as developing from a particular state of mind is at base then, more Rosenberg-referential than respectful any longer of Greenbergian aesthetic standards.

In reaction to Fried's ever more precise formulation of a new formalist/modernist method developing out of Greenberg, Rose increasingly began to position herself against formalist criticism, seeing it as being both exclusive and excessively judgmental. In "Art Criticism in the Sixties" the symposium held in 1966 at Brandeis University, she commented on the state of contemporary art criticism asserting that:

> Formal criticism was an attempt to make art criticism more objective and scientific, it necessarily concentrated on the explicit properties of the art work, ignoring anything implicit as ineffable. Today I think, if we wish to keep pace with the art work being done, critics must be willing to discuss what is implicit in an art work; that is its content and intention. These cannot be verified but they can be discussed, keeping in mind that any statements about content and intention are merely assertions, hypotheses open to question.[28]

Here, Rose sees value in the earlier tradition of writings such as Rosenberg's which do not reject the formal qualities of works as basic to discussion, but include as well the implicit manifestation of the artist in the work. Rose goes on to say that "If we deal with intentions and content, we are once more thrown back on the question of value. Insofar as the critic has his own system of values, he will find certain intentions and certain kinds of content superior to others. The degree to which an artist is capable of realizing his intentions is

an aesthetic question but the evaluation of his intentions on the other hand is a moral question."[29] In this, Rose directly opposes the evaluative parameters of formalist criticism in order to re-open for discussion certain aspects of aesthetic productions which were becoming more and more assertive both visually and theoretically as the sixties progressed.

Formalist criticism, especially between 1945 and 1965 had monopolized in a largely positive way the serious discussion of American art. But its utility, especially with respect to evaluating Minimal and Pop art in the sixties, was uncertain. Formalism refused as a matter of judgment and principle, to deal with some of the essential theoretical questions raised by artists working within these new movements, both of which were denied the citation of originality. The aesthetic (as well as the historical) role which these traditions came ultimately to play was considerable, and the formal influence even on Color-Field painting in the mid-sixties was such that they could no longer be held as entirely unrelated and non-conversant developments. Because of this there appeared a need for a wider range of critical approaches to address new non- or anti-formalist issues. Rose was one of the first to sense this need, but she was not alone.

The writings of Donald Judd provided an artist's inside perspective for addressing these issues. He described explicitly the theories which had been motivating his own early sixties work, and commented on the work of his contemporaries, praising or rejecting them for applying principles which he considered important. In this way, he played a prescriptive role as had Fried and Greenberg, but also acted as a spokesperson for his art, and that of many others whose work he respected. He was interested in the conceptual as well as the formal, but not in the personal.

Judd's article "Specific Objects" published in 1965, was the first major article by one of the originators of "Minimalism," describing the kind of work soon to be given that name. The first illustration in the article was Oldenburg's "Soft Light Switches" (1964), an image which visually underlined the fact that Pop and Minimal art had in common powerful reduction, oneness and an inherent monumental style. He began his discussion saying:

> The main thing wrong with painting is that it is a rectangular plane placed flat against the wall. A rectangle is a shape itself; it is obviously the whole shape; it determines and limits the arrangement of whatever is on or inside of it Most sculpture is made part by part Painting and sculpture have become set forms. The use of three dimensions [here he means Minimal art] isn't the use of a given form So far, three-dimensions is a space to move into. The charac-

teristics of three-dimensions are those of only a small amount of work, little with comparison to painting and sculpture. At any rate it will be larger than painting and much larger than sculpture Because the nature of three-dimensions isn't set, something credible can be made, almost anything of course. Something can be done within a given form such as painting but with some narrowness and less strength of variation.[30]

Judd set out in these first few paragraphs of his article the limitations he saw in painting and sculpture (i.e. traditional conceptions of those media) and established for artists the new possibilities in the so-called three-dimensional. The fact that radical sculpture was largely untouched critically opened it to interpretation, and Judd projected some of the possible characteristics for the new art based there. He was not speaking in this article about his own work, but rather as a critic, he was objectively looking at the field, assuming the role which Greenberg and Fried had occupied with respect to painting. He focused on the work of several contemporary artists, especially Oldenburg and Stella, and it is in his discussion of Stella toward the end of the article that his evaluations refer back to his prescriptions in the beginning:

> Stella's shaped paintings involve several important characteristics of three-dimensional work. The periphery of a piece and the lines inside correspond. The stripes are nowhere being discrete parts. The surface is farther from the wall than usual, though it remains parallel to it. A painting is not an image. The shapes, unity, projection, order and color are specific, aggressive and powerful.[31]

At the time of Judd's article, Fried did not see Stella's shaped canvases this way in *Three American Painters* of 1965. He was not concerned with or interested in the conversation between the medium and the advent of so-called three-dimensional art. In 1966, Stella's new shaped canvases changed radically from his earlier formats. In discussing this new development, Fried addresses an earlier issue which he described as the difference between literal shape (the picture structure) and depicted shape (shape on the surface) and their alternate dependence upon and relation to each other. He related the problems of literal and depicted shape in Noland and Olitski's canvases and in Stella's earlier shaped canvases to Stella's new pictures. He saw in them new possibilities for abstract painting which still did not violate the "canons" of modern painting by introducing spatial illusion or denying essential pictorial structure and moving toward an area between painting and sculpture.

By this time, Minimal art had come into play and though Fried recognized it, he distinguished Stella's painting from it

in order to bring the latter in line with his own aesthetic and historical perceptions. He saw the work as the most recent critique of the generative force of literal shape, something which had been constantly confronted in modernist painting. He wrote:

> Because Frank Stella's paintings, especially those executed in metallic paint, represent the most unequivocal and conflictless acknowledgement of literal shape in the history of modernism, they have been crucial to the literalist view I have just adumbrated, both because they are seen as extreme instances of a putative development within modernist painting — i.e. the increasingly explicit acknowledgement of literalness per se — and because they help to make that development visible or anyway arguable in the first place. They are among the last paintings that the literalists like Judd are able to endorse more or less without reservation; largely because the ambition to go beyond them — to pursue their apparent implications — was instrumental in the abandonment of painting altogether by these same artists.[32]

Here, Fried answers Judd's suggestions that the relationship of Stella's stripes to the periphery of the painting (i.e. literal to depicted shapes) makes them more like the three-dimensional works he proposes in "Specific Objects." The suggestion of sculptural qualities in Stella's striped paintings are seen by Judd as Stella's advancement out of the modern tradition of painting as established by Greenberg and Fried and into the possibilities of a medium between painting and sculpture.

Stella's new paintings according to Fried ignore the relationship of literal and depicted shape in favor of a variety of shapes and dispositions in relation to one another and to the support. The shape of the support is taken into account in such a way that it does not affirm the dependence of depicted on literal shape, so much as it establishes an unprecedented continuity between them. In this, Fried is positing Stella's new paintings as an answer to the problem of the unstable relationship between literal and depicted space, encountered throughout modernist painting history, and suggesting that Stella is proposing in these works a new and potentially liberating possibility for modern painting. Judd on the other hand is looking to Stella as confirmation of the idea that certain painters and sculptors are moving toward the art form which he theorizes as being immanent.

Minimal art ultimately presented little visually to prod critics to formal discussion. Instead its ideology became the source of widespread interest. Neither the formalist critics nor the minimalists themselves came to any collective agreement on ideology and/or achievement. The art was so essentially theoretical that it generated a critical crisis not unlike that which developed around Johns' early work. By the mid-sixties, there was considerable debate and discussion among critics in the art periodicals regarding not only the issues raised by the work of a particular artist but also with regard to the most responsible and intellectually defensible position for art critics to assume in evaluating and elucidating the new, highly theoretical art of Minimalism with its overt references to both Pop and Color-Field work. The result of it all was a shift of viewpoint or strategy in the writing of many critics, as the critical factions multiplied and became increasingly opposed.

By the time of his 1967 article, "Art and Objecthood," Fried's criticism and methodology had taken a radical turn. This article marks a second phase in the development of Fried's critical writing — a phase related to but significantly different from the first. He stated most explicitly in a footnote to this article his post-Greenberg position:

> Moreover, seeing something as a painting in the sense that one sees the tacked-up canvas as a painting, and being convinced that a particular work can stand comparison with the painting of the past whose quality is not in doubt, are altogether different experiences: it is, I want to say, as though unless something compels conviction as to its quality it is no more than trivially or nominally a painting. This suggests that flatness and the delimitation of flatness ought not to be something like the "minimal conditions for something's being seen as a painting"; and that the crucial question is not what these minimal and so to speak timeless conditions are, but rather, what at a given moment is capable of compelling conviction, of succeeding as painting. This is not to say that painting has no essence; it is to claim that that essence - i.e. that which compels conviction - is largely determined by and therefore changes continually in response to the vital work of the recent past . . . the task of the modernist painter is to discover those conventions that at a given moment alone are capable of establishing his work's identity as painting. Greenberg approaches this position when he adds: "As it seems to me, Newman, Rothko and Still have swung the self-criticism of modernist painting in a new direction simply by continuing it in its old one. The question now asked through their art is no longer 'what constitutes art, or the art of painting, as such, but what irreducibly constitutes "good" art?' Or rather, 'what is the ultimate source of value or quality in art?'" But I would argue that what modernism has meant is that the two questions — What constitutes the art of painting? and what constitutes "good" painting? — are no longer separable; the first disappears, or increasingly tends to disappear, into the second. (I am of course, taking issue here with the version of modernism put forward in my *Three American Painters*).[33]

The re-insistence on quality seems to come in reaction to the theoretical writings and art of the Minimalist group which explore conceptually rather than qualitatively the nature of Minimal art. The essay itself engages primarily the idea of the viability of the species of theatricality which Minimal art sets up, as Fried becomes increasingly interested in the viewer/object relationship.

By 1967 Rose had established her position in opposition to Fried. Beginning in 1967, Rose engaged in a series of discussions of criticism in *Artforum* entitled "Problems in Criticism: Politics in Art" in which she expanded further her opposition to formalist criticism, and drew parallels between art theory and political theory and therein declared her own notions of "effective" criticism. In the first of this series, she criticized the early assertions made by Fried regarding the unquestionable affectiveness of formalist criticism:

> Fried writes of a new type of disagreement among critics, the disagreement that occurs when two or more critics agree, or say that the work of a particular artist is good or valuable or important, but when the terms in which they try to characterize the work and its significance are fundamentally different.[34]

Rose felt that Fried was not content simply to discredit his opposition, but rather desired to annihilate it in a manner familiar to anyone who has read Marxist political writing. Such polemics charge the opponent with "ideology" attempting thereby to destroy the opposition on the grounds that no discourse was possible because the opponent is not representing the same world, that in fact the entire edifice on which his thought rests is determined by class values. Rose felt that a criticism based on a general field approach is best suited to the complexity of the contemporary situation than any one featuring a linear or cyclical view of art history. Such an approach, she suggests, could contrast and compare material horizontally instead of trying to organize it vertically as a series of radical advances constituting a "perpetual revolution." Evaluation would necessarily be part of such a criticism, but it would not be all of it, and such evaluation would come only after classification and investigation. Rose's stance here is not radically changed from her earlier writings, but her strong condemnation of the exclusive formalist approach and her introduction of parallels with political rhetoric was new.

What Rose ultimately was advocating as "synthetic criticism" was in fact already practiced by a small and influential group of art historians including most notably William Rubin, Robert Rosenblum and Leo Steinberg, all of whom were writing occasionally on the contemporary art scene and shared in various ways and to varying degrees Rose's contextual, iconographic approach. The methods of these critics and others proliferated in the late sixties and early seventies into new, widely varied political, feminist, and psychological sympathies developed in tandem with the increasingly malleable aesthetics of post-sixties art.

1. Calvin Tomkins, *Off the Wall: Robert Rauschenberg and the Art World of Our Time* (New York: Penguin Books 1980), 46.

2. Harold Rosenberg, "Introduction to Six American Artists," *Possibilities*, 1 (Winter 1947-48): 75.

3. Clement Greenberg, *The Nation* 162, no. 18 (May 4, 1946): 552.

4. Max Kozloff, "The Critical Reception of Abstract Expressionism," *Arts* 39, no. 10 (December 1965): 28.

5. Clement Greenberg, *Action Painting* (Dallas: Museum of Contemporary Arts, 1958).

6. Kozloff.

7. This idea of risk as the impetus for artistic creation is precisely the second tradition of discussion among the moderns cited above.

8. Harold Rosenberg, "The American Action Painters," *Tradition of the New* (New York: Grove Press, 1961), 23-39.

9. Thomas Hess, *Abstract Painting: Background and American Phase* (New York: Viking Press, 1951).

10. Rosenberg, "The American Action Painters."

11. Kozloff, 29.

12. Kozloff, 29.

13. Clement Greenberg, "'American Type' Painting," *Art and Culture* (Boston: Beacon Press, 1961), 223-28.

14. Tomkins, 167.

15. Tomkins, 167.

16. Clement Greenberg, "After Abstract Expressionism," *Art International* 6, no. 8 (October 1962): 26.

17. This article was based on the first of three lectures given at the Museum of Modern Art, New York in the spring of 1960 and was first published in *Harper's Magazine* (1962). The subject of his discussion was Jasper Johns' first one-man show in New York which included works such as *Target with Faces* and the American Flag variations.

18. Leo Steinberg, "Jasper Johns: The First Seven Years Of His Art," *Metro* 4/5 (1962): 23.

19. Steinberg, 25.

20. Steinberg, 24.

21. Erwin Panofsky, *Studies in Iconology: Humanistic Themes in the Art of the Renaissance* (New York: Oxford University Press, 1939), 3-31.

22. Michael Fried, "Modernist Painting and Formal Criticism," *The American Scholar* 33 (October 1964): 645.

23. Fried, "Modernist Painting and Formal Criticism," 646.

24. David Carrier, "Greenberg, Fried and Philosophy: American-Type Formalism," *Aesthetics: A Critical Anthology*, ed. George Dickie and R. J. Sclafani (New York: St. Martin's Press, 1977), 461-69.

25. Fried's philosophical background at Princeton, and knowledge of R.P. Blackmur's writing established the real intellectual standards of his criticism.

26. Barbara Rose, "Kenneth Noland," *Art International* 8, no. 4 (1966): 58.

27. At the time Barbara Rose was married to Frank Stella, who as has been stated, was engaged in constant discussion with Michael Fried. That Rose was influenced by or shared ideas with Fried is conjectural, but plausible. The later modifications of her critical stance, however, appear to be a pronounced rejection of his theories.

28. Barbara Rose, *Art Criticism in the Sixties* (New York: October House, 1967), 5 (from statement delivered at the symposium held at Brandeis University, 1966, with same title).

29. Rose, *Art Criticism in the Sixties*, 8.

30. Donald Judd, "Specific Objects," *Arts Yearbook* 8 (1965):111.

31. Judd, 113.

32. Michael Fried, "Shape as Form: Frank Stella's New Paintings," *Artforum* 5, no. 3 (November 1966): 22.

33. Michael Fried, "Art and Objecthood," *Artforum* 5, no. 10 (June 1967): 12-23, note 4.

34. Barbara Rose, "Problems in Criticism IV: Politics in Art I," *Artforum* 6, no. 6 (February 1968): 31-32.

Criticism as Content, Form and Value

Mitchell F. Merling

This essay undertakes to demonstrate that the transition from first to second generation abstraction (that is from the Abstract Expressionists to the Pop, Minimal and Color-Field artists of the 60's) is marked by a massive increase in historical self-consciousness and self-examination. That historical self-consciousness is, I believe, coincident in many cases with the forms of art produced in the period. In the first part of the present essay I wish to define and trace the intellectual genealogy of that accelerated historical self-consciousness, and to suggest some of its causes. In the second part, devoted to the intentions and achievements of the Minimalists, I hope to show on a micrological level how these artists exploited Clement Greenberg's evolutionary historiography in order to give meaning to their own work, and to indicate on a macrological level how they attempted both theoretically and practically to move beyond Greenberg's evolutionism and thereby achieved a position reminiscent of earlier and more radical avant-gardes.

Two immediate causes may be seen as motivating the sharpened reflexivity of the second generation of postwar abstract artists. The first is the burdensome and demanding residue of the first generation's accomplishment, and a sense of the necessary, almost archetypal oedipal reaction. Indeed, Pollock, Rothko and de Kooning (existing as both historical and historiographical figures) had by the early sixties acquired a certain patriarchal, if not a pentatuchal, status. The primary historical reaction was signaled by the attack of the young critic, Barbara Rose, on Harold Rosenberg's celebratory chronicles of Abstract Expressionism on the grounds of mystification and obfuscation.[1] Second, the increased intellectuality of the young painters in question, most of whom were college-educated, as well as the entrenchment of art history and criticism as an institution at the time, gave a certain predetermined shape to this generational shift.[2] It is not the intention of the present essay to determine which of these two ingredients, the historical "crisis" or the ability to articulate it, should be given precedence — but it seems necessary at this point to note their simultaneous appearance and their somewhat symbiotic relationship. It is hard to disagree with Sidney Tillim's conclusion of 1964 that "All post-Abstract Expressionist art depends for its *topical* validity on some direct response to this disenchanting legacy,"[3] but it should be further noted that it is at this stage that the Abstract Expressionist

vanguard is viewed as an *historical* phenomenon by the critical establishment for the first time, marking a distinct phase in its divergence from the course of European modernism.

The chief lesson learned by critics as they examined the drying up of the well of creativity in the late fifties and the resurgence (if not the immediate maturity) of the second generation of artists, was the poverty of models for discussing radical historical change. Early attempts at furnishing a paradigm rely on a Wölfflinian dialectic of painterly and linear styles which is ultimately transformed into Leo Steinberg's theory that the history of contemporary art shows how avant-garde styles are produced within and productive of a perpetual dialectic of novelty and initial incomprehension.[4] According to this theory, new art becomes accepted and academized, thereby demanding another radical movement in order to maintain the momentum of shock characteristic of, and requisite for, modern aesthetic experience. Thus, the production of new style is really a self-sacrifice performed in the service of the security of the future. The position of both the public and the artist is, however, ultimately one of cynical despair in the face of what is by necessity the eternal recurrence of the "new." In Renato Poggioli's words, "[It is false that] . . . the avant-garde is ending or about to end, that it has been superseded or liquidated." He claims that ". . . we could say that the avant-garde is destined to perish only if our civilization is condemned to perish. . . . But if such a situation is not imminent or unavoidable, then the art of the avant-garde is condemned or destined to endure, blessed in its liberty and cursed in its alienation."[5]

What was necessary, then, at the start of the sixties was a theory of cultural production that would provide not only an historiographical model but an alternative to aesthetic *anomie*. Although its main thesis was formulated as early as 1936, that theory was made to order with the 1961 publication of a selection of Clement Greenberg's essays under the title *Art and Culture*. By Greenberg's definition, ". . . the true and most important function of the avant-garde was not to "experiment," but to find a path along which it would be possible to keep culture *moving* in the midst of ideological confusion and violence."[6] That is, modern art must function in a state of self-sufficiency apart from the politics of the period yet performing its political role (i.e. the dissent necessary

merely for the proof of democracy's existence) almost in spite of itself. Basic to Greenberg's ideology was the notion that the subject matter of the avant-garde work becomes "the disciplines and processes of art and literature themselves,"[7] a method operative in both Joyce's prose and Picasso's painting: "the reduction of expression for the sake of expression, the expression mattering more than what is being expressed."[8]

Avant-gardism as a cultural phenomenon is presented by Greenberg as standing in contrast to the self-reflexiveness of a (decadent) Alexandrian culture: "The avant-garde moves while Alexandrianism stands still. And this precisely is what justifies the avant-garde's methods and makes them necessary."[9] In other words, Greenberg has solved the problem of the eternally recurrent new by introducing an ethical dimension, which emphasizes the positiveness of the solidity of the bond linking the present to the past.

The first example of a productive response in the art of the 60's to the historical conditions and ideologies traced above is that of the continuation of the new within the broader limits of a pre-established avant-garde tradition. This was the path chosen by the Color-Field painters. The historiography of these painters was formulated by their pre-eminent critical advocates, Greenberg and Michael Fried. The main assumption of their advocacy was that vanguardism is hermetic (as distinct from popular culture) and intrinsically self-critical. The subject matter of the vanguard work, in this later formulation, is not only the processes of art but the history of the processes of art. Thus, the best work of the present includes, *and* contains a criticism of, the best work of the past. From this vantage point, to break absolutely with the established but weakening vanguard would not represent a vanguard action, but a break with the tradition of vanguardism itself. Implicit in the title of Greenberg's essay, "Post-Painterly Abstraction,"[10] is the idea that any worthwhile art which will emerge in the period after Abstract Expressionism must in some way represent a continuation of its project. All else is mere novelty and, in Greenberg's words, "novelty as distinct from originality, has no staying power."[11]

Michael Fried modified and critiqued Greenberg's conception of the history of modernism while retaining many of its salient features. The most important change is a new stress on the freedom of choice available to the artist regarding the use to which he puts the art of the recent past, rather than the necessity of any particular use. "More than anything else, the dialectic in the thought of these men [the Color Field painters] is an ideal of action as a radical criticism of itself founded upon as objective an understanding of one's present situation as one is likely to achieve."[12] While "there is nothing teleological about such an ideal," the fact remains that modern painting is determined by the course upon which it has already been set.[13] Modernist painting of the highest quality, then, "preserves" and presents "what it can of its history, not as an act of piety to the past but as a source of value to the future."[14] Thus, the ultimate value of a work is, as in Greenberg, moral although it is now its "fecundity" for the future which provides the standard of aesthetic and ethical measurement. In short, Greenberg, with Fried following him, put forth a prescriptive theory of modernism — reformulated with special vigor in the early 60's and available to any artist who read any art journal — which had replaced simple "formalism" as an aesthetic norm, with "historicism."[15]

This aesthetic historicism can be seen as the primary ideology behind Greenberg's and Fried's championship of the Color-Field painters. Following Greenberg's definition of great modernist art as both flat and about the delimitation of flatness, Fried was able to erect a canon of modernist painters following Manet. The Friedian genealogy of "Jackson Pollock — Helen Frankenthaler — Morris Louis — Kenneth Noland — Larry Poons" privileges neither end of the spectrum, but rather valorizes the whole group, and, more importantly, privileges the dialectic itself, which is legible from either direction.[16] Greenberg's attack on the encroachment of Pop art (with its only lightly mitigated introduction of mass culture material to high art) as "a new episode in the history of taste, but not an authentically new episode in the history of contemporary art,"[17] is absolutely consistent with the reading sketched above of Greenberg's historicism as fundamentally evolutionist. He accuses Pop of being merely novel, rather than original. For Greenberg, true originality would have to be grounded in tradition, that is, in the *originality* of the Abstract Expressionists.

Pop art represents something more to Greenberg than mere novelty, however. Other critics likened its aims and its relation to Abstract Expressionism as analogous to Dada's derivation from synthetic Cubism. However, the problem which Pop presents to the evolutionist critic is not merely the appropriation of a pre-existing historical style, but the threat of perpetual revolution for its own sake (the historical condition which Greenberg's theory of cultural production had all along been attempting to avert). The ideological substance of Greenberg's assertions that Pop was a mere episode in the history of taste is that Pop is none other than kitsch. Kitsch, as Greenberg had defined it in the late thirties, is the concept *against which* he initially defined modernist culture. Kitsch is for Greenberg, in effect, culture's evil twin, for like van-

guardism it is a product of the socio-cultural conditions of early modern capitalism, with its ills and injustices. In Greenberg's definition, kitsch not only arises at the same time as the avant-garde, but parallels and profits by the same dialectical processes (though governed by the principle of novelty rather than the radical originality of self-criticism). In Greenberg's words, "the precondition for kitsch is the availability close at hand of a fully matured cultural tradition, whose discoveries, acquisitions, and perfected self-consciousness kitsch can take advantage of for its own ends."[18] Further, where "the avant-garde mimics the processes of art, kitsch, we now see, mimics its effects."[19]

The juxtaposition of both avant-garde and kitsch moments in Pop, where the two are in effect not immediately separable, and where their historical processes are in any case the same, was seen by Greenberg as a threat to the sublimely autonomous and hermetic character of modernism. For Greenberg, then, Pop, as a species of kitsch, represented an attack on modernism from within, by the object it had initially defined itself against. If Pop was not recognized for what it was, Greenberg warned, there would be the danger that the avant-garde, whose task it is to save the past for the future, may be overwhelmed by kitsch, which plunders the past in order to satiate the "whims" of the present.

The moral substance of Greenberg's influence is evident in a 1965 controversy over Pop and its significance. A Greenbergian attack on Pop was conducted in an article by Walter Darby Bannard (a leading proponent of Hard-Edge Abstraction) entitled "Present-Day Art and Ready-Made Styles: In which the formal contribution of Pop art is found to be negligible."[20] The premise of this article is that Pop art had abdicated its modernist responsibility for self-criticism and had defined itself merely in response to the aesthetic of late Abstract Expressionism. According to Bannard's historiography (which reconciles Steinberg's notion of the plight of the contemporary art public with Rose's analysis of the birth of academic Action Painting), Abstract Expressionism, as a true vanguard, created a corpus of canonical works which were then imitated in the derivative work of the so-called Tenth Street painters. At the same time, their achievement created a public which learned to hunger after the shock of aesthetic innovation, and which considered novelty as pure value, without understanding the necessity for the hermetic traditionalism of great modernist art.

In other words, Abstract Expressionism created the need for its own "jazzy successor" which was found in the inauthentic school of Pop. Pop, in its pre-1964 "painterly" phase, appropriated the formal discoveries of Abstract Expressionism (the loose brushwork, the play of surface and depth, and so on) and employed them in the service of a predetermined armature of popular and ironic subject matter. Further, whereas Fried could establish a self-valorizing genealogy of modernism from Pollock to Poons, such a genealogy was seen as intrinsically impossible with Pop, where, at best, one could represent such an evolution as deriving from de Kooning, and passing through Rauschenberg and Johns, to Lichtenstein, Rosenquist, Indiana, Oldenburg, Segal, Warhol and Kaprow — all of the latter existing as points on a plane rather than on a line, and where Kaprow could be seen as having perhaps taken this evolution as far as it could possibly go: beyond art into life itself, that is, from avant-garde to the ur-kitsch of the "Happening." Pop, then, is a self-destructive movement, based on novelty as value and without fecundity for the future, and therefore, not an "authentically new episode in the evolution of contemporary art."

Bannard's argument can only be understood as the setting forth of Greenberg's evolutionism in an objective and "historical" manner. The accusation of "novelty" is in this case significant within the historiographical terms set forth above. In contrast to the usual condemnation of the new on the grounds that it has already been done, the denigration of the new for that reason alone is only possible from within the essentially conservative standpoint of evolutionism.[21]

The response by the proponents of Pop art to Bannard's attack is significant. Peter Plagens attempted to valorize the movement by arguing along evolutionist lines that Pop *did* partake of the self-critical dialectic of modernism. For Plagens, Pop not only presented new subject matter but also offered new formalist solutions, which outdistanced Color-Field painting in the modernist task of essentialism: the abolition of pictorial illusion in the service of "flatness and the delimitation of flatness." In other words, Plagens took the challenge offered by Greenberg's historicism, and appropriated its dialectical aesthetics while abandoning its ethical content. In Plagens' words, "The color and space of Greater Pop has probed and shifted the space of Abstract Expressionism; it has not destroyed it or abandoned continuous formalist revolution (which it *has* according to socio-historical appreciation). What has happened is another step . . . We are re-examining the gristle of painting: what to do with a surface."[22]

There is another dimension, however, to Plagens' attack, for the title of his essay, "Present-Day Styles and Ready-Made Criticism: In which the formal contribution of Pop art is found to be Minimal," not only expressed his antagonism to the obviousness of Bannard's intellectual debt to Greenberg

and his followers, but also argued that some of the credit for the achievement of the emergent Minimalist artists was due to the "fecundity" of Pop. According to Plagens, Pop prepared the way for Minimalism first as a radical critique of the formal qualities of Abstract Expressionist space, and second as a critique of the necessity of iconographic innovation. Most importantly, however, Plagens argued in ways partly parallel to and derived from Greenberg for the historical understanding of the evolution of modernism. According to Plagens, then, the historical and genealogical truth of the emergence of Pop and Minimalism can be made to argue for aesthetic truth within the outlines of Greenberg's evolutionism.

It is revealing that the constitution of the Minimalists as a movement involved the appropriation of painters from other movements. That is, rather than being seen as a *movement*, the property of a specific group of artists who had defined themselves as such, it was seen as a general trend towards simplicity as a "sensibility" or tendency of the period. The most inclusive of the definitions of this sensibility, Barbara Rose's and Lawrence Alloway's, include such Color-Field painters as Noland and Stella as well as Pop artists such as Lichtenstein and Warhol.

According to Alloway's definition, serial systems of making and the use of preconceived ideas rather than the working out of pictorial solutions in the process of the execution of a painting is characteristic of the new art of whatever sub-style, whether Minimalist or "Systemic."[23] This accords well with Richard Wollheim's well-known description of Minimalist works as having ". . . Minimal art-content, in that they are to an extreme degree undifferentiated in themselves and therefore possess low content of any kind." Further, the manufactured surfaces of the works of such artists as Judd, LeWitt and Andre come "not from the artist but from a non-artistic source like nature or the factory"[24] — a definition that easily includes both Andre's firebricks and Warhol's Brillo boxes.

According to Fried, however, these works cannot take their place within canonical modernism, for they "assert the values of wholeness, singleness, and indivisibility — of a work's being, as nearly as possible, 'one thing,' a single, 'Specific Object,'" —[25] the antithesis of the fecundity of Greenberg's increasingly de-sacralized, but still critically operative cosmography. Yet the problem of the Minimalists' response to the challenge of evolutionist ideologies remained — how did they operate within that tradition, while halting it, or seeming to, at every point. Barbara Rose's 1964 article "The Second Generation, Academy and Breakthrough" and her subsequent essay "ABC Art"[26] were attempts to answer that question by writing alternatives to Greenberg's and Fried's "histories," while retaining their evolutionist structure.[27]

In the first article,[28] written at the threshold of the movements which were then declaring themselves to be new (Pop, Happenings and early Minimalism), Rose presented the changeover from the first and second generations as a sort of historical crisis. According to her, the age of heroic abstraction typified by de Kooning was followed by one dominated by servile imitators of him whose inauthentic, pseudo-existentialist works flooded the market — this was the "Academy." It was those who chose the more difficult path, the followers of Pollock, who made possible the breakthrough of the second generation. Rauschenberg followed Pollock in his explorations of surface and depth, and through the incorporation of found objects into his canvases. Johns, perhaps more fecund for the decade to follow, abolished the "illusion" that there was something behind the picture space. His depictions of flags or light-bulbs had the appearance, at least from a distance, of being no different from the objects themselves.[29] Finally, she argued, figures such as Al Held, Kenneth Noland and Ellsworth Kelly eliminated both the "crisis content" of Abstract Expressionism with their impersonal *facture* and its spatial dilemma, characterized by "push-pull" or "relational" structure, by "stressing flatness and broad areas of color."[30] According to Rose's dialectical history, then, "the second generation began in a critique of Abstract Expressionism in terms of its *internal* contradictions and ended in a *resolution* of these contradictions in favor of a simplified conceptual abstraction . . ."[31]

In the second article, Rose attempted to place the Minimalists within a larger tradition by returning her focus of argument to the early extremes of modernism. In the expanded context of the history of modernism, she argued, Minimalism would seem to participate in a dialectic of renunciation that ran parallel to the dialectic of creation of painterly and post-painterly abstraction. These renunciations are "on Duchamp's part, of the notion of the uniqueness of the art object and its differentiation from common objects, and on Malevich's part . . . of the notion that art must be complex."[32] This understanding of modernism ultimately enables Greenberg and Fried to be read (or misread) as promulgating themselves the notion that as the course of the European tradition since Manet is "about flatness and the delimitation of flatness," the history of European modernism is the story of each art getting rid of its extraneous qualities in the quest for an absolute and radical purity of form. The realization of the

pictorial surface as the aesthetic absolute of the modernist pictorial enterprise, as Rose sees it, supports "renunciation" as well as "originality" within its dialectical course.

Fried, too, had been forced when confronted by the historical fact of major aesthetic accomplishment to acknowledge the workings of a reductivist dialectic in the work of Frank Stella. He called the works from Stella's irregular polygon series "... the most extreme statement yet made advocating the importance of the literal character of the picture-support for the determination of pictorial structure."[33]

In "Questions to Stella and Judd," a 1964 interview, the Minimalists make explicit their idea of this evolutionist/reductivist strain in modern art. Both make the claim that their art was in a sense the "utmost" because it is the "end" to which European art has tended. In their view, the art of the present is founded on the radical precepts of early modernism, on the work of Mondrian and Malevich. Tradition is opposed to innovation in their negative discussion of Vasarely, and a genealogy is constructed through Pollock and Morris Louis, a genealogy which features the recognition of the canvas as pure presence without illusion — a self-sufficient and internally unified entity without the "relational" composition characteristic of the tradition of pre-modernist European painting, and persisting in the work of the Abstract Expressionists.

Donald Judd epitomized the period's reversal of values:

> You're getting rid of the things that people used to think were essential to art. But that reduction is only incidental. I object to the whole reduction idea, because it's only reduction of those things someone doesn't want. If my work is reductionist it's because it doesn't have the elements that people thought should be there. But it has other elements that I like. . . . Why is it necessarily a reduction?[34]

He admits, however, that "Painting's been going toward that for a while."[35]

Stella concluded that "My painting is based on the fact that only what can be seen there *is* there."[36] The lack of drawing, the resistance of the surface, and the assertion of the indivisibility of the canvas through non-relational art spells the "end of the European tradition," an end that is both the goal and the summation of that tradition.

In effect, the attack on the European tradition by the Minimalists was carried out through sculpture, rather than painting. This reversal of priorities is signaled by Judd's criticism of di Suvero as a "painterly" sculptor, and hinged on a presentation of his work as anthropomorphic and on the similarity of his arching "relational" forms to Abstract Expressionist brushstrokes. In Judd's words: "Di Suvero uses beams as if they were brush strokes, imitating movement as Kline did. The material never has its own movement. A beam thrusts, a piece of iron follows a gesture; together they form a naturalistic and anthropomorphic image."[37] Thus, Judd's aesthetics are predicated upon an insistence on the unity and the literal and figurative integrity of the sculpture, much as the emphasis on the two-dimensionality of the pictorial surface was the aesthetic (and, for Greenberg, the ethical) absolute of the Color-Field tradition. For Judd, the indivisibility of the object provides the standard of absolute truth by which to measure the relative topical success of any work of art.

A corollary to this argument is Judd's insistence on the contemporary primacy of sculpture over painting. According to his understanding of the medium, painting can come close to the abolition of illusionism, demonstrated as an aspiration by the work of Kelly, Newman and Reinhardt. However, this aspiration is impeded by problems in the medium itself, and the accomplishments of such men as Yves Klein or Stella are anomalous triumphs over such inherent difficulties, for:

> It's possible that not much can be done with both an upright rectangular plane and an absence of space. Anything on a surface has space behind it. Two colors on the same surface almost always lie on different depths. An even color, especially in oil paint . . . is almost always both flat and infinitely spatial. . . . Except for a complete and unvaried field of color or marks, anything spaced in a rectangle and on a plane suggests something in and on something else, something in its surround, which suggests an object or figure in its space . . . That's the main purpose of painting.[38]

Thus, although painting was previously seen as the normative medium, Judd transferred Greenberg's evolutionist and essentialist rationale to sculpture. Having done that, however, he was able to reverse that rationale into an argument for the priority of sculpture, and finally to demand that sculpture in effect replace painting as *the* modernist aesthetic enterprise.

This demand is most overt in his analysis of the work of Frank Stella. Rather than seeing in Stella's oeuvre a concord of literal and depicted shape and the ultimate acknowledgement of the two-dimensionality of the painting surface, as does Michael Fried, Judd prefers to see an actual evolution of painting into sculpture as the real achievement of the work:

> Stella's paintings involve several important characteristics of three-dimensional work. The periphery of a piece and the lines inside correspond. The stripes are nowhere near being discrete parts. The surface is further from the wall than usual, though it remains parallel to it. Since the surface is exceptionally unified and involves little or no space, the

parallel plane is unusually distinct.[39]

Stella, thus, according to Judd, has finally acknowledged the canvas not as fundamentally two-dimensional, as in Greenberg's formulation, but rather as a three-dimensional bearer of the "illusion" of two-dimensionality.

In Judd's ultimate formulation, characteristic of the new rhetoric surrounding Minimalism as well as his own polemics in general, "Three dimensions are real space. That gets rid of the problem of illusionism and of literal space, space in and around marks and colors — which is riddance of one of the most salient and objectionable relics of European art."[40] Despite the fact that this statement is antithetical to Greenberg's and Fried's own beliefs, it is predicated upon their aesthetic program both in its evolutionism and its essentialism.

Thus, at the same time as Minimalism increasingly presented itself as the "end" of the European tradition, it took pains to acknowledge the organic relationship of its efforts to that monolithic entity which had come to be known through Greenberg as "the history of European painting since Manet." In their every literary or artistic activity, both Stella and Judd affirm their art as the last term in a teleology. The only sense in which it represented a radical break from tradition is where it aimed to be definitive.[41] However, as has been shown, such an attempt at definitiveness is necessarily antithetical to Greenberg's progressive stasis, and as such it placed Minimalism immediately in a position of radical vanguardism in terms of offering a challenge to an established artistic culture (a position which, tellingly, Pop art never managed to achieve).

The Minimalist work, then, must be seen as a bearer of double meanings: both as an "object" in and for itself *and* as a participant in a complex historical dialogue. Furthermore, it is in the latter way, according to the terms just described, that it is most fruitful to understand a Minimalist product, since a "formalist" reading is already accounted for by the artists as a historically charged element of the work. That a critical reading which robs Minimalism of its historical and polemic context would be contrary to the intentions of the artists themselves is confirmed by the extent to which these meanings are made explicit in and are recuperable through their writings and their works.

A primary characteristic of Minimalist works, standing somewhat in contradistinction to the ultimate desire for a final product marked by wholeness and indivisibility, is the interest the works exhibit in the process both of their determination and of our perception of them as objects existing in time. One would say that Minimalist work generally is therefore identifiable more by its temporal than its spatial complexity.

This latter characteristic is most evident in the work of Donald Judd, in terms of the multiple readings that are progressively revealed to the viewer through the experience of the object in space,[42] and in the lead reliefs and mixed media reliefs of Robert Morris.[43] In Morris' words: "I was interested in making objects that were involved with some kind of process or literary idea of history or state that an object might have other than just that visual one. And," he adds, "at the same time I was making those plywood forms."[44]

Those plywood forms, "depicting" elementary geometrical shapes and painted elephant gray, are among the works most vehemently attacked by Michael Fried in "Art and Objecthood." For Fried, these boxes represented both the literal and figurative "hollowness" of Morris' production, as well as its insuperable "theatricality." Indeed, one of the first of these boxes, the so-called "Column" of 1961, was employed as the sole "performer" in one of that artist's earliest performances where it first stood upright and then on its side for a total of six minutes.[45] According to Fried, the columns are aesthetically unsuccessful because they rely on an extra-artistic context (the theater) to provide meaning. Within the terms described above, however, it should be apparent that it is the relationship of the columns to their own artistic past, as a product of an historical as well as gestative evolution (rather than anything foreign to Friedian aesthetics), that determines their reference or content.

That this is so, that the concern of the Minimalist work is to collapse history,[46] and to make that historical process into both an aesthetic subject and an aesthetic "object," fulfilling as it does so and in its own way Clement Greenberg's prognosis for the aesthetic conditions under which modernism is operative, is displayed even more explicitly in Morris' dance piece "Site," performed by the artist himself and the dancer Carolee Schneeman at the Judson Memorial Church in 1964.[47] The performance is governed by a seeming simplicity of action and intent, if not by bluntness: the curtain rises on a stage bare except for what appears to be another "column" or plywood box, characteristic of the artist. After a few moments, the artist himself appears, dressed in workman's clothing and wearing rubber gloves. Slowly and without effort he reveals that what had seemed, from the audience's viewpoint, to be a solid three-dimensional construction is in reality a succession of flat screens or planes. He does this by removing them one by one from the stage. When the last one is removed, Ms. Schneeman is exposed to the audience's gaze, nude, and in the pose of Manet's Olympia.

Through the invocation of this iconic symbol of (a Greenbergian and monolithic) modernism, Morris was able to present his own participation in the "course of European painting since Manet" as an end to that evolution. On the other hand, the work may be seen as a polemic *against* painting and as propaganda for the art of sculpture — making clear the presence of three-dimensional and sculptural life behind the two-dimensional representation that was mistaken as an advance upon it. Indeed, the course of the action *as it unfolds in time* is the very opposite of Greenberg's understanding of the task of the artist as a seeker after "flatness and the delimitation of flatness," but it nevertheless acknowledges a Greenbergian dialectic working in reverse.[48]

However, the fact that the artist is wearing a rubber mask molded after his own features (and this *must* have been apparent to the audience) for the purpose of concealing the effort of the performance, would seem to call attention to the artist's skepticism of, or at least distance from, such a full-fledged evolutionism. Some of the questions it asks are: is history ever accomplished so effortlessly or markedly without strain? Or, is the artist merely an unwitting tool of dialectical Spirit revealing itself in historical fact? Is the "tradition" of European painting since Manet as "hollow" as the artist's own boxes were seen to be? Finally, is it *this* tradition that is eternally present and made manifest in those gray boxes?

One must, I think, see the performance as one artist's attempt both to place himself within a larger historical context, made both possible and necessary by Greenberg's evolutionism, and to critique that mode of historical understanding. Furthermore, the nature of the uneasy coupling of these opposite intentions makes it necessary that the piece be read as asserting the critique *itself* as both outcome and "end" of the European tradition.

At an historical moment, one would add, that both favored and enabled such a recapitulation, it is *as* an end (to be understood in the same sense as the Friedian critique of "objecthood" employed the word as coterminous with "destiny"), that Morris and his fellow Minimalists meant their work to be understood. By "ending" the European tradition, by making that end visible, in other words, Minimalism both did and did not partake of the American avant-garde first acknowledged and then codified by Greenberg. It did so by asserting its genealogy unequivocally. Its intention both to encompass and to deny such a dialectic, however, raised it to the status of an autonomous and truly radical avant-garde.

1. Barbara Rose, "The Second Generation: Academy and Breakthrough," *Artforum* 4, no. 1 (September 1965): 53-63. The pictorial accompaniment to Rose's attack is discussed by Michael Plante in his essay in this volume.

2. This is discussed by Megan Fox.

3. Sidney Tillim, "The New Avant-Garde," *Arts* 38, no. 2 (February 1964): 21 (italics added).

4. Leo Steinberg, "Contemporary Art and the Plight of its Public," *Other Criteria* (New York: Oxford University Press, 1975), 3-16. The connection between nineteenth-century historical paradigms and modernist historiography was pointed out by Barbara Rose in "Problems of Criticism IV: The Politics of Art, Part I," *Artforum* 6, no. 6 (February 1968): 32.

5. Renato Poggioli, *Theory of the Avant-Garde* (Garden City: Icon, 1965), 109.

6. Clement Greenberg, "Avant-Garde and Kitsch," *Art and Culture* (Boston: Beacon Press, 1961), 5.

7. Greenberg, 6.

8. Greenberg, 7-8.

9. Greenberg, 8.

10. Clement Greenberg, "Post-Painterly Abstraction," *The Great Decade of American Abstraction: Modernist Art 1960 to 1970*, ed. E. A. Carmean (Houston: The Museum of Fine Arts, 1974), 72-74.

11. Clement Greenberg, "After Abstract Expressionism," *New York Painting and Sculpture: 1940-1970*, ed. Henry Geldzahler (New York: E.P. Dutton for the Metropolitan Museum of Art, 1969), 371.

12. Michael Fried, *Three American Painters* (Cambridge: The Fogg Art Museum, 1965), 8.

13. Fried, 8. See also Rosalind Krauss, "A View of Modernism," *Artforum* 11, no. 1 (September 1972): 48-51.

14. Fried, 8.

15. Compare Poggioli's negative, but prescient definition, "the avant-garde itself is only the artistic equivalent of a transcendental historicism" — a historicism which, according to Poggioli, 165, is oriented "agonistically" to the future rather than the past.

16. That is, it could be projected into the past, as in the valorization of Louis in terms of his "fecundity" for Noland.

17. Greenberg, "Post-Painterly Abstraction," 74.

18. Greenberg, "Avant-Garde," 10.

19. Greenberg, "Avant-Garde," 15.

20. Walter Darby Bannard, "Present-Day Art and Ready-Made

Styles," *Artforum* 5, no. 4 (December 1966): 30-35.

21. Rose, "Problems of Criticism."

22. Peter Plagens, "Present-Day Styles and Ready-Made Criticism," *Artforum* 5, no. 4 (December 1965): 39.

23. Lawrence Alloway, "Systemic Painting," *Minimal Art: A Critical Anthology*, ed. Gregory Battcock (New York: E. P. Dutton, 1968), 37-60. This anthology is cited hereafter as *Minimal Art*.

24. Richard Wollheim, "Minimal Art," *Minimal Art*, 387.

25. Michael Fried, "Art and Objecthood," *Minimal Art*, 119.

26. Barbara Rose, "ABC Art," *Minimal Art*, 274-97.

27. The same is true of Judd's activity as a critic as well, despite his repudiation of evolutionism in "Complaints: Part I," *Complete Writings: 1959-1975* (Halifax: The Press of the Nova Scotia College of Art, 1975), 197-99.

28. Rose, "Second Generation."

29. Fried characterized this device as the identity of literal and depicted shape (stemming from Leo Steinberg's analysis of Johns' Flags, Targets, and Maps) which, accompanied by "deductive structure" was seen by him as characterizing the most advanced of recent art.

30. Rose, "Second Generation," 58.

31. Rose, "Second Generation," 58 (italics added).

32. Rose, "ABC Art," 277.

33. Fried, *Three American Painters*, 40. In the same essay, 43, Fried takes into account the transformation of an evolutionist dialectic to a reductivist one, as follows: "According to this [reductivist] view, the assertion of the literal character of the picture-support manifested with growing explicitness in modernist painting from Manet to Stella represents nothing more nor less than the gradual apprehension of the basic "truth" that paintings are in no essential respect different from other classes of objects in the world; only misguided respect for a moribund pictorial tradition obscures that "truth" from the public at large and prevents more artists — if that term makes sense in this context — than have already done so from acting upon it." He adds, 44, "perhaps I ought to make clear that the position I have just adumbrated is repugnant to me; but . . . it makes adequate sense as an interpretation of the formal development of modernist painting . . ." This discussion is continued in Fried, "Shape as Form: Frank Stella's New Paintings," *New York Painting and Sculpture: 1940 to 1970*, 422, note 11.

34. Bruce Glaser, "Questions to Stella and Judd," *Minimal Art*, 159.

35. Glaser, 156.

36. Glaser, 158.

37. Donald Judd, "Specific Objects," *Complete Writings*, 183.

38. Judd, *Complete Writings*, 182.

39. Judd, *Complete Writings*, 183-84.

40. Judd, *Complete Writings*, 184.

41. This is not to say that they meant to end art itself.

42. Rosalind Krauss, "Allusion and Illusion in Donald Judd," *Artforum*, 4, no. 9 (May 1966): 24-26.

43. Compare *Untitled*, 1964 (Cat. 24).

44. Michael Compton and David Sylvester, *Robert Morris* (London: The Tate Gallery, 1971), 51.

45. Rosalind E. Krauss, *Passages in Modern Sculpture* (Cambridge: The MIT Press, 1981), 201.

46. As Robert Klein suggests in "Notes on the End of the Image," *Form and Meaning* (Princeton: Princeton University Press, 1981), 170-75.

47. Illustrated in Krauss, *Passages in Modern Sculpture*, Fig. 177.

48. See note 16.

The Sixties: Pop goes the Market

Jennifer Wells

In 1964 the New York art scene was described as consisting of "three or four dealers, four or five critics, five or six museum people, maybe ten collectors. And no more."[1] Despite its surprisingly small membership, this network actively encouraged the rapid acceleration of a market for contemporary American art. Overall, the sixties evinced a major change in patterns of patronage and connoisseurship. Historically, art critics have had the role of establishing reputations among artists, but during the period under discussion here, new collectors, enthusiastic and receptive to the young vanguard artists, purchased their works prior to critical "authorization," ensuring their immediate recognition and financial security. The Pop movement established itself almost instantly, perhaps faster than any other in the history of art, largely because of the frenzied buying activity of the new collectors, the so-called "vanguard audience."[2]

In addition to these bold collecting efforts in the private sector, museums recognized the young generation with mid-career retrospectives and numerous group exhibitions. Commercial galleries routinely mounted annual solo shows as well as "movement" surveys. The impact of mass media and its excited exposure of the ecstatic art scene combined with new market patterns to effect a near total reversal of the traditional processes by which artists were recognized, as was stated by Harold Rosenberg:

> The texture of collaboration between dealers, collectors and exhibitors has become increasingly dense to the point at which the artist is confronted by a solid wall of opinion and fashion forecasts constructed, essentially out of the data of the art market.... The presence of this potent professional establishment has radically affected the relation, once largely regulated by the taste of patrons, of the artist to society and to his own product.[3]

By the late sixties, the well-publicized collecting activity had snowballed and the financial growth potential for contemporary art seemed limitless. Auction houses noted record high prices for living artists[4] and several older "blue-chip" artists such as Jasper Johns and Robert Rauschenberg received five-figure payment for their early works.

The relationship of a museum to the contemporary avant-garde, always a problematic one, received a great deal of scrutiny throughout the decade. The Museum of Modern Art, the Whitney, and the Jewish Museum provided the central focus of institutional activity in the sixties, while the Guggenheim played a lesser role because of the commitment to its permanent collection. Although no serious critical or historical account of the three new aesthetic directions — Pop, Color-Field, and Minimalism — was mounted until the Metropolitan Museum's exhibition *New York Painting and Sculpture: 1940-1970*, museums did respond to contemporary art in various group shows, shows of recent acquisitions and thematic exhibitions. The Museum of Modern Art had received much criticism for not recognizing Abstract Expressionism during the most salient period of that movement. In response to this accusation and at the request of European institutions, MOMA organized *The New American Painting* in 1959. This exhibition traveled to eight European countries and, as an afterthought, was shown at the museum upon return.

Despite its overwhelming popularity among the public art audience, Pop art was not actually celebrated as a movement by a major museum exhibition until the recent *Blam!* show at the Whitney Museum (1984) which brought together Pop with its presumed progeny, Minimalism and Performance.[5] The Museum of Modern Art responded early on to Pop art with a symposium held in December 1962 featuring critics and curators all of whom berated the artists and their work. The single exception to the negative assessments came from Henry Geldzahler, Assistant Curator of American Art at the Metropolitan Museum of Art. Yet, despite the lack of curatorial enthusiasm, MOMA's International Exhibition Program organized an exhibition of Pop that traveled to Holland, Sweden, Germany and Austria in 1963. The Guggenheim then featured several artists associated with the Pop movement in a show *Six Painters and the Object* also held in 1963.

A prime demonstration of how a major museum defined its relationship to the current aesthetic tendencies during the sixties can be seen in MOMA's 1965 exhibition *The Responsive Eye*. This exhibition, purported to be ahead of its time, actually obscured the contemporary directions by bringing together diverse artists under the critically-fabricated label "Op." Only after the exhibition had taken place did it become apparent that the artists shown did not represent the same or even similar tendencies in their work. Between 1964 and 1966 the most popular forums for displaying recent works of art were the annual MOMA *Recent Acquisition* shows which introduced such artists as Jim Dine, Agnes

Martin, Jules Olitski, Larry Poons, Andy Warhol and Tom Wesselmann. It is interesting to note the prevailing cautionary tone of the museum in the presentation of recent works: "This year's show contains a high proportion of recent work and illustrates the risks deliberately taken in forming the museum's collection."[6] The first time the museum brought together the three aesthetic directions surveyed in the current exhibition was in the 1967 summer exhibition *The 1960's: Selections from the Permanent Collection*. At the same time a major loan exhibition entitled *Two Decades of American Painting* was prepared by MOMA's International Council and sent to Japan, India and Australia, but never shown in New York or elsewhere in the United States.

The Whitney excelled in exhibiting contemporary art in the "Annual" format which basically served as a recapitulation of each season. These exhibitions gave exposure to a broad range of artists and to an to even broader range of talent. In addition to the Annuals, the Whitney featured contemporary talent in a series of large-scale survey exhibitions. In the inaugural exhibition at the new Madison Avenue headquarters of the Whitney, *Art of the United States: 1670-1966*, a large portion was devoted to recent developments and featured many artists included in the current exhibition. This exhibition became the focus of an article written by Barbara Rose in which she criticized the Whitney's selection of contemporary works which had not received critical attention but had been featured in the media and represented in private collections.[7] Undaunted, the Whitney then showed the private collection of art book publisher Harry N. Abrams, whose affinity for Pop was well publicized. This exhibition was the first of its kind in that it featured a private collection which primarily included contemporary works of art.

Most routinely responsive to the vanguard movement was the Jewish Museum. Previously devoted to ethnic and Judaic arts, it became for a brief period one of the leading forces in the contemporary art scene, as it was the only New York museum with a flexible exhibition space (unencumbered by permanent holdings). Supported by Albert and Vera List, and under the ambitious direction of Alan Solomon, the museum gave important mid-career retrospectives to Helen Frankenthaler (1960), Robert Rauschenberg (1963), Jasper Johns (1964) and Kenneth Noland (1965). Largely because of the policies active at the Jewish Museum, mid-career retrospectives became the rule for the young generation of painters and sculptors. By contrast, most Abstract Expressionist painters had only garnered such recognition posthumously, or well into their later careers in the sixties. Besides those retrospectives mentioned above, were those given at the end of

the decade to Claes Oldenburg, Frank Stella, Roy Lichtenstein, Jim Dine, and Andy Warhol.[8] In addition to individual artist retrospectives, *Primary Structures*, held at the Jewish Museum and curated by Kynaston McShine, was perhaps the most important and intriguing show of the decade, uniting various contemporary sculptural directions for the first time. The museum's commitment was to "define relevant new tendencies in art as they crystallize and gather momentum, rather than after they are on the downslope of collective impulse, and thus lend themselves to a more historical assessment."[9]

While institutional buying activity was not as feverish or competitive as among the private collectors, a limited number of important works produced during the period did in fact enter the collections of major American museums relatively early. However, European institutions, specifically the Tate Gallery in London, the Stedelijk Museum in Amsterdam and the Moderna Museet in Stockholm, appear to have been even more active in acquiring important works by artists who matured in the sixties, especially those associated with Pop.

The Museum of Modern Art had been the first museum to purchase work by Jackson Pollock in 1940 and through the forties and fifties collected other works by the Abstract Expressionists. Beginning with Alfred Barr's purchase of Jasper Johns' *Target with Four Faces* in 1958, the Modern continued to demonstrate through purchase its support of contemporary movements. In 1959 Barr purchased Frank Stella's *The Marriage of Reason and Squalor* which had been featured in Dorothy Miller's *Sixteen Americans Show* held in the same year. The sixties brought additional funds and gifts to the museum expressly designated for the acquisition of contemporary works of art. Most important were the promised purchase gifts of the architect and former curator of the museum's Architecture and Design collection, Philip Johnson. Among the works given to the museum by Johnson were Andy Warhol's *Gold Marilyn* in 1962 as well as (at a later date) works by Frank Stella, Claes Oldenburg, Dan Flavin, Donald Judd and a large body of work by Robert Morris. In 1963 the museum purchased works by Jules Olitski and Larry Poons which were shown in a Recent Acquisition show in 1964. Other purchases made by the museum in 1964-66 included works by Tom Wesselman, Marisol and Jim Dine. The direct acquisitions of contemporary art seem to have tapered off and were more conservative due to the announcement in 1967 of the gift of the Sidney and Harriet Janis collection. This was the largest single gift of modern and contemporary art (103 works) in the museum's history. The collection consisted of works by the Cubists, Surrealists, Abstract Expressionists and

Oldenburg, Rosenquist, Lichtenstein, Marisol and Segal.

The Whitney Museum's acquisitions made during the period reveal a strong commitment to contemporary work rather than to work of the preceding generations. The Whitney's collection was strengthened by the efforts of Seymour and Jane Lipman who began collecting cooperatively with the museum's curators in 1964. By 1966 they had amassed a collection of some eighty modern and contemporary sculptures most of which were featured in the 1966 Whitney Annual Exhibition of Contemporary American Sculpture. Concurrent with Lipman's activities were those of a large group of donors known as the Friends of the Whitney Museum who were responsible for important acquisitions made in 1965-66 of works by Al Held, Johns, Kelly, Poons and Lichtenstein.

Strongly supplementing the major museum recognition of the new American vanguard was the increased presence of the aggressive commercial gallery, an institution which experienced a tremendous growth in numbers in the early sixties from 123 (1955) to 246 (1965).[10] The postwar New York market had been developed largely by dealers such as Peggy Guggenheim and her Art of the Century Gallery which opened in 1942, Samuel Kootz, Betty Parsons and Charles Egan. Parsons opened her gallery in 1946 and gave Jackson Pollock his first show the following year. She was later to show Mark Rothko and Barnett Newman. Egan represented Willem de Kooning and Franz Kline. In the early 1950's, Sidney Janis took over the representation of these Abstract Expressionists.[11] Significantly, these dealers and others like them represented European modernists as well as the young generation of American abstractionists. Despite the activities of energetic dealers, the late forties and fifties market was in fact sustained by a relatively small group of collectors which included men like Philip Johnson, Ben Heller, Richard Brown Baker, Burton and Emily Tremaine, Joseph Hirshhorn and Seymour Knox.[12]

By 1964 the three most important galleries were those of Leo Castelli, Andre Emmerich and Sidney Janis. Also prominent in the New York art world was Richard Bellamy, director of the Green Gallery which closed in 1965. These galleries were among the first to group artists who appeared to work in similar styles, attempting to establish movements, showing artists not necessarily in their stable but also those they felt related to the artists they represented. The first show in either a museum or gallery to recognize the similarities among the Pop artists was Sidney Janis' New Realists in November 1962 which featured twelve American artists working in this tendency, including Jim Dine, James Rosen-

quist and Claes Oldenburg. This was followed by Four Environments by Four New Realists in January 1964 (Dine, Oldenburg, Rauschenberg and Rosenquist). Unlike Janis, Leo Castelli preferred to show his artists in groups without themes. Castelli held two to three group shows a year in the mid-sixties leaving the remaining eight months for one-man shows. Predominant in both group and one-man shows from 1964-66, in addition to Johns and Rauschenberg, were Lichtenstein, Stella, Judd and Warhol.

Another forum for contemporary art was the Venice Biennale, an international exhibition of contemporary art. The two Biennales which enclose the period under discussion here are of particular importance. In 1964 Alan Solomon was chosen to be the American commissioner. His selection, Four Germinal Painters — Four Younger Artists brought the Color-Field works of Morris Louis and Kenneth Noland together with the paintings and assemblages of Jasper Johns and Robert Rauschenberg. They were joined by younger, less-established artists, John Chamberlain, Jim Dine, Frank Stella and Claes Oldenburg. Robert Rauschenberg won the International Painting Prize, the first American to ever receive that honor, confirming the perceived importance in Europe of recent American vanguard art. In the 1966 Biennale, Henry Geldzahler served as the commissioner selecting Helen Frankenthaler, Roy Lichtenstein, Jules Olitski and Ellsworth Kelly to represent the current American aesthetic direction. Despite the positive reception of the American artists, in particular, Roy Lichtenstein, none of the entries received awards.

The groundwork for the positive commercial reception of contemporary art was laid by the prior achievements of the American avant-garde: Abstract Expressionism. Historically the market for contemporary American art emerged at the end of World War II when New York was increasingly seen as eclipsing Paris as the international art capital. Critical recognition abroad and at home coincided with a general increase in aesthetic sophistication among wealthy and well educated Americans, especially those in the growing upper middle class who were interested in and able to buy art. Evidence of a growing (even necessary) acceptance of American vanguard art on the part of a new art public stands in a 1955 report from Fortune magazine which predicted that the expanding market would turn toward modern, contemporary art. "Against the rising demand for art, the available floating supply of Great Art is an ever shrinking quantity."[13] Listed as "blue-chip" painters are de Kooning, Pollock, Baziotes, Motherwell and Kline.

Jackson Pollock's sudden death in 1956 precipitated the

delayed, if inevitable, financial success of the Abstract Expressionists. The Metropolitan Museum's purchase of *Autumn Rhythm* in 1957 for $30,000 dollars secured the financial position of the American vanguard (the museum had proposed this purchase to the Board of Trustees in 1956 but at that time they disapproved the $10,000 dollar price).[14] The upward swing of Pollock's prices in the late fifties assisted those of his contemporaries, namely de Kooning and Rothko, marking the true beginning of a major price explosion in the New York art market. The market undoubtedly gained momentum the following year when Jasper Johns' first one-man show at the Leo Castelli Gallery in January 1958 almost sold out. At this opening Alfred Barr bought *Target with Four Faces* for MOMA. The painting had also been featured on the cover of the January issue of *Art News*, one of the most influential art magazines at the time. While immediate financial and critical recognition came easier to Johns and the generation of the sixties, it was an evident offshoot of the belated market explosion in first generation prices. For both younger and older artists financial momentum developed at roughly the same time in the late fifties and early sixties. Reciprocally in the mid-sixties the booming market for Pop artists lent further support to price increases for the Abstract Expressionists. However it is obvious that the prices secured by the first generation led by Pollock, which give evidence of a growing audience for American vanguard art, succeeded in establishing a high starting plateau for the market entered by the second generation of postwar American artists.

Concurrent with the emergence of a thriving market for vanguard art was (as already indicated) the progressive exhaustion of the supply of "blue-chip" Old Master paintings. Prices for historically established works rose to astronomical heights. The "investment" solidity of Old Master and Impressionist markets was well publicized with the 1961 sale of Rembrandt's *Aristotle Contemplating the Bust of Homer* sold to the Metropolitan Museum for a record 2.3 million dollars. By 1965 an Impressionist work broke the million dollar mark when Cézanne's unfinished *Les Baigneuses* was sold to the National Gallery in London for 1.4 million dollars. At this point Impressionist works effectively became Old Masters in terms of value. However, unlike the relatively few works by verifiable Old Masters still available, there were large numbers of Impressionist works in the possession of private collectors. The commerce in both areas maintained the high financial temperature of the art market throughout the decade. At virtually any price contemporary work seemed by comparison a good investment.

There was particular interest in Pop among the young collectors, and the popular press. Andy Warhol's silkscreened canvases of Marilyn Monroe and Elizabeth Taylor became contemporary icons for a new consumer society that was suddenly confronted by vernacular imagery in the form of high art. Pop painting and sculpture addressed this new society in the form of Wesselman's bathroom still lifes, Warhol's *Campbell's Soup Cans*, and Lichtenstein's cartoon images. While the public reaction was hysterically positive, art critics were vehemently opposed, calling such patrons of this movement "the new vulgarians."[15] For most, Pop failed to demonstrate the contemplative, intellectual qualities that Abstract Expressionism and later Color-Field painting championed. Pop's innate association with the commercial aspect of art production, of the mass media, dampened any hope of enthusiasm or acceptance from the critics who asserted that these artists painted for the public.

During the mid-sixties it became quite clear that the art world had become a subject of great interest in the popular press. Pop created a media explosion probably attributable to the correspondence between the imagery used by the artists and its affinity with commercial imagery. American audiences were drawn to the recognizable images which had been transformed into two- or three-dimensional objects of art. As the audience for art grew so did the mass media coverage of the art world. The media impact was widespread. As Thomas Hess expressed it later: "I really don't know why art suddenly became a possible thing for an upper middle class man or woman to buy. I think that it has something to do with media: newspapers, magazines and television.... I think it went from the studios into the media and then bounced to the collectors."[16]

The first mass audience attention given to the New York art scene was in 1949 when Jackson Pollock was featured on the cover of *Time* magazine under the caption "Jack the Dripper." This was the only instance of recognition among the Abstract Expressionists in the popular press at the height of their activity — clearly the time was not right.

It was not until the early sixties and the arrival of Pop that the press took substantial interest in the art scene once again. Articles on the various collectors of Pop art appeared in fashion magazines such as *Vogue* and *Ladies' Home Journal*. Financial journals made recommendations on the various artists' and movements' investment potential, and newspapers covered gallery and exhibition openings in their social columns. In 1965 when *Newsweek* published its article on the art scene, "Vanity Fair: The New York Art Scene," it illustrated how the art world itself had become the center of

attention and the artist and his work mere commodities suppliers in an exchange of fashionable goods. Several years prior *Life* magazine ran a feature entitled "Sold Out Art" which stated flatly that buyers had lost interest in the Abstract Expressionists and preferred the works of artists who paint recognizable objects. Along with the article were reproductions of work by artists such as Lee Bontecou, Lichtenstein, Rosenquist and Rauschenberg accompanied by a price range for each artist.[17] The most popular type of article appears to have been that featuring the collectors, complete with extensive color spreads of young couples posed in front of their Wesselman or Warhol. One of the most barometric images (one that appeared in both *Life* and *Ladies' Home Journal*) was that of Ethel Scull in front of Andy Warhol's portrait *Ethel Scull Thirty-Six Times* of 1963 (private collection). This same 1965 issue of *Life* featured the collections of publisher Harry Abrams and a relatively unknown insurance man, Leon Kraushar who amassed one of the largest collections of Pop art during the period. Beneath a photograph of Mr. Kraushar in his living room overflowing with works by George Segal, Tom Wesselman, Rosenquist and Warhol was the caption in heavy italics, "These pictures are like IBM stock, don't forget that, and this is the time to buy."[18] The commercial impact of the popular media was more massively influential. Almost immediately media coverage proceeded to create market differentials between the various movements of the period. Pop triumphed in the marketplace while other movements softened financially by comparison. Scrutiny of the collections amassed during the sixties indicates an increasingly pronounced emphasis on Pop. The "Pop" collectors, for the most part neophytes in the art market, moving outside the established collecting and connoisseurship patterns, were for obvious reasons more attractive to the popular press than to the serious art periodicals.

The most visible large-scale collectors of the decade were Robert and Ethel Scull, owners of a fleet of New York taxicabs, "Scull's Angels." Throughout the sixties their family name was synonymous with Pop art. Theirs was a collection that generated a documentary film, an essay by Tom Wolfe and numerous magazine spreads.[19] Robert Scull bought quickly and competitively to assemble a large collection at a rather modest cost. In retrospect it was one of the largest and most rapidly acquired collections ever to be so quickly and profitably dismantled, selling at high auction prices in 1973, presumably revealing the shrewd business acumen Scull had shown based on his "good eye." A relatively small percentage of the collection (roughly thirty of the two hundred items) was Pop work. The largest proportion consisted of Abstract Expressionist painting, but this was often overlooked by collectors and the press who were most impressed by Pop holdings. Moreover, approximately fifteen works had been commissioned by the Sculls, including portraits by artists such as George Segal and Andy Warhol.

The Sculls began collecting art in the late fifties, with works by Mark Rothko, Franz Kline and other members of the Abstract Expressionist group. But in 1958 they became especially interested in Jasper Johns and Robert Rauschenberg. The Sculls' interest in these two artists led them to the dealer Leo Castelli, with whom they would continue to do business through the decade. In 1960, at the height of their involvement with the New York Art scene, Scull began to finance the Green Gallery, directed by Richard Bellamy, an interesting story in itself.[20] This was an extremely shrewd move for Scull as it allowed him to scrutinize new and unpublicized talent with the option of being the first to purchase at prices he probably controlled.

The innovative Green Gallery opened in 1960, and began immediately to show works by a variety of young artists. The gallery was the first to give one-man, uptown shows to James Rosenquist, Claes Oldenburg, Robert Morris, Larry Poons and Donald Judd. Prices were kept low to emphasize the neophyte character of the artists shown (Rosenquist's first show in February 1962 sold out with prices below $1000 dollars; two years later when he began to exhibit at the Leo Castelli Gallery, the prices for his work began at $6000 dollars). In many cases, artists such as Donald Judd, chose the Green Gallery for its flexibility and experimental image. Despite the recognition received by the artists shown there, and the strength of the overall market, the gallery closed in 1965 for financial reasons, attributed in retrospect to various forms of mismanagement.

In the same year the Sculls made more headlines when they purchased Rosenquist's *F-111*. It was heralded by the *New York Times* as "Pop's biggest picture bought by Pop's biggest collector."[21] Five months later, Scull made the news again as he put thirteen paintings by Abstract Expressionists and Second Generation artists on the auction block. This auction of contemporary art was the first of its kind and gave an impressive demonstration of the health of the contemporary art market when relatively recent works such as Rauschenberg's *Express* (1963) sold for a sum comparable to those achieved by de Kooning and Kline.[22] The intense activity between Scull and the art marketing community at large encouraged a steady rise in the value of contemporary painting and sculpture. But the true impact of Scull's participation in the art market was not fully realized until the landmark auc-

tion in 1973 at Sotheby Parke-Bernet in which fifty (primarily Pop) selections were sold.[23]

In addition to the Sculls, there were other collectors who played important roles in the sixties art market, but who did not maintain such a high profile in the popular press. Among these collectors were Richard Brown Baker, Philip Johnson, the Albert Lists and Burton Tremaine. Most of these collectors had supported many first generation artists, but assembled the bulk of their collections during the sixties. Richard Brown Baker was particularly interested in Pop artists such as Lichtenstein and Rosenquist but included in his collection works by Color-Field painters Morris Louis, Kenneth Noland and Jules Olitski. Baker has preferred to remain outside the resale market, giving a portion of his collection to the Yale University Art Gallery and to the Museum of Art, Rhode Island School of Design. Philip Johnson had an integral role in shaping the collection of American art at the Museum of Modern Art, operating during the sixties as perhaps the most influential trustee and "captive collector." Most of his acquisitions were made specifically for the museum. The Lists, in addition to their involvement with the Jewish Museum, have been continuously active donors and supporters of many museums and university galleries and have made extensive gifts to a multitude of institutions. Vera List prefers not to be called a collector, as she insists she bought the works because she liked them and not for any other reason.[24] Burton and Emily Tremaine were especially active purchasers from the Castelli circle of artists with Johns, Rauschenberg, Lichtenstein, Stella and Warhol dominant in their acquisitions of sixties work.

Perhaps the most surprising and the most prodigious collection of the period was amassed by the Italian industrialist, Count Giuseppe Panza di Biumo. His fervent buying activity, like Scull's, had an enormous impact on the mid-sixties market as he made his purchases "en masse." Panza preferred to collect a body of work representative of a particular phase in an artist's career as opposed to a single work of art. He started collecting the work of nine artists including Rothko, Kline, Rauschenberg, Oldenburg, Rosenquist and Lichtenstein in depth, buying as many as twelve canvases at a time. As he moved into the sixties he began to encounter some difficulty in obtaining works due to his distance from New York and competition from other collectors, namely the Tremaines and Sculls. Panza attributes the absence of Jasper Johns from his collection to this problem, since Scull and Tremaine were able to see the work upon completion and make an immediate purchase. At first Panza purchased many works through the mail after Leo Castelli had sent photographs to him for his approval. In 1962 alone he purchased

eight Rosenquists, ten Oldenburgs, and four Lichtensteins. Always on the cutting edge of new movements, Panza was one of the first to collect work by the Minimalist sculptors, beginning with Robert Morris in 1964 and later Donald Judd and Dan Flavin. Panza bought dozens of Minimalist works and when the scale was too large, he purchased the plans. One cannot help remain slightly puzzled by the motives of a collector who built a collection so quickly and seemingly so impersonally. The idea that his purchases were mandatorily made in quantities raises questions concerning the aesthetic nature of the transaction. Questions aside, Panza's collecting pattern was continued in the late sixties and seventies by Dr. Peter Ludwig of Cologne who also made massive purchases through the Leo Castelli Gallery, not only supporting the artists and gallery but effectively continuing upward pressure on the prices of certain artists such as Johns, Rauschenberg and Rosenquist.[25]

Yet, even granting the importance of major collectors the crucial strategist in the sixties art market ultimately proved to be the dealer, the requisite intermediary between artist and collector or museum. The most important dealers during the period, in terms of artists they represented, were Leo Castelli and Andre Emmerich. Other galleries which represented artists included in this exhibition and which were integral members of the art scene include the Pace, Poindexter and Tibor de Nagy galleries. Sidney Janis who represented Jim Dine, Claes Oldenburg and Tom Wesselman, was also an important guiding force, especially during the formative years of the Pop movement although his reputation had previously been established by the Abstract Expressionists he represented.

The most visible dealer in the sixties was Leo Castelli, who represented Lichtenstein, Chamberlain, Stella, Warhol, Rosenquist, Judd, Morris and Bontecou, in addition to Johns and Rauschenberg. Oldenburg and Flavin joined the gallery in the early seventies. Castelli opened his gallery in 1957. He was the first to show Johns and Rauschenberg. His success with them undoubtedly supported the sales of the next generation of artists he represented. By 1965 the "star status" achieved by Johns and Rauschenberg was already shared with Lichtenstein and Warhol. Stella, who had already been featured in important museum exhibitions among them MOMA's *Sixteen Americans* in 1963, *Three American Painters* and *Post-Painterly Abstraction* in 1964, did not have the same financial success as did certain Pop artists despite his critical acclaim. Castelli attributes this to his joint representation of Stella with Lawrence Rubin who preferred to keep Stella priced conservatively instead of capitalizing on the

growing market for contemporary art.[26] Rubin however, does not have the same view and feels he set the prices according to the artist's wishes.[27]

Castelli had a virtually unique ability to produce star status for his stable. All gallery events were well attended, and moreover, well publicized in advance. Key factors in Castelli's marketing strategy were his satellite galleries, which he set up through other established dealerships outside New York as a way of promoting his stable on the West Coast and abroad. These satellites enabled Castelli to serve collectors outside New York, with the freshest New York products. The result was an incredible and geographically diversified growth of the market for the contemporary art he represented. Through these galleries, Castelli did a great deal to decentralize the market for contemporary art which in turn expanded that same market. In California he showed work at the Virginia Dwan Gallery as well as at Irving Blum's Ferus Gallery. The first of these collaborative relationships abroad was established in 1962 with the Galerie Ileana Sonnabend in Paris. After her divorce from Leo Castelli in 1959 and her marriage to Michael Sonnabend in 1960, Ileana Sonnabend opened her gallery, committed to showing work of American artists such as Rauschenberg, Johns, Rosenquist, Dine, Lichtenstein, Wesselman, Oldenburg, Warhol and Segal as that work was being produced.[28] The gallery provided the first opportunity for Europeans to view samples of current American art. Little prior effort had been made to establish such galleries in the forties or fifties for the Abstract Expressionists. Many curators and collectors, among them, Edi de Wilde, director of the Stedelijk Museum in Amsterdam, Pontus Hulten, director of the Moderna Museet in Stockholm and collectors Panza and Ludwig came to view the shows of American artists at the Sonnabend Gallery on a regular basis.[29] Additional exposure for Castelli's artists was provided when the Pop artists were featured in the *American Pop Art* exhibition which traveled to the Hague, Amsterdam, Stockholm, Berlin and Brussels from 1964-65. The majority of works shown came from the Sonnabend Gallery. This European exposure rapidly established international reputations for all of Castelli's artists, something which set them apart from the earlier generation of American artists as well as from many artists of their own generation.[30] This early exposure abroad undoubtedly played an important role in Rauschenberg's success at the 1964 Venice Biennale, as Europeans had been able to familiarize themselves with the current American vanguard without traveling to New York. Furthermore, this European reception once established reconfirmed the position of the American vanguard, thus increasing the value of their work at home.

Another unique aspect of Castelli's gallery was the loyal patronage of a small group of partisan collectors. In an interview, Castelli stated, "There were two camps: mine and Greenberg's."[31] This statement intimates the existence of a dichotomy in the art market among collectors. According to Castelli the lines were quite clearly drawn between the group of artists he represented and those at Emmerich or Knoedlers, though Castelli contends that some of the important collectors affiliated with his gallery now collect work by Color-Field painters, Morris Louis and Helen Frankenthaler.[32] Andre Emmerich disagrees with Castelli's notion that this partisan pattern of patronage was unique to the sixties. Instead he believes that collectors limited their purchases to one particular movement.[33] Castelli's gallery and loyal group of collectors clearly established the market for the Pop artists and later a smaller market for the Minimalists. Greenberg and later Fried,[34] were as dedicated to the Color-Field painters as Castelli was to the Pop artists. Represented by Andre Emmerich and later also by Lawrence Rubin these artists did not have nearly the amount of commercial exposure, nor did they attract such high profile collectors as the Sculls or Tremaines. However, they commanded the attention of the critical audience and were the primary subject of the scholarly exhibitions and writings of the period. In addition to their critical essays both Fried and Greenberg featured the Color-Field painters in exhibitions they organized, such as *Three American Painters* and *Post-Painterly Abstraction* in 1963 and 1964. Those collecting works by Color-Field artists were likely to have had an association with a critic rather than with a particular dealer. Castelli's most important clients during the sixties, the Sculls, Tremaines and Panzas bought almost exclusively from Castelli; Emmerich's from Emmerich.[35] Often the artists themselves bought or traded their own work for that of their contemporaries, oftentimes represented by the same gallery.

By 1966 the art market had boomed, fueled consistently by the "mania" for contemporary collecting. Concurrent with this development was the arrival of two foreign collectors, new to the New York art scene yet so confident in the future and value of these artists that they took immediate market action. The massive purchases made by Drs. Peter and Irene Ludwig in the late sixties, after Panza had turned his efforts toward more conceptual projects, made an astounding impact on the market. By the mid-seventies, the Ludwigs were succeeded by Charles and Doris Saatchi of London, who were even more influential in the art market. Their purchases of works, again primarily those of the Pop artists, were on an

enormous and systematic scale, as all three preferred to assemble a large body of work representative of a specific period in each artist's career.

In an important auction of contemporary art featuring six works from the Scull collection held in late 1970 the large majority of works were sold to foreign buyers including Lichtenstein's *Big Painting #6* and Oldenburg's *The Stove* which both went to a German dealer from Cologne, Rudolf Zwirner.[36] Although this was not the first time important contemporary works had been purchased by German collectors or dealers, the existence of a major demand for contemporary American art abroad was becoming increasingly apparent.[37] This overwhelming European response to contemporary American art is a unique achievement of the sixties. The dominance of an aggressive collecting force in America appears almost naturally to have given way to an even hungrier European contingency by the late sixties and early seventies. The fact that the majority of contemporary works sold at auction and in the galleries were purchased by foreign collectors documents this change in the pattern of sales very clearly. Certainly the rapid escalation of prices coincided with an economic recession in America, and this prevented many young collectors from purchasing the work of artists they had supported several years earlier. However, other collectors appear simply to have been sated with certain works, in particular Pop, and sold them through auctions or to museums here and abroad, and appear to have abandoned the market thereafter. Again the prime market example of the "end of it all" is the Scull sale of 1973. In the wave of publicity following this sale, the fact that the majority of works sold went abroad further decreasing the body of sixties work in this country, generally failed to be mentioned. What the event makes clearest, however, is that the supply of work by these artists had exceeded the local demand and that the work no longer commanded the investment or aesthetic attention of the collectors responsible in many cases for establishing and supporting the reputations in the first place.

The original phenomenon of a self-generating market established within the New York art scene which had initially exposed the world to this young generation of artists had in fact disappeared by the end of the decade. The initial expansion had sparked the enthusiasm of a new, younger collecting force which embraced the new art and established an American market for this work, but as this group dissolved, it was replaced by the presence of European collectors. The market continued to grow but the scene had changed radically.

1. Alan Solomon, *New York: The New Art Scene* (New York: Holt, Rinehart and Winston, 1967), 64.

2. For the term "vanguard audience" see Thomas B. Hess, "A Tale of Two Cities," *The New Art*, ed. Gregory Battcock (New York: Bantam Books, 1966), 161-78. In his rather pessimistic view Hess states, "Society as a whole assigns to the vanguard audience the duty of containing, and where possible emasculating modern art."

3. Harold Rosenberg, "Adding Up: The Reign of the Art Market," *Art on the Edge* (Chicago: Chicago University Press, 1975), 276.

4. In an auction held at Sotheby Parke-Bernet Gallery on November 18, 1970, *Big Painting No. 6* (1965) by Pop artist Roy Lichtenstein sold for $75,000 dollars, a record price for a living artist. The painting was originally commissioned by Robert Scull who paid $6000 dollars in 1965.

5. Barbara Haskell, *Blam! The Explosion of Pop, Minimalism and Performance* (New York: W.W. Norton for the Whitney Museum of American Art, 1984).

6. This remark can be found in each *Recent Acquisitions* pamphlet between 1964-66 published by The Museum of Modern Art.

7. Barbara Rose, "The New Whitney: The Show, "Is the Museum Today a Church or a Discotheque?", *Artforum* 5, no. 3 (November 1966): 54.

8. Claes Oldenburg and Frank Stella were shown at the Museum of Modern Art in 1969 and 1970, Roy Lichtenstein at the Guggenheim in 1969 and both Jim Dine and Andy Warhol at the Whitney in 1970.

9. Sam Hunter, "A Statement," *Arts Yearbook* 9 (1967): 6.

10. Steven W. Naifeh, *Culture Making: Money, Success, and the New York Art World* (Princeton: Princeton Undergraduate Studies in History, 1976), 81.

11. Laura de Coppet and Alan Jones, eds. *The Art Dealers* (New York: Clarkson N. Potter, Inc., 1984), 22.

12. Naifeh, 105.

13. Eric Hodgins and Parker Leslie, "The Great International Art Market," *Fortune* (December 1955): 119.

14. In that same year Ben Heller purchased Pollock's *Blue Poles* for $32,000 dollars which had been sold four years earlier for $6000 dollars. Heller sold the painting to the National Gallery of Australia, Canberra, in 1973 for a record 2 million dollars. For further information on the Pollock market see Israel Shenker, "A Pollock Sold for 2 Million, Record for American Painting," *The New York Times* (September 22, 1973): 1.

15. The term "new vulgarians" was first used by Max Kozloff in his article "Pop Culture, Metaphysical Disgust, and the New Vulgari-

ans," *Art International* (March 1962): 34-36.

16. Thomas B. Hess as quoted in Emile de Antonio and Mitch Tuchman, *Painters Painting* (New York: Abbeville Press, 1984), 106.

17. "Sold Out Art: More Buyers Than Ever Sail in to a Broadening Market." *Life* 55 (September 20, 1963): 125-9.

18. "You Bought It Now You Live With It," *Life* (July 1965): 72. Leon Kraushar died in 1967 and six months later his wife sold the collection of sixty works to Karl Stroher for $600,000 dollars. Pop had apparently become a true, marketable commodity, an investment potential, an alternative to stocks and very appealing to the young, upwardly mobile middle class.

19. The film documents the sale of their works on October 18, 1973; "Bob & Spike" by Tom Wolfe first appeared in the Sunday magazine of the *New York World Journal Tribune* on October 4, 1966 and was later reprinted in Tom Wolfe, *The Pump House Gang* (New York: Bantam Books, 1968). The Scull collection was featured in Emily Genauer, "Can this be Art?", *Ladies' Home Journal* (January 1965): 155, and in "Life with Pop," *Time* (February 1964): 70-72, Allen Talmey, "Art is the Core," *Vogue* (July 1964): 116-124 and "You Bought It Now You Live With It," *Life* (June 1965): 68-74.

20. As Calvin Tomkins points out, Scull agreed to purchase $18,000 dollars worth of works of art a year to provide Bellamy with the necessary finances to run the gallery. For further details see, Calvin Tomkins, *Off the Wall: Robert Rauschenberg and the Art World of Our Time* (New York: Penguin Books, 1980), 179.

21. *F-111* sold for a reputed $60,000 dollars. See the *New York Times* (May 13, 1965): 39.

22. At the October 13, 1965 auction held at Parke-Bernet, *Express* sold for $20,000 dollars, de Kooning's *Police Gazette* for $37,000 dollars and Kline's *Initial* for $18,000 dollars.

23. For further information see Barbara Rose "Profit without Honor" *New York Magazine* (November 5, 1973): 80-81.

24. Interview with Vera List, October 4, 1985.

25. Interview with Leo Castelli, September 25, 1985.

26. Interview with Leo Castelli, September 25, 1985.

27. Lawrence Rubin opened his first gallery, the Galerie Lawrence, in Paris in 1959. In that same year he was introduced to Clement Greenberg by his brother William Rubin, now Director of Painting and Sculpture at The Museum of Modern Art, who also introduced him to the work of Stella, Louis, Noland and Kelly. William Rubin arranged for his brother to be Stella's European dealer shortly after his first exhibition in Dorothy Miller's *Sixteen Americans* (1959) and at roughly the same time Stella joined Leo Castelli's stable. Larry Rubin returned to New York in 1969 and opened the Lawrence Rubin Gallery and continued to handle Stella, dividing works between himself and Castelli. In 1977 Rubin became president of M. Knoedler & Co.

28. For more on Ileana Sonnabend see Sam Hunter, *Selections from the Ileana and Michael Sonnabend Collection* (Princeton: Schneidereith & Sons for the Princeton Art Museum, 1985).

29. Laura de Coppet and Alan Jones, eds., *The Art Dealers* (New York: Clarkson N. Potter, 1984), 114.

30. Lawrence Rubin's Galerie Lawrence, also in Paris, represented Helen Frankenthaler, Morris Louis, Kenneth Noland, as well as Frank Stella, but did not assume as major a role in the European art market.

31. Interview with Leo Castelli September 25, 1985.

32. Interview with Leo Castelli September 25, 1985.

33. Interview with Andre Emmerich October 18, 1985.

34. See Megan Fox's essay on Criticism.

35. A curious exception to this observation is the exclusion of Frank Stella, one of Castelli's "stars" in the Panza collection. In addition, the Sculls were not so receptive to his sixties work. Castelli attributes this to a variety of reasons but also points to the fact that he did not have complete control of Stella's market due to his joint representation with Lawrence Rubin. This situation impeded a more rapid growth for Stella's market as Rubin was holding back on price increases.

36. See note 4 above.

37. In 1967, the collection of Pop art amassed by Leon Kraushar in New York was sold to Karl Stroher of Cologne.

The New Visual Culture

Ima Ebong

In the period after the second World War, debate on the condition of high culture centered around issues of quality, the maintaining of a sense of value and permanence against the relentless rise of mass production with its opposing logic of transience and disposable commodities. All these elements characterized the emerging mass culture. Among the various prescriptions put forward by cultural critics, Clement Greenberg's strategy of containment stands out as the dominant theoretical model penetrating beyond the boundaries of academic discourse into the fabric of modern American art, defining its role and interpretive range within American culture as a whole.

The bases of Greenberg's theories were developed in three key essays, "Avant-Garde and Kitsch," (1939), "The New Laocoon," (1941) and "Modernist Painting" (1950). The earliest of these, "Avant-Garde and Kitsch," was perhaps the most important in articulating an historical tradition of independence for art. The effectiveness of Greenberg's reading of an avant-garde heritage lay in locating its origin. "In seeking to go beyond Alexandrianism, a part of Western bourgeois society has produced something unheard of heretofore: — avant-garde culture. A superior consciousness of history — more precisely, the appearance of a new kind of criticism of society, an historical criticism — made this possible."[1] In effect, the strength of Greenberg's analysis of an avant-garde heritage depended on the aristocratic values of independence, and the conscious disengagement of culture from the historically unstable realm of Western bourgeois society. The benefits of this disengagement were examined by him in detail in "Avant-Garde and Kitsch":

> The nonrepresentational or "abstract," if it is to have aesthetic validity, cannot be arbitrary and accidental, but must stem from obedience to some worthy constraint or original. This constraint, once the world of common, extraverted experience has been renounced, can only be found in the very processes or disciplines by which art and literature have already imitated the former ... Picasso, Braque, Mondrian, Miro, Kandinsky, Brancusi, even Klee, Matisse and Cézanne derive their chief inspiration from the medium they work in. The excitement of their art seems to lie most of all in its pure preoccupation with the invention and arrangement of spaces, surfaces, shapes, colors, etc., to the exclusion of whatever is not necessarily implicated in these factors.[2]

By the sixties it seemed that Greenberg's framework for the operation of avant-garde culture had to be expanded. This was forced in part by the development of Pop art and Minimalism which brought to fruition and contemporaneity the developments of Dada and Surrealism, which were seen by Greenberg as having been historically marginal.[3] In addition the appropriation of imagery and materials from mass culture challenged the notion of cultural specialism.

Combining with these developments, the observations of Marshall McLuhan (writing in the early sixties around the same time as Greenberg anthologized his writings), had an impact on contemporary attitudes particularly through his attempt to define the role of technology on the perceptual patterns of contemporary culture.

In many respects McLuhan had several affinities with Pop artists, most especially the desire to come to terms with the nature of mass media images. McLuhan, however, was less constrained by Greenberg's previous historical definitions of high art and culture. Contradictive of Greenberg's views, his often controversial observations effectively changed the nature of the debate on these issues, subsuming artistic and cultural distinctions under the dominant influences of technology. In this way, he established a thread between art and mass culture seemingly antithetical to Greenberg's program. The role he conferred on the artist implied an ongoing dialogue between technology, the avant-garde and mass culture; these interconnecting forces formed the basis of his observations. His all-inclusive theories coming at a transitional period in societal attitudes made him something of a cult figure in the sixties. "... . Naturally, he offended the more doctrinaire liberals, but he did not offend the liberal faith; naturally he disturbed the scientists, but they were the very priests against whom he was insulating those interested in him. He attracted the avant-garde artists because he preached the leadership of art; the younger teachers because he showed them new ways to teach and made them acceptable."[4] McLuhan's work it would seem stood in absolute opposition to Greenberg's in its wide cultural embrace and populist appeal. Yet like so many cultural commentators of the fifties and sixties both men were moved to react (although in antithetical ways) to the threat of a wildly enthusiastic consumer culture.

In the *Gutenberg Galaxy* published in the fifties McLuhan's

belief in historical change perpetuated through technological devices influenced his view of culture. In this work he set out to examine comprehensively the impact of print technology on Western mankind. Underlying his investigation was a hierarchical, but nonetheless conveniently fluid notion of the nature of influence. Moving from the particular to the general, technology affected conceptual and intellectual patterns which in turn determined social and cultural norms.

In his third and most controversial book *Understanding Media*, once again, technological processes altered perceptual patterns, leading to larger societal changes. What distinguished twentieth-century man from his "Gutenberg" counterpart was the development of electronic technology seen as an extension of the human nervous system. Like the nervous system, electronic information was communicated in spontaneous and rapid fragments forcing instant human response from man. This "speeding up" of communication caused changes in man's mode of relating to his surroundings, most especially in aural and visual patterns of perception. Thus, McLuhan opens the book with the following assertion unequivocally stated:

> After three thousand years of explosion, by means of fragmentary and mechanical technologies, the Western world is imploding. During the mechanical ages we extended our bodies in space. Today, after more than a century of electric technology, we have extended our central nervous system itself in a global embrace, abolishing both space and time as far as our planet is concerned.[5]

The tendentious prose of McLuhan was viewed by several critics as overly dramatic and irresponsibly unorthodox in its approach. Consequently what McLuhan had to say was examined with scepticism, despite his often insightful opinions on technology and society. Behind the exuberant tone of writing lay a didactic strain; *Understanding Media* read like a carefully orchestrated script in which the reader was made an active participant. The deliberate puns and aphorisms ("The medium is the message")[6] were designed to provoke laughter, or puzzlement, seemingly a willful attempt to engage the reader. In this vein a major part of *Understanding Media* was devoted to developing an epistemological base well suited to its iconoclastic task. To devise such a system McLuhan drew on many sources in literature, anthropology, psychology, linguistics and most importantly aesthetics. The work of modernists such as Pound, Yeats, Joyce, Wyndam Lewis, Wölfflin and Marcel Duchamp were ultimately synthesized to form a mosaic-like structure capable of decoding the multiple permutations of the rapid pace and sensory audio-visual patterns of the new, totally man-made environment.

Differences between McLuhan and Greenberg are evident in their respective understandings of modernism. Greenberg who also frequently cited random modernist sources such as Yeats, Eliot, Picasso, and Klee, saw the work of these figures as an effective example of the complete level of self-sufficiency attainable within the arts. ". . . . The excitement of their art seems to lie most of all in its preoccupation with the invention and arrangement of spaces, surfaces, shapes, colors, etc., to the exclusion of whatever is not necessarily implicated in these factors."[7] McLuhan's reading and use of modernist sources is clearly different. His Yeats has little in common with the sublime introspection that one finds in Greenberg's citation of the poet:

> Nor is there singing school but studying
> Monuments of its own magnificence.[8]

McLuhan, seeing beyond the intrinsic merit of the object, recognized in Yeats the inescapable consequences of man's creation of extensions of himself through technology. The death of the garden marks the end of the pastoral age and the birth of the mechanical through technology born from man. McLuhan succinctly uses the Yeats epigram:

> Locke sank into a swoon;
> The Garden died;
> God took the spinning jenny
> Out of his side.[9]

So dynamic and mercurical was the period that the same poet could serve two divergent schools of thought.

Greenberg's ideas regarding the self-generating capacity of avant-garde art was for the most part consistent and clear in its position. The same may not be said for McLuhan, who had confusingly complex opinions regarding the role of art within modern society. Many of McLuhan's observations reflect a theatrical moment of reflection on the notion that, in essence, art and technology are very similar, affecting together perceptual patterns within society, although with different roles to play. Technologies or media, as extensions of man, function for utilitarian ends as information systems. The process of "uncovering" and articulating the moment of realization of more profound effects is the function of art which presumably strives to make conscious or objective the nature of change in society. In a perpetual dialogue technology effects change, art reveals it. McLuhan therefore arrives at the conclusion that both art and technology have essentially formal systems and elements in common:

> Cubism, by giving the inside and the outside the top, bottom, back, and front and the rest, in two dimensions,

drops the illusion of perspective in favor of instant sensory awareness of the whole. Cubism, by seizing on instant total awareness, suddenly announced that *the medium is the message*. Is it not evident that the moment that sequence yields to the simultaneous, one is in the world of the structure and configuration? Is that not what has happened in physics as in painting, poetry, and in communication? Specialized segments of attention have shifted to total field, and we can now say, "The medium is the message" quite naturally. Before the electric speed and total field, it was not obvious that the medium is the message. The message, it seemed, was the "content," as people used to ask what a painting was *about*. Yet they never thought to ask what a melody was about, nor what a house or a dress was about. In such matters, people retained some sense of the whole pattern, of form and function as unity.[10]

For Greenberg and McLuhan it was important to develop a concrete understanding of the formal elements of their subject matter. But in the end Greenberg's work remains exclusive to its class, a hermetic model. McLuhan's ideas by contrast incorporate a wide range of sources. His "collage" of prose was meant to provide a more elastic paradigm that could support the heterogeneous mould of cultural experience in the sixties. Paradoxically though, McLuhan adopts a formalist methodology in order to define the structural and textual characteristics of the visual media and technology in general. His quest for definitions becomes an aesthetic process similar to determining the different qualities of paint on a modernist canvas.

Harold Rosenberg's appraisal of *Understanding Media* was one of the most perceptive critiques of McLuhan made at the time (1965). Indeed, Rosenberg viewed McLuhan's work as an artistic enterprise. While this minimized the importance of McLuhan's cultural impact, Rosenberg correctly assessed the importance of artistic theory in formulating McLuhan's study of the impact of technology:

> A remarkable wealth of observation issues from the play of McLuhan's sensibility upon each of today's vehicles of human intercourse, from roads and money to games and the computer. After "Understanding Media," it should no longer be acceptable to speak of "mass culture" as a single lump. Each Pop form, this work demonstrates, has its peculiar aesthetic features: the comics, a crude woodcut style; TV, a blurred "iconic" image shaped by the viewer out of millions of dots (in contrast to the shiny complemented image of movie film) . . . In sum, McLuhan has built a philosophy of history on art criticism, which he has directed not at styles of literature and painting, or architecture but at the lowly stuff of everyday life . . . Other observers have been content to repeat criticisms of industrial society that

were formulated a century ago, as if civilization had been steadily emptied out since the advent of the loom. As against the image of our time as a faded photograph of a richly pigmented past, McLuhan, for all his abstractness, has found positive, humanistic meaning and the color of life in supermarkets, stratospheric flight, the lights blinking on broadcasting towers . . . *Understanding Media* is a concrete testimonial (illuminating as modern art illuminates, through dissociation and regrouping) to the belief that man is certain to find his footing in the new world he is in the process of creating.[11]

In concluding, Rosenberg pinpointed the importance McLuhan's work had in offering an alternative critique to contemporary society. This was accomplished by opening up and defining the world as a collection of arbitrary yet interconnecting formal systems. McLuhanesque formalism ultimately licensed Pop artists' taking of images of contemporary culture and transferring them into the realm of high art.

My aim in this essay has been to examine the highly influential writing of McLuhan for what it reveals about the links forged between traditional aesthetics, and an analysis of visual culture in the sixties. McLuhan's ideas signal important attitudinal changes in the sixties, not entirely technologically motivated as McLuhan observed, but in part due to important economic and social changes. Generally, the progressively altering demographic character of the United States produced an ever larger population that was fairly affluent and consumption conscious. Full consideration of these factors is not within the scope of this essay but rather the examination of more specific concerns of collective visual perception.

I shall in the following pages explore briefly the formal affinities between art and the visual media, which through widespread use of television, magazines and newspapers formed the core of visual culture in the sixties. By drawing on examples from the mass media and Pop art I hope to highlight perceptual aspects to test the character of the relationship of "high art" against the most prominent developments in the visual culture of the period.

During the sixties the growth of technical changes within the television industry had an increasingly impressive impact on the visual dynamics of the medium. The invention of the portable television camera and video recorder enabled production crews to have an unlimited amount of freedom in their movements. This development with its malleable potential changed the style in which events were reported. Instant images of events occurring within an hour or less were routinely available to the viewer and live reporting became the norm, enhancing the role of the roving television reporter

and journalist. Something of a voyeuristic and competitive tendency developed, inherently dramatic scenes rather than simply informative ones were much sought after and the visually "newsworthy" image became fundamental to program development.

The new potential for quickness and immediacy evolved rapidly to news programs which soon consisted of neatly edited segments packaged not unlike commercials, to give fast, visually pre-sorted and tailored information of the day's events.[12] Electronic editing created an almost seamless join between images and programs. Such quick and schematic information delivery created a paralogical structure of its own; the most tragic news item would very often be abruptly interrupted for a commercial message of several seconds duration. The resulting fragmentation of meaning became the visual norm in viewing television.

A "news event" such as the assassination of President Kennedy in 1963 gave full expression to the inherent capabilities of the electronic video editing process. The fragmented blurred images of Kennedy's assassination were recomposed several times, each version providing its own "presence" as a version of events through changeable juxtapositions of past and present action, compressed into a few minutes. Eric Barnow's account of the coverage of November 22, 1963 indicates the fictional inferences possible through technology when he commented on its visual effects:

> A fantastic kaleidoscope began to reach television screens; interviews that networks were gathering with their remote units on Capitol Hill and elsewhere; a shot of Jacqueline Kennedy accompanying the dead president's body from Parkland Hospital, leaving for Love Field; ... Amid all this, video tapes of events before the shooting ... Kennedy's visit to Texas had been covered by local stations not by networks; now these videotaped events, juxtaposed with new developments, had an almost unbearable impact. Suddenly John Kennedy and a radiant Jacqueline Kennedy were on the screen, waving to the crowds from their limousine. Then — more grisly — a chamber of commerce breakfast in Fort Worth that morning.[13]

Warhol's paintings often reflect with great facility the formal characteristics of the television medium as already described. His *Jackie* series of 1964-65 suggests a sensibility clearly attuned to tele-visual qualities. In the flat screen-like arrangement, one sees the disjuncture of sequence from event, as we scan row after row containing conflicting images, first pleasant and then unhappy (see Warhol's *Sixteen Jackies* Plate 15). The blurred indistinct outline so typical of the texture of television imagery is also faithfully captured.

Close-up shots, so frequently a method of scrutiny in television reporting, are reflected in the images scrutinized with microscopic intensity. The reticent and impenetrable silkscreen surface onto which Warhol prints his images parallels the seamless glass tube of the television screen. He seems innately aware of television's gestural nuances, the slow motion and the posturing of images of authority as a canonical form of the historical present. Television's photographic qualities absolutely haunt his *Jackie* series of 1964.

The large-scale production of color television units, coupled with full color programming by local and national networks, constitutes yet another series of developments linked to technological innovation designed and promoted with the mass market consumer in mind. Archival material on the promotion and marketing of color viewing forms, provides an interesting index to the cultural conditioning of visual experiences through the sixties. Color television "hunger" was not induced suddenly, but rather in a somewhat calculated fashion color viewing became a necessary part of the visual diet for the majority of the population. In a 1968 publication on color television the following remarks were made in an article on "Selling Color Television":

> Large amounts of money have been spent on, and a great amount of creative effort devoted to, the promotion of color programming — both in other media and through our own. From double-truck, full-color ads showing that peacock in all his finery, to tint-dipped poodles and three-color sky-writing and all of the countless promotional stunts in our facile industry's bag of tricks, pioneering color TV purveyors have thumped the drums in every conceivable way to call attention to video's new miracle.[14]

The television medium's processing of color imagery in the late fifties and early to mid-sixties paradoxically produced images that were far from identical to visual experiences derived from natural colors. Control panels were often designed to compensate insofar as possible for the normal expectations of hue on what in effect could be described as an electronic canvas offering only a limited range of color corrective possibilities. However, in spite of these devices, there were often problems beyond production or viewer control that were part of the visual experiences of watching color television in its early period. Some of these characteristics were pointed out by the color engineer Howard Ketcham in an article on color television published in 1968:

> The electronic processes peculiar to color TV do some highly irregular things to color. Although great improvements have been made during recent years, there are still danger areas that require consideration. For example: red

bleeds into other colors, especially lighter, neutral areas. White often looks bluish or yellowish. A bluish white is sometimes an asset when the cleanliness of white is to be emphasized, but it can be a drawback at times. Pale pastels have a tendency to fade and appear colorless, but bright, medium value pastels appear intensified. Deep reds sometimes lose character and appear brownish . . . There is also a marked difference in color reception on different makes of TV sets. Some emphasize the warmer colors, others the cool hues. Thus the same red or pink may appear almost orange on one set and rose or magenta on another. This distortion must be compensated for.[15]

This "television" color, with distinctive ranges of pinks, reds, yellows, had certain parallels with acrylic-based color saturated images that were popular among artists generally in the sixties. Warhol's images once again come closest to characterizing television's chromatic peculiarities. In *Liz* (1965) the florid hues that saturate the face suggest the bleary outlines and exaggerated natural tones of an electronically processed color television image of the period.

Affinities with yet other forms of commercial color may be detected for instance in the semi-fluorescent character of Day-Glo pigments, a product much lauded by its manufacturers for its wide spectral range (66 different colors were available). Day-Glo pigment was highly versatile. It could be applied to many surfaces that were traditionally difficult to "color." It was used on plastics, vinyl-coated fabrics, kitchen ware and advertising billboards. In the art of the sixties the inclination, almost the mania, to use these brilliant new colors can be demonstrated in Rosenquist's *Car Touch* of 1966 (Cat. 33) and in Warhol's *Flower* series from the same date. Both works have in common a familiarity with these new commercial pigments, demonstrating a sensitivity to the period artificiality of color found in mass media other than early color television. Yet color television remained the "power" in mass media generally. Its effect is most clearly evident in magazine images of the sixties, where every video-relatable aspect is heightened. Magazines became literally tele-visual as they tried to compete for a declining audience.[16] Layouts were bolder, even garish, with lettering forced to become metaphoric of the complex audio-visual address of color television. Rapid visual messages were induced by juxtaposing often wildly contrasting images, as seen throughout the 1960's issues of *Life* magazine. The peculiar nature of this new tele-visually reprocessed world seems most clearly and consistently reflected in high art in works of Rosenquist and Warhol.

The new color television which dominated media aesthetic had a characteristic texture, comprised of the slightly off-focus image noticeably low in definition. Interestingly, it appears as routinely in the work of Pop artists, as in glossy magazines, newspaper print and television. Amidst the profusion of commercial images characterized by their rapid turn-over, non-Pop painting in the sixties seemed increasingly to offer moments of stasis. In this sense the most important painting was not so much a reflection of contemporary culture but rather a reaction featuring slow-motion or frozen still frames.

The artist in the mid-sixties became more than ever a "high" cultural producer even while moving at certain times and in certain ways within the mass culture ambience of new image types. Unlike the media producer he was not bound by rigid guidelines geared towards the temporal qualities of film and television entertainment. The artist was by and large producing for a context that expected permanence in some form or other. Seeking to demonstrate this, many artists took pains to reveal their labored aesthetic decisions in series of deliberately paced processes in a succession of works. Images in mass culture on the other hand concealed process increasingly in this period as the public thrived on momentary visual "effects" and surprise.

Yet, a by-product of the avant-garde's response (in whatever form) to television, newspaper and magazine imagery was a problematic breakdown of the purity of formal and visual categories of high art. It became in fact possible to experience visual sensations in high art allied in various ways to those gained from watching television, or scanning a magazine. Overall, the contemporary visual environment seemed to encourage a sensibility practiced in its visual dexterity. This included the ability to scan spaces efficiently, a largely unconscious skill actively utilized in urban environments to negotiate complex metropolitan terrain in rapid, schematic fashion. Rosenquist's *Car Touch*, (1966) comprised of two motorized panels depicting images of two cars simulates this restless, momentary quality of sixties vision (Cat. 33). His close-up portraits of vehicles locked in a sequence of spasmodic motion simulates urban traffic and emphasizes the sheer quantity of visual space occupied by a commonplace piece of technology, a feature taken for granted in contemporary experience. The cars moving so close together makes the image more than an urban fact; it becomes an intensified and even original perceptual moment. The art historian and critic Brian O'Doherty attempted to define the unique mechanics of seeing, so much a part of contemporary (sixties) urban culture. In the following quote he strives to evoke in words, the type of moment that Rosenquist tries to catch and suspend between his enframed oscillating cars:

.... The vernacular glance is what carries us through the city every day, a mode of almost unconscious, or at least divided, attention. Since we usually are moving, it tags the unexpected and quickly makes it familiar, filing surplus information into safe categories ... The vernacular glance develops a taste for anything, often notices or creates the momentarily humourous, but doesn't follow it up, nor does it pause to remark on unusual juxtapositions, because the unusual is what it is geared to recognize, without thinking about it. It dispenses with hierarchies of importance, since they are constantly changing according to where you are and what you need. The vernacular glance sees the world as a supermarket. A rather animal faculty, it is pithy, shrewd, and abrupt like slang.[17]

The term "artificial realism"[18] best describes the experience of culture in the sixties. It defines aptly a decade in which the primacy of visual imagery, processed through electronic, audio-visual or photographic means was crystallized, forming the dominant part of both popular and high cultural experience. In many ways the most important "real" events were witnessed through these secondary sources. Even retrospective views of the decade were and are strongly tainted by a "visual" sense of history. With this idea in mind television critic Michael Arlen has observed:

.... Now it is the camera that provides our points of reference, our focus. Indeed, our sense of great events has become so overwhelmingly visual — Mrs. John F. Kennedy reaching out across the back of that car in Dallas — that many people (whose forbears were once doubtless as widely deprived of man-made imagery and color as their progeny are now inundated by them) appear to believe that the visual plane is the only plane that life itself happens on. Consider, for instance, those fragments from the vast network news coverage of Vietnam which were never really stories as such (those reiterated glimpses of helicopters landing, of men fanning out in the tall grass, of distant planes and puffs of smoke and napalm ...), but which come down to us as scenes....[19]

The paradox of "artificiality" and "reality" extended into much of avant-garde culture. Both imagery and materials as well as a sensibility were provided by man-made artifacts. Something was, then, ultimately transformed by the subjective or objective scrutiny engendered by the analysis and intensity of debate which dominated high art of the sixties. It was inevitable that so momentous a happening in art discourse should eventually be reflected in the interior spaces of museums and galleries. In this environment a complex history of culture, possessed with the texture of successive attempts to translate reality into art forms absorbed its present and made it part of the past — but a strange and decidedly unsettling past, as McLuhan might have predicted.

1. Clement Greenberg, "Avant-Garde and Kitsch," *Art and Culture* (Boston: Beacon Press, 1965), 4.

2. Greenberg, 6.

3. For further discussion of Greenberg's theory of aesthetics and subsequent interpretations by Pop and Minimalist artists, see Mitchell Merling's essay.

4. Donald F. Theall, *Understanding McLuhan* (Montreal: McGill-Queen's University Press, 1971), 203.

5. Marshall McLuhan, *Understanding Media. The Extensions of Man* (New York: McGraw-Hill, 1964), 3.

6. McLuhan, 7.

7. Greenberg, 7.

8. Greenberg, 7.

9. McLuhan, 25.

10. McLuhan, 12.

11. Harold Rosenberg, "Philosophy In A Pop Key," *The McLuhan Explosion. A Casebook on Marshall McLuhan And Understanding Media*, ed. Harry Crosby and George Bond (New York: American Book, 1968), 70.

12. For more information on technological innovation in the visual media see Eric Barnow, *Tube of Plenty. The Evolution of American Television* (London: Oxford University Press, 1975), chapters 3 and 4.

13. Eric Barnow, 333.

14. Norman E. Cash, "Selling Color Television," *Color Television. The Business of Color Casting*, ed. Howard W. Coleman (New York: Hastings House, 1968), 140.

15. Howard Ketcham, "The Basics of Color," *Color Television. The Business of Color Casting*, 22.

16. The impact of television and its influence on other forms of visual media is discussed by Robert P. Snow, *Creating Media Culture* (London: Sage Publications, 1983), 161.

17. Brian O'Doherty, *American Masters. The Voice and Myth in Modern Art* (New York: E.P. Dutton, 1974), 264-65.

18. The phrase was originally used by Michael Arlen in an essay on television. See Michael J. Arlen, *The Camera Age. Essays On Television* (New York: Farrar, Strauss, Giroux, 1981), 211.

19. Arlen, 13.

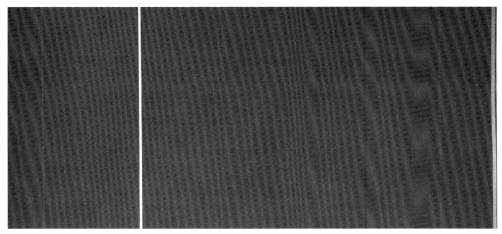

Plate 1. Barnett Newman, *Vir Heroicus Sublimis*, 1950-51,
Oil on canvas, 95 3/8 x 213 1/4 inches, Collection, The Mu-
seum of Modern Art, Gift of Mr. and Mrs. Ben Heller.

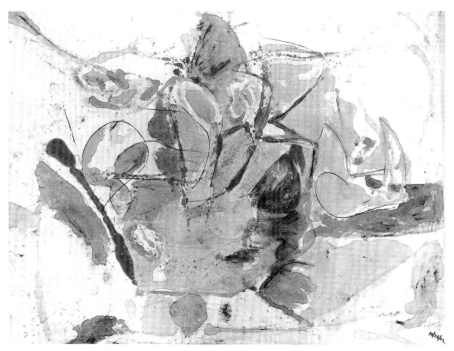

Plate 2. Helen Frankenthaler, *Mountains and Sea*, 1952, Oil
on canvas, 86 3/8 x 117 1/4 inches, Collection of the artist
(on loan to the National Gallery of Art, Washington, D.C.).

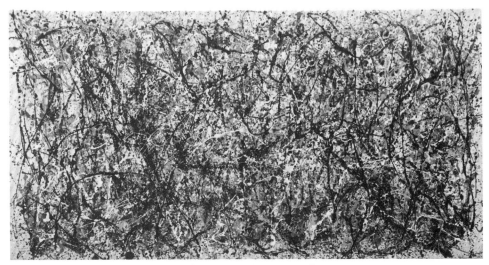

Plate 3. Jackson Pollock, *One (Number 31, 1950)*, 1950, Oil and enamel paint on canvas, 106 x 209 5/8 inches, Collection, The Museum of Modern Art, New York, The Sidney and Harriet Janis Collection Fund.

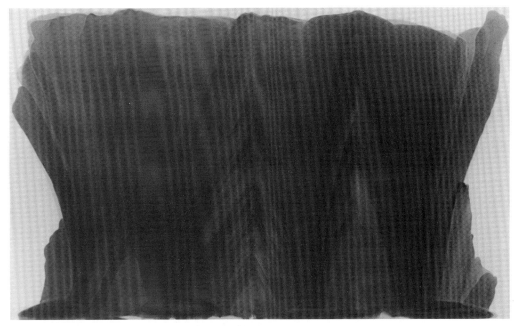

Plate 4. Morris Louis, *Tet*, 1958, Synthetic polymer paint on canvas, 95 x 153 inches, Collection of Whitney Museum of American Art, New York.

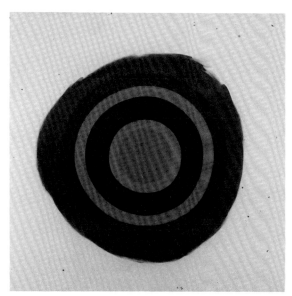

Plate 5. Kenneth Noland, *Song*, 1958, Synthetic polymer paint on canvas, 65 x 65 inches, Collection of Whitney Museum of American Art, New York, Gift of the Friends of the Whitney Museum.

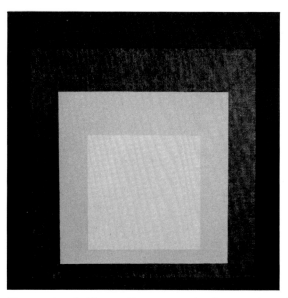

Plate 6. Josef Albers, *Homage to the Square, Apparition*, 1959, Oil on masonite, 47 1/2 x 47 1/2 inches, The Solomon R. Guggenheim Museum, New York.

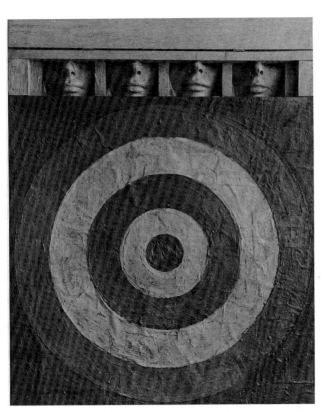

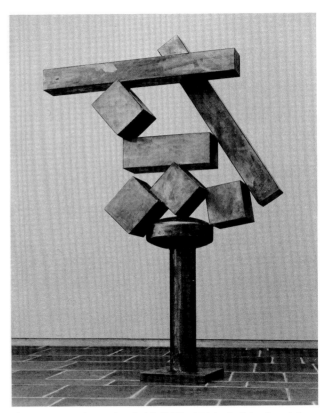

Plate 7. Jasper Johns, *Target with Four Faces*, 1955, Encaustic on newspaper over canvas surmounted by four tinted plaster faces in wood box with hinged front, 33 5/8 x 26 x 3 inches, Collection, The Museum of Modern Art, New York, Gift of Mr. and Mrs. Robert C. Scull.

Plate 8. David Smith, *Cubi XVIII*, 1964, Polished stainless steel, 115 3/4 x 21 3/4 inches, Courtesy, Museum of Fine Arts, Boston, Gift of Susan W. and Stephen D. Paine.

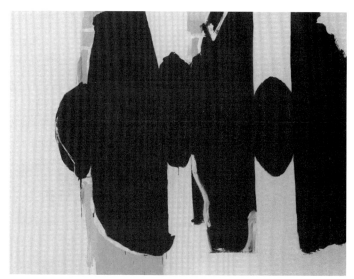

Plate 9. Robert Motherwell, *Elegy to the Spanish Republic, No. 58*, 1957-61, Oil on canvas, 84 x 108 3/4 inches, Collection, Rose Art Museum, Brandeis University, Waltham, Massachusetts, Gift of Julian J. and Joachim Jean Aberbach, New York.

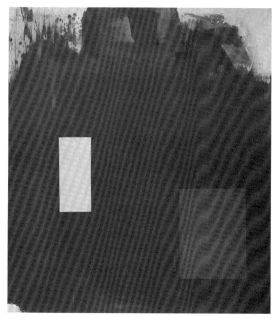

Plate 10. Hans Hofmann, *Memoria in Aeternum*, 1962, Oil on canvas, 84 x 72 1/8 inches, Collection, The Museum of Modern Art, New York, Gift of the artist.

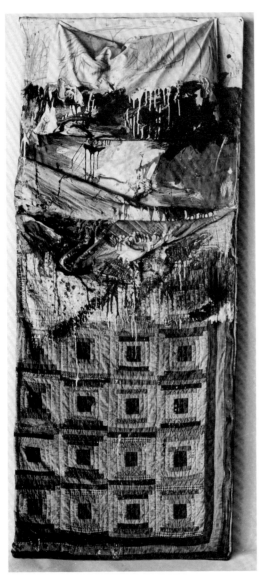

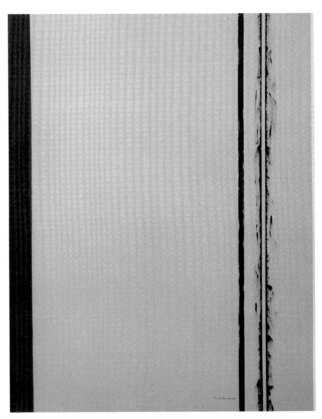

Plate 11. Robert Rauschenberg, *Bed*, 1955, Combine painting, 75 1/4 x 31 1/2 x 6 1/2, Collection, Mr. and Mrs. Leo Castelli.

Plate 12. Barnett Newman, *Third Station*, 1960, Oil on canvas, 78 x 60 inches, Collection, Mrs. Annalee Newman.

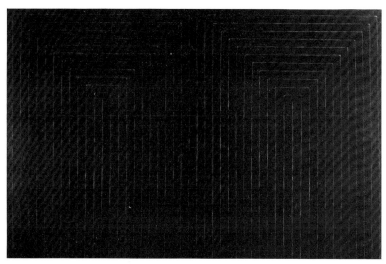

Plate 13. Frank Stella, *The Marriage of Reason and Squalor*, 1959, Oil on canvas, 90 3/4 x 132 3/4, Collection, The Museum of Modern Art, New York, Larry Aldrich Foundation Fund.

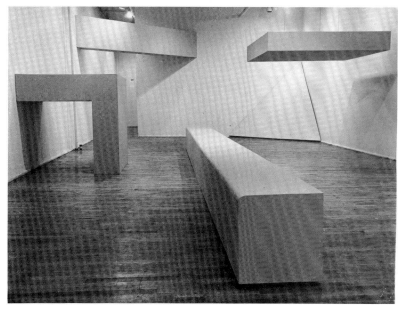

Plate 14. Robert Morris, *Exhibition at the Green Gallery*, 1964.

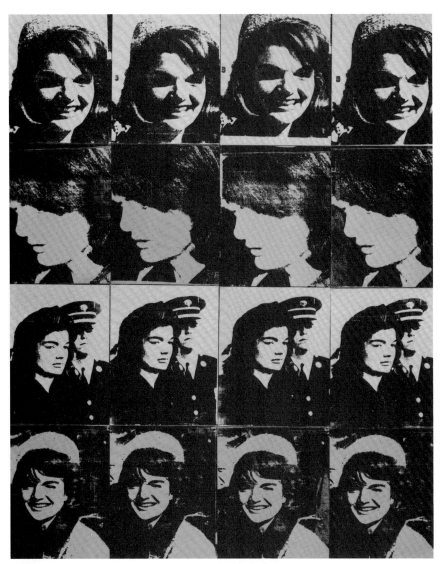

Plate 15. Andy Warhol, *Sixteen Jackies*, 1964, Acrylic and silkscreen enamel on canvas, 80 x 64 inches, Collection, Walker Art Center.

Catalogue

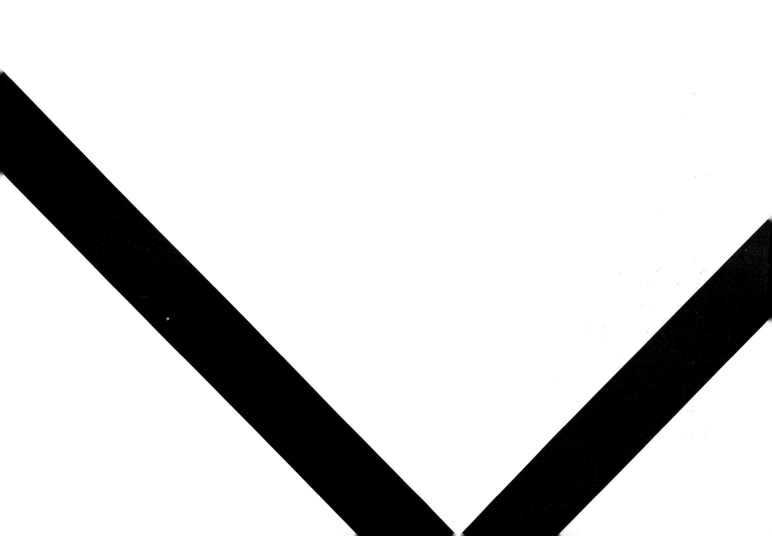

Carl Andre

CONCRETE CRIB
1965
11 x 11 x 17 1/2 inches
Cast concrete
Rose Art Museum, Brandeis University, Waltham, Massachusetts
Anonymous gift
1966.9 a-n
Catalogue No. 1

PROVENANCE
Tibor de Nagy Gallery, New York; purchased by Rose Art Museum, March 1966

BIOGRAPHY
Born in Quincy, Massachusetts, 1935. Attends Phillips Academy, Andover, Massachusetts, studies with Patrick Morgan, 1951-53. Employed at Boston Gear Works, Quincy, 1954, travels to England and France. Intelligence analyst with U.S. Army, 1955-56. Editorial assistant in publishing, New York, 1957-58. First large wood sculpture, 1958-59. Employed by Pennsylvania Railroad in New Jersey, 1960-64. Lives in New York.

Neither clearly shaped by human hands nor shaping space on an environmental scale, Carl Andre's *Concrete Crib* exemplifies the position of "structural" sculpture in Andre's terse history: "The course of development, /Sculpture as form, /Sculpture as structure, /Sculpture as place."[1]

Andre's earlier development from "carving" to "cutting" had generated vertical pieces of human scale made from massive timbers. His desire to work more directly with the literal nature and presence of things later encouraged him to use even less overtly manipulated materials such as firebricks, concrete blocks and styrofoam beams, piled or laid side by side in increasingly flat configurations. In *Concrete Crib*, fourteen concrete blocks are stacked and presented, the material itself not relegated to carrier of meaning external to its physical existence.

The open tower of blocks clearly does not constitute prior sculpture's traditional container expressive of an internal, animating force. Even if it can be said that there appears a core of undifferentiated nothingness, that too is permitted to seep out without manipulation. There can be no mystery as to the piece's structure, for the uniformity of its openness (on all six surfaces) permits it to be instantaneously and completely understood *as* structure.

This explicitness is reinforced by the blatant and unmediated simplicity of the unit forms. *Concrete Crib* is all object and no illusion. Andre's "particles," the concrete blocks, are as definite, obdurate and literal as can be imagined. They are uniformly the same, random and interchangeable. Objects of "manufacture," they are at once man-made and untouched, continuing the concentrated object quality and presence of works by Jasper Johns, Robert Rauschenberg and Claes Oldenburg, but cultivating it in abstract, fabricated and non-referential forms. There can be no doubt that the interior of each block is identical with its exterior, just as the interior of the crib is the same as its exterior.

Appropriated from building for sculpture, these elemental materials exchange the internal illusionism of prior art for the literal presence of things seen and used in the world, microcosmically intensifying the awareness of their shape, color and scale. By setting up an unmitigated condition of confrontation with a self-consciously material presence, the works have the ability to redirect the viewer's consciousness away from themselves to the macrocosm of the perceptual field in which they stand.

The geometry of *Concrete Crib* is obvious, additive and symmetrical. It recalls child-like play with blocks, but shares with Andre's other work the distinctly "grown-up" physical densities and scale of railroad ties, bricks, lead tiles and boulders. This geometric uniformity ensures a visual uniformity in which no single element or view takes precedence or subjugates other elements or views into relational hierarchies. No slight of hand or mechanical bond is used to make the piece cohere; it is a case of pure compression, driven only by the organic law of gravity. Thus the purity and subtlety of Andre's handling of his materials, so apparently unaesthetic by traditional standards in its simplicity, clarity and specificity, subverts traditional conceptions of "artistic" manipulation and intervention.

In their utterly unmanipulated state, Andre's use of concrete blocks in sculpture preserves their intrinsic character, a conceptual stance parallel to Frank Stella's desire to keep the paint on his paintings as "good" as it was in the can, and by inference, to reduce to an absolute minimum the amount of emotional or personal sentiment in the piece. In this sense, the bricks and blocks are even more appropriate carriers of Andre's Minimalism than the cut timbers, for they not only reject modeling, shaping or gesture, but their given shape precludes arbitrary acts of cutting.

Yet even as it is "objective," literal and definite, the *Concrete Crib* escapes us. From the apparent accessibility of its units and structure comes questions about the nature of exteriors and interiors and the communications between them, about what constitutes "hollowness," of how horizontal becomes vertical, of what it means to build, shape and impose an artistic will. Born to a family at home with the manipulation of stone, wood and metal, Andre's aesthetic intelligence rediscovers in the specificity of material and the clarity of Minimalist geometric order something of the provocative and elusive mystery of scaleless Neolithic monuments.

CC

1. David Bourdon, "The Razed Sites of Carl Andre," *Artforum* 5, no. 2 (October 1966): 15.

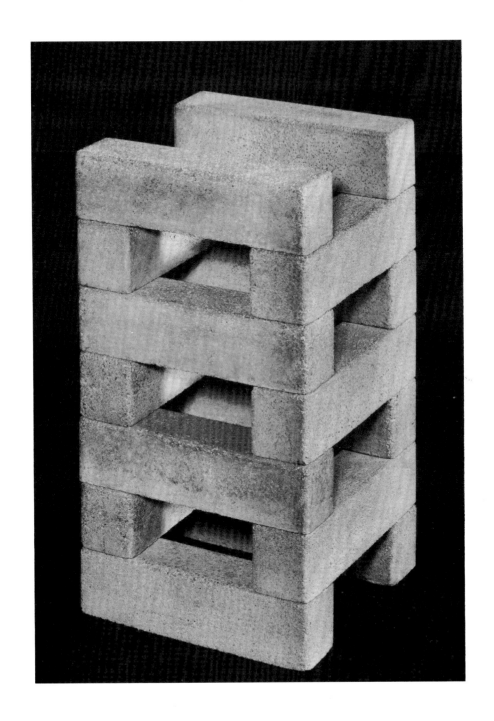

Richard Artschwager

TELEPHONE DIRECTORY
1965
44 1/4 x 47 3/4 x 20 7/8 inches
Formica on wood
Collection Mr. and Mrs. Boyd Mefferd, on loan to the Wadsworth
Atheneum
Catalogue No. 2

PROVENANCE
Collection of the artist

BIOGRAPHY
Born Washington, D.C., 1923. Attends Cornell University 1941-48,
inclusive of U.S. Army service during those years. Studies with
Amédée Ozenfant, 1949-50. Apprenticed to a cabinetmaker, 1953.
Manufactures furniture beginning 1956. Begins to sculpt, 1959;
begins furniture series, 1962. First show of furniture at Leo Castelli
Gallery, 1964.

More than any other artist exhibited here, Richard Artschwager
bridged the progressively narrowing gap between Pop art and Mini-
malism. His use of recognizable imagery places his interests within
the wider concerns of Pop. However, the incorporation of recogni-
zable imagery is subverted by the abstract and schematic use he
makes of it.

Like Pop artists, Artschwager is concerned with the replication of
common everyday objects, mainly pieces of furniture. In his dead-
pan replications of those objects, stripped of all detail, Artschwager
achieves a kind of humor that is generated by the disparity between
his replications and their "real" sources. On the most superficial
level, Artschwager emphasizes, almost to the point of ridicule, the
sheer ugliness of day-to-day life in mid-twentieth century America,
where all contact with nature and natural objects is avoided except
from a safe distance. Fake fur, synthetic cheeses or, here, wood-
laminate formica represent that distance.

However, unlike Oldenburg, Artschwager is not interested in the
explicit transformation of his models in such a way as to call
attention to that transformation. The *Telephone Directory* is not
transformed in scale, as Oldenburg's works often are. Further, for-
mica is a material potentially characteristic of such an object. In ef-
fect, the *Telephone Directory* is an outstanding example of the use of
literal and depicted shape, that is a concord rather than discord be-
tween representation and represented object, and as such is closest
in spirit to Andy Warhol's *Brillo Box* (Cat. 38), that artist's most mini-
mally inflected work.

More like the Minimalists is Artschwager's use of cubic volumes
for an effect of drastic simplicity. The use of cubes is characteristic of
(in works shown here) Donald Judd, Robert Morris, Carl Andre, John
McCracken, and less explicitly, Sol LeWitt and Agnes Martin. Like
Minimalism as well is the artist's interest in creating conceptually
simple forms and disrupting them, in this work via reference, in or-
der to create perceptual ambiguity in the viewer (compare Cat. 24,
25). The meaning created through this reference is not primarily his-
torical as in Oldenburg, but rather aspires in some loose way to eter-
nal philosophical and aesthetic relevance.

By choosing to replicate furniture in his works of art, Artschwager
cannot help but recall the Platonic paradigm of ideality, utility and
aesthetic irrelevance expressed in *The Republic*, by the idea of the
chair, the chair and the depicted chair. By implication of this exam-
ple, Plato argues that art is twice removed from the idea, and is thus
capable of leading men astray if they attempt to re-enact in everyday
life the moral principles they derive from the imitation of it. In sup-
port of his argument that artists are inadequate leaders of men, Plato
asserts that they know nothing of the true nature of the things they
imitate (their chairs are unreliable as guides for craftsmen). In a work
such as the *Telephone Directory*, however, Artschwager counters
the notion that essences reside outside the object. The information
that this telephone directory is able to provide is truth about the na-
ture and function of art. It casts doubt on our perceptions, not of this
particular "telephone directory" as an adequate representation, but
of the particulars of everyday telephone directories, and as such it
confirms the universality of the "idea" of such an object as it is em-
bodied here.

Finally, it is difficult not to take Artschwager's life as an artist as a
species of colossal rejoinder to the Platonic attack on art. Although,
according to his own narration, it was due to his wife's urging that he
became an artist, the decision to replicate furniture must have been
his own. That this ex-craftsman (whose art is devoted to the practice
of imitation) is replying to the one time ephebe (who mounted a
philosophical attack on art) with the Apellean rejoinder to "stick to
your last," is a possibility not to be discounted.

MFM

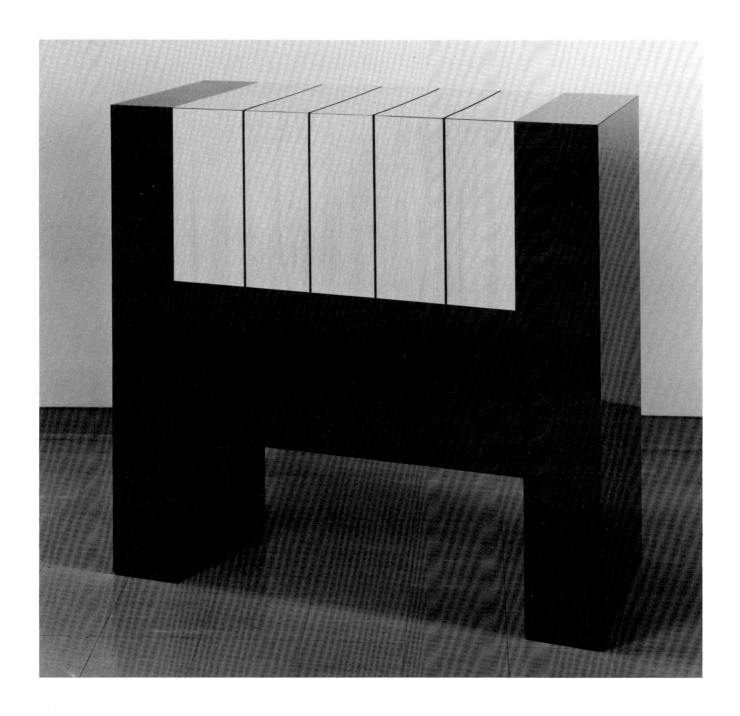

Walter Darby Bannard

SEASONS # 2
1965
66 3/4 x 62 3/4 inches
Alkyd resin on canvas
Signed "W.D. Bannard" on stretcher
Rose Art Museum, Brandeis University, Waltham, Massachusetts
Anonymous Gift
1966.10
Catalogue No. 3

PROVENANCE
Tibor de Nagy Gallery, New York.

BIOGRAPHY
Born 1934, New Haven, Connecticut. Studies at Phillips Exeter
Academy, Exeter, New Hampshire, 1950-52. Studies at Princeton
University, Princeton, New Jersey, 1952-56, B.A. 1965. Lectures at
New York University and Museum of Fine Arts, Boston, 1966.
Visiting critic, Columbia University Art School, New York, 1968.
Recipient of Guggenheim Fellowship 1968-69, and National
Endowment of the Arts Award, 1968-69.

Darby Bannard's "Seasons" series of 1965 examines through com-
plex, yet subtle structural and coloristic manipulations the visual and
spatial relationship between figure and ground. In *Season #2*, Ban-
nard isolates a run of abstract structures on a highly varnished
surface of a single color. The shapes themselves are geometrically
derived and executed in single flat colors, but their curving and tilt-
ing sides oscillate strangely between flatness and three-dimensional-
ity. Sides seem to be foreshortened but are then contradicted by the
irregularity of an adjacent shape or opposite side. The close-valued
colors and occasional contrasts as in the red and white "triangles"
and lower green polygon within the run of shapes heighten the im-
plication of lighted and non-lighted surfaces of three-dimensional
objects. Yet nothing but the eccentric shaping actually reinforces a
three-dimensional reading, and the actual flatness of the support
dominates.

Bannard's interest in carefully disciplined color resulted in his
great refinement of illusory effect. In *Season #2*, for example, the
close-valued and close-hued colors not only of the individual struc-
tures but of the light green field, contribute to an ambiguous flow be-
tween figure and ground. This ambiguity is heightened by the
reflective quality of the varnished surface which declares its flatness
but when not reflecting, allows a reading of the spatial projections of
the shapes. The ground weaves through the separate depicted
shapes, at times coming forward when adjacent to a low intensity
color, then falling back when juxtaposed to a high intensity color.

Further, due to the subtle color contrasts between shapes and
ground, there is a lateral oscillation as the shapes alternately hold
their own space or are surrounded and consumed by the ground.[1]

The space between the shapes is particularly active because it is
sufficiently wide and complex in structure to hold as shape itself. A
comparable ambiguous relation between figure and ground was pur-
sued by several of Bannard's contemporaries, especially Kelly. But
no other artist achieved Bannard's mastery of the intricate workings
of low-contrast color. In his hands, hue change and small shaping
gestures counterpoise position and flow within the overall picture
structure without ever sponsoring either possibility unequivocally.

MF

1. Kermit Champa, "Darby Bannard's New Paintings," *Artforum* 7, no. 2 (Oc-
tober 1968): 62-63.

83

Larry Bell

UNTITLED
1964
12 1/2 x 12 1/2 x 12 1/2 inches
Metal and vacuum-plated glass
Collection Viki List
Catalogue No. 4

PROVENANCE
Unspecified

BIOGRAPHY
Born in Chicago, 1939. Moves to California and attends high school in Encino. Attends Chouinard Art Institute, Los Angeles, 1957-59. Lives in Venice, California and New York City.

Larry Bell is one of several artists from the West Coast (specifically Los Angeles) who were very much involved with the sixties reformulation of ideas about what could constitute painting and sculpture. The *Untitled* in the present exhibition can trace its genealogy back to Bell's early sixties work which featured shaped canvases depicting regular geometric (and often cubic) forms. Utilizing rectilinear bands, Bell developed a powerful illusionism in which the paintings frequently appear to be isometric projections of nested cubes. The obvious next step was to permit his painted constructions to snap into three-dimensional space, making actual boxes, retaining at first geometric coating patterns for certain surfaces. In 1964, Bell completely relinquished these arbitrary additions to his structures and began to concentrate on the potential inherent in the Platonic regularity of the cube and coatings deposited over the glass surface as a whole.

The complex coatings on Bell's cubes are extremely thin layers of vaporized metal, deposited on the glass in a vacuum chamber. Their varying indices of refraction alter the path of light rays passing through them (like gasoline on water) generating sets of colors and qualities of light that are infinitely responsive to the viewer's position in relation to a given surface. Thus Bell creates an abstract, non-referential surface which is not an illusionistic depiction of something else, but is itself *intrinsically illusory*. In effect, Bell makes a virtue of painting's vice (in modernist terms)[1] by appropriating its problematic illusionism and reforming it, reusing ancient ideas about the painting as window (the glass) and Renaissance perspective projections (the cube) considered inimical to modernist painting's inherent and depicted flatness.[2] The use of a perfectly cubic glass support (if it can be called a support for the mineral layer chemically bonded to it) not only connects Bell's work to Robert Morris' and Donald Judd's investigations, but serves to separate *Untitled* from traditional sculptural concerns. The creation of an integral stand of transparent plexiglass permits the piece to be illuminated from all directions, dis-

solving the sense of a "base" and appearing to float the piece free from the forces of mass and gravity. Despite the fact that *Untitled* can be said superficially to define a volume, it functions much more powerfully to define an atmospheric quality entirely alien.to sculpture's traditional density.

The evanescent effect of the coatings is in fact much more reminiscent of the Color-Field painting of Rothko's clouds or Olitski's sprays, but Bell's technological distancing precludes even their severely restricted personalisms of facture or gesture. At the same time, the extraordinary experience of peering into and *through* one of Bell's boxes provides an inarguably "signature" experience as the viewer is permitted to focus on the color patterns on the surface, register the effect of two parallel sides simultaneously, or utilize the transparency of the medium to verify "illusion" against "reality," comparing things *seen* and *seen through* the piece. The structure provided by the chromed and gleaming stainless steel edging continues the L.A. "fetish finish"[3] of the glass (a quality shared with John McCracken) and also acts as a delimiter to the expansive vision of the interior, while running the risk of lending a certain preciosity to the whole. In Bell's subsequent work, constructed entirely of very large panels of coated glass, his singular clarity of material, complexity of vision and architectural scale remove this risk once and for all.

CC

1. "Three dimensions are real space. That gets rid of the problem of illusionism and of literal space, space in and around marks and colors—which is riddance of one of the salient and most objectionable relics of European art. The several limits of painting are no longer present. A work can be as powerful as it can be thought to be." Donald Judd, "Specific Objects," *Complete Writings 1959-1975* (Halifax: Press of the Nova Scotia College of Art and Design, 1975), 184.

2. Barbara Rose, *A New Aesthetic* (Washington: Washington Gallery of Modern Art, 1967), 10-11.

3. Barbara Haskell, *Larry Bell* (Pasadena: Pasadena Art Museum, 1972), 19.

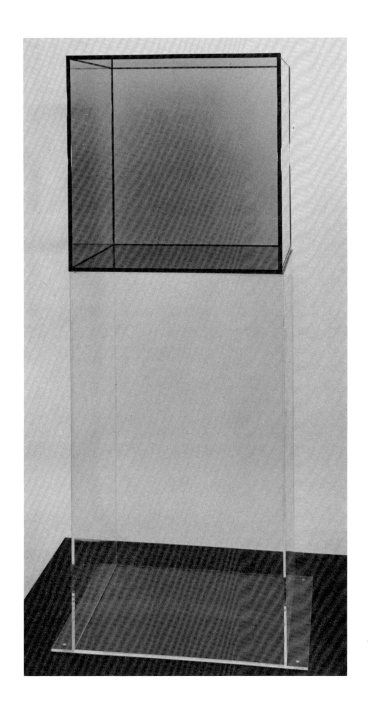

Lee Bontecou

UNTITLED
1965
21 x 60 x 3 inches
Iron
Courtesy Leo Castelli Gallery, New York
Catalogue No. 5

PROVENANCE
Museum of Contemporary Art, Chicago to Leo Castelli Gallery, 1972.

BIOGRAPHY
Born in Providence, Rhode Island, 1931; grows up in Nova Scotia. Studies at Art Students League, New York 1952-55 with William Zorach and John Hovannes. Fulbright Fellowships to Rome, 1957 and 1958; Tiffany Foundation Grant, 1959. First one-man show at G Gallery, 1959; first show at Leo Castelli Gallery, 1960. Second prize 28th Biennial of American Art, Corcoran Gallery of Art, 1963. Exhibits in Paris at Galerie Ileana Sonnabend, April 1965. First prize, Annual Invitational, National Institute of Arts and Letters, 1966.

Lee Bontecou's structures from 1960 through 1963 are unique in their interrelation of structure, support and image. The cavernous apertures in high relief become both the primary structure and subject of the object and deny any singular plane of support. *Untitled,* 1965, represents a break from Bontecou's characteristically tight interweave of sculptural elements. It develops instead from a clear statement of the rectilinear frame and the planar support. This image works for Bontecou with a moderate degree of relief. The separate sculpted images or apertures are sporadically, rather than continuously, worked into an incipiently pictorial surface. The piece indicates a development outward from the few dominant relief elements characterizing Bontecou's earlier work, toward an increased complexity of the image. Striations of metal create repetitive patterns whose alternating directions fracture the image into segments which are further punctuated with several competing and decentralized apertures.

Bontecou's imagery was subjected to much unconvincing analysis by contemporary critics and curators who wanted to associate her works with those of the Pop artists. Her work was frequently seen as "Nouveau Realisme," or "Neo-Dada" because her forms were suggestive of natural objects. Additionally, Bontecou has been variously associated with a "feminist" approach to art, because her deep cavernous apertures and membranes of canvas are seen as deriving from female anatomy. The razors and saws incorporated into these apertures are interpreted as vicious mouths and teeth, suggesting a particularly hostile feminism.[1] Ultimately, however, her images do not facilitate any specific interpretation. There is an element of Surrealism inherent in them insofar as they are randomly suggestive of complex biological and mechanical structures and are therefore not entirely abstract. But they remain images derived from the imagination rather than from specific subjects of reality, and therefore preclude the possibility of interpretation.

MF

1. Gene Baro, "A Gathering of Americans," *Arts Magazine* 37 (September 1963): 32.

Anthony Caro

KASSER
1965
23 1/4 x 48 1/2 x 12 1/2
Painted steel
Museum of Fine Arts, Boston
Gift of Graham Gund
1980.465
Catalogue No. 6

PROVENANCE
Formerly owned by Account Management Corporation, Boston

BIOGRAPHY
Born in London, 1924. Studies intermittently with sculptor Charles Wheeler, 1937-42. Attends Christ's College, Cambridge, 1942-24, M.A. in Engineering. Studies sculpture at Farnham School of Art, 1944; Regent Street Polytechnic Institute, 1946-47; sculpture and drawing at Royal Academy Schools, 1947-52. Part-time assistant to Henry Moore, 1951-53. Meets Clement Greenberg, Kenneth Noland, visits United States, 1959. Teaches at Bennington College, Vermont; faculty includes Jules Olitski; Kenneth Noland a neighbor, 1963-1965. Visits David Smith's studio, 1965. Visits United States several times a year after 1965, since 1954 has lived in London.

Anthony Caro's *Kasser* occupies a particularly interesting position between the aesthetics of sixties Color-Field and Minimalist work. Formed entirely of three pieces of steel—one U-shaped beam and two thin slabs—welded together, *Kasser* looks extremely spare and severe, as if partaking of the Minimalist reduction of the superfluous even as its clarity, openness and opticality connect it to painters such as Kenneth Noland. Made sometime in the spring and early summer of 1965 during a stay at Bennington College, *Kasser* was in fact constructed after conversations with Jules Olitski about making sculpture as "naked" as possible and as part of a series using relatively similar parts.[1] However, despite its apparent simplicity, *Kasser* is fundamentally different from the non-relational, non-hierarchical, unitary "objectness" that characterizes most mature Minimalist production.

Significantly, Caro himself had passed through an Expressionist period in the 1950's similar to that to which the artists of the sixties reacted. Caro's visit in 1959 to America acquainted him with the constructed works of sculptors such as Stankiewicz and David Smith, and radically re-oriented him away from the monolith in the direction of Picasso's Cubist abstractions.[2] By 1965, Caro had firmly established himself as one of the most important sculptors on both sides of the Atlantic, preserving a continuity with the traditions of constructed sculpture even as he contributed to the formation of the sixties aesthetic of hard, colorful, non-autographic form.

Like Stella's bands or Noland's chevrons, *Kasser*'s steel parts are minimally anthropomorphic, having none of the curving profiles of living, biological forms. The piece rests directly on the ground (its support), like paint on unprimed canvas, without a veneer of base underneath it that might interfere with our perception of it *as* a sculptural mass responsive to gravity. From one view, one end-slab functions as a "plane," connected by a short beam (a "baseline") to the other end slab which is seen on edge as a "line." Moving around the piece reverses these readings. The end-slabs are not placed *on* the beam, but are attached *to* it, precluding even its slender form from acting as base. Unlike most Minimalist sculpture, in which the perceptual and conceptual gestalts are interchangeable, *Kasser*'s component *parts* are optically interchangeable; stressing both their individuality and their formal progressions. This interchangeability is strengthened by Caro's habit of painting all the component parts of his pieces a single color, subjugating differences of surface and shape and forcing their cohesion as a visual whole.

Eschewing the architectural orthogonality we would expect from such structural materials, in *Kasser* Caro tests the feeling inherent in subtle adjustments of angle and position, finding in a minimal inflection of formal gesture those abstract analogues of relationship and experience that make sculpture expressive. Our inability to see as lifeless plastic form of roughly human scale rising up against the pull of gravity reiterates Caro's connections back to the totemic presences of David Smith. At the same time, the geometric anonymity and *presentness* of the steel assert themselves as *literal* form and "Specific Object," not as illusionistic or rhetorical representations of another form of life. That the open-ended blackness created by the profile of the central beam at one end can be read as either constituting an almost animistic interiority or as displaying an intellectual rigor in which nothing is concealed exemplifies the delightful paradox of which the best modernist sculpture partakes.

CC

1. William S. Rubin, *Anthony Caro* (New York: Museum of Modern Art, 1975), 183.

2. Rubin, 29.

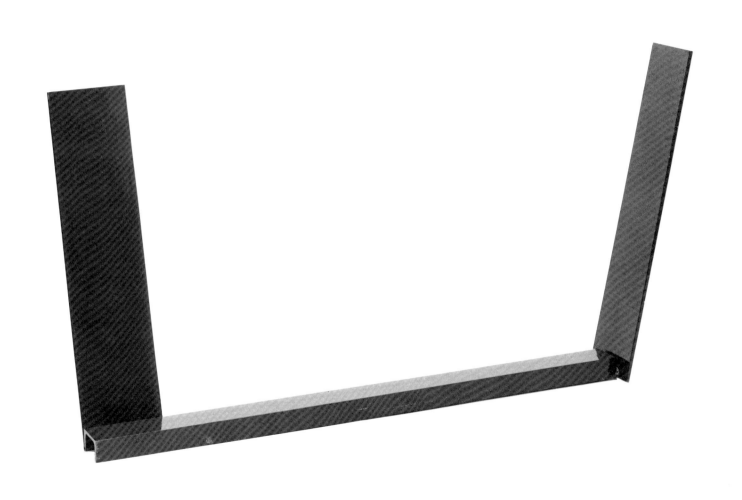

John Chamberlain

RED RYDER
1964
19 x 28 x 22 inches
Welded and painted auto metal
Museum of Fine Arts, Boston
Gift of Susan Morse Hilles
1974.121
Catalogue No. 7

PROVENANCE
Unspecified

BIOGRAPHY
Born April, 1927, Rochester Indiana. Studies at the Art Institute of Chicago, 1950-52, University of Illinois and Black Mountain College, 1955-56. First works with crushed automobile motor and body parts, 1957. First show at Leo Castelli Gallery with Frank Stella, 1962. Moves to painting found metal auto parts, 1964. Recipient of Guggenheim Fellowship, 1966.

John Chamberlain's sculpture results from a confluence of aesthetic traditions, but through his unique approach to both materials and structure, it challenges the traditional properties of the medium, opening up formal possibilities previously untried in sculpture. During his early training at the Art Institute of Chicago, Chamberlain was strongly impressed by the current work of the Abstract Expressionists, especially de Kooning and David Smith. Their work proved to have a continued formal influence on his later work, though he largely abandoned the psychological implications carried by the overtly turbulent work of Abstract Expressionism.[1]

His earliest structures are reminiscent of Abstract Expressionism precisely in the turbulence of the constructed forms and in the use of extant color to isolate pieces as separate gestures. Like Smith, Chamberlain builds relational structures from found metal parts. Metal strips and pipes create strong calligraphic effects interposed between the curving planes and volumes deployed in space. Chamberlain made his first scrap metal sculpture in 1957 from parts of a '29 Ford and thereafter became interested in specific auto parts as well, for both color and prefabricated form. He was not making any direct references either to automobiles or to public taste, but to the abstract forms and pre-existent color of the parts. Like Di Suvero earlier, Chamberlain cast off any literary associations of earlier Surrealist-inspired sculpture, retaining only the gestural quality that related his and Di Suvero's work to Abstract Expressionism.[2]

Red Ryder is a characteristic example of Chamberlain's later works emphasizing the construction of volume from curving planes of metal in an overlapping, collage-like organization with no apparent armature or core. The forms themselves are, in a sense, hollow shells articulated as parts into a mass of implied volumes. The parts are not constructed in a relational sense as in Smith's Cubis, but are subordinated to the whole. The undulating forms of *Red Ryder* combine organically into an openly expanding whole of involuted metal shells. Chamberlain's approach to sculpture, ignoring any core or imposed armature denies the tradition of sculpture which relied on these as the inherent identities of the medium.

Chamberlain's approach to sculpture seems to anticipate the work of Minimal sculptors. Judd in particular seems to have sensed in Chamberlain the possibility of generating sculptural mass from without—from an enclosing shell.[3]

Chamberlain's use of color in sculpture was influential as well. In 1959, he used the color of the found parts to enhance formal contrasts within his works. By 1964, he began to spray separate parts with auto enamel—a move away from roughness and unfinish characteristic of Abstract Expressionism, in the direction of precise surfaces. In *Red Ryder*, a deep enamel red dominates with metallic gold and white parts punctuating the whole structure. The effect is of pictorial color used to articulate parts and to consolidate the whole. The incorporation of color into sculpture ultimately opens new possibilities for the medium, allowing for an aesthetic interchange between painting and sculpture not previously possible.

MF

1. Wayne Anderson, "American Sculpture: the Situation in the Fifties," *Artforum* 6, no. 10 (Summer 1967).

2. Anderson.

3. Rosalind Krauss, *Passages in Modern Sculpture* (London: Thames and Hudson, 1977), 127.

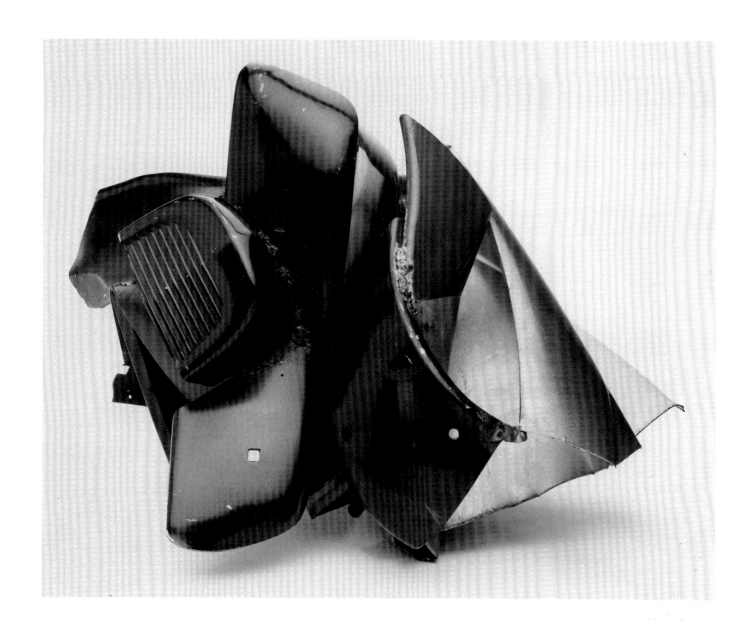

Mark di Suvero

DEPARTURE 2001
1964
36 x 49 x 43 inches
Steel and wood
Albert A. List Family Collection
Catalogue No. 8

PROVENANCE
Unspecified

BIOGRAPHY
Born in Shanghai, 1933. Moves with family to San
Francisco, 1941. Studies at San Francisco City College, 1953-54;
University of California, Santa Barbara, 1954-55; University of
California, Berkeley, 1956-57 (B.A.). Moves to New York, 1957.

Mark di Suvero's assertion that "My sculpture is painting in three
dimensions," makes evident his interest in and development out of
Abstract Expressionism's painted gesture.[1]

Three years after having settled in New York, di Suvero had ap-
propriated both the increased scale of fifties painting as well as the
directness of its kinesthetic attack. This was clear in his work shown
at the Green Gallery in 1960. *Departure 2001* of 1964 shares with
virtually all of his work of the early and mid-sixties the use of rough
and unaesthetic, often brutal materials, which maintain a continuous
physicality and preserve that sense of rawness and life autographic in
the work of Willem de Kooning or Franz Kline.

Part of the movement christened "Assemblage," di Suvero, along
with artists such as Robert Rauschenberg, John Chamberlain,
Richard Stankiewicz and Claes Oldenburg, scavenged for aban-
doned architectural members and industrial leftovers as the raw
material for his constructions. Di Suvero makes no attempt to dis-
guise the identity of his parts, thereby retaining the feeling of their
derivation from the urban environment and simultaneously increas-
ing the tension of their transformation from detritus into aesthetic
elements.

In *Departure 2001*, wood and steel are joined and juxtaposed so
as to present surprising contrasts of strength, density and surface
quality in which the coarseness of the rough steel and broken, splin-
tered wood invoke a world of vast forces, superhuman scale, indus-
trial machinery and toiling muscle. An oblique section of an ancient
wooden beam rises from the flat painted steel base plate in such a
manner as to suggest that it is just barely protruding from the
"ground," or, alternatively, submerged in a liquid. Moving in the op-
posite direction, the graceful cantilever of a slender steel beam lever-
ages a broken chunk of dilapidated telephone pole into a liberated
"departure" from gravity. Connected to the steel beam with two

pieces of springy steel, the apparent massiveness of the telephone
pole is in fact released into a visual buoyancy that can be physically
induced with the push of a curious finger; a movement that di Suvero
would later develop in larger pieces designed to enable passengers
to ride through space on the whirling members of his sculpture.

The visual lift of the pole is given a humanness of gesture by the
presence of a group of gnarled chain links and loops at one corner of
the piece where they assume a finger or hand-like quality, as if aspir-
ing to climb to the the height of the black pedestal base (this associa-
tion of links, hooks and hands is made explicit in a work such as
Hand of 1964).[2]

The exuberant physicality of di Suvero's constructions frequently
evokes associations with human gestural or figurative actions.[3] Par-
ticularly when his beam elements are at or above human scale, his
sculpture can (using completely non-referential pieces) seem to
enact primary struggles for freedom and liberation common to all
human beings. Assembled through a process of improvisatory engi-
neering, di Suvero finds resolution in the complex and tensioned or-
der of his pieces, physically demonstrating that for him it is in the
delicate balance of powerful forces that beauty is to be found.

CC

1. "Di Suvero uses beams as if they were brush strokes, imitating movement,
as Kline did. The material never has its own movement. A beam thrusts, a
piece of iron follows a gesture; together they form a naturalistic and anthropo-
morphic image. The space corresponds." Donald Judd, "Specific Objects,"
Complete Writings 1959-1975 (Halifax: Press of the Nova Scotia College of Art
and Design, 1975), 183.

2. James K. Monte, *Mark di Suvero* (New York: Whitney Museum of American
Art, 1976), 42.

3. Barbara Rose, "On Mark di Suvero: Sculpture Outside Walls," *Art Journal*
35, no. 2 (Winter 1975-76): 118-125.

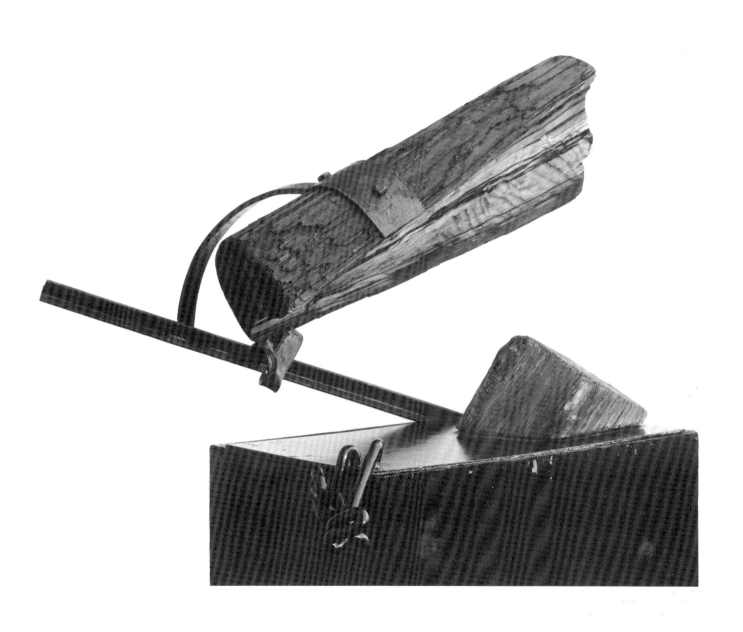

Jim Dine

DOUBLE ISOMETRIC SELF PORTRAIT (SERAPE)
1964
56 7/8 x 84 1/2 inches
Oil on canvas with objects
Collection of The Whitney Museum of American Art, New York
Gift of Helen W. Benjamin in memory of her husband Robert M.
Benjamin
Catalogue No. 9

PROVENANCE
Unspecified

BIOGRAPHY
Born Cincinnati, Ohio 1935; receives first degree from Ohio University 1957; visiting lecturer at Yale University, New Haven 1965. Artist-in-residence at Oberlin College, Ohio 1965; visiting lecturer at Cornell University, Ithaca, New York, 1967.

Double Isometric Self-Portrait is comprised of a large canvas divided into two parts by a wooden bisecting line that is related physically to the rectangular frame of the canvas as a whole. Drafted in black outlines are two images of bath robes placed adjacent to each other. Then, there are added two similarly aligned objects made up of a hook attached to a metal chain which is linked to a wooden bar. These two items hang parallel to the picture plane and cross most of the vertical dimension of the canvas.

The clear simplified outline of each robe is filled in with a complex variation of flatly painted areas of color. Taken together, both robe images form multicolored configurations of shapes which are quoted and repeated on different parts of the canvas. Basic colors of red, yellow, green, and blue are played off against unmodulated blocks of brown, white, orange, pink and other variations of primary tones. These colors appear in another painting of the same year *Self-Portrait Next to a Colored Window* of 1964 in which Dine's program of color is articulated in grids, which are literally separated from a monochrome version of the robe motif. The range of colors presented in detached, abstract form in *Self-Portrait Next to a Colored Window* appear in *Double Isometric Self-Portrait* in a more integrated manner where color and representational form structurally support each other. *Double Isometric Self-Portrait* represents one of Dine's most coldly analytical images. The highly expressionistic brushwork typical of much of the artist's work during the sixties is not present. In this painting Dine seems most concerned with the measure of things, defining proportion symmetrically as if to provide a framework for a less rigid application of color. Dine entertains polarities, forming an abstraction of blocks of color within an outlined representational whole. Color appears here with a controlled randomness. Ultimately, this is a painting about self-imposed limits pushed to the maximum of expressive potential.

IE

Friedel Dzubas

BLUE JUNCTION
1966
67 x 83 inches
Acrylic (Magna) on canvas
Collection of the artist
Catalogue No. 10

BIOGRAPHY
Born in Berlin, 1915. 1925-31 attends Königstädtische
Oberrealschule in Berlin. 1939, flees Germany to London; later to
New York via Montreal. 1948, meets critic Clement Greenberg.
1952, first one-man exhibition at Tibor de Nagy Gallery. Becomes
U.S. citizen, May, 1959. 1965, changes from oil-based paint to
Magna acrylic.

Friedel Dzubas' work plotted a course at the end of the fifties that
brought to his paintings a frenetic, color-saturated surface, reduced
in facture and suppressed in linear compositional hegemony. The
character of these paintings owes a good deal to the work of Helen
Frankenthaler, with whom Dzubas shared a studio in New York in
1952 (the year of Frankenthaler's seminal *Mountains and Sea*). Dur-
ing 1960, Dzubas made a radical break in his production and em-
barked upon a series of black and white "calligraphic" paintings.
These all-over images composed of hermetic, linear patterns allowed
Dzubas to work through his admiration for Pollock. The black and
white paintings explore not only all-over conception, but display as
well a flirtation of sorts with the dynamic of the framed edge. In some
of the pictures, Dzubas actually drew a frame inside the edge of the
canvas, thereby blurring the optical distinction between the picture
plane and the support.

Dzubas had abandoned the black and white paintings by 1962,
recommencing directions his work had assumed at the end of the
previous decade. Still concerned with color and facture, he ap-
proached these new paintings in an entirely different way. Colored
shapes were juxtaposed against increasingly larger areas of bare can-
vas, with a dramatic reduction in the number and variety of hues in
each painting. In the 1962-63 pictures, Dzubas' shapes emerge dis-
tinctly, but retain ragged edges which maintain some references to
his earlier "expressionist" work and subvert in this way the potential
for total geometric clarity.[1]

The avoidance of geometric precision observable in the 1962-63
paintings is far less evident in *Blue Junction* of 1966. Here, Dzubas
toys with an hard-edged emphasis but he maintains as well an irreg-
ular geometry preferring shapes whose biomorphic inexactitudes are
more firmly rooted in the work of Jean Arp than that of Ellsworth
Kelly. In 1965 Dzubas switched from oil paint to Magna acrylic, a
medium which is far less fluid and movable. In the paintings done

with Magna, there is far less facility of touch, and much more
reliance on basic shape and field depiction. " . . . I had come to a
point in working with oil where I could do too much. Oil became
extremely mobile on a primed surface, and the mobility was too se-
ductive. . . . [Magna] doesn't let itself be pushed around.that eas-
ily. . . . you never quite know what you will get. That prevents you
from being too facile."[2]

In *Blue Junction* four vaguely rectangular shapes of violet, green-
black, blue, and gray-blue are poised on a field of green-gray (it ap-
pears to be a lighter tone of the black). The chromatic variations
among the four shapes are a necessary design construction for there
is comparatively little variation in tone among the shapes, and al-
most no variation in color saturation, or texture. The more vivid
colors — the two shades of blue — are poised in the middle of the
canvas with the violet and black shapes stacked on top of them. This
makes for a visual buoyancy: the two blue shapes function to keep
the darker rectangles afloat on the field. This reading is encouraged
by the two topmost rectangles whose boundaries seem to spread be-
yond the edge of the picture.

Dzubas continues the expressive courting of the picture support
which he began in the black and white paintings from 1960. In *Blue
Junction* the top half of the painting is flat, with equivocal relation-
ships existing between figure and ground. The bottom half of the pic-
ture, however, contains a clear forward-backward dynamic. The
employment of flat, almost regularized, shapes allowed Dzubas to
explore color relationships more precisely than ever before in his
work. Yet, the hermetic coloristic "seal" achieved by Ellsworth Kelly,
pursuing a similar direction, was obviously distasteful to Dzubas. He
refused to allow his picture to become entirely flat. Not only is this
apparent in the figure-ground dynamics which occur in *Blue Junc-
tion*, but as well it is observable from the kind of quasi-sculptural
modeling with white that Dzubas employs. In the juncture between
the gray-blue and black shapes — extending wedge-like from the
right edge — Dzubas has inserted a strong white which gradually
recedes into the ground following the curvilinear shape of the blue-
gray rectangle. Hence the white wedge can be seen to establish ei-
ther the frontmost *or* deepest point of the picture. In doing so it serves
to subvert the flatness of the rectangles. This use of selective light-
modeling in an essentially flat pictorial context has a long tradition in
American painting, having been used — most effectively by Georgia
O'Keeffe and Arthur Dove — by artists unwilling to surrender to
flatness. Skirting the issue of flatness was distasteful to many of
Dzubas' peers, especially Kenneth Noland. But it allowed Dzubas to
maintain selective degrees of illusion which he found necessary to
the expressive perfection of his color relationships.

MP

1. Charles W. Millard, *Friedel Dzubas* (Washington, D.C.: The Smithsonian
Institution Press, 1983), 27.

2. Millard, 28-29.

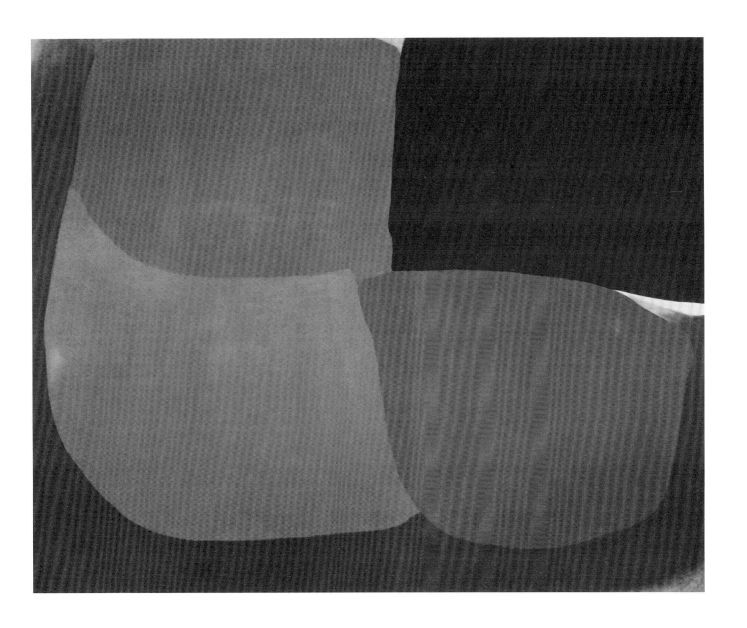

Dan Flavin

UNTITLED
1966
96 x 19 1/2 x 4 1/2 inches
Fluorescent light fixtures
The Albert A. List Family Collection
Catalogue No. 11

PROVENANCE
Unspecified

BIOGRAPHY
Born Jamaica, New York, 1933. Serves in U.S. Army. Studies painting and art history in new York, 1956. Executes quasi-Abstract Expressionist works, to 1961; Icons, 1961-63. First self-sufficient fluorescent light sculpture, *The Diagonal of May 25, 1963* (1963) shown in *Black, White and Gray*, Wadsworth Atheneum, Hartford, 1964.

The present work shows an interest not only in the creation of a minimally inflected object through the use of prefabricated materials, but also in the ways in which deviations from the norms established by those materials can invest such an art work with interest and significance beyond itself. Thus, in the world, which the artist knows must be recalled in the experience of such works of art, lighting fixtures appear overhead to provide light, and not, as here, placed on the wall to confront the viewer nakedly, and are further different from this work in that they are most often constructed of tubes of equal lengths in order to provide even illumination. Through the transformation of an industrial model, *Untitled* immediately conveys an aesthetic intention on the artist's part, but must be seen as well as conversing with and reinforcing the mental presence of the cognitively pre-existent model from which it deviates. In this way, *Untitled*'s aim to constitute a medium for perceptual investigation and to stress the participatory character of aesthetic experience is extremely similar to Robert Morris' fiberglass sculpture (Cat. 25).

Although *Untitled*'s simplicity urges a reading as a unified, single shape, the particular configuration of these tubes around a central void forces the object to be read as both relying on the wall as support, and as independent of it. This reinforces the intention of the artist to refer not only to pre-existing, prefabricated objects, but also to the history of painting. These groupings of fluorescent fixtures tend to recall in three dimensions the stripe paintings of Morris Louis. Here, the relationship between the cool white tubes and the wall from which they are partly liberated lacks the *pictorial* tension between empty ground and pure sensuous color essential to the success of Louis' work. In effect, these too literal restatements, almost Pop

transformations, of Louis' pictorial ambitions function as an implicit critique of the notion of the pictorial per se.

Thus, *Untitled* must be read as both dependent on and adversarial to the tradition of monumental abstract painting as it is exemplified in Louis' work, which had, by the early sixties, acquired almost a talismanic significance for the pictorial investigations of Kenneth Noland, Helen Frankenthaler and Jules Olitski. In effect, Flavin shares with Robert Morris and Donald Judd an attitude of ambivalence to canonical modernism. However, more like Sol LeWitt's quasi-pictorial sculpture (Cat. 18), with which *Untitled*'s formal arrangement bears obvious comparison, this ambivalence is expressed most explicitly in the work of art itself. That Flavin's metamorphosis from a pictorial vocabulary to a sculptural one was at least in part ideologically charged, is evident in the artist's sudden and historic conversion in 1963 from an idiom still close to painting to a style employing completely non-"artistic" materials.

Flavin's use of lighting, then, can be seen to have proceeded gradually towards, and ultimately beyond, Louis' ambition to liberate color from both line and surface. This ambition (and the aesthetic polemic it contains) was emphasized by the placement of a photograph of one of Flavin's first fluorescent sculptures next to Donald Judd's call to arms in the latter's 1965 article "Specific Objects":

> Three dimensions are real space. That gets rid of the problem of illusionism and of literal space, space in and around marks and colors — which is riddance of one of the salient and most objectionable relics of European art. *The several limits of painting are no longer present.* . . . Actual space is intrinsically more powerful and specific than paint on a flat surface."[1]

However, the fact that the tubes of Flavin's *Untitled* remain bound to a wall which is forced to function as a quasi-pictorial support, but from which it asserts its independence, further reinforces the work as both assertively "minimal" and anti-pictorial. In contrast, Flavin's post-1966 work became increasingly three-dimensional and thus more conventionally sculptural.

If Flavin's wall-mounted fluorescent fixtures are ultimately to be considered important as works of art, it is not only as instigators of perceptual self-consciousness in a way that is typically Minimalist, but also as acknowledgements of the polemical function of art that is one of the Minimalists' most lasting and subversive assertions regarding the character of aesthetic relevance.

MFM

1. Donald Judd, "Specific Objects," reprinted in *Complete Writings 1959-1975* (Halifax: The Press of the Nova Scotia College of Art and Design, 1975): 184. Italics added.

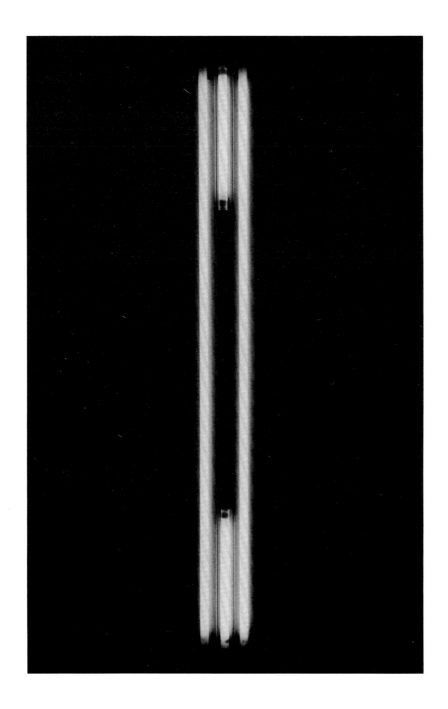

Helen Frankenthaler

PARKWAY
1966
101 x 24 inches
Acrylic on canvas
Collection of the artist
Catalogue No. 12

BIOGRAPHY

Born December, 1928 in New York City. 1946-49, attends Bennington College; studies with Paul Feeley. Meets critic Clement Greenberg, 1950; studies for three weeks with Hans Hofmann in Provincetown. First one-person exhibition at Tibor de Nagy Gallery, 1951. Marries Robert Motherwell in 1958. Retrospective show directed by Frank O'Hara, Jewish Museum, 1960. Begins to use acrylic paints in 1962.

Although Helen Frankenthaler provided what amounted to a new artistic direction using her innovative soak/stain technique in *Mountains and Sea* (Plate 2) of 1952, it was an aesthetic direction she did not explore for several years. The soak/stain technique served her by reducing the facture inherited from Abstract Expressionist painting. But she negated the inherent tendency of the stains to form luminous flat areas of color, instead retaining a vocabulary consisting of thick, linear drawing, as well as the spills and splashes which still registered as Expressionist in character.

In the early sixties, Frankenthaler significantly reduced the complexity of visual incidents in her paintings and began centering her images within tracts of bare canvas. The combination of these two factors directed attention toward color and a new-found preference for flat shapes manipulated out of the puddles and pools formed by pouring paint on a flat surface. In allowing the nature of stained paint to be freely felt in her pictures, Frankenthaler managed to wed her technique to her form.[1] By 1964 — with a firm control of an acrylic medium — Frankenthaler embarked on a group of paintings which make use of a similar format and together constitute something like a series (*Tangerine*, *Interior Landscape*, and *Buddha's Court* are examples). Each painting consists of a centered shape (or groups of shapes) surrounded by areas of luminous, billowing color extending to the edges of the picture. In *Buddha's Court*, 1964, the central image is encompassed by three successively larger rectangular fields which roughly mimic the proportions of the canvas. However, Frankenthaler remains unwilling to surrender color to structure, and there is little exactness to the rectangles which veer away from strict geometric depiction. Critics have noted that there is a "clash of two temperaments"[2] contained within the 1964 paintings: the strength of an inclination to allow color to dictate form which is opposed to a desire to construct a stable format and test its reusage.

Parkway, 1966, is an elongated rectangle consisting of eleven "shapes" or "bands" of color. Interspersed are four sections in which the ground is visible. The colors of various sections are green, blue-green, yellow, red or brown, with the brightest and darkest tones set opposite each other at the narrow ends of the picture. One of the two yellow sections is resting against the bottom edge of the canvas, and the brown section abuts the top edge. Each area of color fully extends to the right and left edges of the painting, and because of the painting's relatively slight width (24 "), each of the areas can be read alternately as a regularized "band" of color (implying continuity beyond the framing edge) *or* as a specific shape contained and fully realized *within* the painting's edges. The individual sections of the picture bear individual characters, with the red areas being more regularized and "band-like," and the green sections providing for a more biomorphic reading.

The elongated nature of the picture support seems uniquely American and particularly endemic to this period, with its usage being explored as well by Friedel Dzubas and Jules Olitski. Additionally, this format was successfully used by members of the preceding generation, most notably Jackson Pollock and David Smith. For Frankenthaler, the narrowing of the picture field which occurs in *Parkway* allows for a heightened attention to detail which is lost in larger compositions. *Parkway* manages to elucidate, in an extremely self-conscious fashion, the nature and accomplishment of Frankenthaler's other pictures from the period. The painting focuses and defines the way in which she uses the edge of her shapes and fields to construct space, abstractly yet with optical relief. The use of sharp edges contrasted against soft (bled) edges denotes pictorial depth and distance, and reinforces the landscape motif present in much of her painting. But as well, *Parkway* demonstrates the expressive potential of her edges, a quality often sacrificed in her large-scale paintings.

Parkway is a painting very much of its period. In many ways it is a response to the painting being produced by the new masters of the early sixties, especially Noland and Stella. The manipulation of areas of clear color within a restricted framework with reduced facture are all conditions of this period. But additionally, *Parkway* harbors potentials which Frankenthaler realized in other paintings produced after its execution. In the years after 1966, Frankenthaler's paintings followed two directions: the first continuing her concern with surface, color saturation, and tonal relationships, and the second path involved with developing a minimal complement of shapes to construe a fairly complex spatial construction, restrained and direct in character.[3] Each of these concerns is present in *Parkway*, with its stack of seemingly straightforward shapes of uninflected color, displaying endless variation within a context of simplicity and restraint.

MP

1. Barbara Rose, *Frankenthaler* (New York: Harry N. Abrams, 1971), 90.

2. E. C. Goossen, *Helen Frankenthaler* (New York: The Whitney Museum of American Art, 1969), 14.

3. Rose, 100-02.

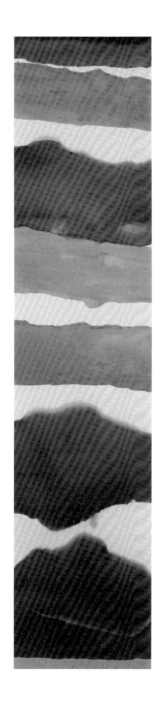

Al Held

TWO CIRCLES
1965
83 1/4 x 53 1/2 inches
Oil on canvas
Courtesy Andre Emmerich Gallery
Catalogue No. 13

PROVENANCE
Unspecified

BIOGRAPHY
Born in Brooklyn, New York, 1928. Studies at Art Students League
under Harry Sternberg, 1948-49 and at the Academie de la Grande
Chaumière, Paris, 1950-52. Associates with other American artists in
Paris, including Ellsworth Kelly, Jack Youngerman, George
Sugarman, Sam Francis, Jules Olitski, Kenneth Noland, 1950-52.
Returns to New York in 1953; works as a carpenter, truck driver and
on road construction in San Francisco 1954-55. Starts removal
business in New York, 1955-60. Founder, with others of Brater
Gallery, New York, 1956. Associate professor of Art, then professor,
Yale University, 1962-68. Recipient of Logan Medal, Art Institute of
Chicago, 1964, and Guggenheim Fellowship, 1966.

At the end of the 1950's, Al Held's painting placed him within a
group of so-called "second generation" Abstract Expressionists who
worked from the principles of Abstract Expressionism, but relin-
quished many of the socio-political attitudes of the original group.
Held's canvases, thickly laden with pigment and worked in broad
gestural brushstrokes were his answer to a felt need for greater clarity
within the tradition of contemporary painting. By 1960-61, Held had
moved to define with increasing force abstract shapes within his
painting field, finally settling on large-scale geometrically abstract
structures.

Two Circles, 1965 is a characteristic example of the maturity of
this manner of Held's work. In it he uses two large geometric forms
with great formal and chromatic clarity, emphasizing both their indi-
viduality and interrelation in the picture field. Held gives his simple
forms individuality by cropping them, and their immense scale in re-
lation to the picture field ultimately gives them a feeling of enormous
weight, monumentality and oneness. The white space of the ground,
especially in the narrow area between the two shapes is activated by
the compression of the large shapes and their implied potential to
converge.

Often in works such as this, Held would begin a canvas with irreg-
ular biomorphic shapes and continually overpaint them until arriving
at essentially geometric shapes. His approach to the structure is
therefore distinct from that of Noland, Kelly and Stella who develop
their painting with a preconceived notion of structure. Held reworks
the forms until he perceives their resolution within the field. This
process results in a heavy layer of pigment on the canvas and, in the
case of *Two Circles*, a visible deposit of brushmarks which move
around the surface in response to the contours of the forms, reinforc-
ing their shapes and modifying their color presence.

The surface with its evidence of the artist's process and the rela-
tionship between the shapes and ground suggests Held's position
outside of both Abstract Expressionism and the mainstream moder-
nist painters of the mid-sixties although he remains responsive to
them. Held's approach is not theoretical but empirical, involved
more with process than with modernist canons. That Held was in-
cluded with these artists in most of the major contemporary shows in
the mid-sixties indicates that he shared at least some of their formal
predilections. But discussions of his work often misinterpreted the
extent and character of his sympathies with so-called Hard-Edge
painting.

MF

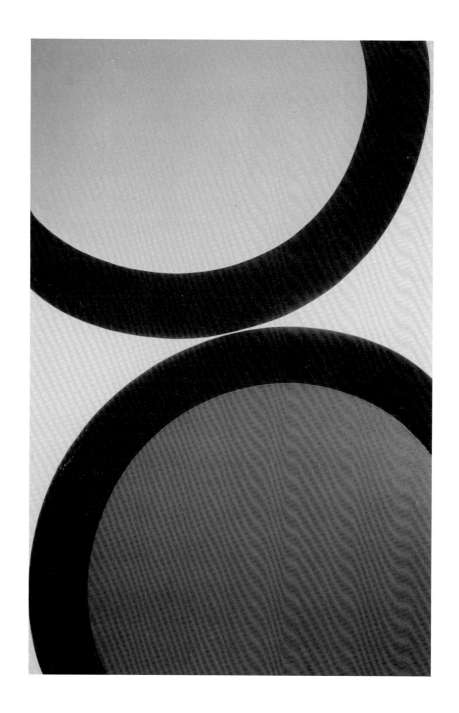

Robert Indiana

THE RED YIELD BROTHER IV
1964
68 x 68 inches
Oil on canvas
Stenciled on verso, "Robert Indiana, The Red Yield Brother IV, New York, Coenties Slip, 1964"
Collection of Ruth and Jerome Siegel
Catalogue No. 14

PROVENANCE
Stable Gallery, New York

BIOGRAPHY
Born New Castle, Indiana, 1928. Studies at the Munson-Williams-Proctor Institute, Utica, New York, 1947-48. Attends School of the Art Institute of Chicago, 1949-53 (B.F.A.). Receives scholarship to attend the Skowhegan School of Painting and Sculpture, summer 1953. Studies at the University of Edinburgh and the Edinburgh College of Art, Edinburgh, Scotland, 1953-54. Moves to Coenties Slip in Manhattan and meets Ellsworth Kelly, Agnes Martin and James Rosenquist. MOMA acquires *The American Dream* in 1961. First one-man show at the Stable Gallery, 1962. Participates in MOMA's *Americans 1963* and Sidney Janis' *New Realists* exhibitions. Collaborates with Andy Warhol on the film *Eat*, 1964. Exhibits at the Corcoran Biennial, 1965. *Love* show at the Stable Gallery, 1966.

Following Rauschenberg and Johns, Indiana featured in his mid-sixties work the representation of factual objects such as numbers and letters. But, while his predecessors retained a degree of fifties painterliness, gesture and treatment of surface through the sixties, Indiana's work reflected a cooler sensitivity. A self-proclaimed "American painter of signs," Indiana's paintings became a forum for the promotion of his personal social concerns. These messages were articulated and supported by a strict geometry of form and a pure, saturated palette.

Fascinated by highway signs and other roadside advertisements, Indiana borrowed the geometric shapes of these highly visible, almost ubiquitous objects, incorporating them along with stencil lettering into his work. Living in a loft at Coenties Slip (a building which also housed Ellsworth Kelly, James Rosenquist, and Agnes Martin among others) Indiana was acutely aware of the continual procession of trucks, railroad cars, and ships seen from his loft window. These with their identifying markers provided yet another typographic source.

The Red Yield Brother IV carries the plea for worldwide peace made by British political activist, Bertrand Russell in the early sixties.[1] Indiana first chose the familiar yet provocative, roadside "model" to carry this message of universal pacifism in *Yield Brother*, 1962 (The Bertrand Russell Peace Foundation, London, England). Indiana concurrently used the word "yield" as a public statement against integration struggles in the South. In the present piece Indiana addresses the family of man as a whole, father, mother, sister, brother. The idea of a warning is articulated not only in the word "yield" but in the strict geometry of the composition as well. The work is comprised of four panels, hung diagonally to form an overall diamond shape, a constant device in Indiana's work during the sixties, operating well as a support for circular signage. Indiana juxtaposes flat but bold hues of red and yellow to create a vibrant intensity which reinforces the importance of his personal warning against racism. The emblematic circles placed within the rigid confines of the triangular panels support the words separated by smaller yellow dots. The stenciled letters arranged around the circles ultimately became Indiana's overt semiotic code. The inner circle is divided in two by yellow semicircles, the space between them boldly outlined in crimson.

The hard-edge quality established by tight geometry and stenciled letters is further reinforced by pure, saturated colors. Indiana was undoubtedly influenced in matters of color and clear shape by his neighbor and friend, Ellsworth Kelly whose preoccupation with simple shapes and a vivid color resounds in Indiana's work.

JW

1. John W. McCoubrey, *Robert Indiana* (Philadelphia: The Institute of Contemporary Art, 1968), 15.

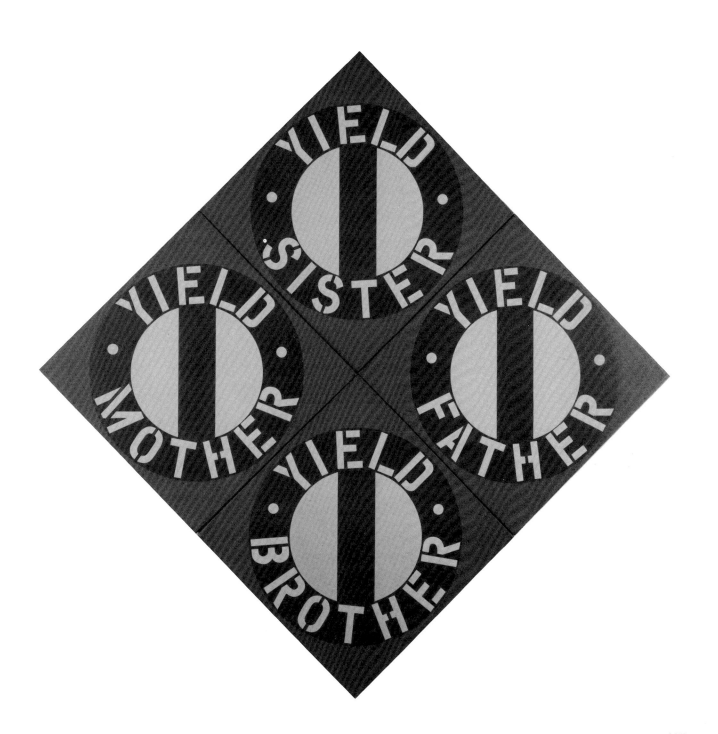

105

Robert Indiana

LOVE
1965
12 x 12 inches
Oil on canvas
Collection of Betsy B. Jones
Catalogue No. 15

PROVENANCE
Stable Gallery, New York

Love was one of the most evocative and familiar images from the mid-sixties, later evolving into the quintessential "sign" of the culture during the period as that culture was universally understood.

In the *Love* paintings Indiana was primarily involved with color functioning both through contrasting intensities and clear, busy shapes. Indiana relies on the juxtaposition of precise boundaries of saturated color to create pictorial interest, reminiscent of contemporary work by Ellsworth Kelly. For the *Love* structure Indiana has divided the word in half, stacking the letters so that VE forms the base supporting L and a leaning O. This economical graphic arrangement provides for a potent, compact composition and simultaneously allows the artist to interrelate the letters to form a distinctive linear structure that appears to exist on a separate plane opposing the field of flat color. The brilliantly dense red letters react strongly to the concentrated cerulean ground. Yet, this intense contrast of color serves ultimately to connect figures and ground into a singular pictorial unit.

According to Indiana, *Love* grew out of an earlier autobiographical work which refers to the artist's childhood experiences in the Christian Science Church. Indiana was struck by the stark church interior where the only decorative element allowed was the inscription, usually in gold, "God is Love."[1] In 1964 Indiana incorporated the reversal of this religious motto into a painting for Larry Aldrich, whose collection of contemporary art was housed in a deserted Christian Science Church. In *Love is God*, 1964 (Larry Aldrich Museum, Ridgefield, Connecticut) the stenciled words have been isolated in a circle which floats on a spectrum of color radiating from the center of the diamond-shaped canvas. *Love* is closely related to Indiana's earlier work which revolves around a group of monosyllabic verbs such as "eat," "die," "hug," and "err," that collectively constitute Indiana's well publicized philosophy articulated in the *American Dream series*, begun in 1961. *Love* however, lacks the overt moralistic and social message conveyed in both *The Red Yield Brother IV* and *The American Dream*, 1961 (The Museum of Modern Art).

JW

1. Robert Indiana in Barbaralee Diamonstein, *Inside New York's Art World* (New York: Rizzoli, 1979).

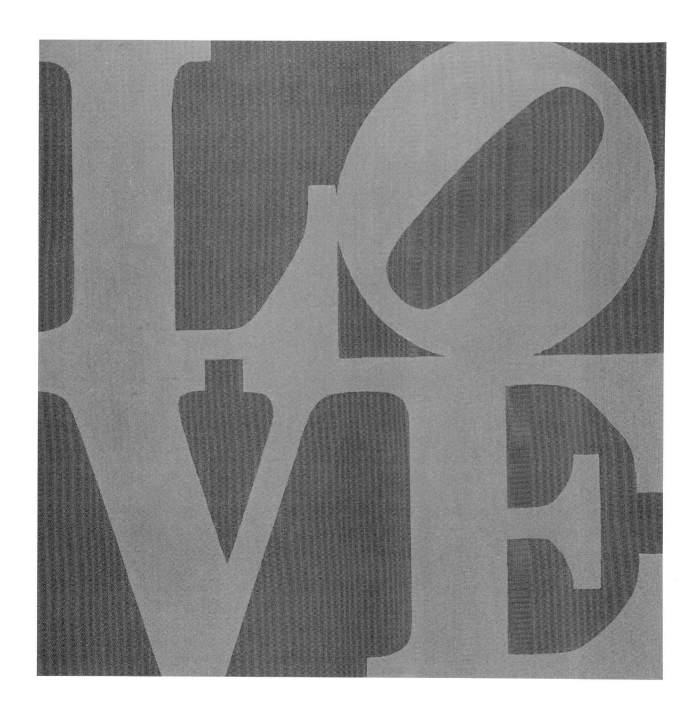

Donald Judd

UNTITLED
1965
20 x 48 x 34 inches
Stainless steel, amber plexiglas, wire
Courtesy Leo Castelli Gallery, New York
Catalogue No. 16

PROVENANCE
Unspecified

BIOGRAPHY
Born in Excelsior Springs, Missouri, 1928. Attends College of
William and Mary, 1948-49; Columbia University, 1949-53 (B.S. in
Philosophy), 1958-61 (Fine Arts Department); Art Students League,
New York City, 1947-53, Columbia, 1957-62 (M.A.). Since 1959,
critic for art publications, especially *Arts Magazine*. Lives in New
York and Marfa, Texas.

In the early sixties, Donald Judd emerged as one of the most important period critics, as well as one of New York's most important artists and theorists. Judd himself saw his work as neither painting nor sculpture, recognizing instead that his "Specific Objects" offered new aesthetic experiences devised in such a fashion as to function both alone and as critiques of previous work. Judd's earliest work had consisted of wall-mounted wood and metal reliefs. These then were followed by a group of box-like structures, usually hand-made and constructed of wood. His work took on its characteristic "mature" quality with the use of machined forms fabricated from sophisticated materials such as plexiglass, steel and anodized aluminum.

Untitled of 1965 is a structural, perceptual and conceptual whole. Its obdurate physical presence forces it to be *seen*, not *read* in an illusionistic manner related to painting or gestural sculpture. Physically it consists of two slabs of stainless steel and three slabs of amber plexiglass. The shorter, stainless steel ends are highly reflective, effortlessly appropriating density and texture from their surroundings. The plastic top and sides both ally and oppose themselves to the steel. They are rigid and strong. Sometimes they are reflective, like the steel, and become effectively opaque. Usually, however, they are transparent, permitting a viewer to see through them. Echoing the reflective steel, the transparent view they permit is modulated by the material—seeing through the plexiglass is slightly soft, slightly unsteady, not quite certain. But the color of the plexiglass is sticky, soft and warm, everything the steel is not. Importantly, the color is intrinsic to the material, an integral characteristic—not something applied as to a surface. Because the color is visible only with the pas-

sage of light *through* the material, it makes light integral to the piece, not merely a reflective surface condition.

The steel has no more or less structural function than the plexiglass. It is more rigid but it is not made to work any harder. *Untitled* is constructed so as to reduce to an absolute minimum the number of forming pieces. This simultaneously reduces the amount of order needed to formulate or apprehend it, one of Judd's stated objectives. The piece does not even have a bottom, assuming location on a hard, flat, gallery floor for its static completion. In order to make immediately clear that it is made of thin flat slabs of great strength, yet with the whole forming a graceful, airy volume, the piece is not joined at the corners. Instead, five wires put the steel in tension, the plexiglass in compression, imploding the surface planes together until they create a definite volume.

Together, all the parts make a unique whole, sufficiently clear as to permit it to be seen in relation to prior sculpture and painting, reflexively commenting upon and criticizing them by its presence. In their pristine clarity, their lack of modulation, and their flat strong color the plexiglass panels share much with contemporary Color-Field painting. Situated vertically as the sides of a box, they assume the vertical orientation of traditional painting. However, by being placed with their lower edge on the floor, instead of on a wall, we see their flatness and their thickness much more strongly—their transparency making us aware of their presence as *object*, in a manner parallel to what is sensed in an oblique view of Frank Stella's deep stretchers.

The polished stainless steel is reminiscent of constructed sculpture, particularly David Smith's carefully abraded and burnished surfaces. Judd, however, does not wish to mark his material with kinesthetic gesture, and so has the steel mechanically brought to a finish that becomes utterly *impersonal*.

Untitled's shape is expressive of Judd's intention to banish any totemic presence from his work. It lies on the floor, relatively low, making it unlike an upright person. It is a box, a shape given by geometry, not an arbitrary manipulation of elements. As a geometric solid, it does not require an arbitrary compositional order, but seems to *have* an intrinsic order rather than to display a given one. Its scale is definite—it is too large to be ignored, too small to be architectural, large enough to be a literal and powerful presence. It is a piece of sculpture that begins by attempting to be what most pre-Minimal sculpture is not—and ends by becoming something definitively new. For Judd, "The difference between the new work and earlier painting and present sculpture is like that between one of Brunelleschi's windows in the Badia di Fiesole and the facade of the Palazzo Rucellai, which is only an undeveloped rectangle as a whole and is mainly a collection of highly ordered parts."[1]

CC

1. Donald Judd, "Specific Objects," *Complete Writings 1959-75* (Halifax: Press of the Nova Scotia College of Art and Design, 1975), 187.

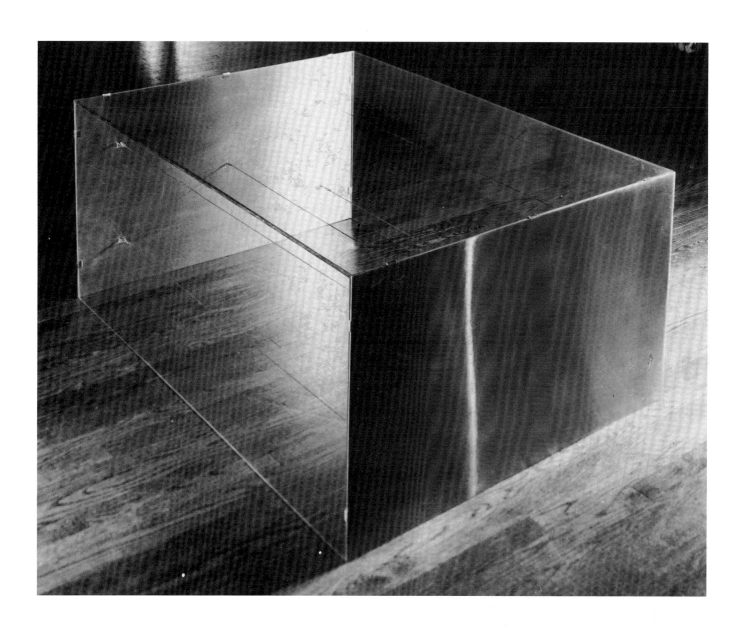

Ellsworth Kelly

WHITE OVER BLACK
1963
72 x 76 x 8 inches
Painted aluminum
The Albert A. List Family Collection
Catalogue No. 17

PROVENANCE
Unspecified

BIOGRAPHY
Born 1923. Attends Pratt Institute of Design, Brooklyn, New York, 1941-43. Military service 1943-45. Attends School of Fine Arts, Boston, 1946-48. Residency in Paris, 1948-54. First exhibition in New York at the Betty Parsons Gallery, 1956. Participates in *The Annual Exhibition of Contemporary Painting and Sculpture*, Whitney Museum of American Art, *'54 - '64: Painting and Sculpture of a Decade*, Tate Gallery, London and in *Post-Painterly Abstraction*, Los Angeles County Museum of Art, 1964. Wins first prize at the *Pittsburgh International Exhibition of Contemporary Painting and Sculpture*, Carnegie Institute and is included in *The Responsive Eye*, The Museum of Modern Art and *The Annual Exhibition of Contemporary Painting*, Whitney Museum of American Art, 1965. Exhibits at the XXXIII Venice Biennale; participates in *Primary Structures*, The Jewish Museum, *The Annual Exhibition of Contemporary Sculpture and Prints*, and *Art of the United States: 1760-1966*, both at the Whitney Museum of American Art, 1966. *American Sculpture of the Sixties*, Los Angeles County Museum of Art and *International Exhibition*, Guggenheim Museum, 1967.

Ellsworth Kelly's formative years were spent in Paris (1948-54) where he was greatly influenced by Jean Arp's raised wooden reliefs of biomorphic and "automatic" shapes. Kelly's work of the sixties is also indebted to Matisse's bold, late cutouts which reduced figuration to large planes of flat color. Upon his return to America, Kelly continued to work, relatively isolated from his contemporaries. Though his work from the sixties has affinities with proponents of the "shaped canvas" and the Minimalists, his development was "resolutely innerdirected: neither a reaction to Abstract Expressionism nor the outcome of a dialogue with his contemporaries."[1]

For Kelly the most significant formal element was shape. In the mid-sixties shape became in fact the subject matter for Kelly's work. *White Over Black* is a painted aluminum relief, perhaps the first of a series produced in 1963 which anticipates and conditions much of Kelly's painting and sculpture throughout the mid-sixties. As the title announces, the thickly painted white shape anchored to the upper right corner is diagonally suspended, and gradually liberated from the surface, several inches over an undifferentiated black field. It thereby disrupts the continuity of the picture plane and challenges the traditional concepts of the painted surface. Prior to the reliefs Kelly relied on intense color contrasts to distinguish shape. By raising the white bar the optical confusion dissipates and the shape is made to project physically. Shape and field are no longer interchangeable, nor are there any ambiguous figure-ground relationships.

The shape employed by Kelly in this relief is unlike the "capsule," a dominant form in 1963. Rather it is suggestive of Kelly's earlier Paris abstractions such as *Cité* of 1951 (collection of the artist) which were inspired by fragments of natural and architectural forms or by the patterns of their shadows. This arbitrary shape, close in form to an irregular rectangle lies tangential to the edge of the support. The shape intrudes aggressively onto the black field and asserts pressure on the edges to define and articulate some composite of shape and field. The shape goes soft, bowing out mid-way across the field, impinging on the black to create increasingly greater pictorial tension. Despite the minor edge inflections, it remains taut as it stretches across the support. By flaring the form and extending it over the limits of the support, accentuating the work's multiple dimensionality, the white shape can now exist in actual space, no longer confined to the boundaries of the picture plane.

The absence of the "sensual" color that appeared consistently in Kelly's mid-sixties work can be accounted for by the fact that Kelly systematically reverts back to black and white when his work undergoes a major change in shape and scale. Black and white provide the purest definition of form and allow Kelly to concentrate on light-dark relationships that will later be translated into color.

JW

1. William Rubin, "The Big as Form," *Artnews* 62, no. 7 (November 1963): 34.

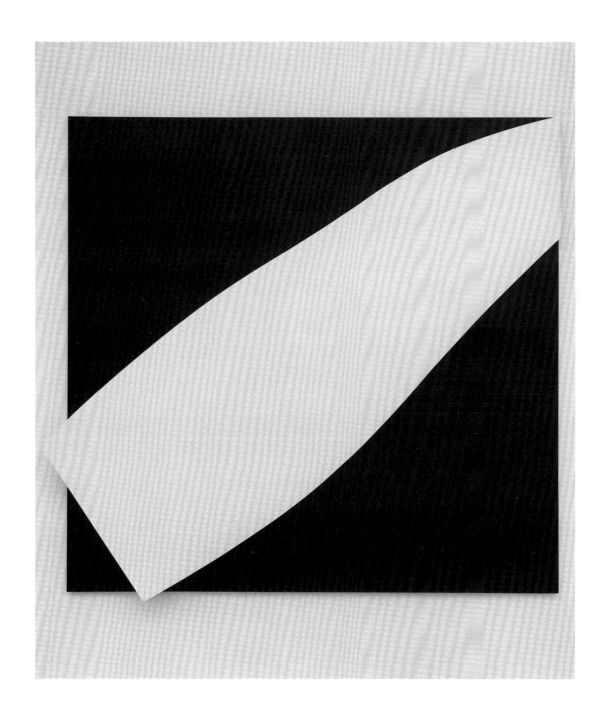

Sol LeWitt

UNITITLED
1964
72 x 72 x 3 inches
Painted Wood
The Sol LeWitt Collection, Courtesy of the Wadsworth Atheneum
WATL146.593.1976
Catalogue No. 18

PROVENANCE
The artist

BIOGRAPHY
Born Hartford, Connecticut 1928. Attends Syracuse University
1945-49. Serves with U.S. Army in Asia, 1951-52. Moves to New
York, 1953, where he attends Cartoonists and Illustrators School.
1954-55, various jobs in graphic design. Works as clerk and
receptionist at the Museum of Modern Art. First constructions, 1963;
first white modular cubes, 1965.

This LeWitt grid is perhaps the most aggressively and self-
consciously "Minimal" work in the present exhibition. Black, blank
and silent, it possesses no analogue to natural appearance or process
— its glossy surface betrays no trace of the artist's hand. The square
shape of the work shows no capacity for expansion or transforma-
tion. One does not learn more about the work through the experi-
ence of it — it is immediately present in its totality. The artist's
choice of the particular geometric configuration enhances the sense
of containment. A quadripartite division would focus attention on
the central crossing of the mullions. Here, a void repeats the shape of
the periphery, but the scale of the work prohibits the elaboration of
any additional relationships.

The work forms part of a series of black grids, fabricated just be-
fore the white three-dimensional grids for which the artist is better
known. The later grids evince, more than mere seriality, an interest
in incompleteness and transformation, becoming rather than being
as such. The white grids, however formally self-sufficient, demand a
knowledge of the series for a full understanding of their meaning.
They are randomly and cumulatively reactive to their environment,
deflecting light and susceptible to shadowing. In the present piece,
the black surface absorbs the light, emphasizing the work's singular
detachment from its environment.

This work occupies a medialogically indefinite position between
painting and sculpture, a primary characteristic of Minimalist works
in general. Its formal elements recall earlier twentieth-century prec-
edents, specifically those of Mondrian and Malevich, without, how-
ever, developing any of the tension between grid and ground that
would make the wall serve as the latter. In terms of its carved-out
quality, the work suggests a Stella-like deduced structure, where an
identity is created between literal and depicted shape. Yet, while this
structural ideology may have led, in Stella, to a painting approaching
the object conditions of sculpture and susceptible to virtually endless
variation, LeWitt's adoption is the more radical historically, both in
terms of its radical definitiveness and its closure to variation. The
work's placement on the wall, rather than as a freestanding sculp-
tural piece, encourages an interpretation of it as constituting at least
in part a polemic against painting, rather than a liberation of it.

MFM

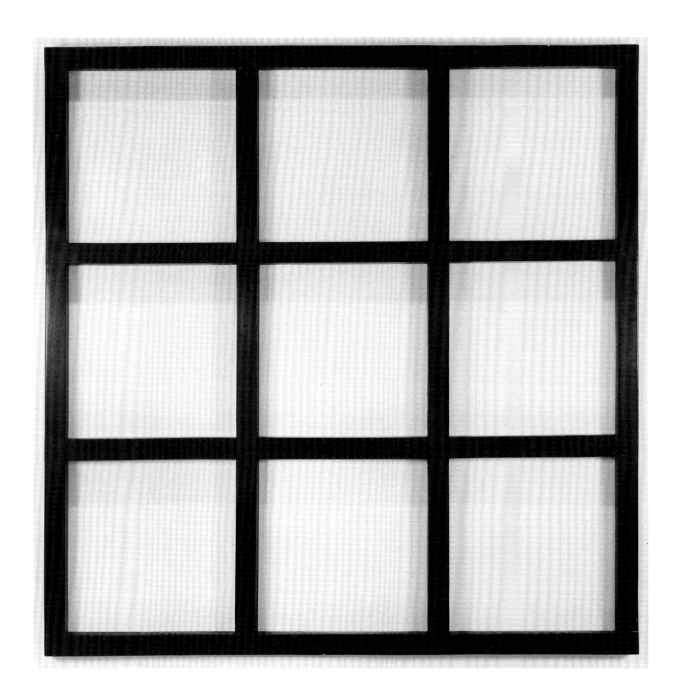

113

Roy Lichtenstein

ARCTIC LANDSCAPE
1964
23 1/2 x 29 1/2 inches
Oil and magna on plexiglass
Yale University Art Gallery
Gift of the Woodward Foundation
1977.49.15
Catalogue No. 19

PROVENANCE
Unspecified

BIOGRAPHY
Born New York City, 1923; studies at Art Students League, New York with Reginald Marsh, 1940; completes advanced degrees at Ohio State University, 1949. Teaches at State University of New York at Oswego, 1957-60; becomes professor at Rutgers University, 1960; begins to use cartoon images and commercial printing techniques, 1961. First one-man exhibition at Leo Castelli Gallery, New York, begins reproductions of Cézanne, Picasso and Mondrian, 1962; first European one-man exhibition at Galerie Ileana Sonnabend Paris, 1963. Begins paintings of monuments, landscapes and brushstrokes, 1964; works in ceramics, begins sculptures, 1966.

Recasting the process of perceiving as an independent experience has always been of primary importance to Lichtenstein. Identifying and dissecting the sustaining effects of visual experience forms an integral part of his work. *Arctic Landscape* appears in this vein as a visual construction. The thick aluminum frame creates a shallow rectangular box, covered in the front by a transparent sheet of glass onto which Lichtenstein's familiar dots are painted in full and half tones of blue. On the lower half of the plexiglass screen are painted the yellow hills of the landscape, compressed into the frame by thick undulating outlines. On the upper half of the glass sheet a white band of cloud is painted. Behind the dulled transparent surface lies an opaque screen separated by the thickness of the aluminum frame. Its surface is painted with a complex configuration of dots structured so that they appear in continual collision with their plexiglass counterparts. The painting is engineered so that visually, one experiences optical fluctuations and shifts of colored dots which cluster to form illusionistic patterns representationally resembling cloud formations. The overall effect is reminiscent of the moiré dazzle of sixties Op art. Against these constant fluctuations of blue dots the solid white and yellow surfaces provide restful interludes. The insistent compression of shapes against the plexiglass surface refuses to yield to plane-recession dynamics. The result is an impenetrable landscape in which spatial movement occurs vertically or laterally.

Lichtenstein's originality lay in his complete mastery of the Ben-Day dot technique which he used as a process for re-interpreting visual experience. By 1964 he abandoned comic book imagery as too distracting for his empirical investigations into the process of seeing. His re-interpretations of Cézanne, Mondrian and Picasso are most overt as analyses of visual structure. But these works are too burdened by the weight of historical familiarity. The process of reduction to essential visual experience is most effectively realized in his landscapes.

Lichtenstein's erudite re-reading of perceptual moments in painting and his re-routing of them into twentieth-century terms can best be seen by comparison with the general structure of nineteenth-century romantic landscape painting,[1] which *Arctic Landscape* shares through its great expanse of sky, low horizons and muffled, compressed surfaces given to lateral reading. However, Lichtenstein's twentieth-century re-interpretation of the romantic format moves beyond the atmospheric sonority inherent in the nineteenth-century cultivation of the sublime landscape. Lichtenstein extracts from his image the purity of optical sensations, " . . . the landscapes and finally his microscopic analyses of the traditional language of painting illustrate the successive stages reached in a clearly deliberate manner; for Lichtenstein always gives the impression that he is developing up to their logical conclusion previously established hypotheses."[2]

IE

1. In his essay "The Abstract Sublime," *Art News* 59 (February 1961) 38-42. Robert Rosenblum examines the influence of nineteenth-century landscape painting and the concept of the sublime on Abstract Expressionist painting. He creates a framework within which the stylistic similarities between nineteenth-century painters such as Caspar David Friedrich and the work of twentieth-century artists such as Mark Rothko, and Barnett Newman are defined. With this comparison in mind, the similarities drawn in the entry between nineteenth-century painting and Lichtenstein's painting emphasize both his links with the past and his revisionist program. Inevitably Lichtenstein's landscape, although indebted to the past, provides an image more closely aligned with the formal and optical concerns of painting in the sixties.

2. Alberto Boatto, "The Comicstrip Under the Microscope," *Lichtenstein,* ed. Alberto Boatto and Giordano Falzoni (Rome: Fantazaria, 1966), 58.

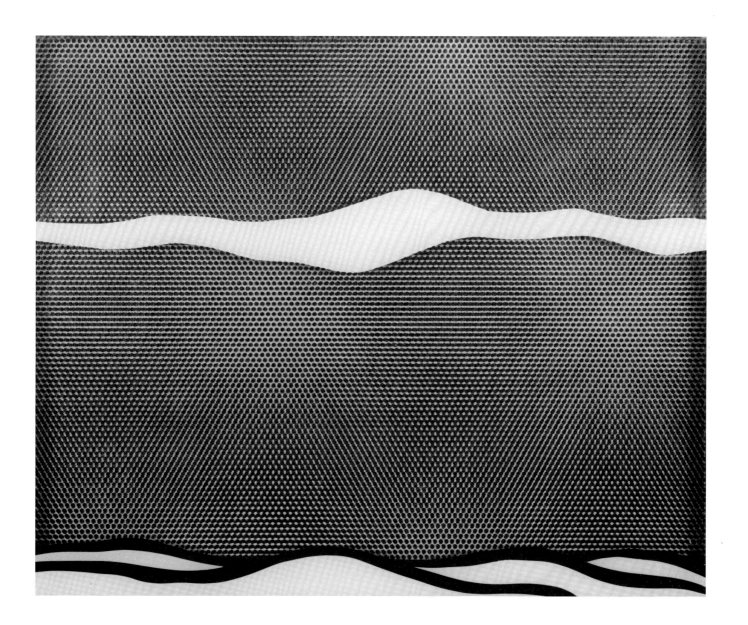

Roy Lichtenstein

LITTLE BIG PAINTING
1965
68 x 80 inches
Oil on canvas
Collection of Whitney Museum of American Art, New York
Gift of the Friends of the Whitney Museum of American Art
66.2
Catalogue No. 20 (NOT IN EXHIBITION)

PROVENANCE
Unspecified

Lichtenstein's brushstroke paintings, produced 1965-66, transform a recognized mode of representation into subject matter. In *Little Big Painting* the activated brushstrokes, emblematic of de Kooning and Kline, are ironic, yet obvious comments on the gestural characteristics of Abstract Expressionism which Lichtenstein's cool, commercialized tendencies flatly deny. The highly personal and emotional content of the brushstroke has been drained and simplified in Lichtenstein's industrialized style into a form characteristic of mass-produced imagery. Though the brushstroke clearly refers to Abstract Expressionist painters, the actual source was in fact a comic strip of a "mad" artist who crosses out the face of his rival with a large black brushstroke "X." Lichtenstein originally painted the artist's hand holding the brush while painting the "X." Later he focused on the actual commercial style used to render that "X."

Paradoxically, the highly charged, rapid strokes of a loaded brush are simulated by Lichtenstein's meticulous and manually neutral technique. The passionate, kinesthetic thrust of Abstract Expressionist brushwork has metamorphosed into calm arabesques. The quick, enmeshed strokes of vivid red and yellow emerge from broad, undulating sweeps of white which leave a residue of drips and splatters across the regimented field of blue Ben-Day dots. The juxtaposition and disparity between the two textures coalesce into an overall optical display allowing the colorful strokes to stand out boldly. Lichtenstein has limited his palette to intensely brilliant and concentrated shades of green, red, yellow and white, in clear reaction against the muddy richness of Abstract Expressionist color and in reference to commercial models. The consistency of Lichtenstein's paint application has been emphasized by emphatic black lines which imply the thick, carefully built-up ridges. More generous strokes produce drips and splatters which have been isolated on the background screen.

Little Big Painting, the first in the brushstroke series, was painted in the mid-sixties when the cooler, "commercial" styles of artists such as Lichtenstein, Warhol and Judd had displaced the preceding generation of gestural or "action painters" whose work it re-interprets. This was not the first reference to another artistic style made by Lichtenstein. Between 1962 and 1964, concomitant with his cartoon paintings, he executed several paintings which were based on well-known works by Cézanne, Picasso and Mondrian. These compositions like those of the brushstrokes, have been massively simplified and re-arranged by a series of lines and dots which become essential facets of their revised iconography and conform to Lichtenstein's intentionally commercialized style. Lichtenstein felt in each instance that he was altering, "a new work of art which has other qualities than the Picasso or the Mondrian or the Abstract Expressionist painting."[1]

JW

1. Roy Lichtenstein in an interview with Alan Solomon, reprinted in "Lichtenstein," *Fantazaria* 2 (August 1966): 38.

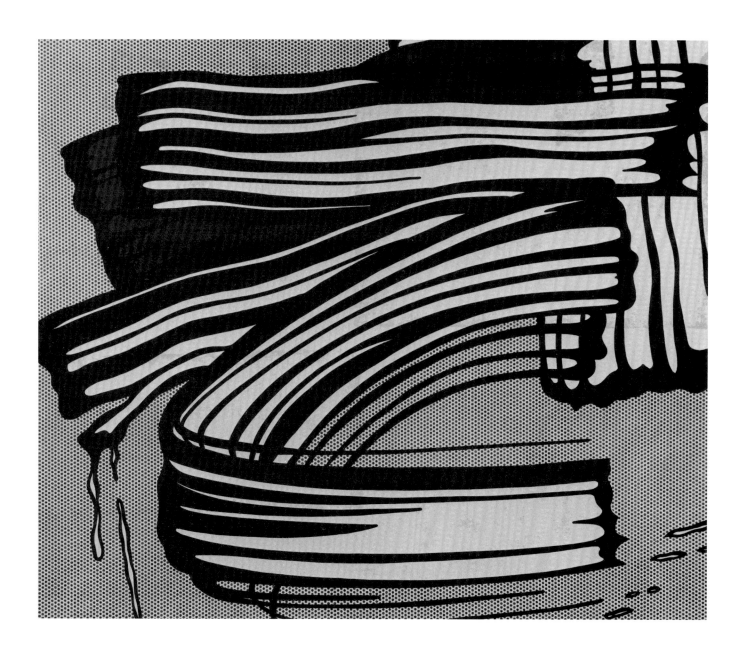

Marisol (Escobar)

BABY BOY
1962/63
88 x 31 x 24 inches
Wood and mixed media
The Albert A. List Family Collection
Catalogue No. 21

PROVENANCE
Unspecified

BIOGRAPHY
Born Paris 1930; studies at the Academie des Beaux-Arts, Paris, 1949; Art Students League New York, 1950; takes courses at the New School and studies with Hans Hofmann 1951-54 and begins exhibiting sculpture at the Tenth Street Gallery 1951-54. Attracts nationwide attention in *Life* magazine article, 1958; exhibits in Dorothy Miller's *Americans* show at the Museum of Modern Art in which she is given a room devoted to her work, and stars in Andy Warhol's movie *The Kiss* of 1963. Begins incorporating self-portraits in her sculpture, 1964; designs commissions for *Time* magazine and the *London Daily Telegraph*, 1967. Leaves America 1968; returns in early 1970's.

Marisol's child colossus marked a new stage in the development of her work. One moves from the narrow expressionistic wooden surfaces typified by the roughly-hewn figures in works such as *The Family* (1955) and *The Spectators* (1958) to fully self-contained images made with greater authority and considerable skill in projecting the formal reciprocity of elements within a sculptural unit.

The pivotal work in this regard was a 70" figure *ABCDEFG and Hi* made between 1961-62. But it is in *Baby Boy* that evidence of Marisol's full maturity is attained. This is clearly visible in the interplay of two- and three-dimensional elements, combined with penetrating mimicry of physiognomic characterization. Also evident is Marisol's development of a looser narrative structure as a framework for setting her sculpture. From the sixties onwards sculptural figures are arranged in small groups as self-contained yet thematically related objects. This method of display characterized her 1964 exhibition at the Stable Gallery in which *Baby Boy* formed part of a pair with *Baby Girl*, a sculpture of similar size shown seated alongside.[1]

In *Baby Boy* Marisol's use of tectonic forms, seen in the large rectangular box torso and massive tubular limbs which magnify the child-like physical gesture of the figure, captures its unselfconscious and ungainly stance. A moment of infant narcissism is made all the more forceful to the viewer by a large roundly carved hand which clutches the small doll. Like all Marisol's sculpture from the sixties, the creation of formal and psychic tension is attained by ambiguities between two- and three-dimensional shapes. In this work the brightly painted collar is played off against linear stripes, compressing them further into the flat wooden surface of the rectangle. The triangular wedge of the collar is echoed in the lower half of the figure. Here the tension between recognized imagery and abstract form fluctuates as the incised triangle delineates part of the figure's clothing but also resonates as a sculptural device against the painted elements, stressing positive and negative accents as well as the tensions inherent between literal and depicted shapes. These formal concerns are reminiscent of Ellsworth Kelly's *White Over Black* (1963), and Noland's *Off* (1965) (Plates 17 and 26).

Further tensions are created by intrusive fragments of ready-made items. The smoothly carved wooden hand juts out from the flat painted surface. Its three-dimensional structure is compromised by the arm to which it is attached. This abruptly collapses into the flatly painted structure of the torso. The photographic portrait of Marisol affixed to the doll's face is impassive, further establishing a textural counterpoint to the hand-worked areas of the sculpture, as does the "Marisol" doll placed centrally, which mimics the overlapping painted forms. The doll's cloth arms are spread outward and in turn overlap the baby's wooden hand in a physical projection of planes. The white cloth fabric of the skirt introduces yet another variation of surface texture.

Most critics in the sixties seemed reluctant to align Marisol too closely with contemporary movements with the exception of Pop art; which through its blatant use of found objects linked her most closely with the work of Robert Rauschenberg and Jasper Johns. Both pre-Columbian and Hofmann-derived Cubist principles have been attributed as viable influential sources in her work. *Baby Boy* reflects Marisol's deliberate attempt to field the entire range of contemporary artistic traditions, often making an "assemblage" of artistic devices. Her sculptures of 1964-66 reveal this in particular.

IE

1. *Baby Girl*, 1963 is in the collection of the Albright-Knox Art Gallery, Gift of Seymour H. Knox.

Agnes Martin

HARVEST
1965
72 x 72 inches
Acrylic and pencil on canvas
Vassar College Art Gallery
Gift of Mrs. John D. Rockefeller III (Blanchette Hooker '31)
71.336
Catalogue No. 22

PROVENANCE
Unspecified

BIOGRAPHY
Born in Saskachewan, Canada, 1912. Comes to United States in 1932. Attends several universities, receives B.A. and M.F.A. from Columbia. Becomes United States citizen in 1940. Lives intermittently in New York City, Portland, Oregon, and New Mexico during the 1940's and 1950's. Teaches at the University of New Mexico in the late 1940's, teaches children in Harlem in the early 1950's. Returns to New York in 1957, leaves for Cuba, New Mexico in 1967.

Returning in 1957 to New York where she had sporadically lived and studied, Agnes Martin found her mature idiom in the creation of symmetrical alignments of repeated forms. At Coenties Slip, where Ellsworth Kelly and Jack Youngerman also had their studios, she began a decade of living and working during which she, like most of the other artists featured in this exhibition, gradually regularized the facture and structures of her Minimalist painting.

Drawn in pencil over an acrylic base on canvas, *Harvest* is, in spite of its medium, a painting. In this work, line, the traditional skeleton of painting, has in its delicacy been reduced to near invisibility, and at the same time enlarged to primacy—there is *only* line. Like Abstract Expressionist work, *Harvest* presents us with the process-record of the physical encounter between artist and material; however, it is a meeting from which all sense of the psyche *in extremis* has been drained, leaving only a contemplative silence. From a distance, the lines themselves seem to dissolve optically into their ground. Examined closely they physically dissolve as the structured irregularity of the canvas warp and woof interacts with the pencil, producing an almost random succession of tiny mountain tops, each capped with a minute deposit of lead.

There is a poignant tension established in the inevitable disparity between the metric perfection of the preconceived grid and the passage of a human hand across the rough canvas surface. Necessarily recording the trembling muscular kinesthesis, the varying inflections of pressure upon the lead, Martin's lines become an infinite fugue and variation upon the perfect line. Like Mondrian's Neo-Plasticism in which the logic of intersecting orthogonals causes "the abolition of all particular form," there is no single unit square that separates itself from the whole of *Harvest*. Instead, the modular unit of division spaces hundreds of lines generating tens of thousands of squares (of which, like snowflakes, no two are identical). Deployed across the painting, Martin's lines become a cogent demonstration of how the many can become one without subordination, the unit modules perceptually uniting to establish a unit *field*.

Martin does not permit her grid to approach the edges of her canvas. Although the lines cohere internally as a field-structure reminiscent of Pollock's all-over webs, *Harvest* cannot be read as a "stamped out" piece of a larger field. Instead, it suggests a whole complete unto itself, a unitary field floating free. Eschewing any overt illusionism, Martin's lines do not depict something floating, but rather float free of the support themselves, creating a blooming efflorescence of form in which categorical form becomes its own denial. For Martin, ". . . my paintings have neither objects, nor space, nor time, not anything—no forms. They are light, lightness, about merging, about formlessness, breaking down form."[1] *Harvest*'s perceptual complexity creates a phenomenological field suggestive of metaphoric contemplation, a suggestion reinforced by Agnes Martin's use of titles which turn back out from the works to which they are applied towards the fecundity of nature.

CC

1. Lawrence Alloway, *Agnes Martin* (Philadelphia: Institute of Contemporary Art, 1973), 10.

John McCracken

VIOLET BLOCK IN TWO PARTS
1966
26 x 36 x 45 inches
Plywood, fiberglass and lacquer
Collection of Whitney Museum of American Art, New York
Gift of the Howard & Jean Lipman Foundation, Inc.
66.92
Catalogue No. 23

PROVENANCE

BIOGRAPHY
Born Berkeley, California, 1934. Graduates from the California
College of Arts and Crafts, Oakland, 1962. First New York one-man
show, Robert Elkon Gallery, 1966. Participates in the Jewish
Museum's *Primary Structures* and the Whitney Museum's 1966
Annual Exhibition of Contemporary Sculpture and Prints.

McCracken belongs to the geographically widespread group of
sculptors who participated in a New York-based Minimalist direc-
tion. His inclusion in *Primary Structures* and the 1966 Whitney *An-
nual* demonstrated how much his reductive forms and "primary
structures" strongly echoed those of Judd and Morris. But in distinc-
tion to Judd and Morris, color was clearly the most basic expressive
issue for McCracken who thought of color as being "the structural
material I use to build the forms I am interested in."[1] Although *Violet
Block in Two Parts* is similiar to Morris' *Untitled* in this exhibition
(Cat. 25) in shape and experience, the Morris piece is devoid of
color. McCracken is obviously more interested in material as colored
matter rather than as an armature of form. His piece is meant to dis-
place space rather than define it.

Violet Block consists of a very simple, straightforward repeated
shape. An economy of form allows McCracken to give maximum at-
tention to what is of fundamental concern, color. McCracken em-
ploys a relatively traditional architectural vocabulary of forms—the
block (used singly, in pairs or threes), the pyramid and the post and
lintel. These simple, uninformative and immediately recognizable
forms become the neutral vehicle for color so that color ultimately
characterizes the shape.

McCracken sprays his pieces with as many as thirty coats of paint
which are then rubbed down and polished to obtain an overtly sen-
suous finish and characteristically high degree of luster. The original
handcrafted plywood blocks are obscured by the highly polished,
reflective, almost anonymous surface. The pristine quality of surface
achieved is characteristic of many of McCracken's Los Angeles con-
temporaries generally working towards a refinement of form.

The deep saturation of the violet gives the piece a cool, seductive
quality. The more light that is cast on the blocks, the more the color
resounds, exuding a concentration of brilliant color, an effect remi-
niscent of Flavin's fluorescent light tubes.

JW

1. Artist's statement in Larry Aldrich, "New Talent U.S.A.," *Art in America* 54,
no. 4 (July/August 1966): 66.

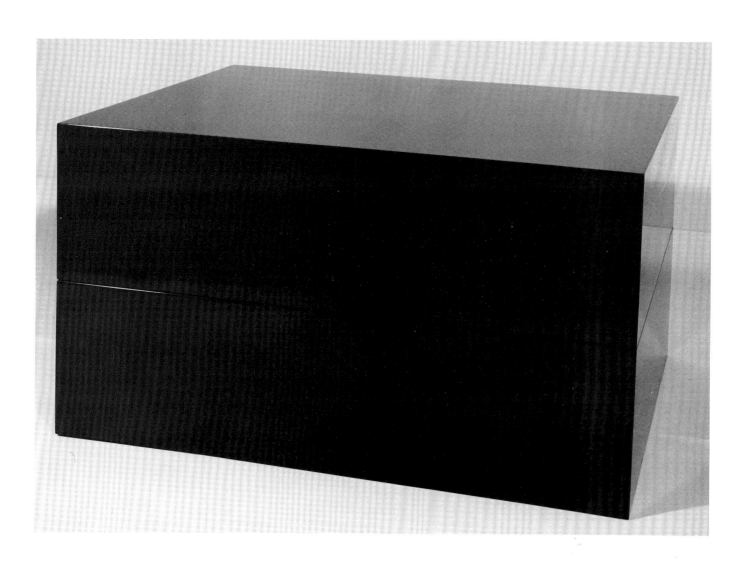

Robert Morris

UNTITLED
1964
24 x 11 1/2 x 3 inches
Lead
The Albert A. List Family Collection
Catalogue No. 24

PROVENANCE
Unspecified

BIOGRAPHY
Born Kansas City, Missouri, 1931. Attends Kansas City Art Institute, 1948-50, and California School of Fine Arts, San Francisco, 1950-51. Serves in U.S. Army, 1951-52. Attends Reed College, Portland, Oregon, 1953-55. Resides San Francisco 1955. Moves to New York, 1961, and studies art history at Hunter College. Begins teaching 1964.

This work is immediately and recognizably anthropomorphic. The oblong shape of the field recalls the shape of a human face, with the upper studs as eyes and the floating ruler as mouth. The fact that the work presents a recognizable image stands in contrast to the stated call of so-called Minimalist art for the non-referential unity and integrity of the object. Referentiality is reinforced as well by the work's complex relation to its historical antecedents. It exists both as a work by Robert Morris, and depends for some of its meaning on the viewer's prior knowledge of the work of Jasper Johns and Marcel Duchamp.

Morris' dependence on the work of Johns is evident in this work (and in the lead reliefs generally), primarily in the choice of material. Lead (or sculpmetal as Johns used) is matte, metallic, pliant and capable of displaying a residue of the maker's autographic mark. Again recalling Johns, Morris is interested in the redepiction in three dimensions of a pre-existent model (in Johns' case, flashlights, glasses, ale cans and so forth; here, a ruler). However, Johns' sculptures merely reiterate things already in the world, and as such present a certain predictable spatial unity and singularity. In Morris' work, the ruler is but a single element of a much more complex whole. That complexity is characterized by additiveness and the repetition of more random shapes and motives. The connecting elements are stressed in such a way that a quasi-pictorial tension is set up between the blankness of the gray field and the incidence of detail. This work is characterized by its simultaneous existence on many levels and planes, where the absence of a clear space-filling element is as "sculptural" as the occurrence of it. Thus, if Morris' work is more complex than that of Johns, it is made so in order to emphasize a complexity that is not only characteristic of the work, but also is in some sense the subject of it.

Morris' complexity is largely facilitated by the double reference of the work to Duchamp's prior investigation of measure, *Three Standard Stoppages*. There, three pieces of string were thrown to produce new metric "standards" of varying shapes. The lead piece recalls the former work both in its subject matter, and in the wires from which the ruler hangs, which reiterate Duchamp's thrown strings.

However, the lead piece is not merely a repetition of Duchamp's subversion of a measure that is indicative of a standardized and clearly constituted world. It is an investigation of that world in terms of its notional reality as well. In this way it is ultimately indebted to Wittgenstein's investigation of how the world is constituted by language. The lead piece seems intended to function as a sculptural equivalent to Wittgenstein's assertion that words are incapable of conveying extracontextual meanings. Here, Morris makes a similar claim about physical objects. He does this primarily by abstracting the ruler from its normal use, and placing it within the context of a work of art. It is not a ruler, but a representation that is in fact a faulty one. The ruler is calibrated in a way that is incapable of measuring less than increments of half inches. Even for this it is not very dependable since the calibrations are unevenly drawn and the edges lack straightness. Thus, the ruler is only able to function as a reference to measure, and not as a tool for measuring as such.

At the same time, the fact that the ruler is *physically* abstracted (through detachment) from the work of art, enhances the complexity of Morris' investigation. The ultimate effect of this abstraction is to give the sense that the ruler itself is only a fragment of an implied continuous but unquantifiable measure. This implication is enhanced by the contrast of the ruler to the obvious physical restrictions of the field from which it seems to have been forcibly excavated.

The work acknowledges a temporal complexity as well. This is evident in the corrosion of the ruler. Additionally, the ruler's large numbering, and the fact that it is only six inches long seem to refer to children's rulers. Finally, while the work is complete, its lack of "finish" gives the impression of its having been abandoned by its maker. Thus, the ruler in some fashion stands as a single instant in a complex temporal sequence, and its function is to force attention towards the existence of that sequence as well as to the "moment" of the object. In this way, the lead piece asserts its own existence outside the moment of its perception, although it aims to concentrate that moment. The work demands the complicity of the viewer to fully convey its meaning, because it asserts itself as both a part of a world held in common with the viewer and as being about that world. However, beginning with the gray polyhedrons of 1966, Morris abandons complexity of reference in order to continue his investigation of perception with simple, conceptually abstract forms.

MFM

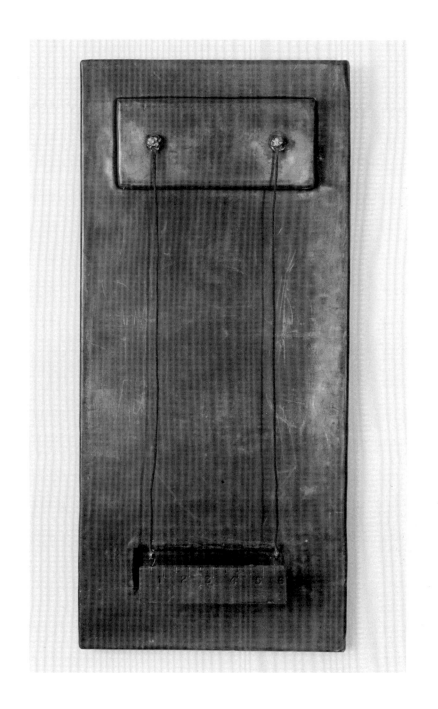

Robert Morris

UNTITLED
1966
36 x 48 x 90 inches
Reinforced fiberglass, polyester resin, and fluorescent light
Collection of Whitney Museum of American Art, New York
Catalogue No. 25

PROVENANCE
Unspecified

Untitled represents for Morris a decisive break from his early, historically referential work in the direction of minimally inflected objects, which (in spite of their simplicity) may still be seen as carrying historical meaning, if not historical form. In his 1966 series of articles, "Notes on Sculpture,"[1] Morris argues that "To begin in the broadest possible way it should be stated that the concerns of sculpture have been for some time not only distinct from but hostile to those of painting" (223). Within the historically charged, evolutionist defense of painting climaxed by Michael Fried's "Art and Objecthood" of 1967,[2] Morris presents his work as antagonistic in fundamentals to that enterprise. Thus, the so-called Minimalist works, exemplified by *Untitled*, themselves possess a polemical function that is lost to us in the actual experience of the object, but nonetheless recuperable through a contextual re-examination of the criticism of the period.

This is evident in Morris' own rejection of his prior work, exemplified by the untitled lead relief exhibited here (Cat. 24): "The relief has always been accepted as a viable mode. However, it cannot be accepted today as legitimate. The autonomous and literal nature of the subject demands that it have its own equally literal space — not a surface shared with painting" (224). Thus, with the second series of gray polyhedrons, Morris returned fully to the premises of a fully sculptural enterprise.

By Morris' definition, shape is the "single most important sculptural value" (228). That shape is made immediately perceptible to the viewer as such by the object's relative simplicity of form, its size (it is not so large as to discourage the viewer from attempting to apprehend it as a totality), and by the fact that it sits on the floor, subservient to the laws of gravity, and thus legible as a sculptural mass. Essential to Morris' prescriptive definition of the "truly" sculptural is the notion that the work must employ the sculptural means described above to create the equivalent of a gestalt, that is as a mental rather than merely physical, and thus purely putative, unity. In Morris' words, "Complex irregular polyhedrons allow for divisibility of parts insofar as they create weak gestalts. They would seem to return one to conditions of works that . . . transmit relations easily in that their parts separate" (228). The absence of such unity would dispel the perceptual conditions necessary to bind viewer and object together in a phenomenologically concentrated relationship.

For that reason, and unlike the first columns of 1961, the 1964-66 works aim at relatively greater perceptual complexity, concordantly made possible by a greater relative complexity of *shape*. Here, that complexity is actualized by the slight but perceptible deviations from the simple geometrical norms provided by regular polyhedrons. In this work, the sides subtly taper upward from the floor, the object is split in half, and a fluorescent fixture is placed inside to illuminate it. The effect of these deviations is, first, to assert a conceptual complexity on the part of the artist, which directs our attention to the fact that what is visible is not a mere geometer's figure. However, the object is animated this way only to the degree necessary to refocus our attention on those deviations, and ultimately to return our attention to our own perception of the whole object rather than its purely formal details.

Thus, keeping the unity of the object in mind, the viewer is forced to distinguish between interior and exterior, the object and surrounding space, the live and the fixed. The perceptual ambiguity of these categories is accentuated by the closeness of the two solids, and their identical shapes — is the work a single polyhedron sliced in half or two equal polyhedrons joined together? The answer must be simultaneously both and neither.

The gestalt or unity of the object enables the viewer to acknowledge its complexity, while not losing sight of its essential totality, a totality inclusive of the viewer who simultaneously experiences the "known constant" of the object and the "experienced variable" of the object as it is perceived (234). The work is non-"relational" internally; in Morris' words, it "takes relationships out of the work and makes them a function of space, light and the viewer's field of vision" (232). In a work such as this, then, Morris does not, as initially appears, abandon the spatial and temporal complexity evidenced by the untitled lead relief. Rather, he refines those interests into a distilled and less subtle, but truly abstract, perceptual experience. In *Untitled*, Morris has replaced legible efficacy of reference with even more legible reality.

MFM

1. Reprinted in Gregory Battcock, ed., *Minimal Art: A Critical Anthology* (New York: E.P. Dutton, 1968), 222-35. Hereafter referred to in the text by page reference.

2. Reprinted in *Minimal Art: A Critical Anthology*, 116-47.

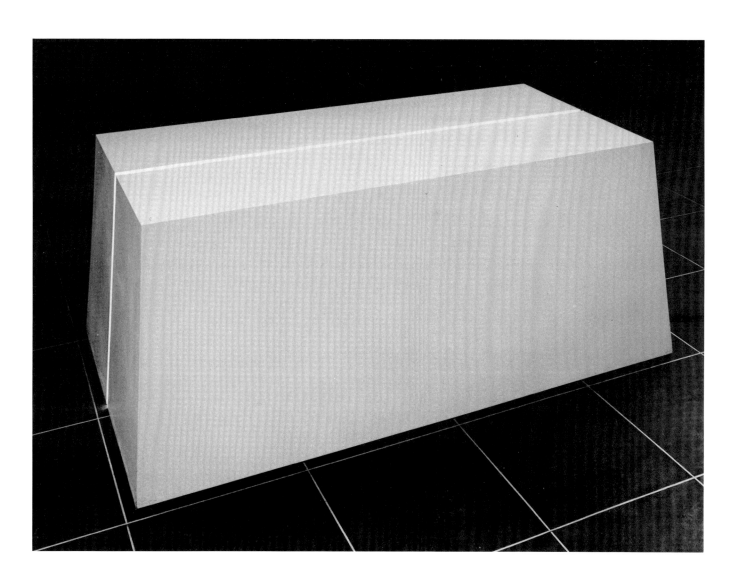

Kenneth Noland

OFF
1965
60 x 60 inches (diamond orientation)
Acrylic on canvas
Collection of Mr. and Mrs. Graham Gund
Catalogue No. 26

PROVENANCE
Unspecified

BIOGRAPHY
Born, 1924, Asheville, North Carolina. Attends Black Mountain College on G. I. Bill, studies with Ilya Bolotowsky and Joseph Albers, 1946-48. First one-man exhibition, Galerie Raymond Creuze, Paris, 1949. Summer 1950, meets Clement Greenberg. Begins Targets series, 1958. Joins Andre Emmerich Gallery 1961. Develops Chevron series, 1963; Asymmetrical Chevrons, 1964; shaped canvases, 1964.

Off, 1965, is one of a series of diamond-shaped canvases which Noland produced intermittently between 1963 and 1967. Noland had begun in 1963 to experiment with accelerating the complex and slightly equivocal figure-ground dynamic which had become so essential to the success of his asymmetrical Chevron paintings. By allowing the painted motif (depicted shape) and the surface shape of the canvas to coincide exactly (in the diamond shape), he was able to maintain the visual tension between the stripes and the empty canvas which he had produced in the asymmetrical Chevron pictures, and at the same time to suppress the foreground-background relationship which had begun to emerge in these paintings and threatened his notion of flatness.

Off is a square canvas which has been tipped through a quarter of a revolution, resulting in the diamond shape or lozenge. The picture contains four stripes which run (reading from left to right) from a luminous rose tone at the point furthest left from center to a golden-yellow stripe, to a saturated black, and finally to a blue stripe along the two sides constituting the right "edge" of the lozenge. The white ground is visible between each of the stripes.

Although the use of a lozenge format was a new departure for Noland, it was an established modernist structure having been introduced by Mondrian, and continued by (among others) Bolotowsky, with whom Noland studied at Black Mountain College.

In numerous examples such as *Composition in Black and Gray* of 1919 (collection of the Philadelphia Museum of Art), Mondrian's rectilinear grid is organized in counterpoint with the diagonal orientation and boundaries of the canvas. Like many of the lozenge paintings of Bolotowsky, Mondrian's seems potentially a cutout of a larger

structure existing beyond the picture plane. Yet, in opposition to this reading, the internal composition appears resolutely organized to converse directly and clearly with the diagonal orientation and the diamond shape. Bolotowsky, on the other hand allows *his* diamonds to be read dominantly as cutouts, maintaining a strict vertical-horizontal impulse which is largely unaffected in conception by the diamond shape. In *Off*, the sense of the picture having been cut out of a larger composition is minimal, because the rose and blue bands of color are adjacent to the two opposite corners along the horizontal axis, where they manage to interlock with the limits of the picture. Because each stripe is the same width, there is no encouragement for visually extending the blue or rose stripe in either left or right directions.

The role that color plays in *Off* is difficult to determine, and it seems that Noland was ultimately discouraged by the diamond shape because it restricted his largely intuitive development of color.[1] That the earlier Chevron paintings demonstrate a more "liberated" color sensibility than *Off* is apparent. But rather than regarding the clearly fixed structural conditions of *Off* as having *only* limited Noland's color choices, the diamond's rigidity can be seen alternatively as having made possible a more controlled type of color-run than was the norm in earlier works. It is important to note the visual impact which even the most low-keyed color exerts set within the tense white field of the lozenge. The regularizing nature of the stripes set within the lozenge format allows the color of each stripe to assume strangely individual radiance. The optical weight, which each colored stripe finally carries, works against a stable (clear and continuous) reading of the painting, but the force of the structure re-establishes the surface unity of the field.

The black stripe is the most dramatic element in the picture by virtue of its optical density as well as its location nearest to the center of the field. From the black stripe, a sequential right to left reading is induced by the gradual lightening of tone as the painting progresses into the yellow stripe, and finally the rose stripe which provides a visual pause since—situated in the left corner—it echoes the overall proportions of the lozenge. This sequential reading toward the left side is opposed by the blue stripe which is compelling by virtue both of its brilliance, and its significant compositional "weight" which anchors two contiguous sides of the painting. In opposing the simple right and left reading the blue stripe generates a heave, or visual twist, which is both intensified and complicated by the areas of white ground which refuse to be either just stripes, or just ground. In fact the equivocally energized white represents the real success of *Off*, for with it Noland accomplishes a previously unattained degree of simultaneous optical poise and movement of surface, as well as maintaining a prescribed flatness.

MP

1. Diane Waldman, *Kenneth Noland: A Retrospective* (New York: The Solomon R. Guggenheim Museum, 1977), 33.

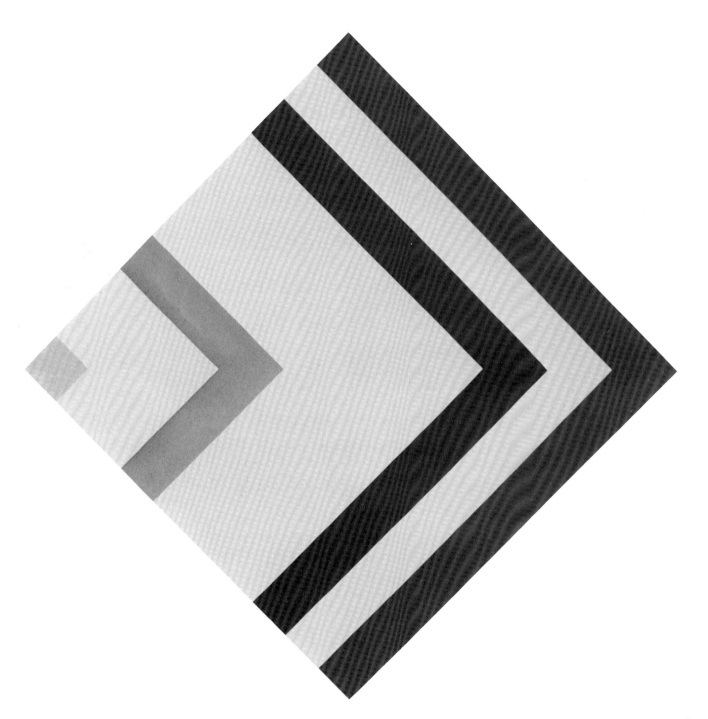

129

Claes Oldenburg

SOFT TOILET — "GHOST" VERSION
1966
52 x 28 x 33 inches
Liquitex, canvas, wood and kapok
The Albert A. List Family Collection
Catalogue No. 27

PROVENANCE
Unspecified

BIOGRAPHY
Born Stockholm 1929. Attends Yale University, 1946-50. Moves to New York 1956. Executes "The Street" 1960; "The Store" 1961. First large soft sculptures 1962. First Monument drawings shown at Sidney Janis Gallery, 1965.

The *Toilet* is an early "ghost" or soft version, constructed before the final vinyl sculpture. The brushstrokes, applied uniformly to a canvas surface in an "all-over" pattern, seem in this context to imply a critique of the Abstract Expressionist calligraphic mark, as does the messy addition and binding together of parts.

Like Marcel Duchamp's *Fountain* of 1917, the *Toilet* is abstracted from its use. Thus, it presents a contrast to modernist architectural theory where plumbing in general is seen as valuable for the very fact of its utility. As in the *Wedding Cake* (Cat. 28), one is forced to confront a disparity between the representation and what it represents. The softening of and application of brushstrokes to the object immediately connote artfulness as an aesthetic value opposed to the very functional nature of the "subject."

Works of art relating to bodily functions possess at least some tradition in the history of art — the most obvious antecedent for the *Toilet* being the above-mentioned Duchamp. That work's bluntness was considered an affront to gentility,[1] although it was probably the lack of transformation of the object rather than the object per se that was found so troubling when the *Fountain* was first exhibited. Nevertheless, by turning the object on its side, rendering it useless, and by making a classical pyramidal composition of it and signing it, Duchamp called attention to the way any object could be aestheticized.

While Duchamp's intention was to shock and antagonize the viewer, Oldenburg seems more interested in the potentially seductive qualities of the work of art. In *Toilet*, he does this through the softening of the object, which makes it pneumatic and pliant in a way that is immediately sensible as erotic. Through this transformation, Oldenburg aestheticizes the object physically rather than rhetorically, making it immediately recognizable as art, and in every way less resistant to aesthetic response than *Fountain*.

In further contrast to Duchamp's rejection of the *Fountain's* potential function, the *Toilet's* functional qualities are in fact emphasized in order to evoke human presence unequivocally. Thus, the *Toilet* is able to remind us of the function of our own bodies, and of our bodies generally at the same time. Like it, we are covered with skin, are filled with things we don't know much about, and, in some profound sense, we are *fabricated*. Additionally, the *Toilet* itself is invested with a basic human function. It is, as it were, essentially digestive.

Within the terms of contemporary criticism, the formal qualities of Oldenburg's works were considered to contain his primary contribution. In Donald Judd's words:

> The trees, figures, food or furniture in a painting have a shape or contain shapes that are emotive. Oldenburg has taken this anthropomorphism to an extreme, and made the emotive form, with him basic and biopsychological, *the same as the shape of the object*, and by blatancy subverted the idea of natural presence of human qualities in all things.[2]

However, the present interpretation of Oldenburg proposes that a formalist reading is already accounted for by the work where it appears as an element in tension with the actual content of the work in order to produce meaning.

First, the imagery of Oldenburg's production is recognizable in a way that is contrary to the supposed hermeticism of abstraction. More importantly, it is the very recognizability of the image that allows access to it on a "formalist" level. Thus, every viewer is able to note the disjunctions between the representation and its subject (in terms of its evident aesthetic transformations) and to become, in effect, a formalist critic (or a parody thereof, lacking the philosophical, political and historical rationales that form the bases for Greenberg's formalism).

On a deeper level, however, the *Toilet* and other works like it force attention not only toward the formal qualities of the object, but also toward the act of perception of those qualities. In this way, Oldenburg's soft sculptures form an important precedent for the more circumscribed perceptual inquiries of the Minimalists.

MFM

1. See Rosalind E. Krauss, *Passages in Modern Sculpture* (Cambridge, Mass.: The MIT Press, 1981), 76-77.

2. Donald Judd, "Specific Objects," *Complete Writings 1959-1975* (Halifax: The Press of the Nova Scotia College of Art and Design, 1975), 189. Italics added.

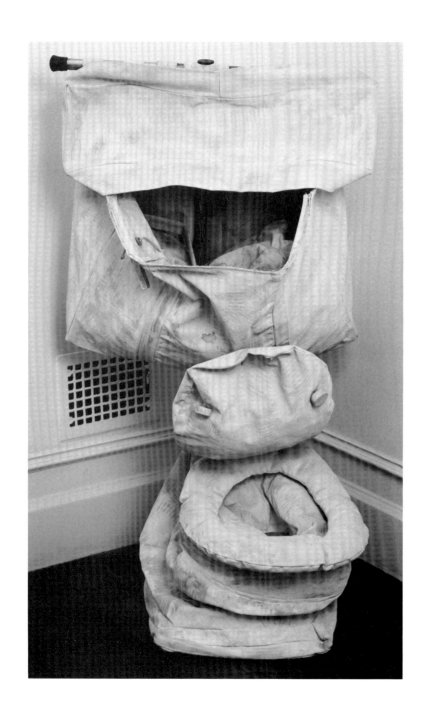

Claes Oldenburg

**WEDDING CAKE MADE FOR WEDDING OF JUDITH AND JIM
ELLIOTT**
1966
7 inches high
Painted plaster
Anonymous, New York
Catalogue No. 28

PROVENANCE
Unspecified

The cake was made for the wedding of Judith and Jim Elliott, where the pieces were distributed to the guests as party favors, or souvenirs. The represented object is not transformed in scale, nor is it "softened" in the artist's characteristic manner. It is unpainted, using the whiteness of the plaster to suggest the object. Indeed, due to the pastiness of the material, the "cake" looks fresh enough to be eaten. Here, the artist displays a gesture towards realistic trompe-l'oeil which is anomalous to his work as a whole.

As a straightforward redepiction of an item for consumption, it is to the works from *The Store* (1961, now dispersed) that the *Wedding Cake* must be compared. In those works, Oldenburg replicated common objects and such edibles as form part of the American foodscape: hamburgers, bottles of soft drink, and, necessarily, pieces of cake or pie. However, the sloppy modeling and loose painting of those works, recalling the Abstract Expressionist calligraphic mark in terms of the quasi-independence of the brushstrokes from the depicted shape, are abandoned here.

The cake represents something of a return to the themes of Oldenburg's earliest sculpture. However, this subject matter is now seen through a Minimalist sensibility that values primary shapes, simple colors and clean edges. The *Wedding Cake* is a primary geometrical form, a segment of a cylinder. Theoretically acceptable to the Minimalist taste, the literal shape (the form) is no different from what is depicted.

Further differentiating this work from those of *The Store* is the lack of reference to truly common objects without specific destinations — this work is special, as a wedding cake is food for special occasions. Further, the artist creates here an object different in intent from those of the large-scale public commissions he is mainly concerned with at the time. The work's clarity of purpose is immediately evident: it is actually a monument to something — the wedding of a friend, and its character as an aesthetic object relies at least in part on its commemorative qualities. Its realism has a purpose, a conceit: the [cake/marriage/remembrance-of-the-wedding] will not go stale.

Nevertheless, the work forms a definite part of Oldenburg's corpus, not only in terms of formal qualities that betray its date, but also in terms of its structured relation to the beholder, who is encouraged to perform an integrative role in the aesthetic experience of the work. The subject of the work of art is nourishment, we are encouraged to look upon the work of art as at least delectable. It is a gift to the wedding couple not directly, but to their guests, as a souvenir. It is valuable to these guests not only as a gift of the artist, but also as an expression of his "gift." It is returned to us, the art audience, through redemptive aesthetic experience, in which it functions both as a record of something in which we can only vicariously participate, and as a bringing closer to us of something beyond the art object itself. This is evident in the presentation of the work as a slice, that is, as a fragment of a larger whole — the idea of the cake in its totality. The triangular relation of artist, work and beholder, then, is something Oldenburg explicitly sets up through his use of common object forms, which we are asked to respond to both as representation and as represented object.

MFM

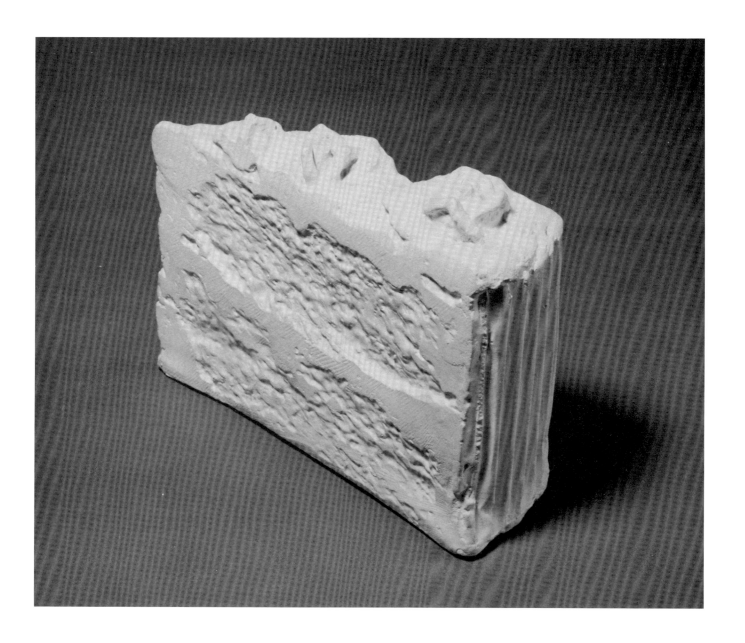

133

Jules Olitski

HALF CHINESE PATUTSKY
1964
92 x 92 inches
Magna acrylic on canvas
Signed verso, upper left, and center, in crayon
Collection of Department of Art, Brown University
Gift of artist through Richard Rubin
71.4326
Catalogue No. 29

PROVENANCE
Gift of artist 1971

BIOGRAPHY
Born New York, 1922; studies at the National Academy of Design, New York, 1940-42; travels to Paris, 1949-51; first one-man exhibition in New York at the Zodiac Gallery, 1958; one-man exhibition at French and Company, 1959; makes first stain paintings, 1960; develops spray painting technique, 1965; participates in *Three American Painters* exhibition at the Fogg Art Museum, 1965; included in XXIII Venice Biennale, 1966.

"Whereas the nineteenth century artist took us to the window to look at the view, the twentieth century artist takes us to the window to look at the window."[1] The quiet restrained colors and spare arrangement of circular elements make this painting appear deceptively simple to read. Given time, it reveals a hidden structure dependent as much on a harmony of relational wholes, as on the distinctive characterization of its colored elements. Like chordant sounds the reverberations of these color-shapes are projected into the silent white expanse of canvas.

The large square field of white cotton duck canvas is slightly patchy in appearance through the process of oxidation that comes with age. Yet, it still floats easily the thin fluid pigments stained in circular shapes which soak through the canvas. In the upper right corner of the canvas is a purple disk. To the lower right corner another round shape similar in size but stained in tones of deep blue is lodged between the corner of the framing edge, and in the lower center is a large crimson stained circle, which through its size controls (as an inescapable point of reference) but does not dominate our reading of the canvas as a whole. A thin yellow-white colored ring encapsulates the crimson stain, sealing it in, as if to contain the seeping effect of the crimson pigment.

In this painting Olitski underscores the symbiotic nature of the pigment and the canvas, making them read together as an integrated structure that refuses the illusion of depth. The colored stains lie within the canvas texture; as such the crimson, purple and blue color-shapes appear to the eye as flat, smooth weightless disks unencumbered by the tactile presence of paint placed on the surface of the canvas. The shapes resonate laterally, pigments bleed outwards. Within the canvas as a whole the subtle referential power of the colored disks generates optically the felt lateral tensions. The two small disks, like martellos, form markers warning of the proximity of the framing edge, towards which the large crimson disk appears to move. Lateral influences are felt vertically, as the deep purple disk on the top right of the canvas seems to pull the large crimson shape towards it.

These kinetic inferences are not induced by the formal organization observable in the work of other stain painters, such as Kenneth Noland, whose characteristic tight aggressive chevron forms of the mid-sixties project their color unequivocally towards the viewer. *Half Chinese Patutsky* with its low-keyed colors and diffuse formal composition appears by comparison with Noland more of an organic entity, with an inner life of its own. Tensions are more inwardly directed.

Part of a family of paintings made during 1963 and 1964, *Half Chinese Patutsky* marked for Olitski a period of intensive investigation of available techniques to make color a predominant and free abstract element. Color is developed so as to locate where the tensions lie on the canvas and to heighten or mitigate them. This particular painting hints at new concerns that are fully developed in the canvases of 1966. The relational play of the colored disks evolves into a magnified quasi-monochrome surface which seems to hold color within it—a feature facilitated by Olitski's new spray technique. The recognition of the framing edge suggested in the position of the purple and blue disks in *Half Chinese Patutsky* develops in both more and less overt ways later in his work.

As a colorist Olitski stands out in the mid-sixties as the prime liberator of color from conventional considerations and structures. With his ability to suspend his colors "magically" he makes them into buoyant abstractions with a unique chromatic range. Certain qualities are reminiscent of Josef Albers' *Homage to the Square* series, but the overt geometric support system of Albers is nowhere present.

Ultimately, Olitski re-interprets the painterly qualities eschewed by most sixties abstractionists but he manages this without returning to the emphatic personalized brushwork of the fifties, cultivating instead a totally new form of painterliness—one which carries no touch within it.

IE

1. Neil Marshall, *Jules Olitski. New Paintings* (New York, Andre Emmerich Gallery, exhibition of March 18—April 5, 1978).

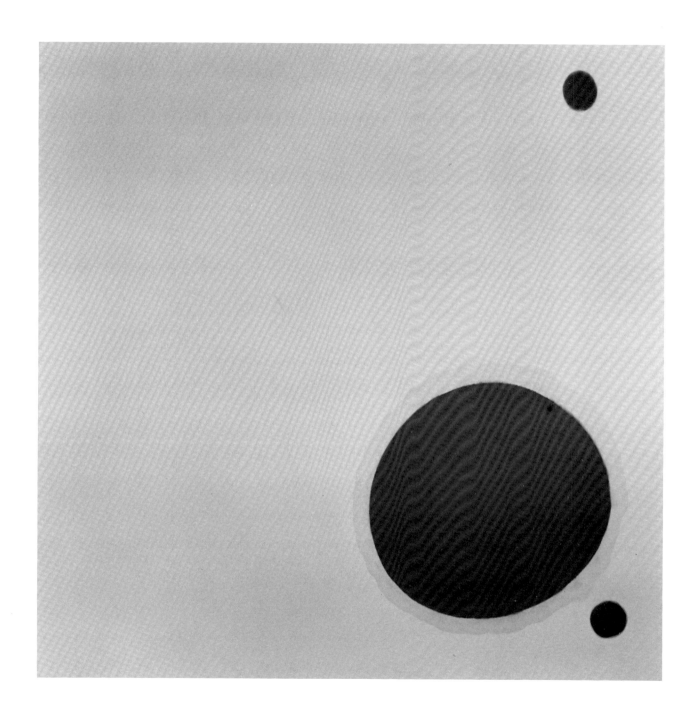

Jules Olitski

DEMIKOVSKY TRANCE
1965
79 x 21 inches
Acrylic on canvas
Signed Jules Olitski verso
Private Collection, Providence
Catalogue No. 30

PROVENANCE
Poindexter Gallery, New York

Demikovsky Trance of 1965 is one of Jules Olitski's first fully sprayed paintings, the fruition of a desire expressed to Kenneth Noland and Anthony Caro in Bennington that he would like to make paintings out of "colors sprayed into the air and remaining there."[1] In his earlier stain paintings of 1960-64, deliberate acts of composition had been required to place and form the areas of color, permitting a limited coloristic interaction between Olitski's brilliant hues and making color play a secondary role to shape and position.

Olitski's conception "of painting as possessed by a structure—i.e., shape and size, support and edge—but a structure born of the flow of color feeling,"[2] seems to have both driven and been driven by his use of ever more fluid mediums for his color. In retrospect, the progression from viscous oil paint to liquid acrylic to atmospheric sprays was the necessary sequence through which he could discover progressively greater chromatic freedom. Using as many as three guns and nine screw-on cans of paint,[3] Olitski's method of spraying paint established a process of applying color so kinesthetically free as to release him from the kinds of "shaping" constraints under which other Color-Field painters like Frank Stella and Kenneth Noland worked.

In *Demikovsky Trance*, there are three astonishingly "sweet" hues—yellow-orange, purple-pink and blue—which form the clouds of color that come rolling up off the surface of the canvas at the viewer. The eye, unable to establish the distinctive boundaries and contours of form to which it is accustomed, renders the entire color image volatile and shifting, ever unstable and indeterminate, thereby preserving that openness and holistic unity so highly prized by sixties artists. At first appearing virtually *non*-compositional, closer examination reveals that Olitski's act of organization in *Demikovsky Trance* is one of establishing proportional dominances of a given spray through repeated passes, changing the angle of attack of the spray or holding the gun momentarily to build up a deposit of color. In this manner, Olitski *begins* with color, letting it generate shape and form before finally finding the picture in the whole.[4]

Unlike traditional Cubist or Cubist-derived styles, the contrasts within *Demikovsky Trance* are of hues and not values, opening up an arena of purely coloristic space based on the aggressive optical projection or recession of individual hues. The heavy orange at the bottom vaporizes into an acidic yellow-orange which then possesses the lower third of the canvas. It is challenged towards the painting's center by a lush cloud of dense purple-pink (perceptually dense, the paint layer is sufficiently thin that the obvious texture of the raw canvas is nowhere obscured) that enters the canvas on a diagonal and billows outward to establish a powerful and convincing sense of pictorial relief. At the top of the canvas, however, no clear dominance of color is established. Instead, a mottled speckle and spatter of paint deposits cohabit the surface of the painting, establishing a sense of ground plane for the areas of more figurative color. Even as a veil of blue begins to form on the left edge, Olitski does not indicate a clear coalescence of any single color, suggesting instead the varying conditions from which such a chromatic gestalt might arise.

The color in *Demikovsky Trance* is of such a fineness of deposit that it trails away, especially when viewed closely, without ever establishing *definitive shape*.[5] One of Olitski's few acts of decisive mark-making was the use of a large rectangular underlay (or overlay?) that roughly bisected the canvas vertically during an early stage of spraying. Only furtively visible and at times nearly entirely subsumed by the colors laid down in later layers, this *non*-line echoes a sense of the arbitrariness of conventional drawing, which then is dissipated by the color flow.

The relative absence of internal shape in this first series of spray paintings seems to have suggested to Olitski that the canvas' format should carry some of the burden of overt "form." This shifting of emphasis from the interior surface of the painting to its exterior profile suggests a certain allusion to the human figure in both its scale and proportions.[6] The familiar size of this format clearly terminates the *indeterminacy* of internal form, closing off and presenting a definitive aesthetic event that obviates the tendency of the painting to be read as a glimpse of an infinite continuum of color and reinforces the sense of *Demikovsky Trance* as a self-sufficiently whole experience of color.

CC

1. Michael Fried, "Jules Olitski's New Paintings," *Artforum* 4, no. 3 (November 1965): 40.

2. Michael Fried, "Olitski and Shape," *Artforum* 5, no. 5 (January 1967): 20.

3. Fried, "Jules Olitski's New Paintings," note 4, 40.

4. Kermit S. Champa, "Albert Stadler: New Paintings," *Artforum* 6, no. 1 (September 1967): 32.

5. Walter Darby Bannard, "Notes on American Painting of the Sixties," *Artforum* 8, no. 5 (January 1970): 45.

6. Michael Fried has suggested that it be understood as a reaction to Stella and Noland's "deductive" configurations. Fried, "Olitski and Shape," 20-21.

Jules Olitski

BEYOND BOUNDS
1966
92 3/8 x 62 3/16 inches
Acrylic sprayed on canvas
Collection of the Wellesley College Museum
Museum purchase
1967.9
Catalogue No. 31

PROVENANCE
Unspecified

The rapid progress of Olitski's painting from 1964-66 evolved a working through of the soak/stain technique which led ultimately to his exploration of a spray/deposit method of picture making. During this period, Olitski's earlier formal interests—those which involved the relationship between color and shape—gradually gave way to a heightened concern for color relationships as a manifestation of content. This is evident in *Beyond Bounds* where Olitski developed fully his manipulation of the spray technique. The result is a controlled yet strangely emotional exploration of color relationships.

The soak/stain pictures which Olitski produced in 1965, such as *Tin Lizzie Green* (collection of the Museum of Fine Arts, Boston) contain much the same type of relational part-to-part composition upon which he had depended in the conventionally stained work from 1963 and 1964. Because of the translucent quality of the water based stains, rectilinear shapes can be made to appear one atop the other, and thus made to relate back to front, establishing complex conditions of opposing recession and frontality.

With the adoption of the spray/deposit technique, Olitski was able to transform almost completely the character of his paint surface. The self-conscious presentation of the support—the raw canvas—which was omnipresent in much of Color-Field painting dissipated, and in its place Olitski presented an elusive new surface, with a heightened sense of optical complexity. The scattering of specks of sprayed pigment—formed by drops of paint combining with air as they fell—produces a layered (but seemingly substanceless) richness of texture and color, which pulsates as the viewer's eye travels across the surface, seeing first the top layer of paint, and then sensing the deeper layers of color beneath the top spray. The spray pictures hearkened a return to a degree of spatial illusion for Olitski. He ignored the self-evident and dominating character of the physical ground (the unprimed canvas) canonical in much earlier Color-Field painting and created a radical new "flat" surface of his own devising.

Beyond Bounds is dominated by a run of vermillion paint which gradually gives way to a spray of violet, beginning roughly at the mid-point of the composition and becoming stronger as it moves into the left half of the painting. The vermillion of the painting is visually dominant due to the high intensity of the hue and the large surface area covered. The viewer is likely to find these sections first, then move intuitively toward the violet of the left of the canvas, where a "reverse" reading from right to left is initiated. Gradually the violet gives way to a deep shade of violet-gray, which when juxtaposed against the sharp violet and vermillion hues, reads as a black. Visual sorting of the image is a slow process because of the lack of distinct edges in the interior portion of the canvas. This indistinctness is visually compounded by the presence of opaque slabs of color along the four edges of the canvas, which by their contrast define the sprayed section (the interior) as optically contained and fluid. Additionally, Olitski achieves a sense of tactility which does not depend upon any notion of "boundary" or edge.

The oscillation which occurs at the juncture of the run of vermillion and violet color in *Beyond Bounds* is partly suppressed by the framework constructed by bands of blue-gray and green-gray paint located at the top and bottom edges of the pictures, by the light gray band along the left edge (formed by the masking of that section when the other parts of the canvas were sprayed—this band created by a *lack* of surface), and by a faint yellow strip drawn along the right edge of the painting. The three impasto bands of blue and green (two at bottom, one at top) extend off the picture plane in two directions, remaining anchored to the right edge of the picture, and not extending so far as the left edge. Because these bands of color are literally situated on the edge of the picture plane, they serve to characterize the physically forwardmost point of the painting's spatial construction, and the other portions of the picture, by necessity, function in a dominantly recessional mode. The slabs' relation to the edge—both in shape and proximity—signifies that their function is clearly one of the delimitation of boundaries. Yet, it is an ambiguous delimitation for the spray area continues outward from the sides of the painting, where the slabs are slight in scale and oscillate between the interior and exterior of the painting, as well as along the vertical axis where they slip past the top and bottom slabs toward the left half of the canvas.

A clear advantage of the spray technique makes itself felt in *Beyond Bounds*; there is virtually no mixing of color in such a way as to produce gray, or mediated, tones. In the interior portion of the painting, the only "impure" areas of color are those containing the violet-black tone, which is the result of oversaturation of color rather than a slippage of hue, such as the incidental gray tones formed in stained painting where wet colors collide. In *Beyond Bounds* the gray tones are pushed out to the edge, allowing the interior of the picture to function as pure color, which in the finest of Olitski's paintings provides the illusion of density and substance.[1]

MP

1. Kermit S. Champa, "Olitski: Nothing but Color," *Art News* 66, no. 3 (May, 1967): 38.

Larry Poons

SANGRE DE CHRISTO
1964
90 x 135 inches
Acrylic on canvas
Signed and dated "L. Poons 1964"
Collection of Mr. and Mrs. Graham Gund
Catalogue No. 32

PROVENANCE
Unspecified

BIOGRAPHY
Born 1937 in Ogibuko, Japan. 1940, family emigrates to Far Rockaway, New York. Enters New England Conservatory of Music to study composition in fall, 1955. Enters the School of the Museum of Fine Arts, Boston in fall of 1957; leaves the Museum School after six months. Paints first "dot" picture in 1962; introduced to acrylic paint by Agnes Martin. First one-man show at Green Gallery, 1963. First one-man show at Leo Castelli Gallery, 1967.

During the early sixties, Larry Poons' painting rested on the cusp between conventional Color-Field painting and the type of "proto-Minimalist" work exemplified by Agnes Martin and Frank Stella. Using a compass and ruler on graph paper, Poons was able to experiment with pictorial structures composed of sometimes regularized and sometimes randomized systems of dots. Eventually transferring this system to a painting medium, the earliest dot paintings consisted of a ground of saturated color, with a lightly pencilled grid over the ground and networks of dots of intense hues distributed across the surface of the canvas. Eventually, the dots translated into lozenges — developing an ellipsoid shape as in *Sangre de Christo*, 1964 — as Poons' color usage became increasingly more complex.

The field in *Sangre de Christo* is comprised of an intensely saturated red-orange hue. The grid network is barely visible, but the lozenge network harbors an obvious visual accountability implying the grid's presence. The lozenges display a wide variety of colors, but they form two specific groupings segregated according to tonal characteristics. The first group consists of the high-keyed colors such as blue, green and rose, and the second group includes the more subtle browns and grays, brought to the same low value and faintly visible against the intensely red field. The warm-cool contrast exerted between the field and the high-keyed lozenges results in a comprehensive general visual tension across the whole image, an effect intensified by the persistence of an optical after-image. The tonal character of the after-images generated in *Sangre de Christo* relates in intensity to the lower-scale brown and gray lozenges, allowing them enough visual strength to function as a second, more recessed level of the picture field.

Poons initially realized the potential for large-scale Color-Field pictures when he saw the work of Barnett Newman in the late fifties. The lozenge pictures constituted a sort of visual dialogue with Newman. They allowed Poons a format for producing pictures in which structure is subordinate to color, and total visual apprehension replaces careful focus. The all-over field paintings Pollock produced in 1948-50 which "accepted responsibility for all of their available surface area"[1] inform the lozenge paintings as well. Poons carries his pictorial structure to the edge — and then beyond it — and unlike any other artist since the mature Pollock, manages to subvert incidents of focus and detail in favor of all-over apprehension.

Sangre de Christo displays a remarkable sensitivity to surface quality that transcends Newman's accomplishment and was probably stimulated by the work of Agnes Martin.[2] Martin's often fragile, unreflective surfaces and "pristine" sensibility inspired Poons to displace geometry in his paintings and emphasize color and texture. Poons produced essentially two kinds of pictures during this period. One group — of which *Sangre de Christo* is a member — displays a fabulous optical density or "surface tension"[3] and contains high-pitched color with large numbers of visual incidents. The other group consists of less frenetic pictures in which the number of elements is reduced and the field more prominent and recessional. Curiously, in *Sangre de Christo* Poons has it both ways. Though the heightened level of surface tension produces an obvious flatness, there is a forward-backward oscillation produced by the contrast of the high-valued colored lozenges versus the subtler brown and gray lozenges. As well, although the majority of the lozenges occur along a horizontal plane, the bright blue lozenges align themselves along diagonals — deviating from the horizontal and vertical axes — thereby implying a third direction which can be read as recessional. An advantage of the lozenge over the dot rests with the former's ellipsoid shape which can be made to exhibit a directional orientation. Poons randomizes the orientation of the lozenges along the horizontal axis (and the almost unapparent vertical axis), but the blue lozenges are (for the greater part) uniformly aligned in one direction following a diagonal orientation. Some of the diagonals intersect to form orthogonal shapes which lend some illusion of depth. But, for the most part, Poons is able to achieve a visual depth without resorting to illusion, and to maximize his coloristic impulse as well while maintaining a minimal yet controlling shadow of geometrical structure.

MP

1. Kermit S. Champa, "New Paintings by Larry Poons," *Artforum* 6 (Summer, 1968), 39.

2. Kenworth Moffett, *Larry Poons: Paintings 1971-1981* (Boston: Museum of Fine Arts, 1981), 6.

3. Champa, 40.

James Rosenquist

CAR TOUCH
1964
88 x 74 inches
Oil on two motorized canvas panels
Collection of the artist
Catalogue No. 33

PROVENANCE
Collection of the artist

BIOGRAPHY
Born Grand Forks, North Dakota; studies at University of Minnesota with Cameron Booth, 1952-54; first one-man exhibition at Green Gallery 1962; exhibits in Paris at Galerie Ileana Sonnabend 1964; exhibits *F-111* at Jewish Museum 1965; exhibits work in Europe and Japan, 1966.

Car Touch is comprised of two panels each depicting the front and rear sections of automobiles. Rosenquist's keen observations of the texture of the contemporary environment is reflected in this painting, through the smoothly painted flat surfaces which evoke the sleek, polished finish of paint surfaces of metal. This close-up portrait of automobiles, while clearly grounded in representation, achieves through its economy of composition an abstractness, visible not only in the prevailing use of unsaturated colors, pink, blue, green-blue and white, but also through the essential formality of the configurations in which the car shapes are set by broad, flat bands of color.

In contrast to the economy of the composition as a whole, much descriptive detail is captured through Rosenquist's dexterous modulations of his colors. This allows considerable elaboration on certain aspects, such as the distorted reflections of metal one sees in the highly polished surfaces of cars. In the fenders of the car panel on the right, the blue tones in particular are given greater descriptive range through Rosenquist's highly controlled chiaroscuro. His power as a colorist is however evident throughout the painting, particularly within the broad areas of pink which contain especially subtle gradations from light to dark, interrupted by zones of lead white which become pictorially rhetorical elements in their own right.

The motorized canvases, are in a sense portraits of motion, mimetic sequences quoted from the choreography of urban environments enacted several times over in traffic congested cities. *Car Touch* introduces as a frame of reference features from the completely artificial landscape of man. It is an "allegory of simulation"[1] recounted through materials and a sensibility engendered by a particular environment. The seemingly unending reiterated sequence of motion is reminiscent of Marcel Duchamp's complex allegory of au-

tomation harnessing human desire as recounted in *The Large Glass* of 1915-23. Yet, Rosenquist's work, whatever the kinetic similarities, is more rooted in the concern with raw perceptual experience and optical sensation that formed an important aspect of art in the sixties. As a kinetic construction driven by motors, *Car Touch* also reflects the passing interest in the collaboration of art and technology with which several artists experimented during the sixties.

Rosenquist's evocation of the textures and the fractured optical sequences of contemporary life emerge with his own unique sense of juxtaposition throughout his work in the sixties. In this vein, the spare double sequences of composed imagery can be seen in paintings such as *1, 2, 3, Outside* (1963) and *Broome Street Truck* (1963), as well as *Car Touch*.

IE

1. Phrase quoted from Jean Baudrillard, "The Precession of Simulcra," ed Brian Wallis, *Art After Modernism: Rethinking Representation* (New York: The New Museum of Contemporary Art, 1984), 253.

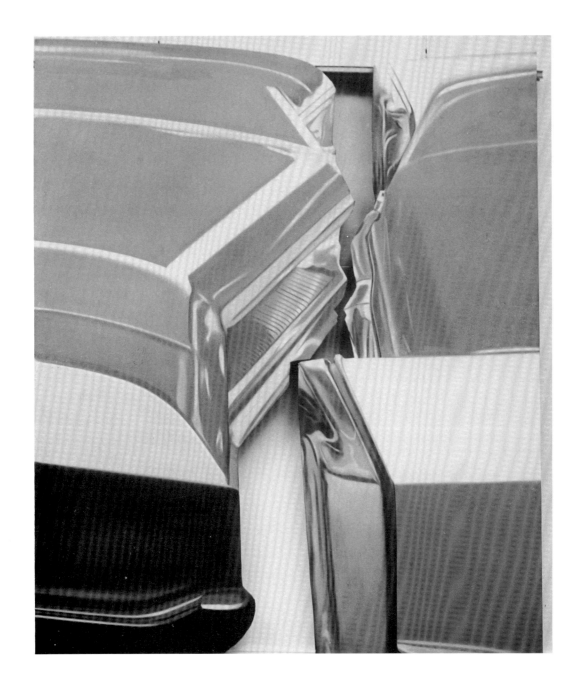

George Segal

VERA LIST
1965
49 1/2 inches
Plaster and iron
The Albert A. List Family Collection
Catalogue No. 34

PROVENANCE
Commissioned by Vera List, 1965

BIOGRAPHY
Born in the Bronx, New York, 1924. Studies at Pratt Institute of Design, Brooklyn, New York, 1947-48. Receives B.Sc. from New York University, 1949. Operates chicken farm in Middlesex County, New Jersey, 1949-58. Represents the United States at the Sao Paulo Biennial, and is included in the "New Realists" exhibition at the Sidney Janis Gallery, 1962. Receives M.A. from Rutgers, 1963. Teaches art at Roosevelt Junior High School, 1961-64. Exhibits regularly with Sidney Janis, 1965.

"Segal's sculpture is the only instance of someone less than Giacometti's age having used the figure convincingly."[1] Painting in the late fifties, Segal found himself restricted by the intrinsic flatness of the canvas and unable to achieve adequate dimensionality in his figures or in the space they occupied. This also restrained his efforts to imbue his figures with deeper psychological and philosophical nuances. In 1958 he translated his painterly images into life-sized figural sculptures which could then be situated in real space within environments of "found objects" having a plastic presence of their own. These first sculptures were highly expressive, stocky armatures constructed of two-by-fours and chicken wire, held together by burlap strips dipped in plaster which Segal situated in front of his paintings as if the figures had just stepped out of the picture plane. This process was radically altered when one of his students who was the wife of a chemist at Johnson & Johnson, brought to class a new type of medical bandage impregnated with plaster. Segal quickly discovered that this kind of bandage could be wrapped around parts of the body, successfully removed and re-assembled to retain an exact impression of the body. In this process the body and clothing of the sitter are documented as precisely as possible, retaining the sitter's idiosyncratic gestures. The chalky white, expressionistic surface of the plaster leaves the figure mute and motionless. The life-size scale allows Segal to punctuate the space around the figures which is further enhanced by the particulars of the setting.

Vera List is an unusual work in that it is one of three commissions Segal agreed to during the sixties. Unlike Warhol who in addition to his portraits of movie idols, accepted numerous private commissions for portraits throughout the decade, Segal preferred to concentrate his efforts on subjects which evoked deeper psychological responses or reflected a broader view of mainstream American life. Mrs. List, an important patron of the arts, requested the portrait after she tried to buy *The Couple on the Bed* which had already been sold.[2] Additionally Segal consented to do a double portrait of Pop art collectors, Robert and Ethel Scull and a portrait of his art dealer Sidney Janis, where the subject is shown examining an easel displaying his prized Mondrian *Composition 1933*. While the latter two portraits offer a direct commentary on the art "scene," *Vera List* is more ambiguous in its context. She is seated in an upright position, legs tightly crossed with her arms resting on the sides of the metal chair. She gazes forward, caught in a frozen moment of introspection. The image is similar to earlier Segal works such as *Woman Shaving her Leg* of 1963 (Museum of Contemporary Art, Chicago) where Segal studies a single body gesture as a way to convey inherently expressive form as well as a more overt range of psychological meanings.

Segal's work matured aesthetically within the milieu of artists such as Dine, Oldenburg and Marisol who were working in assemblage and figuration. His interest in recreating quotidian experiences, a factor common among Pop artists and directly related to Allan Kaprow's "Happenings," is best expressed in his works that capture the more mundane moments in ordinary people's lives in coffee shops, gas stations, or cinemas. Segal's affinity for the solitary figure in an enclosed environment has been compared among other things to Edward Hopper's realist genre paintings of the thirties.

JW

1. Donald Judd, "In the Galleries," *Arts* 36, no. 10 (September 1962): 55.

2. Interview with Vera List, October 17, 1985.

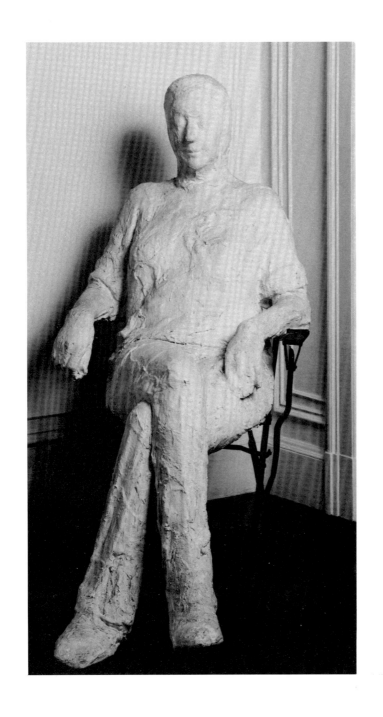

Frank Stella

ABAJO
1964
96 x 110 inches (irregular shape)
Metallic paint on canvas
Collection of the Gund Art Foundation
Catalogue No. 35

PROVENANCE
Unspecified

BIOGRAPHY
Born 1936, Malden, Massachusetts. Studies with Patrick Morgan at Phillips Academy, Andover, Massachusetts, 1950-54. Princeton University, 1955-58, studies history and works with William Seitz and Stephen Greene. First one-man exhibition at Leo Castelli Gallery, 1960. 1961, marries Barbara Rose, art critic. 1963 Artist-in-residence, Dartmouth College, paints Dartmouth series. 1964, begins Running V series; 1965, begins irregular polygons.

Abajo, 1964, represents the culmination of Frank Stella's formal concerns during what is considered the first stage of his development. The cusp between the end of the first stage and the beginning of the second is commonly thought to lie in 1964-65, the second stage beginning with the production of the irregular polygons (Cat. 36). The high point of achievement which constitutes *Abajo* and the Running V series occurs in part because Stella pulled back from his constant pursuit of new structures and allowed himself to consolidate formal issues which had emerged somewhat randomly in earlier pictures. Through 1963, Stella had been primarily engaged with problems of the elaboration of structure and the need to prove elaborated structures pictorially viable.[1]

The Running V pictures which were executed in 1964 and early 1965 are so named for a series of V-shaped tracks which continue unbroken across the length of the paintings. The twenty-seven bands of color in *Abajo* begin in an horizontal orientation at the left edge, and as they continue away from this edge they dip and rise to form a chevron-like structure, hence the "V." As the bands reach the right edge of the picture they do not return to their original horizontal position. Stella does, however, maintain the bands as parallel throughout. In *Abajo*, there are two chevron occurrences, the first being inverted—created by the succession of notches along the vertical axis formed at the juncture of the horizontal bands and at the beginning of their diagonal descent. The second chevron is formed from the intersection of the descending and ascending bands in the right half of the picture. Of the three directions which the bands take as they cross the surface—horizontal, descending and ascending—only the ascending bands at the far right of the canvas are of uniformly regular lengths. The horizontal portion of the bands decreases in length along the vertical axis as they progress to the bottom of the canvas, and the descending portion of the bands which occurs at the first notch increases in length from top to bottom. Therefore, the first chevron—the inverted chevron—swings to the left, deviating from the vertical axis. The upright chevron in contrast maintains a strict vertical orientation. The shape which is induced between the two V's (or notches) becomes a residual trapezoid, the recognition of which produces a visual heave in the middle of the canvas. The resulting modulation which occurs as the painting is read from left to right creates an illusion of uncertain depth: the inverted chevron seems to advance from the picture plane (defined by the horizontal portion of the bands), and the upright chevron recedes somewhat.

Abajo is painted with a green-gray metallic paint which functions unlike either an oil-based or acrylic paint. Dramatic in terms of sheer surprise, closer examination reveals that the metallic paint allows for the absorption of pigment by the canvas, and for the retention of crystalline particles on the surface to create a lustrous, rich sheen slightly detached from the color. Stella manages to achieve with the metallic paint an overall luminosity without compromising saturation or hue in the way additions of varnish or glaze would.

Abajo's success as a painting is dependent upon the insistently narrative left to right reading which the picture forces as the viewer's eye follows the bands through their at once variable yet manically constant course. This type of sequential apprehension is enforced in part by the shaped canvas, in which the depicted image corresponds absolutely to the shape of the support. The genesis of the deductive structure, where the shape of the support dictates the depicted image, is a vital component of Stella's pictorial conception from the first Black paintings onward. *Tomlinson Court Park*, 1959, is an example of an early painting in which the depicted shape echoes the framing support, not precisely but proportionately, as the members of each concentric rectangle decrease in length as the bands continue from the outer edge into the center of the composition. *Tomlinson Court Park*, and many of the other pictures from this period, contain illusory depth brought about by the perspectival effect of the concentric rectangles. In many of the Black paintings, the relationship between the framing support and the depicted image is one of variation and inversion rather than exact correspondence. However, in *Abajo* Stella has perfected his conception of deductive structure. In Michael Fried's terms, Stella has shown an "exaltation of deductive structure as sufficient in itself to provide the substance, and not just the scaffolding or syntax, of major art."[2]

MP

1. William Rubin, *Frank Stella* (New York: The Museum of Modern Art, 1970), 89.

2. Michael Fried, *Three American Painters* (Cambridge: Fogg Art Museum, 1965), 36.

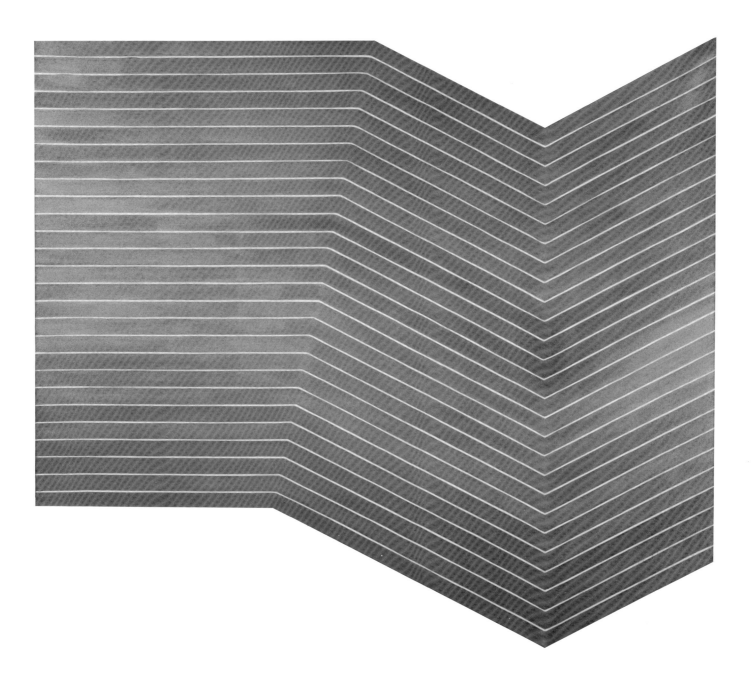

Frank Stella

SUNAPEE IV
1966
125 x 127 inches (irregular shape)
Acrylic on cotton duck
Collection of the Department of Art, Brown University
Gift of the artist through Richard Rubin
69.5402
Catalogue No. 36

PROVENANCE
Collection of the artist, to Brown University, 1969

Frank Stella's irregular polygon series of 1966 was executed in eleven shapes selected from earlier sketches exploring the idea of the interpenetration of contrasting geometrical shapes with four color variations of each.[1] This serial practice not only allowed him to work out his experiment of constructing an image from abstract shapes, but also provided an opportunity to study the effects of color on the spatial characteristics of each shape.

The essential advance which Stella makes in this series from his previous works is in moving away from the dependence of depicted shape (that which is painted on the surface) on literal shape (or the frame). Stella's regular stripe paintings had been the ultimate celebration of this relationship in that the stripes start from and reiterate the shape of the canvas without modifying it spatially. In this series, the depicted shapes themselves dictate the literal shape because the outer limits of their composition become the frame. In this approach, Stella's painting process is similar to the process of sculpture in that the construction of separate elements leads to the formation of the whole. As the "outline" of the sculpture results from the deployment of separate elements in space, so the literal shape of Stella's paintings results from the composition of shapes. The depicted shapes within the canvas cannot be deduced from the literal shape, because the frame itself results from their exterior sides only. This is perhaps the greatest formal shift from the earlier stripe paintings such as *Abajo*.

In *Sunapee IV*, the construction of depicted shape is one of the most complex within the series. It appears that the shapes themselves were built around each other, starting perhaps from the central orange polygon and developing outward. In this piece as in all of the series, a 6" stripe weaves around the sides of several shapes, reinforcing their separate form and their relation to other shapes. But the stripe takes on the character of shapes themselves because it does not serve as a border surrounding the perimeter of the composition or as a divider between shapes. Rather, it is sufficiently wide to act as an independent formal element. It seems clear then that Stella was not interested in the containment of shapes within the painting, or with the containment of the painting as a whole, but with the spatial conversation of separate elements.

Stella's use of both shape and color in *Sunapee IV* suggests an ambiguous spatial illusionism which is not immediately reconcilable with the assertive two-dimensional presence of the work. The horizontal and vertical sides of shapes are all parallel, giving stability and coherence to the composition as a whole. But dynamically opposing diagonals on the sides of the central orange polygon imply spatial oscillation. The upper half of the shape seems to project forward as the diagonals suggest depicted perspective. This back and forth oscillation is then counteracted by the wide blue and red bands surrounding the central polygon which serve to "anchor" it again to the two-dimensional.

Stella's chromatic vocabulary throughout the series combines a variety of low intensity colors with deeper hues to affect formal balances between the shapes. The high intensity of the central orange polygon reinforces its perspectival ambiguity. The dark red of the running stripe gives it weight and reinforces it as a shape, and further serves to "push back" the lower intensity gray, green and yellow areas. Edges are not hard, but masked and allowed to bleed softly, so that the shapes have a certain autonomy as they emerge. They seem therefore not merely created by their juxtaposition to other shapes.

MF

1. William Rubin, *Frank Stella* (New York: Museum of Modern Art, 1970), 111.

149

David von Schlegell

FLIGHT PLAN
1964
54 x 36 x 23 inches
Aluminum and steel
University Gallery, University of Massachusetts at Amherst
Gift of the Class of 1964
UM 64.11
Catalogue No. 37

PROVENANCE
Unspecified

BIOGRAPHY
Born in St. Louis, Missouri, 1920. Studies engineering at the University of Michigan, 1940-42 and painting at the Arts Student League, New York City, 1945-48 and with his father, William von Schlegell, 1945-50. Lives in Ogunquit, Maine and New York City.

In *Flight Plan* one can see the gestural strength and impulsion of Abstract Expressionist painting tempered by the sixties interest in more coherent structure, more impassive surfaces, and cooler and more depersonalized form. Having painted throughout the fifties, von Schlegell turned to sculpture in 1961 when it seemed to open possibilities unavailable to him in painting. Working first in wood, in 1964 he shifted to the flowing and cantilevered aluminum constructions, free of overtly organic connotations, that became his trademark for the rest of the decade.[1] The use of aluminum permits von Schlegell to retain some of the vectored aggressiveness of Action painting even as he shows his interest in the power of a large, unified shape moving boldly through space in a manner parallel to the colored forms of Stella, Noland or Kelly. Drawing upon his experience with the engineering of nautical and aeronautical structures, von Schlegell escapes the ponderousness of heavy metal by using the tensile strength of aluminum for weightless effects much as Color-Field painters use stained acrylic paint. He found that with a minimum of physical material his structures could be as "strong and light,"[2] as open and lyrical as sculpturally possible.

Flight Plan consists of a larger-than-human aluminum shape juxtaposed with an L-shaped segment of steel beam on a small base. These two elements could almost constitute an engineering treatise on surface and structure (skin and bone), or an aesthetic one on line and plane (drawing and painting). The dark hardness of the steel beam rises undiminished from the ground, as if it were of infinite strength and independent of gravity. At the same time the aluminum form billows upward as if it were equally unconstrained, clearly machined but not at all *machine-like*, pushing against the beam as if to carry it away. When the growing curve of shiny metal suddenly folds with a sweep, we sense the softness of the aluminum, and a kind of anthropomorphism in its dramatic yielding to gravity's pull. Thus the piece fulfills one of Robert Morris' prime conditions for knowing an object, sensing "the gravitational force acting upon it in actual space."[3]

Despite echoes of Brancusi, *Flight Plan* is as clearly not a monolithic solid as Larry Bell's, Donald Judd's or Robert Morris' constructions. Instead, the thin aluminum sheets lend themselves to an almost literal presentation of the transformation of plane into volume as the two-dimensional surface distorts and takes on a third dimension, making explicit the points of contact and the boundaries that separate painting and sculpture. The orderly rows of rivets, like obvious brushmarks, define the surface of the piece, countering the reflective aluminum's ability to visually appropriate its environment. Unlike the Minimalists, many of whom have their conceptual pieces industrially fabricated, von Schlegell insists upon a muscular process of personal improvisation to preserve and give life to his powerfully shaped metal pieces, finding in their abstract forms visual analogues for the joy of moving through physical space.

CC

1. Jay Jacobs, "The Artist Speaks," *Artforum* 56, no. 3 (May-June 1968): 53.

2. Jacobs, 56.

3. Robert Morris, "Notes on Sculpture." *Artforum* 4, no. 6 (February 1966): 43.

150

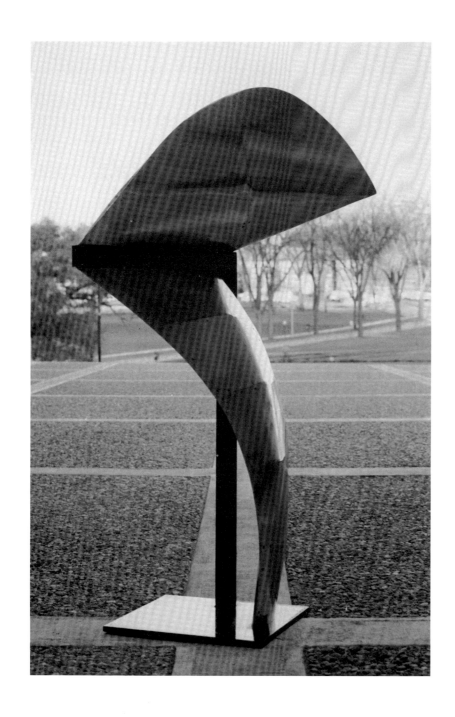

Andy Warhol

BRILLO
1964
17 x 17 x 14 inches
Painted wood
Courtesy Leo Castelli Gallery, New York
Catalogue No. 38

PROVENANCE
Leo Castelli Gallery

BIOGRAPHY
Born Forest City, Pennsylvania; studies at Carnegie Institute of Technology, Pittsburgh, 1945-49. Moves to New York, designs advertisements and window displays for magazine and department stores, 1949; paints dollar bills and Campbell soup cans, makes silkscreen works, including *Marilyns*, 1962; moves into studio called "The Factory," begins *Jackie* series, 1963; exhibits *Flower* series in Paris, makes Brillo Boxes 1964; announces retirement from painting, 1965. Makes films and produces the Exploding Plastic Inevitable show with Velvet Underground band, 1966; begins celebrity portrait series, 1972.

The *Brillo* sculpture is characterized by smoothly painted white wooden surfaces onto which have been applied the "Brillo" logo (in red and blue via silkscreen). Immediate recognition of the object's status as a mass-produced commodity, precedes its identity as an art object. As such, Warhol's sculpture thrives as a provocative polemic, responsive to the viewer's experience of the Brillo box as a commercial entity, while also standing as a preconceived, patterned object conceptually aligned with the preoccupations of artistic enterprise during the sixties.

Brillo, as a box and a three-dimensional structure responds in its literal shape to the Minimalist aesthetic of other boxes in the exhibition, notably Donald Judd's box and Larry Bell's cube, both untitled works (Plates 16 and 4). *Brillo Box*, although relatable to Minimalist formal ambitions of objecthood, still clings to painterly concerns of spatial configuration evinced by the graphic letters set alive by variations in the size and by the intrusive clean white ground which moves between the letters, making an optically live surface restricted in its lateral expression through inherent three-dimensional geometry and constricting "framing" words applied to the top and bottom of the box. When viewed from less frontal angles the sculpture's unitary potential is realized by the repeated curled flourishes, which like parallel bands, run around the box. In this sense Warhol's *Brillo Box* departs from the indulgent reductivism of the reticent surfaces of the Minimalist boxes in the exhibition, and is more in line with the relational pattern-to-surface dialectic present in the Pop and Hard-Edged

abstractions of works such as Robert Indiana's *Love* and Al Held's *Two Circles* of 1965 (Plates 15 and 13).

By 1964, Warhol had departed from the blurred, repetitive, media-inflected silkscreen paintings that characterize his 1962 and 1963 *Disaster* and *Jackie* series. Still fascinated by multiplicity, this aspect is retained in his later work. The grid-like composition of earlier paintings can still be seen in the Brillo sculptures usually shown as stacked units.

Underscoring the material presence of mass-produced commodities and their artistic fitness as prefabricated pictorial and sculptural concepts, this single Brillo box emphasizes the didactic elaboration of the dialectical considerations between commercial matter and its transference into the arena of high art, issues of explicit concern to later Pop art. But most of all the work seems to satisfy Warhol's epigram "I want to be a machine"[1] in the willful avoidance of originality (it is a copy of one of several copies) and in the closing out of the possibility of human expression of any obvious sort.

IE

1. John Russell and Suzi Gablik, "Andy Warhol," interview with G.R. Swenson, *Pop Art Redefined* (New York: Frederick A. Praeger, 1969), 117.

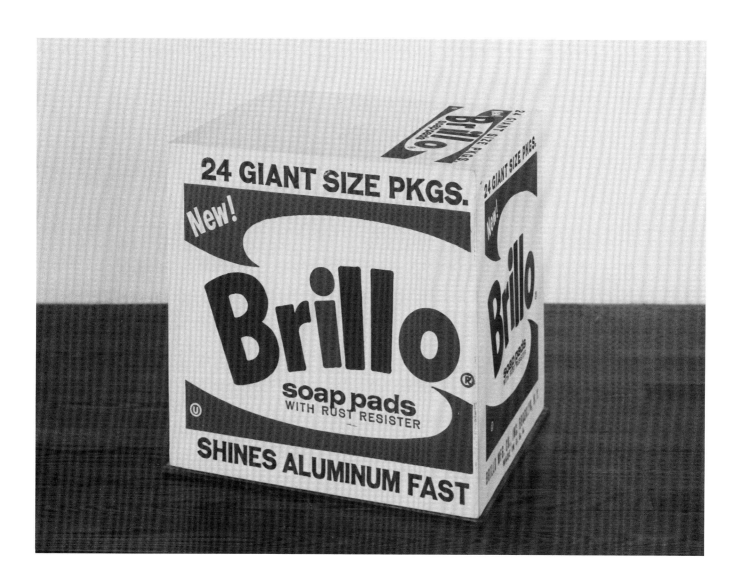

Andy Warhol

FLOWERS
1964
49 1/8 x 48 3/8 inches
Silk screen on canvas
Signed on verso, "Andy Warhol"
Yale University Art Gallery
Gift of the Woodward Foundation
1977.49.31
Catalogue No. 39

PROVENANCE
Unspecified

Flowers was Warhol's first exclusively ornamental, non-specific motif, lacking the emotional and psychological overtones present in his well-known portraits of *Marilyn* or *Jackie*, or the grisly news representations of works such as *Saturday Disaster* (Cat. 41) or *Race Riot* (Cat. 40). *Flowers* is bland, and vaguely abstract even in comparison to the commercial imagery of *Campbell's Soup Cans*. Produced in vast, unnumbered quantities, *Flowers* was initially installed in large groups, meant to consume the wall space of the Leo Castelli Gallery. The prolific repetition was intended to resemble wallpaper and reinforce the purely decorative quality of the theme. The enterprise of producing a "cool" all-over effect achieved its definitive statement with Warhol's *Cow Wallpaper* of 1966.

The actual motif of *Flowers* was taken from a close-up photograph that had been reproduced in a botanical catalogue. It was then enlarged, cropped and transferred to a silk screen by the artist.[1]

By the nature of this process (selection, enlargement, placement and addition of color) Warhol re-invented the image, distorting some of its original graphic features, while retaining others. The image, printed in black (suggestive of the cheap quality of mass-produced photographic reproductions) is filled in with broad, flat areas of color that have been pushed through the screen with a squeegee, completely removing the flower from its original context. The only certain remnant of the photographic original exists in the center of the flower where the artist has printed the stamen and pistils in black.

The four blossoms, arbitrarily arranged, have been isolated on a field of magnified, if not abstracted blades of wavy grass, some of which have been overpainted in green paint. This juxtaposition of elements, the flowers against the grass, is unusual for Warhol who generally limited his compositions to one singularly provocative image. There is neither a correct top nor bottom to the picture and when displayed in a group the canvases are intended to be randomly hung. The sole function of the flower appears to be as a vehicle for color. Each flower is an individually screened area of paint and as the image swells, it becomes a pool of color. Warhol deliberately permits color slippage so that the paint seeps into the blades of grass, slightly out of register. The *Flowers* ultimately remind us of a high-art source in Matisse's cutouts, as the bold, naive forms of color stand out against a subdued background. The subtle, almost bland combination of yellow and white in the Yale picture is atypical of most in the series. Other examples in the series tend to be characterized by a range of vibrant, often garish Day-Glo hues.

JW

1. Jean Stein, ed., *Edie: An American Biography* (New York: E.P. Dutton, 1982), 172.

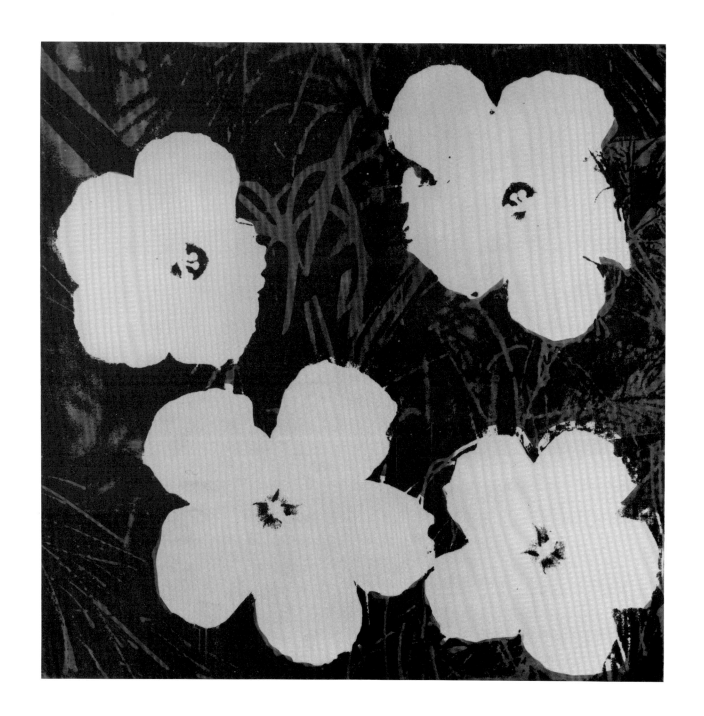

Andy Warhol

RACE RIOT
1964
30 x 32 7/8 inches
Oil and silk screen on canvas
Signed and dated on back, "Andy Warhol, 64"
Museum of Art, Rhode Island School of Design
The Albert Pilavin Collection of Twentieth Century American Art
68.047
Catalogue No. 40

PROVENANCE
Leo Castelli, 1968

Andy Warhol's artistic reputation during the early sixties was predicated on the success of his paintings depicting household consumer items such as Campbell Soup cans, Coca-cola bottles, and Brillo boxes. In 1962 Warhol embarked upon a series of portraits of Hollywood "stars": Marilyn Monroe, Elvis Presley and Elizabeth Taylor were all subjects of Warhol's slightly smudged quasi-commercial representations. Even though each of these personalities was glorified in the rather flat, neutral way the Campbell's soup can had been, a somewhat tattered, even emotional quality surfaces in certain of the portraits — in particular those of the tragic "Marilyn."

Race Riot, 1964, continues the incipient emotionalism from the portraits loosely referred to as the Death and Disaster Series. The series encompasses a group of "media-worthy" tragedies such as car accidents, plane crashes, and the Kennedy assassination. The Race Riot series and the Kennedy series are the most overtly political pictures from the Death and Disaster paintings, although the Kennedy series with its runs of Mrs. Kennedy in mourning shares some of the blander elements of the Hollywood portraits as well.

It requires effort, at times, to avoid thinking of Andy Warhol as a social critic. He should however be regarded as a responsive eye, attuned to media events with a unique ability to visually strengthen images which already resonate with abstract pictorial and psychological power. Considering his depiction of events and people using a structure of repetitions of the same mechanically reproduced image (Plate 15), Warhol's talent must be seen in terms of brilliant pictorial theatricality rather than in purely plastic manipulation.[1]

Race Riot, 1964, is readily identifiable to viewers who followed the media coverage of the events surrounding the race riots in Birmingham, Alabama in 1963. One of the most widely reproduced press images was the source for Warhol's picture.[2] The painting depicts two policemen with dogs as they attack a black man. A contemporary account of the riot narrates the events in Birmingham: "Tension slowly built, until with the arrest of [Dr. Martin Luther] King . . . thousands of Negroes went out to take their protest into the streets. Nothing like it had ever been seen before—in Birmingham, in the South or in the country."[3] Although Americans would eventually become anaesthetized to this type of violent image by the end of the decade, in 1964 it justifiably bore a kind of visceral horror associated with disasters generally.

Race Riot, 1964, is in fact one of Warhol's simplest and most direct images of Death and Disaster. In most of his paintings he adds a visual or psychological twist by using multiple repetitions of the same image, as well as strong discordant color. In an earlier painting, *Red Race Riot* of 1963 (collection of Wallraf-Richartz-Museum, Cologne), Warhol uses a large-scale format and a total of eight images, including the print used in *Race Riot*, 1964. The earlier painting is unified by the jarring red field, but the variety and strange arrangement of the screens make the painting feel wordy, and less than visually arresting. *Race Riot*, 1964, consists of only the one screen executed in black and white. For this reason it is Warhol's most vivid exploration of the visual strength of newsprint imagery. The inconsistent spread of black paint forced over the white by the silkscreen encourages the viewer to read the picture as if it were an enlarged newsprint reproduction. There is a ghostly absence of pigment in certain areas of the picture, such as in the legs of the dog and the heads of the figures in the left half of the composition. Yet, on closer examination the picture reveals a kind of surface evenness requiring careful execution which contradicts the viewer's initial reading.

If there is an emotional unity to the Death and Disaster paintings (each of the subjects is in some way emotional), it is the pall of silence which hangs over each canvas: the silence of death in the car accident scenes, the sign requesting silence near the electric chair, as well as the silent figure of Mrs. Kennedy mourning her husband's passing.[4] This reading is supported by the presence of empty panels adjoining many of Warhol's images, bearing only the field color behind the adjoining images and constituting a sort of a visual silence. There is as well an ironic silence present in *Race Riot*, seen in the row of spectators present at this horrendous scene, all of whom are turned away looking elsewhere. This is less an example of overt social commentary on Warhol's part, than a persuasive argument for the power of the camera, the single eye, to record and transform what is ordinarily not seen, and to do so with the potentially horrifying feeling of no feeling.

MP

1. Stephen Koch, "Warhol," *New Republic*, Vol. 160, April 26, 1969, 25.

2. *Works of Art from the Albert Pilavin Collection: Twentieth Century American Art*, Volume 1 (Providence: Museum of Art, Rhode Island School of Design, 1969), 24.

3. Charles Morgan, Jr., *A Time to Speak* (New York: Harper & Row, 1964), 153.

4. Carter Ratcliff, *Andy Warhol* (New York: Abbeville Press, 1983), 42.

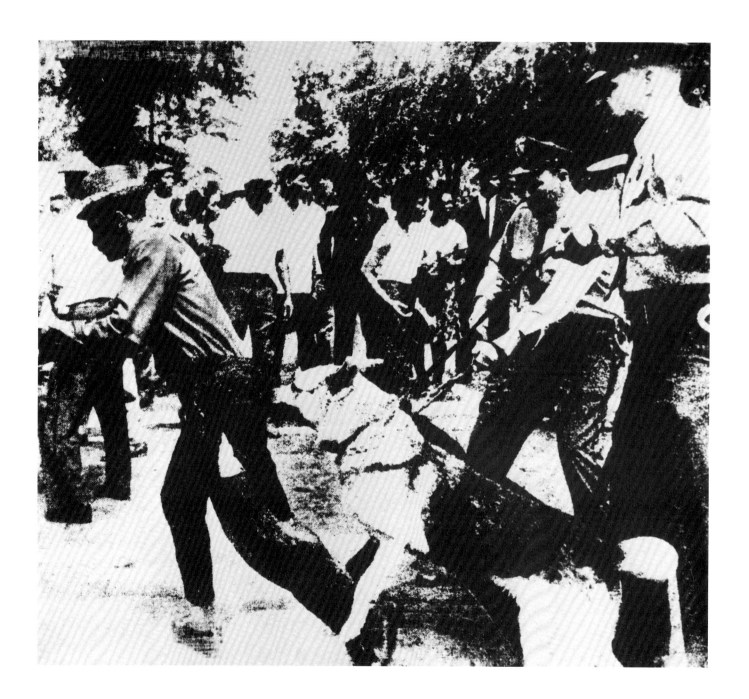

Andy Warhol

SATURDAY DISASTER
1964
118 7/8 x 81 7/8 inches
Synthetic polymer paint and silkscreen
Rose Art Museum, Brandeis University, Waltham, Massachusetts
Gevirtz-Mnuchin Purchase Fund by Exchange
1966.20
Catalogue No. 41

PROVENANCE
Leo Castelli Gallery, New York

One is vulnerable to disturbing events in the form of photographic images in a way that one is not to the real thing. That vulnerability is part of the distinctive passivity of someone who is a spectator twice over, spectator of events already shaped, first by the participants and second by the image maker.[1] Enframed within this large canvas are superimposed images, depicting the scene of a car accident. Trapped both within the flat, seamless monochrome surface of the painting and between the image of mangled car metal, are two victims that fall in extravagant gestures of death across the visual field of the viewer. *Saturday Disaster*'s unsettling images of death never fully give themselves over to purely formal consideration. The eye is forced to search in between the frames in a kind of "question—answer" visual dialogue, in order to make a composite scene from the passive if insistent images. The act of "seeing" becomes a visually rhetorical one, subverted by the "visual noise" of blanched inflections of light registered on the silkscreened images with varying intensity. The blurred outlines ultimately disrupt any complete, satisfactory reading of the scene.

Warhol's concern here with perception as an interdependent parallel structure between form and representation is shared with Lichtenstein's *Arctic Landscape*. But, Lichtenstein reduces dramatic content through the largely neutral image of a landscape in order to feature his scheme of rendering. Warhol on the other hand engages the viewer by stimulating a voyeuristic fascination with the real life drama of others. The viewer is compelled to read through the various formal obstacles to comprehend the scene.

Monochromed versions of Warhol's reiterated images composed in grids are also present in the *Jackie* series, *Race Riots* and other disaster scenes. They represent in their chromatic reticence and mimicry of the cold factual style of sixties media documentary photography (wire photography) some of his most striking and subtly powerful work. Here one sees Warhol exercising as well the film (cinema) editor's instinct for conflation of formal dynamics with subject matter, preselected and presented to the viewer with an almost pathologically objective drive to find the maximum visual shock inherent in such images. This impassively catalogued, baroque gesture of death, represents a different kind of "seeing" routed somewhere between horror and curiosity. *Saturday Disaster*'s morbid context ruptures the elegant visualism typical of much of the painting during this period. The image of bodies trapped between this crumpled metallic American icon is the very opposite of the colorful sleek shiny metal surfaces evoked in Rosenquist's *Car Touch* of 1966.

IE

1. Susan Sontag, "The Image World," *A Susan Sontag Reader* (New York: Random House, 1982), 359.

158

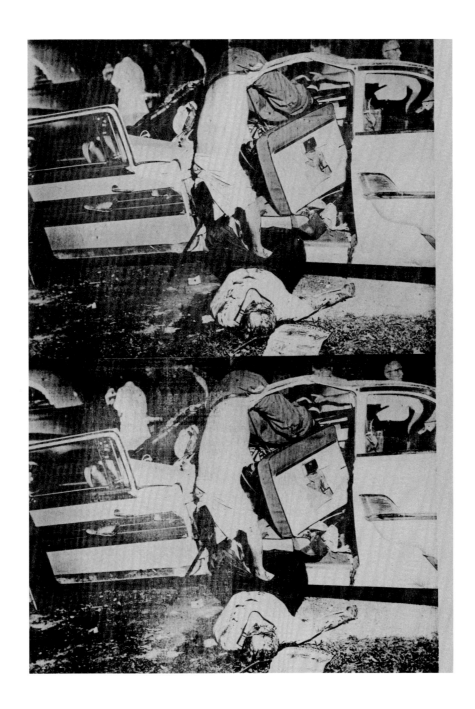

Tom Wesselmann

STILL LIFE NO. 25
1963
48 x 72 x 4 inches
Oil and assemblage on composition board
Rose Art Museum, Brandeis University
Gevirtz-Mnuchin Purchase Fund
1963.8
Catalogue No. 42

PROVENANCE
Collection of the artist; Green Gallery, New York (purchased in 1963).

BIOGRAPHY
Born 1931, Cincinnati, Ohio. Studies at University of Cincinnati 1949-56 (B.A., Psychology). Serves in U.S. Army 1952-54. Brief study at the Art Academy of Cincinnati, 1955-56; Cooper Union Art School, 1956-59. Taught in New York public schools 1959-61. First one-man exhibition, Tanager Gallery, 1961. Begins *Great American Nude* series, 1961. Begins *Still Life* series, teaches at high school of Art and Design, New York and joins Green Gallery, 1962. Begins series of full-size bathtub collages, 1963. Begins plastic-formed nudes, 1965.

Tom Wesselmann's *Still Life* series posits a balance between both formal and contextual aspects of the images incorporated into his collages. The *Still Life* series, begun in 1962, developed out of his earlier series of small (1' x 1') collages which incorporated painting and "found" images from contemporary illustration. Wesselmann gradually increased the scale of the *Still Lifes* in proportion to the increasingly larger sizes of objects employed.

Wesselmann's approach to the scale of his objects in relation to the scale of the picture frame reveals his attitude toward the images from popular culture which he employs in his compositions. His use of objects from everyday life is not unique, but shared by many of his contemporaries, such as Dine and Johns. But whereas Dine and Johns soften the context of elements fixed to the painting surface, changing their original circumstances and focusing on their formal, abstract interest, Wesselmann does not overtly transform the objects.[1] He seems to choose his objects for their formal content as well as their context. His compositions are designed to retain the original identity of each object, so that they "function" with other related objects within the context they create. The composition therefore stands for itself as subject just as the objects constructing the composition represent their subject.

Formal composition is Wesselmann's dominant means to achieving this formal and contextual balance. The *Still Lifes* from 1962-69 are made by a constant re-arranging of individual elements to achieve a solid and inevitable arrangement within a particular framework. Wesselmann's preparatory drawings for the collages indicate that he reworks the position and perspective of all objects so that no single element dominates, and every area of the canvas commands its own space. By making all parts of the composition equally strong, the objective subject matter does not preclude the subjective composition.[2]

In *Still Life No. 25*, individual elements seem to push against the frame, creating an approach to space and surface similar to the all-over brushwork of Pollock or de Kooning. Further, the space is so absolutely packed that an equilibrium develops through the interdependent spatial relationships of all depicted elements. The size, dimension and formal impact of the three-dimensional bread loaf, the potholder and the oven door, are balanced by the sheen and intensity of the metallic foil, apples and sodas. Finally, Wesselmann's loose brushwork in the patterned blue "cloth" further spreads visual intensity throughout the frame.

Wesselmann did not incorporate three-dimensional objects into his works until 1962, when he saw and acquired a three-dimensional loaf of bread from an advertising display and used it in his *Still Life No. 19*. Our *Still Life No. 25* is then formally related to the earlier work, but is perhaps more ambitious in the density of its composition. Because of his desire for a "classical" balance in his compositions, Wesselmann's work does not comment in an overt way on contemporary popular culture. Rather, by preserving the identity of the objects he uses, and neutralizing their novelty through formal balance, Wesselmann creates compositions whose visual rather than literary interest dominates.

MF

1. Slim Stealingworth, *Wesselmann* (New York: Cross River Press, 1980).

2. Stealingworth.

Tom Wesselmann

GREAT AMERICAN NUDE #69
1965
64 3/8 x 55 1/2 inches
Oil on canvas
Wadsworth Atheneum, Hartford
Gift of Susan Morse Hilles
1974.3
Catalogue No. 43

PROVENANCE
Unspecified

Great American Nude #69 is from the first group of cutouts Wesselmann began in late 1964 and finished in March 1965.[1] It is a transitional piece and clearly, a decisive move away from the tight, unified compositions of earlier assemblages such as *Still Life #25* (Rose Art Museum, Brandeis University, Cat. 42) towards a more diversified notion of pictorial structure. Following Stella and other proponents of the shaped canvas, Wesselmann has made the literal and depicted shapes "mutually responsive." By shaping the canvas to conform to the contours of the female figure, image and structure are made inseparable.

Wesselmann began to work on the *Great American Nude* series in 1961, limiting his palette at first to red, white, and blue in response to the "patriotic" theme. Originally drawn to de Kooning's *Women* as a student, he later responded to the work of Matisse whose sense of line and shape he emulates increasingly. A fusion of influences is confirmed in his ambiguous approach and attitude towards what his objects "signify." The nudes are highly generalized, specimen-like figures depicted in the various stages of intimate repose. The oversimplified anatomical details, limited to specific erogenous zones of the female figure, stand against the generally pristine figure, the combination representing some unspecified "essence" of Woman. The absence of facial features except for the lips, confirms that these nudes are not meant to be portraits of particular women (Wesselmann's wife Claire was the model for most of the pictures). This impersonal, generic quality is reinforced by a palette of deliberately commercial and artificial colors; yellow for hair, pink for skin and red for the lips and nipples. The use of synthetic acrylic polymer emulsions, painted in many thin layers with a finishing coat applied by spray, achieves a smooth, virtually flawless surface.

Prior to 1965, Wesselmann inserted still life scenes or landscapes into his *Great American Nude* paintings. But as the scale of the works increased so did his single-minded, fetishistic focus on the erotic aspects of women. In *Great American Nude #69* all superfluous background has been discarded, and the silhouette of the female torso (or the literal shape) now determines the shape of the canvas (the depicted shape). Yet, surprisingly, the figure has been cropped in such a manner (at the hairline, waist and arm) that it still seems residually dependent on a rectilinear support. As the abbreviated form emerges from a traditional compositional matrix it becomes incipiently sculptural.

Wesselmann did relatively few shaped canvases. In 1966 he began to work with a process whereby his nudes could be made of blow-form colored plastic, increasing the life-like contours of the figure.[2] In this medium Wesselmann completed several series of life-size nudes as well as the *Foot* and *Mouth* series of 1966 and 1967.

JW

1. Slim Stealingworth, *Tom Wesselmann* (New York: Abbeville Press, 1980), 44.

2. Stealingworth, 47.

Exhibitions

Selected Group Exhibitions

1963

Toward a New Abstraction. New York: The Jewish Museum. May 19 — September 15, 1963.

Americans 1963. New York: The Museum of Modern Art. May 22 — August 18, 1963.

The Popular Image. London: Institute of Contemporary Arts. October 24 - November 23, 1963.

New Directions in American Painting. Waltham: Rose Art Museum December 1, 1963 — December 6, 1964. Traveling exhibition.

Annual Exhibition. New York: Whitney Museum of American Art. December 11 — February 2, 1964.

Black and White. New York: The Jewish Museum. December 12, 1963 — February 5, 1964.

1964

Four Environments by Four New Realists. New York: Sidney Janis Gallery. January 3 — February 1, 1964.

Black, White and Gray. Hartford, Connecticut: The Wadsworth Atheneum. January 9 — February 9, 1964.

Amerikansk pop-konst. Stockholm: Moderna Museet. February 29 — April 12, 1964.

New Work: Part III. New York: Green Gallery. April 8 — May 2, 1964.

Post-Painterly Abstraction. Los Angeles: Los Angeles County Museum of Art. April 23 — June 7, 1964.

Painting and Sculpture of a Decade: 1954 — 1964. London: The Tate Gallery. April 22 — June 28, 1964.

Four Germinal Painters — Four Younger Artists. Venice: United States Pavilion, 32nd International Biennial Exhibition of Art. June 20 — October 15, 1964.

Group Exhibition: Artschwager, Lichtenstein, Rosenquist, Stella, Warhol. New York: Leo Castelli Gallery. September 16 — October 22, 1964.

Recent American Sculpture. New York: The Jewish Museum. October 15 — November 29, 1964.

1964 Pittsburgh International Exhibition of Contemporary American Sculpture. Pittsburgh: Museum of Art, Carnegie Institute. October 30 - January 10, 1965.

The Shaped Canvas. New York. Solomon R. Guggenheim Museum. December 9, 1964 — January 3, 1965.

Annual Exhibition. New York: Whitney Museum of American Art. December 9 — January 31, 1965.

1965

The Responsive Eye. New York. The Museum of Modern Art. February 23 — April 25, 1965.

29th Biennial Exhibition of Contemporary American Painting. Washington, D.C. Corcoran Gallery of Art. February 26 — April 18, 1965.

Painting Without a Brush. Boston: Institute of Contemporary Art. March 20 — April 25, 1965.

Three American Painters. Cambridge. Fogg Art Museum, Harvard University. April 21 — May 30, 1965.

Flavin, Judd, Morris, Williams. New York: Green Gallery. June 1965.

Shape and Structure. New York: Tibor de Nagy Gallery. 1965.

VII Bienal de Sao Paulo. Sao Paulo. Museo de Art Moderna. September 4 — November 28, 1965.

Word and Image. New York: Solomon R. Guggenheim Museum. December, 1965.

Pop and Op. New York: Sidney Janis Gallery. December 1965.

Annual Exhibition. New York: Whitney Museum of American Art. December 8 — January 30, 1966.

1966

Contemporary American Sculpture: Selection I. New York: Whitney Museum of American Art. April 5 — May 25, 1966.

Primary Structures: Younger American and British Sculptors. New York: The Jewish Museum. April 27 — June 27, 1966.

Art in Process: The Visual Development of a Structure. New York: The Finch College Museum/ Contemporary Study Wing. May 11 — June 30, 1966.

Helen Frankenthaler — Ellsworth Kelly — Roy Lichtenstein — Jules Olitski. Venice: 33rd International Biennial Exhibition of Art. United States Pavilion. June 18 — October 16, 1966.

Systemic Painting. New York. The Solomon R. Guggenheim Museum. September — November, 1966.

Art of the United States: 1670 — 1966. New York: Whitney Museum of American Art. September 28 — November 27, 1966.

10. New York: Dwan Gallery. October 4 — 29, 1966.

Two Decades of American Painting. New York: The Museum of Modern Art, International Council. October 15, — November 27,

1966, Tokyo. Traveled to Kyoto, New Delhi, Melbourne, Sidney.
Eight Sculptors: The Ambiguous Image. Minneapolis: The Walker Art Center. October 22 — December 4, 1966.
First Flint Invitational: An Exhibition of Contemporary Painting and Sculpture. Flint: Flint Institute of Arts. November 4 — 31, 1966.
Vormen van de Kleur. Amsterdam: Stedelijk Museum. November 20 — January 15, 1967.
Annual Exhibition. New York: The Whitney Museum of American Art. December 15, 1966 — February 5, 1967.

1967
10 Years. New York: Leo Castelli Gallery. February 4 — 26, 1967.
30th Biennial Exhibition of Contemporary American Painting. Washington, D.C.: Corcoran Gallery of Art. February 24 — April 9, 1967.
American Sculpture of the Sixties. Los Angeles: Los Angeles County Museum. April 28 — June 25, 1967.
The 1960s: Painting and Sculpture from the Museum Collections. New York: The Museum of Modern Art. June 28 — September 24, 1967.
Guggenheim International Exhibition: Sculpture from 20 Nations. New York: The Solomon R. Guggenheim Museum. October 20 — February 4, 1968.

Selected Exhibitions: Individual Artists

Carl Andre
Eight Young Artists. New York: Hudson River Museum. October 11 — 25, 1964.
One-man exhibition. New York: Tibor de Nagy Gallery. 1965.
Shape and Structure. 1965.
One-man exhibition. New York: Tibor de Nagy Gallery. 1966.
Primary Structures. 1966.
Multiplicity. Boston: Institute of Contemporary Art, 1966.
10. 1966.
One-man exhibition. New York and Los Angeles: Dwan Gallery. 1967.
One-man exhibition. Düsseldorf: Konrad Fischer Gallery. 1967.
Scale Models and Drawings. New York: Dwan Gallery. 1967.
American Sculpture of the Sixties. 1967.
Language to be Looked at and/or Things to be Read. New York: Dwan Gallery. 1967.
A Romantic Minimalism. Philadelphia: Institute of Contemporary Art. 1967.

Richard Artschwager
Group Exhibition, Artschwager, Christo, Hay, Watts. New York: Leo Castelli Gallery. May 2 — June 3, 1964.
Group Exhibition, Artschwager, Lichtenstein, Rosenquist, Stella, Warhol. 1964.
One-man exhibition. New York: Leo Castelli Gallery. January 30 — February 5, 1965.
Contemporary American Sculpture: Selection 1. 1966.
Primary Structures. 1966.
Whitney Annual Exhibition of Contemporary Sculpture and Prints. 1966.

Walter Darby Bannard
One-man exhibition. New York: Tibor de Nagy Gallery. January — February, 1965.
One-man exhibition. London: Kasmin Gallery. 1965.
The Responsive Eye. 1965.
One-man exhibition. New York: Tibor de Nagy Gallery. February, 1966.
One-man exhibition. Chicago: Richard Feigen Gallery. 1966.
One-man exhibition. Los Angeles: Nicholas Wilder Gallery. 1967.
One-man exhibition. New York: Tibor de Nagy Gallery. 1967

Larry Bell
Seven New Artists. New York: Sidney Janis Gallery. 1964.
Boxes. Los Angeles: Dwan Gallery. 1964.
One-man exhibition. Los Angeles: Ferus Gallery. 1965.
One-man exhibition. New York: Pace Gallery. 1965.
Five at Pace. New York: Pace Gallery. 1965.
The Responsive Eye. 1965.
Shape and Structure. 1965.
VII Bienal de Sao Paulo. 1965.
Contemporary American Sculpture: Selection I. 1966.
Primary Structures. 1966.
Whitney Annual Exhibition of Contemporary Sculpture and Prints. 1966.
American Sculpture of the Sixties. 1967.
The 1960's. 1967.
Guggenheim International Exhibition. 1967.

Lee Bontecou
Painting and Sculpture of a Decade: 1954 — 1964. 1965.
One-man exhibition. Paris: Galerie Ileana Sonnabend. 1965.
Seven Decades, 1895 — 1965: Cross-currents in Modern Art. New York: Cordier - Ekstrom Gallery. April, 1966.
One-man exhibition. New York: Leo Castelli Gallery. 1966.
Art of the United States: 1670 — 1966. 1966.
The First Flint Invitational. An Exhibition of Contemporary Painting

and Sculpture. 1966.

Sculpture: A Generation of Innovation. Chicago: Art Institute of Chicago. 1967.

Anthony Caro

One-man exhibition. New York: André Emmerich Gallery. December 2 — 19, 1964.

One-man exhibition. Washington: Washington Gallery of Modern Art. February 24 — March 28, 1965.

Seven Sculptors. Philadelphia: Institute of Contemporary Art. December 1965 — January 17, 1966.

Primary Structures. 1966.

Five Young British Artists. Venice: Venice Biennale. June 18 — October 16, 1966.

One-man exhibition. New York: André Emmerich Gallery. November 19 — December 8, 1966.

American Sculpture of the Sixties. 1967.

Guggenheim International Exhibition. 1967.

John Chamberlain

One-man exhibition. New York: Leo Castelli Gallery. 1964.

One-man exhibition. Paris: Galerie Ileana Sonnabend. 1964.

One-man exhibition. Boston: Pace Gallery. 1964.

Recent American Sculpture. 1964.

One-man exhibition. New York: Leo Castelli Gallery. 1965.

Contemporary American Sculpture: Selection 1. 1965.

One-man exhibition. Los Angeles: Dwan Gallery. 1966.

Art of the United States: 1670 — 1966. 1966.

Whitney Annual Exhibition of Contemporary Sculpture and Prints. 1966.

One-man exhibition. Cleveland: Cleveland Museum of Art. 1967.

Jim Dine

One-man exhibition. New York: Sidney Janis Gallery. 1964.

Four Germinal Painters — Four Younger Artists. 1964.

One-man exhibition. Turin: Galleria Gian Enzo Sperone. 1965.

One-man exhibition. New York: First New York Theatre. 1965.

One-man exhibition. Ohio: Allen Memorial Art Museum, Oberlin College. 1965.

One-man exhibition. London: Robert Fraser Gallery. 1965.

Recent Work by Arman, Dine, Fahlstrom, Marisol, Oldenburg and Segal. New York: Sidney Janis Gallery. May 5 — 31, 1965.

One-man exhibition. London: Robert Fraser Gallery. 1966.

Art of the United States: 1670 — 1966. 1966.

Mark di Suvero

One-man exhibition. Los Angeles: Dwan Gallery. 1965.

One-man exhibition. New York: Park Place Gallery. 1966.

One-man exhibition. New York. Park Place Gallery. 1967.

Recent American Sculpture. 1964.

Untitled Group Exhibition. New York: Park Place Gallery. 1964.

Untitled Group Exhibition. New York: The Green Gallery. 1965.

Untitled Group Exhibition. New York: Park Place Gallery. 1965.

Untitled Group Exhibition. New York: Park Place Gallery. 1966.

Contemporary American Sculpture: Selection I. 1966.

Art of the United States: 1670 — 1966. 1966.

Whitney Annual Exhibition of Contemporary Sculpture and Prints. 1966.

Untitled Group Exhibition. New York: Park Place Gallery. 1967.

Guggenheim International Exhibition. 1967.

American Sculpture of the Sixties. 1967.

Friedel Dzubas

Black and White. 1964.

Post-Painterly Abstraction. 1964.

One-man exhibition. London: Kasmin Limited. January 31 — February, 1964.

One-man exhibition. New York: Robert Elkon Gallery. March 9 — April 3, 1965.

One-man exhibition. London: Kasmin Limited. September 24 — October, 1965.

One-man exhibition. New York: André Emmerich Gallery. April 5 — 23, 1966.

One-man exhibition. Los Angeles: Nicholas Wilder Gallery. September 27 — October 29, 1966.

One-man exhibition. New York: André Emmerich Gallery. December 31 — January 19, 1967.

30th Biennial Exhibition of Contemporary American Painting. 1967.

Dan Flavin

Dan Flavin: some light. One-man exhibition. New York: Kaymar Gallery. March 5 — 29. 1964.

Dan Flavin: fluorescent light. One-man exhibition. New York: Green Gallery. November 18 — December 12, 1964.

Flavin, Judd, Morris, Williams. 1965.

Primary Structures. 1966.

Art in Process: The Visual Development of a Structure. 1966.

Helen Frankenthaler

One-man exhibition. Paris: Galerie Lawrence. 1963.

New Directions in American Painting. 1964.

Post-Painterly Abstraction. 1964.

Painting and Sculpture of a Decade: 1954 — 1964. 1964.

One-man exhibition. London: Kasmin Gallery. 1964.

One-man exhibition. New York: André Emmerich Gallery. 1965.

One-man exhibition. Toronto: David Mirvish Gallery, 1965.

Painting Without a Brush. 1965.

One-man exhibition. New York: André Emmerich Gallery. 1966.

One-man exhibition. London: Kasmin Gallery. March — April, 1966.

Helen Frankenthaler — Jules Olitski — Roy Lichtenstein — Jules Olitski. 1966.

Two Decades of American Painting. 1966.

Al Held;

Whitney Annual Exhibition of Contemporary American Painting. 1963-64.

One-man exhibition. Zurich: Galerie Renée Ziegler. 1964.

One-man exhibition. Dusseldorf: Galerie Gunar. 1964.

Post-Painterly Abstraction. 1964.

Whitney Annual Exhibition of Contemporary American Painting. 1964.

One-man exhibition. New York: André Emmerich Gallery. 1965

Whitney Annual Exhibition of Contemporary American Painting. 1965-66.

Systemic Painting. 1966.

Two Decades of American Painting. 1966.

Vormen der Kleur. 1966.

One-man exhibition. Stuttgart: Galerie Muller. 1966.

The First Flint Invitational: An Exhibition of Contemporary Painting and Sculpture. 1966.

Two Decades of American Painting. 1966.

One-man exhibition. New York: André Emmerich Gallery. 1967.

Whitney Annual Exhibition of Contemporary American Painting. 1967.

One-man exhibition. Zurich: Galerie Renée Ziegler. 1967.

Robert Indiana

Americans 1963.

One-man exhibition. New York: Stable Gallery. May 1964.

Painting and Sculpture of a Decade: 1954 — 1964. 1964.

29th Biennial. Washington D.C.: Corcoran Gallery of Art. 1965.

Whitney Annual Exhibition of Contemporary American Painting. 1965.

Word and Image. 1965.

Whitney Annual Exhibition of Contemporary American Painting. 1966.

Donald Judd

Eleven Artists. New York: Kaymar Gallery. March 31 — April 14, 1964.

One-man exhibition. New York: Green Gallery. April 8 — May 2, 1964.

One-Man exhibition. New York: Green Gallery. October 24 — No-

vember 14, 1964.

Shape and Structure. 1965.

The Box Show. New York: Byron Gallery. February 3 — 27, 1965.

Plastics. New York: John Daniels Gallery. March 16 — April 3, 1965.

Flavin, Judd, Morris, Williams. New York: Green Gallery. May 26 — June 12, 1965.

VII Bienal de Sao Paulo. 1965.

Sculpture From All Directions. New York: World House Galleries. November 3 — 27, 1965.

Group exhibition. New York: Leo Castelli Gallery. December, 1965.

Seven Sculptors. Philadelphia: Institute of Contemporary Art. December 3, 1965 — January 17, 1966.

One-man exhibition. New York: Leo Castelli Gallery. February 5 — March 2, 1966.

Contemporary American Sculpture: Selection I. 1966.

Multiplicity. Boston: Institute of Contemporary Art. April 6 — June 5, 1966.

Primary Structures. 1966.

New Dimensions. New York: A. M. Sachs Gallery. May 10 — 28, 1966.

Art in Process: The Visual Development of a Structure. 1966.

10. 1966.

Whitney Annual Exhibition of Sculpture and Prints. 1966.

Eight Sculptors: The Ambiguous Image. 1966.

10 Years. 1967.

American Sculpture of the Sixties. 1967.

Guggenheim International Exhibition. 1967.

Ellsworth Kelly

Toward a New Abstraction. 1963.

New Directions in American Painting. 1964.

Whitney Annual Exhibition of Contemporary American Painting. 1963-64.

Painting and Sculpture of a Decade: 1954 — 1964. 1964.

One-man exhibition. Washington D.C.: Gallery of Modern Art. December 11 — January 26, 1964. Traveled to Boston: Institute of Contemporary Art. February 1 — March 8, 1964.

Post-Painterly Abstraction. 1964.

The 1964 Pittsburgh International Exhibition of Painting and Sculpture. 1964.

The Responsive Eye. 1965.

One-man exhibition. New York: Sidney Janis Gallery. April 16 — May 1, 1965.

Primary Structures. 1966.

Helen Frankenthaler — Ellsworth Kelly — Roy Lichtenstein — Jules Olitski. 1966.

One-man exhibition. Los Angeles: Ferus Gallery. September 21 —

November 27, 1966.
Systemic Painting. 1966.
Art of the United States: 1670 — 1966. 1966.
Vormen van de Kleur. 1966.
Whitney Annual Exhibition of Contemporary Sculpture and Prints. 1966.

Sol LeWitt
One-man exhibition. New York: Daniel Gallery. 1965.
One-man exhibition. New York: Dwan Gallery. April 21 — 29, 1966.
Primary Structures. 1966.
Art in Process: The Visual Development of a Structure. 1966.

Roy Lichtenstein
One-man exhibition. Turin: Galleria Il Punto. 1964.
One-man exhibition. New York: Leo Castelli Gallery. 1964.
Group Show: Artschwager, Lichtenstein, Rosenquist, Stella, Warhol. 1964.
Amerikansk pop-konst. 1964.
Painting and Sculpture of a Decade: 1954 — 1964. 1964.
One-man exhibition. Paris: Galerie Ileana Sonnabend. 1965.
One-man exhibition. New York: Leo Castelli Gallery. 1965.
29th Biennial of Contemporary American Painting. 1965.
Word and Image. 1965.
Whitney Annual Exhibition of Contemporary American Painting. 1965.
One-man exhibition. Cleveland: Cleveland Museum of Art. 1966.
Two Decades of American Painting. 1966.
Helen Frankenthaler — Ellsworth Kelly — Jules Olitski — Roy Lichtenstein. 1966.
The 1960s. 1967.

Marisol (Escobar)
Americans 1963. 1963.
One-man exhibition. New York: Stable Gallery. 1964.
Painting and Sculpture of a Decade: 1954—1964. 1964.
Whitney Annual Exhibition of Contemporary Sculpture and Prints. 1964.
One-man exhibition. Chicago: Arts Club of Chicago. 1965.
Recent Work by Arman, Dine, Fahlstrom, Marisol, Oldenburg and Segal. New York: Sidney Janis Gallery. May 5 — 31, 1965.
One-man exhibition. New York: Sidney Janis Gallery. 1966.
Art of the United States: 1670 — 1966. 1966.

Agnes Martin
Black, White and Grey. 1963.
One-man Exhibition. New York: Robert Elkon Gallery. 1964.

American Drawings. New York: The Solomon R. Guggenheim Museum. 1964.
Recent American Drawings. Waltham: Rose Art Museum, Brandeis University. 1964.
One-man Exhibition. New York: Robert Elkon Gallery. 1965.
The Responsive Eye. New York: 1965.
One-man Exhibition. New York: Robert Elkon Gallery. 1966.
One-man Exhibition. Los Angeles: Nicholas Wilder Gallery. 1966.
10. 1966.
Systemic Painting. 1966.
30th Biennial Exhibition of Contemporary American Painting. 1967.
One-man Exhibition. Los Angeles: Nicholas Wilder Gallery. 1967.
Whitney Annual Exhibition of Contemporary American Painting. 1967.

John McCracken
One-man exhibition. Los Angeles: Nicholas Wilder Gallery. 1965.
One-man exhibition. Los Angeles: Nicholas Wilder Gallery. 1966.
One-man exhibition. New York: Robert Elkon Gallery. 1966.
Primary Structures. 1966.
Art of the United States: 1670 — 1966.
Whitney Annual Exhibition of Contemporary Sculpture and Prints. 1966.
American Sculpture of the Sixties. 1967.

Robert Morris
Black, White and Gray. 1964.
One-man exhibition. New York: Green Gallery. December 1964 — January 1965.
Flavin, Judd, Morris, Williams. 1965.
Shape and Structure. 1965.
Primary Structures. 1966.
Art in Process: The Visual Development of a Structure. 1966.
Art of the United States: 1670 — 1966. 1966.
10. 1966.
Eight Sculptors: The Ambiguous Image. 1966.
Whitney Annual Exhibition of Contemporary Sculpture and Prints. 1966.
American Sculpture of the Sixties. 1967.
Ten Years. 1967.

Kenneth Noland
Toward a New Abstraction. 1963.
New Directions in American Painting. 1964.
Post Painterly Abstraction. 1964.
Painting and Sculpture of a Decade: 1954 — 1964. 1964.
Four Germinal Painters — Four Younger Artists. 1964.
One-man exhibition. New York: André Emmerich Gallery. Novem-

ber 10-28, 1964.

The Responsive Eye. 1965.

Painting Without a Brush. 1965.

Three American Painters. 1965.

One-man exhibition. New York: The Jewish Museum. February 4 — March 7, 1965.

One-man exhibition. Toronto: David Mirvish Gallery. February 21 — March 16, 1965.

One-man exhibition. London: Kasmin Gallery. April 2 — May 2, 1965.

One-man exhibition. New York: André Emmerich Gallery. February 22 — March 13, 1966.

Systemic Painting. 1966.

Art of the United States: 1670 — 1966. 1966.

Two Decades of American Painting. 1966.

One-man exhibition. Los Angeles: Nicholas Wilder Gallery. November 8 — 26, 1966.

Whitney Annual Exhibition of Contemporary American Painting. 1966.

30th Biennial Exhibition of Contemporary American Painting. 1967.

Claes Oldenburg

Four Environments by Four New Realists. 1964.

Amerikansk pop-konst. 1964.

One-man exhibition. New York: Sidney Janis Gallery. April 7 — May 2, 1964.

One-man exhibition. Paris: Galerie Ileana Sonnabend. October-November, 1964.

Whitney Annual Exhibition of Contemporary Sculpture and Prints. 1964.

Recent Work by Arman, Dine, Fahlstrom, Marisol, Oldenburg and Segal. New York: Sidney Janis Gallery. May 5 — 31, 1965.

One-man exhibition. New York: Sidney Janis Gallery. March 9 — April 2, 1966.

Art in Process: The Visual Development of a Structure. 1966.

Art of the United States: 1670 — 1966. 1966.

Eight Sculptors: The Ambiguous Image.

Whitney Annual Exhibition of Contemporary Sculpture and Prints. 1966.

American Sculpture of the Sixties. 1967.

Guggenheim International Exhibition. 1967.

Jules Olitski

New Directions in American Painting. 1964.

Post Painterly Abstraction. 1964.

One-man exhibition. Chicago: David Gray Gallery. January 6 — February 1, 1964.

One-man exhibition. London: Kasmin Gallery. April 1964.

One-man exhibition. Paris: Galerie Lawrence. Autumn 1964.

One-man exhibition. New York: Poindexter Gallery. October 26 — November 13, 1964

One-man exhibition. Toronto: David Mirvish Gallery. December 12 — January 7, 1965.

One-man exhibition. New York: Poindexter Gallery. March 10 — 25, 1965.

One-man exhibition. London: Kasmin Gallery. April 17 — May 1, 1965.

Three American Painters. 1965.

One-man exhibition. Toronto: David Mirvish Gallery. November 11 — December 5, 1965.

Helen Frankenthaler — Ellsworth Kelly — Roy Lichtenstein — Jules Olitski. 1966.

One-man exhibition. Los Angeles: Nicholas Wilder Gallery. June 1966.

One-man exhibition. Toronto: David Mirvish Gallery. October 15 — November 7, 1966.

One-man exhibition. New York: André Emmerich Gallery. October 29 — November 17, 1966.

Larry Poons

One-man exhibition. New York: Green Gallery. 1964.

One-man exhibition. New York: Green Gallery. 1965.

The Responsive Eye. 1965.

Young America. 1965.

Whitney Annual Exhibition of Contemporary American Painting. 1965.

Systemic Painting. 1966.

Art of the United States: 1670 — 1966. 1966.

One-man exhibition. New York: Leo Castelli Gallery, 1967.

James Rosenquist

Americans 1963. 1963.

One-man exhibition. Los Angeles: Dwan gallery. 1964.

One-man exhibition. Paris: Galerie Ileana Sonnabend. 1964.

One-man exhibition. Turin: Galleria Sperone. 1964.

Four Environments by Four New Realists. 1964.

Group Show: Artschwager, Lichtenstein, Rosenquist, Stella, Warhol. 1964.

One-man exhibition. New York: Leo Castelli Gallery. 1965.

One-man exhibition. Stockholm: Moderna Museet. 1965.

One-man exhibition. Turin: Museo d'Arte Moderna. 1965.

One-man exhibition. Paris: Galeria Ileana Sonnabend. 1965.

One-man exhibition. New York: Leo Castelli Gallery. 1966.

One-man exhibition. Stockholm: Moderna Museet. 1966.

One-man exhibition. Baden Baden, West Germany: Staatliche

Kunsthalle. 1966.
One-man exhibition. Amsterdam: Stedelijk Museum. 1966.

George Segal

Four Environments by Four New Realists. 1964.
Amerikansk pop-konst. 1964
One-man exhibition. New York: Green Gallery. March 11 — April 4, 1964.
New Work: Part III. 1964.
Recent American Sculpture. 1964.
1964 Pittsburgh International Exhibition of Contemporary Painting and Sculpture. 1964 — 65.
Recent Work by Arman, Dine, Fahlstrom, Marisol, Oldenburg and Segal. New York: Sidney Janis Gallery. May 5 — 31, 1965.
Pop and Op. 1965.
One-man exhibition. New York: Sidney Janis Gallery. October 4 — 30, 1965.
Art of the United States: 1670 — 1966. 1966.
Eight Sculptors: The Ambiguous Image. 1966.
Whitney Annual Exhibition of Contemporary Sculpture and Prints. 1966.

Frank Stella

Whitney Annual Exhibition of Contemporary American Painting. 1963.
One-man exhibition. New York: Leo Castelli Gallery. January 4 — February 6, 1964.
Group show: Artschwager, Lichtenstein, Rosenquist, Stella, Warhol. 1964.
One-man exhibition. Paris: Galerie Lawrence. May 12 — June 2, 1964.
Group show. New York: Leo Castelli Gallery. June 6 — 30, 1964.
Black and White. 1964.
Black, White and Gray. 1964.
Post-Painterly Abstraction. 1964.
Four Germinal Painters — Four Younger Artists. 1964.
The Shaped Canvas. 1964.
One-man exhibition. London: Kasmin Limited. September 29 — October 24, 1964.
The Responsive Eye. 1965.
Three American Painters. 1965.
VII Bienal de Sao Paulo. 1965.
Group show. New York: Leo Castelli Gallery. October 2 — 21, 1965.
Whitney Annual Exhibition of Contemporary American Painting. 1965.
One-man exhibition. New York: Leo Castelli Gallery. March 5 — April 6, 1966.

One-man exhibition. Toronto: David Mirvish Gallery. April 15 — May 8, 1966.
Group show. New York: Leo Castelli Gallery. June 14 — 30, 1966.
Systemic Painting. 1966.
Art of the United States: 1670 — 1966. 1966.
Two Decades of American Painting. 1966.
The First Flint Invitational: An Exhibition of Contemporary Painting and Sculpture. 1966.
Vormen der Kleur. 1966.
10 Years. 1967.
One-man exhibition. New York. Leo Castelli Gallery. April 1 — May 10, 1967.
30th Biennial Exhibition of Contemporary American Painting. 1967.

David von Schlegell

One-man exhibition. Durham: University of New Hampshire. 1964.
One-man exhibition. Boston: Stanhope Gallery. 1964.
Whitney Annual Exhibition of Contemporary Sculpture and Prints. 1964.
One-man exhibition. Boston: Ward-Nasse Gallery. 1964.
Three-man Exhibition. Boston: Institute of Contemporary Art. 1965.
One-Man exhibition. New York: Royal Mark's Gallery. 1966.
Primary Structures. 1966.
Whitney Annual Exhibition of Contemporary Sculpture and Prints. 1966.

Andy Warhol

One-man exhibition. Paris: Galerie Ileana Sonnabend. January — February 1964.
One-man exhibition. New York: Stable Gallery. April 21 — May 9, 1964.
One-man exhibition. New York: Leo Castelli Gallery. November 21 — December 17, 1964.
Amerikansk pop-konst. 1964.
One-man exhibition. Milan: Gian Enzo Sperone Arte Moderna. 1965.
One-man exhibition. Paris: Galerie Ileana Sonnabend. May 1965.
One-man exhibition. Philadelphia: Institute of Contemporary Art, University of Pennsylvania. October 8 — November 21, 1965.
Pop and Op. 1965.
One-man exhibition. New York: Leo Castelli Gallery. April 1966.
One-man exhibition. Los Angeles: Ferus Gallery. 1966.
Art of the United States: 1670 — 1966. 1966.
One-man exhibition. Boston: Institute of Contemporary Art. October 1 — November 6, 1966.
Eight Sculptors: The Ambiguous Image. 1966.
Two Decades of American Painting. 1966.

Tom Wesselmann

One-man exhibition. New York: Green Gallery. 1964.

Amerikansk pop-konst. 1964.

1964 Pittsburgh International. 1964.

One-man exhibition. New York: Green Gallery. 1965.

Young America 1965. New York: Whitney Museum of American Art. 1965.

One-man exhibition. New York: Sidney Janis Gallery. 1966.

Art of the United States: 1670 — 1966. 1966.

Selected Bibliography

Selected General Bibliography

Alloway, Lawrence. "Network: The Art World Described as a System." *Artforum* 11, no. 1 (September 1972): 28-33.

————. "Rauschenberg's Development." In *Robert Rauschenberg*. Washington D.C.: National Collection of Fine Arts, Smithsonian Institution, 1976.

————. *Topics In American Art Since 1945*. New York: W.W. Norton and Co., 1975.

Arlen, Michael. *The Camera Age: Essays On Television*. New York: McGraw-Hill, 1964.

————. *Living Room War*. New York: Viking Press, 1969.

Arnason, H.H. *Robert Motherwell*. New York: Harry N. Abrams, 1982.

Art of Our Time: The Saatchi Collection 1. London: Lund Humphries, 1984. Essay by Peter Schjeldahl.

Art of Our Time: The Saatchi Collection 2. London: Lund Humphries, 1984. Essays by Jean-Christophe Ammann, Michael Auping, Robert Rosenblum, Peter Schjeldahl.

Ashton, Dore. *The New York School: A Cultural Reckoning*. New York: The Viking Press, 1973.

Bannard, Walter Darby. *Hans Hofmann*. Houston: The Museum of Fine Arts, 1976.

————. "Notes on American Painting of the Sixties." *Artforum* 8, no. 5 (January 1970): 40-45.

————. "Present-Day Art and Ready-Made Styles: in which the formal contribution of Pop art is found to be negligible." *Artforum* 5, no. 4 (December 1966): 30-35.

Battcock, Gregory, ed. *Minimal Art: A Critical Anthology*. New York: E.P. Dutton, 1968.

————. *The New Art*. New York: E.P. Dutton, 1973.

Blonsky, Marshall, ed. *On Signs*. Baltimore: The Johns Hopkins University Press, 1985.

Brantlinger, Patrick. *Bread and Circuses: Theories of Mass Culture as Social Decay*. Ithaca: Cornell University Press, 1983.

Bürger, Peter. *Theory of The Avant-Garde*. Minneapolis: University of Minneapolis, 1984.

Burke, John, ed. *Print, Image and Sound: Essays on Media*. Chicago: American Library Association, 1972.

Burn, Ian. "The Art Market: Affluence and Degradation." *Artforum* 13, no. 8 (April 1975): 34-37.

Burnham, Sophy. *The Art Crowd*. New York: David McKay, 1973.

Cage, John. *Silence: Lectures and Writings*. Middletown: Wesleyan University Press, 1961.

Canaday, John. *Culture Gulch: Notes on Art and Its Public in the 1960's*. New York: Farrar, Straus and Giroux, 1969.

————. "Pop Art Sells On and On — Why?" *The New York Times Magazine* (May 31, 1964): 7, 48, 52-3.

Carmean, E. A., Jr., ed. *The Great Decade of American Abstraction: Modernist Art 1960 to 1970*. Houston: The Museum of Fine Arts, 1974.

Carrier, David. "Greenberg, Fried and Philosophy: American-Type Formalism." *Aesthetics: A Critical Anthology*. George Dickie and R. J. Sclafani, eds. New York: St. Martin's Press, 1977, 461-69.

Champa, Kermit Swiler. *Mondrian Studies*. Chicago: The University of Chicago Press, 1985.

Coleman, Howard. *Color Television: The Business of Colorcasting*. New York: Hastings House, 1968.

Coplans, John. "Pop Art, U.S.A." *Artforum* 2, no. 4 (October 1963): 27-30.

————. "Post-Painterly Abstraction: The Long-Awaited Greenberg Exhibition Fails to Make its Point." *Artforum* 2, no. 12 (June 1964): 4-9.

Coplans, John and Lawrence Alloway. "Talking with William Rubin: The Museum Concept is not Infinitely Expandable." *Artforum* 13, no. 2 (November 1974): 51-57.

Cavell, Stanley. *Must We Mean What We Say?* New York: Charles Scribner's Sons, 1969.

Dabrowski, Magdalena. *Contrasts of Form: Geometric Abstract Art 1910-1980*. New York: Museum of Modern Art, 1985.

De Antonio, Emile and Mitch Tuchman. *Painters Painting*. New York: Abbeville Press, 1984.

De Coppet, Laura and Alan Jones. *The Art Dealers*. New York: Clarkson N. Potter, 1984.

Curtis, James. *Culture As Polyphony: An Essay On The Nature of Paradigms*. Missouri: University of Missouri, 1978.

Debord, Guy. *Society of The Spectacle*. Detroit: Black and Red, 1983.

Diamonstein, Barbaralee. *Inside New York's Art World*. New York: Rizzoli, 1969.

Martin Duberman. *Black Mountain: An Exploration in Community*. New York: E.P. Dutton, 1972.

Eco, Umberto. "Innovation and Repetition: Between Modern and Post-Modern Aesthetics." *Daedalus* 114, no. 4 (Fall 1985).

Eight Sculptors: the ambiguous image. Minneapolis: Walker Art Center, 1966. Essays by Martin Friedman, Jan van der Marck.

Feigen, Richard. "Art 'Boom:' Inflationary Hedge and Deflationary Refuge." *Arts* 4, no. 1 (November 1966): 23-4.

Finch, Christopher. "Harry N. Abrams Collects." *Auction* 4, no. 2 (October 1970): 33-38.

Finkelstein, Sidney. *Sense and Nonsense of McLuhan*. New York: International Publishers, 1968.

The First Show: Painting and Sculpture from Eight Collections, 1940-1980. New York: The Arts Publishers, Inc. for the Museum of Contemporary Art, Los Angeles, 1983.

Fiske, John and Hartley John. *Reading Television*. London: Methuen, 1978.

Foster, Hal, ed. *The Anti-Aesthetic: Essays on Postmodern Culture*. Washington: Bay Press, 1983.

Francis, Richard. *Jasper Johns*. New York: Abbeville Press, 1984.

Frascina, Francis, ed. *Pollock and After: The Critical Debate*. New York: Harper and Row, 1985.

Fried, Michael. "Art and Objecthood." *Artforum* 5, no. 10 (June 1967): 12-23. Reprinted in Gregory Battcock, ed. *Minimal Art: A Critical Anthology*. New York: E.P. Dutton, 1968, 116-47.

————. "The Confounding of Confusions." *Arts Yearbook* 7 (1964): 37-45.

————. "How Modernism Works: a response to T. J. Clark." *Critical Inquiry* 9, no. 1 (September 1982): 217-34.

————. "Introduction." *XXXIII International Biennial Exhibition of Art, Venice, 1966*. Washington, D.C., National Collection of Fine Arts, Smithsonian Institution, 1966, 19-23.

————. "Jules Olitski's New Paintings." *Artforum* 4, no. 3 (November 1965): 36-40.

————. "Modernist Painting and Formal Criticism." *American Scholar* 33, no. 4 (Autumn 1964): 642-48.

————. *Morris Louis*. New York: Harry N. Abrams, 1970.

————. "Shape as Form: Frank Stella's New Paintings." *Artforum* 5, no. 3 (November 1966): 18-27. Reprinted in Henry Geldzahler, ed. *New York Painting and Sculpture: 1940 to 1970*. New York: E.P. Dutton for the Metropolitan Museum of Art, 1969, 403-28.

————. *Three American Painters*. Cambridge: The Fogg Art Museum, 1965.

Geldzahler, Henry. "Frankenthaler, Kelly, Lichtenstein, Olitski." *Artforum* 4, no. 10 (June 1966)

————, ed. *New York Painting and Sculpture: 1940 to 1970*. New York: E.P. Dutton for the Metropolitan Museum of Art, 1969.

Genauer, Emily. "Can This be Art?" *Ladies' Home Journal* (March 1964): 151-55.

Gendel, Milton. "If one hasn't visited Count Panza's villa, one doesn't really know what collecting is all about." *Art News* 78, no. 10 (December 1979): 44-49.

Glaser, Bruce (moderator). "Oldenburg, Lichtenstein, Warhol: A Discussion." *Artforum* 4, no. 6 (February 1966): 20-24.

Glueck, Grace. "A Collector Intent on Preserving an Era." *The New York Times* (March 31 1985) 11, 29: 1.

Goldin, Amy. "Requiem for a Gallery." *Arts* 40, no. 3 (January 1966): 25-29.

Greenberg, Clement. *Action Painting*. Dallas: Museum of Contemporary Arts, 1958.

————. "After Abstract Expressionism." *Art International* 6, no. 8 (October 25, 1962): 24-32.

————. *Art and Culture: Critical Essays*. Boston: Beacon Press, 1961.

————. *Hans Hofmann*. Paris: Edition Georges Fall, 1961.

————. "How Art Writing Earns Its Bad Name." *Encounter* (December 1962): 67-71.

————. "Louis and Noland." *Art International* 4, no. 5 (May 1960): 26-29.

————. "Modernist Painting." *Art and Literature* 4 (Spring 1965): 193-201. Reprinted in Gregory Battcock, ed. *The New Art*. New York: E.P. Dutton, 1973, 66-77.

————. *Post Painterly Abstraction*. Los Angeles: Los Angeles County Museum, 1964. Reprinted in E. A. Carmen, Jr., ed. *The Great Decade of American Abstraction: Modernist Art 1960 to 1970*. Houston: The Museum of Fine Arts, 1974, 72-74.

————. "Problems of Criticism II: Complaints of an Art Critic." *Artforum* 6, no. 2 (October 1967): 38-9.

————. "The Recentness of Sculpture." *American Sculpture of the Sixties*. Los Angeles: Los Angeles County Museum of Art, 1967. Reprinted in Gregory Battcock, ed. *Minimal Art: A Critical Anthology*. New York: E.P. Dutton, 1968, 180-86.

Guilbaut, Serge. *How New York Stole the Idea of Modern Art*. Chicago: The University of Chicago Press, 1983.

Haskell, Barbara. *Blam! The Explosion of Pop, Minimalism and Performance 1958-64*. New York: The Whitney Museum of American Art in association with W.W. Norton & Company, 1984.

Hess, Thomas B. *Abstract Painting: Backround and American Phase*. New York: Viking Press, 1951.

————. "The Phony Crisis in American Art." *Art News* 63 (Summer 1963): 24-28, 59-60.

Hodgins, Eric and Parker Lesley. "The Great International Art Market." *Fortune* (December 1955): 118. Continued in *Fortune* (January 1956): 122.

Hughes, Robert. *The Shock of The New*. New York: Alfred A. Knopf, 1981.

Hunter, Sam. *American Art of the Twentieth Century: Painting, Sculpture, Architecture*. New York: Harry N. Abrams, Inc., 1973.

————. *Hans Hofmann*. New York: Harry N. Abrams, 1963.

————. *Selections from the Ileana and Michael Sonnabend Collection*. Princeton: The Art Museum, Princeton University, 1985.

"Investing in Art — the Latest Boom." *U.S. News & World Report* (January 27, 1964): 66-69.

Judd, Donald. *Complete Writings 1959-1975*. Halifax: The Press of the Nova Scotia College of Art and Design, 1975.

Karp, Ivan C. "Anti-Sensibility Painting." *Artforum* 2, no. 3 (September 1963): 26-27.

Kinkead, Gwen. "The Spectacular Fall and Rise of Hans Hofmann." *Art News* 79, no. 6 (Summer 1980): 88-96.

Kirschenbaum, Baruch D. "The Scull Auction and The Scull Film." *Art Journal* 29, (Fall 1979): 50-64.

Klein, Robert. *Form and Meaning: Writings on the Renaissance and Modern Art*. Trans. Madeline Jay and Leo Wieseltier. Princeton: Princeton University Press, 1981.

Kozloff, Max. "The Critical Reception of Abstract Expressionism." *Arts Magazine* 39, no. 10 (December 1965): 28.

————. "The Further Adventures of American Sculpture." *Arts Magazine* 39, no. 5 (February 1965): 24-31.

————. "'Pop' Culture, Metaphysical Disgust and the New Vulgarians." *Art International* 6, (March 1962): 34-6.

————. "Pop on the Meadow." *The Nation* (July 13, 1964): 16-18.

Kuh, Katharine. "The New Art and Its Collectors." *Saturday Review* (December 4, 1973): 38-40.

Kuhn, Annette. "Post-War Collecting: The Emergence of Phase III." *Art in America* 65, no. 5 (September/October 1977): 110-113.

Krauss, Rosalind E. "Allusion and Illusion in Judd." *Artforum* 4, no. 9 (May 1966): 24-26.

————. "A View of Modernism." *Artforum* 9, no. 1 (September 1972): 48-51.

————. *Passages in Modern Sculpture*. Cambridge: The MIT Press, 1981.

Lippard, Lucy. *Pop Art*. New York: Praeger Inc., 1966.

————. "Rejective Art." *Art International* 10 (October 1966): 33-37.

McLuhan, Marshall. "Art as Anti-Environment." *Art News* 31 (1966): 55-59.

————. *Understanding Media: The Extensions of Man*. New York: McGraw-Hill, 1964.

McQuillan, Mellisa. "Art Criticism of Michael Fried." *Marsyas* 15 (1970-71): 86-100.

Miller, Jonathan. *McLuhan*. London: Fontana, 1971.

Muller, Gregoire. "Points of View: A Taped Conversation with Robert C. Scull." *Arts* 45, no. 2 (November 1970): 37-39.

The Museum of Contemporary Art: The Panza Collection. New York: LS Graphics for the Museum of Contemporary Art, Los Angeles, 1985.

Naifeh, Steven W. *Culture Making: Money, Success and the New York Art World*. Princeton: Princeton Undergraduate Studies in History, 1976.

Nodelman, Sheldon. "Sixties Art: Some Philosophical Perspectives." *Perspecta* 11 (1967): 74-89

O'Connor, Francis V. "Notes on Patronage: The 1960's." *Artforum* 11, no. 1 (September 1972): 52-56.

Plagens, Peter. "Present-Day Styles and Ready-Made Criticism: in which the formal contribution of Pop art is found to be Minimal." *Artforum* 5, no. 4 (December 1966): 36-39.

Poggioli, Renato. *Theory of the Avant-Garde*. Garden City: Icon, 1965.

Poindexter, Joseph. "Everything You Should Know About Art and Taxes." *Auction* 5, no. 3 (November 1971): 26-29.

"Pop Art — Cult and Commonplace." *Time* 81 (May 3, 1963): 69-72.

"Private Lives with Art." *Vogue* 143, no. 2 (January 15, 1964): 86-95.

Reitlinger, Gerald. *The Economy of Taste: The Art Market in the 1960's*. London: Barrie and Rockliff, 1970.

Roper, Elmo and Associates. "The Public's View of Television and Other Media 1959-1964." In *A Report of Five Studies*. New York: Television Information Office, 1965.

Rose, Barbara. "ABC Art." *Art in America* 53 (October-November 1965): 57-69. Reprinted in Gregory Battcock, ed. *Minimal Art: A Critical Anthology*. New York: E.P. Dutton, 1968, 274-97.

————. *American Art Since 1900*. New York: Holt, Rinehart & Winston, 1967.

————. *American Painting: the Twentieth Century*. Geneva: Skira, 1980.

————. *A New Aesthetic*. Washington: The Gallery of Modern Art, 1967.

————. "Editorial: Art Talent Scouts." *Art in America* 52, no. 4 (August 1964): 19-20.

————. "Kenneth Noland." *Art International* 8, no. 4 (1966): 58.

————. "Looking at American Sculpture." *Artforum* 3, no. 5 (February 1965): 29-36.

————. "The New Whitney: the Show." *Artforum* 5, no. 3 (November 1966): 51-55.

————. "Problems in Criticism IV: The Politics of Art I." *Artforum* 6, no. 6 (February 1968): 31-32.

————. "Problems in Criticism V: The Politics of Art Part II." *Artforum* 7, no. 1 (January 1969): 44-52.

————. "Profit Without Honor." *New York* (November 5, 1975): 80-81.

————. *Readings in American Art.* New York: Praeger Publishers, 1975.

————. "The Second Generation: Academy and Breakthrough." *Artforum* 4, no. 1 (September 1965): 53-63.

Rosenberg, Harold. *The Anxious Object: Art Today and Its Audience.* New York: Horizon Press, 1969.

————. *Art on the Edge.* Chicago: University of Chicago, 1975.

————. "Introduction to Six American Artists." *Possibilities* 1 (Winter 1947-48): 75.

————. *Tradition of the New.* New York: Grove Press, 1961.

Rubin, Laurie. "Robert Motherwell: The Opens." Master's thesis. Brown University, 1984.

Rublowsky, John. *Pop Art.* New York: Basic Books, 1965.

Russell, John and Gablik Suzi. *Pop Art Redefined.* New York: Praeger Publishers, 1969.

Sahlins, Marshall. "Colors and Cultures" *Semiotica* 16 no. 1 (October 1976): 1-23.

Sandler, Irving. *The New York School: The Painters and Sculptors of the Fifties.* New York: Harper and Row, 1978.

————. *The Triumph of American Painting.* New York: Harper & Row, 1970.

Schimmel, Paul. *Action/Precision: The New Direction in New York.* Newport Beach, California: Newport Harbor Art Museum, 1984.

Schwartz, Tony. *Media: The Second God.* New York: Random House, 1981.

Seitz, William C. *Abstract Expressionist Painting in America.* Cambridge: Harvard University Press, 1983.

————. *The Responsive Eye.* New York: The Museum of Modern Art, 1965.

Smithson, Robert. "Entropy and the New Monuments." *Artforum* 4, no. 10 (June 1966): 26-31.

Shenkler, Israel. "A Pollock Sold for $2 Million, Record for American Painting." *The New York Times* (September 22, 1973): 1.

Snow, Robert. *Creating Media Culture.* Beverly Hills: Sage Publications, 1983.

"Sold Out Art: More Buyers Than Ever Sail in to a Broadening Market." *Life* 55 (September 20, 1963): 125-9.

Solomon, Alan. "The New American Art." *Art International* 8, no. 2 (March 1964): 50-55.

————. *New York: The New Art Scene.* New York: Holt, Rinehart & Winston, 1967.

"State of the Market." *Time* (June 21, 1963): 62.

Steinberg, Leo, "Contemporary Art and the Plight of Its Public." *Harper's Magazine* (March 1962): 17-25. Reprinted in Leo Steinberg, *Other Criteria: Confrontations with Twentieth Century Art.* London: Oxford University Press, 1972, 3-16.

————. "Jasper Johns: The First Seven Years of His Art." *Metro* 4/5 (1962): 23.

————. *Jasper Johns.* New York: George Wittenborn, 1963.

————. *Other Criteria: Confrontations with Twentieth Century Art.* London: Oxford University Press, 1972.

————. "Reflections on the State of Criticism." *Artforum* 10, no. 7 (March 1972): 37-49.

Swenson, G. "What is Pop Art? Part 2." *Art News* 62, no. 10 (February 1964): 40-43, 66-67.

Talmey, Allene. "Art is the Core: The Scull Collection." *Vogue* 144, no. 1 (July 1964): 116-124.

Theall, Donald. *Understanding McLuhan: The Medium is the Rear View Mirror.* Montreal: McGill-Queen's University, 1971.

Tillim, Stanley. "The Figure and the Figurative in Abstract Expressionism." *Artforum* 4, no. 1 (September 1965): 45-48.

————. "Further Observations on the Pop Phenonomen." *Artforum* 4, no. 3 (November 1965): 17-19.

Toffler, Alvin. *The Culture Consumers: A Study of Art and Affluence in America.* New York: Random House, 1973.

Tomkins, Calvin. *The Bride and the Bachelors.* New York: The Viking Press, 1968.

————. "Knowing in Action." *The New Yorker* (11 November 1985): 144-149.

————. *Off the Wall: Robert Rauschenberg and the Art World of our Time.* New York: Penguin Books, 1980.

————. "Profiles: Henry Geldzahler." *The New Yorker* (November 6, 1971): 58-113.

————. "Profiles: Leo Castelli." *The New Yorker* (May 20, 1980): 40-72.

Tuchman, Maurice, ed. *Recent Sculpture of the Sixties.* Greenwich, Connecticut: New York Graphic Society for the Los Angeles County Museum of Art, 1967. Essays by Lawrence Alloway, Wayne V. Andersen, Dore Ashton, John Coplans, Clement Greenberg, Max Kozloff, Lucy R. Lippard, James Monte, Barbara Rose and Irving Sandler.

Tuchman, Phyllis. "Minimalism and Critical Response." *Artforum* 15, no. 9 (May 1977): 26-31.

"Vanity Fair: The New York Art Scene." *Newsweek* (January 4, 1965): 54-59.

Wagstaff, Samuel, Jr. "Talking with Tony Smith." *Artforum* 5, no. 4 (December 1966): 14-19.

Waldman, Diane. *Transformations in Sculpture.* New York: Solomon R. Guggenheim Museum, 1985.

Warhol, Andy and Pat Hackett. *Popism: The Warhol 60's.* New York: Harper and Row, 1980.

Williams, Raymond. *Television Technology and Cultural Form.* New York: Schocken Books, 1975.

176

Woodward, Kathleen, ed. *The Myths of Information: Technology and Postindustrial Culture*. Madison, Wisconsin: Coda Press Inc, 1980.

Wolfe, Tom. "Bob and Spike." *The New York World Journal Tribune Sunday Magazine* (October 4, 1966). Reprinted in the *The Pump House Gang*. New York: Bantam Books, 1968.

Wollheim, Richard. "Minimal Art." *Arts* 39 (January 1965): 26-32. Reprinted in Gregory Battcock, ed. *Minimal Art: A Critical Anthology*. New York: E.P. Dutton, 1968, 387-99.

"You Bought It Now You Live With It." *Life* (July 16, 1965): 56-61.

Selected Bibliography: Individual Artists

Carl Andre

Bourdon, David. *Carl Andre: Sculpture 1959-1977*. New York: Jaap Rietman, Inc., 1978.

———. "The Razed Sites of Carl Andre." *Artforum* 5, no. 2 (October 1966): 14-17.

Lippard, Lucy. "New York Letter." *Art International* 9, no. 6 (September 1965): 58-59.

———. "Rejective Art." *Art International* 10, no. 8 (October 1966): 33-36.

Tuchman, Phyllis. "An Interview with Carl Andre." *Artforum* 8, no. 10 (June 1970): 55-61.

Waldman, Diane. "Holding the Floor." *Art News* 69, no. 6 (October 1970): 60.

Richard Artschwager

Richard Artschwager's Theme(s). Buffalo: The Albright-Knox Art Gallery; Philadelphia: The Institute of Contemporary Art, University of Pennsylvania; La Jolla: the La Jolla Museum of Contemporary Art, 1979. Essays by Suzanne Delahanty, Linda L. Cathcart and Richard Armstrong.

Walter Darby Bannard

Bannard, Walter Darby. "Color, Paint and Present-Day Painting." *Artforum* 4, no. 8 (April 1966): 34-37.

Champa, Kermit S. "The Recent Works of Darby Bannard." *Artforum* 7, no. 2 (October 1968): 62-66.

Krauss, Rosalind. "Darby Bannard's New Work." *Artforum* 4, no. 8 (April 1966): 32-33.

Rose, Barbara. "Abstract Illusionism." *Artforum* 6, no. 2 (October 1967): 33-7.

———. "The Primacy of Color." *Art International* 8, no. 4 (April 1966): 22-27.

Larry Bell

Coplans, John. "Larry Bell." *Artforum* 3, no. 9 (June 1965): 27-29.

———. *Los Angeles Six*. Vancouver: Vancouver Art Gallery, 1968.

———. *Ten from L.A.* Seattle: Seattle Art Museum, 1966.

Haskell, Barbara. *Larry Bell*. Pasadena: Pasadena Art Museum, 1972.

Lippard, Lucy R. "New York Letter: Recent Sculpture as Escape." *Art International* 10, no. 2 (February 1966): 48-58.

Rose, Barbara. *A New Aesthetic*. Washington: Washington Gallery of Modern Art, 1967.

Lee Bontecou

Americans 1963. San Francisco: San Francisco Museum of Art, 1963, 106-7.

Ashton, Dore. *Lee Bontecou: Skulpturen, Tekeningen, Lithos*. Rotterdam: Museum Boymansuam Beuningen, 1968.

Benedikt, Michael. "Sculpture as Architecture: New York Letter." *Art International* 10, no. 7 (Summer 1966): 22-23.

Coplans, John. "Higgins, Price, Chamberlain, Bontecou, Westerman." *Artforum* 2, no. 10 (April 1964): 38-40.

Ratcliff, Carter. *Lee Bontecou*. Chicago: Museum of Contemporary Arts, 1972.

Anthony Caro

Fried, Michael. *Anthony Caro*. London: Whitechapel Gallery, 1963. Reprinted in *Art International* 7, no. 7 (September 1963): 68-72.

———. "Anthony Caro and Kenneth Noland: Some Notes on Not Composing." *Lugano Review* 1, no. 3-4 (Summer 1965): 198-206.

———. "New Work by Anthony Caro." *Artforum* 5, no. 6 (February 1967): 46-47.

Forge, Andrew. Interview with Anthony Caro. *Studio International* 171, no. 873 (January 1966): 6-9.

Greenberg, Clement. "Anthony Caro." *Arts Yearbook* 8 (1965): 106-9.

Rubin, William. *Anthony Caro*. New York: Museum of Modern Art, 1975.

John Chamberlain

Anderson, Wayne. "American Sculpture: The Situation in the Fifties." *Artforum* 6, no. 10 (Summer 1967): 60-7.

Coplans, John. "Higgins, Price, Chamberlain, Bontecou, Westerman." *Artforum* 2, no. 10 (April 1964): 38-40.

Restany, Pierre. "The New Realism." *Art in America* 51, no. 1 (January 1963): 102-4.

Rose, Barbara. "Filthy Pictures." *Artforum* 3, no. 8 (May 1965): 20-5.

———. "Looking at American Sculpture." *Artforum* 3, no. 5 (February 1965): 29-36.

Tuchman, Phyllis. "An Interview with John Chamberlain." *Artforum* 10, no. 6 (February 1972): 38-43.

Waldman, Dianne. *John Chamberlain.* New York: The Solomon R. Guggenheim Museum, 1971.

Jim Dine

Diamonstein, Barbaralee. *Inside New York's Art World,* New York: Rizzoli. 1979.

Jim Dine: Five Themes. Minneapolis: Walker Art Center, 1984. Essays by Martin Freedman, Graham W. J. Beal and Robert Creely.

Mark di Suvero

Judd, Donald. "In the Galleries." *Arts Magazine* vol. 35, no. 1 (October 1960): 60. Reprinted in Donald Judd. *Complete Writings 1959-75.* Halifax: The Press of the Nova Scotia College of Art and Design, 1975.

Kozloff, Max. "Mark di Suvero: Leviathan." *Artforum* 5, no. 10 (Summer 1967): 41-46.

Monte, James K. *Mark di Suvero.* New York: Whitney Museum of Art, 1976.

Rose, Barbara. "On Mark di Suvero: Sculpture Outside Walls," *Art Journal* 35, no. 2 (Winter 1975-76): 118-125.

Friedel Dzubas

Carmean, E. A., Jr. *Friedel Dzubas: A Retrospective Exhibition.* Houston: Museum of Fine Arts, 1974.

Danieli, Fidel A. "New Work by Friedel Dzubas." *Artforum* 5, no. 4 (December 1966): 56-57.

Kozloff, Max. "An Interview with Friedel Dzubas." *Artforum* 4, no. 1 (September 1965): 49-52.

Millard, Charles W. *Friedel Dzubas.* Washington D.C.: Smithsonian Institution Press, 1983.

Moffett, Kenworth. *Friedel Dzubas.* Boston: Museum of Fine Arts, 1975.

———. "New Paintings by Friedel Dzubas." *Art International* 19 (May 15, 1975): 16-22.

Rose, Barbara. "In Absence of Anguish: New Works by Friedel Dzubas." *Art International* 7, no. 7 (September 1963): 97-100.

———. "The Second Generation: Academy and Breakthrough." *Artforum* 4, no. 1 (September 1965): 53-63.

Dan Flavin

Burnham, Jack. "Dan Flavin Retrospective in Ottawa." *Artforum* 8, no. 4 (December 1969): 48-55.

Dan Flavin, Fluorescent light, etc. from Dan Flavin. Ottawa: National Gallery of Canada, 1969.

Flavin, Dan. "'. . . in daylight or cool white,' an autobiographical sketch." *Artforum* 4, no. 4 (December 1965): 20-24.

———. "some remarks. . . : excerpts from a spleenish journal." *Artforum* 5, no. 4 (December 1966): 27-29.

Helen Frankenthaler

Ashton, Dore. "Helen Frankenthaler." *Studio International* 170, no. 868 (August 1965): 52-55.

Champa, Kermit S. "New Work of Helen Frankenthaler." *Artforum* 10, no. 5 (January 1972): 55-59.

Geldzahler, Henry. "An Interview with Helen Frankenthaler." *Artforum* 4, no. 2 (October 1965): 36-38.

Goossen, E. C. *Helen Frankenthaler.* New York: Whitney Museum of American Art, 1969.

Rose, Barbara. *Frankenthaler.* New York: Harry N. Abrams, 1971.

———. "The Second Generation: Academy and Breakthrough." *Artforum* 4, no. 1 (September 1965): 53-63.

Rubin, William. "Helen Frankenthaler." *XXXIII International Biennial Exhibition of Art, Venice, 1966.* Washington D.C.: National Collection of Fine Arts, Smithsonian Institution, 1966.

Al Held

Green, Eleanor. *Al Held.* San Francisco: San Francisco Museum of Art, 1968.

Pincus-Witten, Robert. "'Systemic' Painting." *Artforum* 5, no. 3 (November 1966): 42-5.

Rose, Barbara. *American Art Since 1900: A Critical History.* New York, Praeger, 1967.

———. "The Second Generation: Academy and Breakthrough." *Artforum* 4, no. 4 (September 1965): 53-63.

Sandler, Irving. *Al Held.* New York: Hudson Hills Press, 1984.

———. *The New York School: The Painters and Sculpture of the Fifties.* New York: Harper & Row, 1978.

Robert Indiana

McCoubrey, John W. *Robert Indiana.* Philadelphia: The Falcon Press for the Institute of Contemporary Art of the University of Pennsylvania, Philadelphia, 1968.

Swenson, Gene R. "The Horizons of Robert Indiana." *Art News* 65, no. 3 (May 1966): 48-49, 60-62.

Donald Judd

Agee, William C. *Don Judd.* New York: Whitney Museum of American Art, 1968.

Glaser, Bruce and Lucy R. Lippard ed. "Questions to Stella and Judd." *Art News* 65, no. 5 (September 1966): 55-61. Reprinted in Gregory Battcock, ed. *Minimal Art: A Critical Anthology.* New York: E.P. Dutton, 1968, 148-64.

Judd, Donald. *Donald Judd: Complete Writings 1959-75*. Halifax: The Press of the Nova Scotia College of Art and Design, 1975.

Krauss, Rosalind. "Allusion and Illusion in Donald Judd." *Artforum* 4, no. 9 (May 1966): 24-26.

Rose, Barbara. "Looking at American Sculpture." *Artforum* 3, no. 5 (February 1965): 29-36.

———. "Donald Judd." *Artforum* 3, no. 9 (June 1965): 30-32.

Smith, Brydon. *Donald Judd*. Ottawa: National Gallery of Canada, 1975.

Ellsworth Kelly

Ashton, Dore. "Kelly's Unique Spatial Experiences." *Studio International* 170, (July 1965): 40-42.

Coplans, John. *Ellsworth Kelly*. New York: Harry N. Abrams, 1973.

Fried, Michael. "New York Letter: Ellsworth Kelly at Betty Parsons Gallery." *Art International* 10 (January 1964): 54-56.

Geldzahler, Henry. "Interview with Ellsworth Kelly." *Art International* 8, no. 1 (February 1964): 47-48.

Goossen, E. C. *Ellsworth Kelly*. New York: Museum of Modern Art, 1973.

Paintings, Sculptures and Drawings by Ellsworth Kelly. Washington: Gallery of Modern Art, 1963.

Rubin, William. "The Big as Form." *Art News* 62, no. 7 (November 1963): 32-35, 64-65.

Sol LeWitt

Bochner, Mel. "Serial Art Systems: Solipsism." *Arts Magazine* 41, no. 8 (Summer 1967): 39-43.

Legg, Alicia, ed. *Sol LeWitt*. New York: The Museum of Modern Art, 1978. Essays by Lucy R. Lippard, Bernice Rose and Robert Rosenblum.

Roy Lichtenstein

Alloway, Lawrence. "On Style: An Examination of Roy Lichtenstein's Development, Despite a New Monograph on the Artist." *Artforum* 10, no. 7 (March 1972): 53-59.

———. *Roy Lichtenstein*. New York: Abbeville Press, 1983.

Boatto, Albert and Giordano Falzoni, eds. *Fantazaria* 1 (July/August 1966). Issue devoted to Lichtenstein.

Coplans, John. "An Interview with Roy Lichtenstein." *Artforum* 2, no. 4 (October 1963): 31.

———. *Roy Lichtenstein*. New York: Praeger Publishers, 1972.

Roy Lichtenstein. London: The Tate Gallery, 1968. Reprinted 1969.

Waldman, Diane. *Roy Lichtenstein*. New York: The Solomon R. Guggenheim Museum, 1969.

John McCracken

Aldrich, Larry. "New Talent U.S.A." *Art in America* 54, no. 4 (July/August 1966): 66.

Coplans, John. *Ten from LA*. Seattle: Seattle Art Museum, 1966.

V Paris Biennale. Pasadena: Pasadena Museum of Art, 1967, 10, 26-33.

Rose, Barbara. *A New Aesthetic*. Washington: The Washington Gallery of Modern Art, 1967.

Tuchman, Maurice, ed. *Recent Sculpture of the Sixties*. Greenwich, Connecticut: New York Graphic Society for the Los Angeles County Museum of Art, 1967.

Marisol (Escobar)

Campbell, Lawrence. "Marisol's Magic Mixtures." *Art News* 63, no.1 (March 1964): 38-41.

———. "The Creative Eye of the Artist Marisol." *Cosmopolitan* 158, no.6 (June 1964): 62-69.

Chapman, Daniel. "Marisol: A Brilliant Sculptress Shapes the Heads of State." *Look*, no.23 (November 1967): 78-83.

Diament de sujo, Clara. *Marisol*. Venezuela: Instituto Nacional De Cultura Y Bellas Artes, 1968.

———. *Marisol*. Rotterdam: Boysmans-Van Beuningen Museum, 1968.

Glueck, Grace. "Its Not Pop, Its Not Op—It's Marisol." *The New York Times Magazine* (March 1965): 34, 35, 45-49.

Loring, John. *Marisol Prints 1961-1973*. New York: The New York Cultural Center, 1973.

"Marisol." *Time* 81, no. 23 (June 1963): 76-77.

"Marisol's Mannequins." *Horizon* 5 (March 1963): 102-104.

Nemser, Cindy. "Marisol." *Art Talk: Conversations With Twelve Women Artists*. New York: Charles Scribner's and Sons, 1975.

"Sculpture—The Dollmaker." *Time* 85, no. 22 (May 1965): 80-81.

Steinem, Gloria. "Marisol: The Face Behind The Mask." *Glamour* 51, no. 4 (June 1964): 92-97, 127.

Teitz, Richard and Shulman Leon. *Marisol*. Worcester, Massachusetts: Worcester Art Museum, 1971.

Agnes Martin

Lippard, Lucy R. "New York Letter." *Art International* 9, no. 6 (September 1965): 60.

Martin, Agnes. *Agnes Martin: Paintings and Drawings 1957-75*. Essay by Dore Ashton. n.p.: Arts Council of Britain, 1977.

———. *Agnes Martin*. Philadelphia: Institute of Contemporary Art, 1973. Essay by Lawrence Alloway.

Michelson, Annette. "Agnes Martin: Recent Paintings." *Artforum* 5, no. 5 (January 1967): 48.

Robert Morris

Compton, Michael and David Sylvester. *Robert Morris*. London: The Tate Gallery, 1971.

Michelson, Annette. *Robert Morris*. Washington: The Corcoran Gallery of Art, 1969.

Morris, Robert. "Notes on Sculpture." *Artforum* 4, no. 6 (February 1966): 42-44.

———. "Notes on Sculpture, Part 2." *Artforum* 5, no. 3 (October 1966): 20-23.

Tucker, Marcia. *Robert Morris*. New York: The Whitney Museum of American Art, 1970.

Kenneth Noland

Alloway, Lawrence. *Systematic Painting*. New York: Solomon R. Guggenheim Museum, 1966.

Bannard, Walter Darby. "Notes on American Painting of the Sixties." *Artforum* 8, no. 5 (January 1970): 50-53.

Cone, Jane Harrison. "On Color in Kenneth Noland's Paintings." *Art International* 9, no. 5 (June 1965): 36-8.

Coplans, John. "Serial Imagery." *Artforum* 7, no. 2 (October 1968): 34-43.

Fried, Michael. *Kenneth Noland*. New York, Jewish Museum, 1965.

———. "New York Letter." *Art International* 7, no. 5 (May 1963): 69-71.

———. "Shape as Form: Frank Stella's New Paintings." *Artforum* 5, no. 3 (November 1966): 39-40.

———. *Three American Painters*. Cambridge: The Fogg Art Museum, 1965.

Judd, Donald. "Exhibition at the Jewish Museum." *Arts Magazine* 39, no. 6 (March 1965): 545.

Moffett, Kenworth. *Kenneth Noland*. New York: Harry N. Abrams, 1977.

Rose, Barbara. "Kenneth Noland." *Art International* 8, no. 5/6 (Summer 1964): 58-61.

Waldman, Diane. *Kenneth Noland: A Retrospective*. New York: The Solomon R. Guggenheim Museum, 1977.

Claes Oldenburg

Haskell, Barbara. *Claes Oldenburg: Object into Monument*. Pasadena: Pasadena Art Museum, 1971.

Oldenburg, Claes. "Extracts from the Studio Notes (1962-64)." *Artforum* 4, no. 5 (January 1966): 32-33.

Rose, Barbara. *Claes Oldenburg*. New York: The Museum of Modern Art, 1969.

Jules Olitski

Champa, Kermit S. "Olitski: Nothing but Color." *Art News* 66, no. 3 (May 1967): 37-38, 74-76.

Fried, Michael. "Jules Olitski's New Paintings." *Artforum* 4, no. 3 (November 1965): 36-40.

———. "Olitski and Shape." *Artforum* 5, no. 5 (January 1967): 20-21.

Moffett, Kenworth. *Jules Olitski*. Boston: Museum of Fine Arts, 1973.

———. *Jules Olitski*. New York: Harry N. Abrams, 1981.

Greenberg, Clement. "Jules Olitski." *XXXIII International Biennial Exhibition of Art, Venice, 1966*. Washington D.C.: National Collection of Fine Arts, Smithsonian Institution, 1966.

Larry Poons

Champa, Kermit S. "New Paintings by Larry Poons." *Artforum* 6, no. 10 (Summer 1968): 39-42.

John Coplans. "Larry Poons." *Artforum* 3 (June 1965): 33-35.

Kozloff, Max. "The Inert and the Frenetic." *Artforum* 4, no. 7 (March 1966): 40-44.

———. "Larry Poons." *Artforum* 3, no. 7 (April 1965): 26-29.

Lippard, Lucy R. "Larry Poons: The Illusion of Disorder." *Art International* 11, no. 4 (April 20, 1967): 22-26.

Moffett, Kenworth. *Larry Poons: Paintings 1971-1981*. Boston: Museum of Fine Arts, 1981.

James Rosenquist

Alloway, Lawrence. "Derealized Epic." *Artforum* 10, (June 1972): 35-41.

Calas, Nicolas and Elena Calas. "James Rosenquist: Vision in the Vernacular." *Arts Magazine* 44, (November 1969): 38-39.

Goldman, Judith. *James Rosenquist*. New York: Penguin, 1985.

Lippard, Lucy R. "James Rosenquist: Aspects of a Multiple Art." *Artforum* 4, no. 4 (December 1965): 41-45.

Schjeldahl, Peter. "The Rosenquist Synthesis." *Art in America* 60 (March/April 1972): 56-61.

George Segal

Friedman, Martin. *George Segal: Sculptures*. Minneapolis: The Walker Art Center, 1978.

Hunter, Sam and Don Hawthorne. *George Segal*. New York: Rizzoli, 1984.

Kaprow, Allan. "Segal's Vital Mummies." *Artnews* 62, no. 10 (February 1964): 30-33, 65.

Seitz, William. *George Segal*. New York: Harry N. Abrams, 1972.

Van der Marck, Jan. *George Segal*. New York: Harry N. Abrams, 1975. Revised edition, 1979.

Frank Stella

Cone, Jane Harrison. "Frank Stella's New Paintings." *Artforum* 6, no. 4 (December 1967): 34-41.

Fried, Michael. "Shape as Form: Frank Stella's New Paintings." *Artforum* 5, no. 3 (November 1966): 18-28.

———. *Three American Painters*. Cambridge: The Fogg Art Mu-